Literature and the
Visual Arts in Tudor England

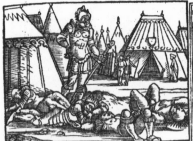

Literature and the Visual Arts in Tudor England

DAVID EVETT

The University of Georgia Press

ATHENS AND LONDON

© 1990 by the University of Georgia Press
Athens, Georgia 30602
All rights reserved
Designed by Barbara E. Williams
Set in Bembo
Typeset by Tseng Information Systems
Printed and bound by Thomson-Shore
The paper in this book meets the guidelines for
permanence and durability of the Committee on
Production Guidelines for Book Longevity of the
Council on Library Resources.

Printed in the United States of America

94 93 92 91 90 5 4 3 2 1

Library of Congress Cataloging in Publication Data
Evett, David.
Literature and the visual arts in tudor England /
David Evett.
p. cm.
Bibliography: p.
Includes index.
ISBN 0-8203-1155-3 (alk. paper)
1. Arts, English. 2. England—Civilization—16th
century. I. Title.
NX543.A1E94 1990
700'.942'09031—dc20 89-4913
CIP

British Library Cataloging in Publication Data
available

the sense of space, which is
the basis of all earthly beauty

E. M. Forster,
HOWARDS END

Contents

Illustrations

Preface

This project began to sprout when I was cultivating the *locus amoenus* and other features of renascence landscape description, with help from an American Philosophical Society Grant-in-Aid. It got lots of sun and water when a year as acting chairman of an art department put me in close daily touch with art historians, especially Walter Leedy and Michael Jacobsen. It really took off during a stint at the Courtauld Institute of Art in London, working in the library and photo collection; talking with John Shearman, then acting director, who had invited me to come, John Newman, and the other scholars; and sallying forth to read in other collections and especially to visit more than forty Elizabethan and Jacobean houses and as many more churches and institutional structures. When I returned, my colleagues in the English department of Cleveland State University underwrote a leave quarter during which part of the book was drafted. A Senior Research Award from the Graduate College at CSU supported a very profitable sojourn at the Huntington Library in San Marino, California, studying and recording the visual features of nearly four hundred sixteenth- and early seventeenth-century books. And a Summer Stipend award from the National Endowment for the Humanities financed a return trip to England to take a second, more informed look at some things and to see some others for the first time. To the staffs of the Courtauld and the Huntington, and the scholars I met there, much thanks; also to those who met my needs at the Victoria and Albert Museum Library, the British Library, the Warburg Institute, the Public Record Office, the Royal Institute of British Architects, the National Trust, the Suffolk County Record Office, and the Cambridge University Library in England; and in the United States the Folger Shakespeare Library, the Newberry Library, the Library of Congress, the National Gallery Library, the Cleveland Public Library, the library of the Cleveland Museum of Art, and the university libraries at Harvard, Wisconsin-Madison, Indiana, Michigan, Case Western Reserve, and Cleveland State.

In the early going, S. K. Heninger, Jr., and Speed Hill gave me strong encouragement from afar, as did Phillips Salman, Barton Friedman, and Walter Gibson close up. Parts of the book were first presented to meetings of the Cleveland State University Faculty Research Seminar, the Midwest Modern Language Association, the North Central Conference of the Renaissance Society of America, the Ohio Shakespeare Conference, and the Spenser at Kalamazoo sessions of the Medieval Institute. They received much salutary criticism. All the chapters were read at various stages by friends and colleagues. I would like to thank Peter Lindenbaum, Richard Peterson, and Suzanne Woods for help with individual chapters, and Michael Donnelly, Stuart Evett, Jeffrey Ford, Kent Hieatt, and Anne Lake Prescott for responses to the book as a whole. Janis Bolster copyedited the manuscript with exemplary care and tact. For their help with the British end of the thing I wish to express my gratitude to Sally and Christopher Brown, Carol and Barrie Rutter, Whit and Lynne Hieatt, Mary Edmond, Jim Murrell, and Sir Roy Strong. My wife, Marianne Brish Evett, has fostered tender but promising seedlings and pruned back my wilder shoots with equal solicitude and firmness. None of these good folk, of course, bears any responsibility for errors, omissions, misreadings, misseeings, and other blunders. No doubt many statements appear here that will seem to readers working from another set of experiences shallow, pointless, redundant, even wrong. I hope that neighboring statements will supply compensatory information, understanding, or pleasure. But in the end, I can only confess that I have fallen in love with the undertaking, and appeal to our fallen state, by quoting another *Unfortunate Traveller:* "Frail earth, frail flesh, who can keep you from the work of your creation?" My father, to whose memory this book is dedicated, would have understood.

Literature and the
Visual Arts in Tudor England

Introduction

In the early 1970s, when I became seriously interested in relationships between the visual arts and literature in Tudor England, the field was dominated by Wylie Sypher's *Four Stages of Renaissance Style* (1955). I found Sypher's study of style in the painting, sculpture, architecture, and literature of Western Europe during the fifteenth, sixteenth, and seventeenth centuries stimulating but unsatisfactory. Although he paid gratifying attention to English literature, he said very little about English work in painting, sculpture, architecture, and nothing about the decorative arts. And he treated all the English arts in stylistic terms derived from art historians who subordinated everything to their admiration for the major monuments of the Italian Renaissance.

In Sypher's defense, I must note that when he was preparing to write his book, even most British cultural historians thought that the visual arts of Tudor England were pretty feeble, so that not much had been published about them. Since 1955, however, a great deal of additional work has been done, so that the qualities of Tudor art can be better appreciated in their own right, rather than in competition with the Continent. Since then, moreover, the many voices of postmodernist critical theory have encouraged us to look at the arts from a variety of new perspectives. (See the Bibliographical Note at the end of this book.) Yet the most recent general surveys—Sypher's chapter "Painting and the Other Fine Arts" in *William Shakespeare: His World, His Work, His Influence,* edited by John F. Andrews (1985), and Murray Roston's *Renaissance Perspectives in Literature and the Visual Arts* (1987)—continue to treat Tudor literature as a derivative of Italian culture, and to ignore most of the theoretical issues.[1] I have thought it desirable, therefore, to undertake a fresh general survey of interrelationships between the visual and verbal arts of the Tudor period, one that tries to take account of the most recent work in critical theory and in both art and literary history.

The book explores a set of interdependent propositions, which can be briefly stated as follows. During the sixteenth century in England,

the position of artists with respect to the world around them underwent a change. At the beginning of the period, artists occupied well-defined slots within a largely stable culture on whose behalf they expressed a body of customary ideas by means of customary forms. By the end of the period, artists' status had become problematic, and the most important of them, at least, were expressing relatively new ideas by means of new forms. The development particularly involved a transition from a traditional, paratactic mode of esthetic organization to an innovative, hypotactic mode. That transition both owed something and contributed something to the change in status. It was also in part determined by the importance, in both education and arts practice, of the imitation of classical models and of Continental works themselves similarly imitative—in other words, by the effects on English culture of that complex of ideas and procedures which—as I explain shortly —I will call the renascence. But none of the major stylistic expressions of renascence thought and knowledge in the idealistic mode— Renaissance, Mannerist, Baroque—completely displaced those already on the ground, nor could they seal out alternative voices and visions, the Tudor versions of the Grotesque and the Demotic modes.[2] By the end of the century, then, artists had a considerable repertory of styles upon which they could call, according to their skill, knowledge, and temperament and to the exigencies of their relationships with patrons and other consumers.

The argument arises from the premise that in sophisticated societies, like that of Tudor England, the fine and applied arts of the mainstream tend to be idealistic, in the sense that their development responds to, if it is not wholly governed by, ideas generated by intellectuals inside and outside the community of artists, under the supervision and with the approval of those who hold most of the political and economic power at the time. The mainstream arts thus largely express the attitudes and interests of the establishment. Yet as artists actually produce works of art they may also embody impulses from outside the establishment. One set of sources for such impulses comprises the traditions, habits, expectations, and needs of ordinary people (including most artists themselves) going about their ordinary business. A second comprises the emotional and imaginative activity of the individual artist trying to deal with the tension between the desire to relax or rebel and the pressure to perform or conform. Both the practical or Demotic mode and the fantastic or Grotesque mode tend to be subversive, to constitute an implicit or even (but less often) explicit critique of the

idealistic modes. (I hope I do not need to point out that artistic modes hardly ever appear in pure forms, and that as common people enter the establishment, or as the establishment is forced to take account of them, or as individual artists carry out commissions or work on their own, the modes interact, struggle, mingle, recover, and change.)

I argue in chapter 1 that at the beginning of the period the dominant style was what I will call *Traditional* (since the terms *Gothic* and *International* are inadequate to comprehend the variety of work encountered). So much is attested by many authorities, whose scholarly and critical work has demonstrated that the Traditional style persisted through most of the sixteenth century. More precisely, well-known studies by John M. Berdan, Mark Girouard, Eric Mercer, John Peter, Douglas L. Peterson, Nikolaus Pevsner, and Yvor Winters have documented the hardihood of certain indigenous forms and attitudes. Recent work by Sidney Anglo, Gordon Kipling, and J. A. van Dorsten has called attention to the International Style influence of French and particularly of Burgundian culture in the early decades of the Tudor period. And Girouard, Sir Roy Strong, and others have explored a "Gothic Revival" in the arts of the 1580s and 1590s.

The overwhelming emphasis of nearly all twentieth-century work on Tudor culture has fallen on what almost everybody calls "the Renaissance." Hundreds of studies of individual artists and writers, of groups of artists, of genres, of particular plays and paintings, buildings and poems, have employed the term. Earlier studies of the several arts have titles like *Tudor Renaissance* (by James Lees-Milne) and *The Elizabethan Renaissance: The Cultural Renaissance* (by A. L. Rowse). For the most part this term, rather loosely defined, has been applied to all the mainstream arts of Tudor England from the accession of Henry VII to the death of Elizabeth and beyond. But Sypher argued that the art historical sequence of Gothic-Renaissance-Mannerist-Baroque more usefully discriminates among various kinds of Tudor work, and despite the distortions introduced by the Italian bias of this approach, the critical yield of work applying this paradigm has been considerable. In its aftermath I propose to use the term *Renaissance* in its customary art historical sense as referring to an art founded on direct and conscious imitation of classical models, governed by an ideal of order in both philosophical and esthetic ways, dominated by esthetic features that produce a sense of balance, stability, harmony, and unity (see ch. 2). Since I reserve *Renaissance* for a particular style, I need something else for the complex movement in education, philosophy, and the arts that lasted from

around 1400 to around 1650 and that had the recovered riches of classi-
cal culture at its center; I will use for this larger phenomenon the term
renascence.

I offer challenges to the positions of earlier scholars along two princi-
pal vectors. The first involves local adjustments to the mainstream ap-
proach in both its monovalent (renascence) and its polyvalent (Gothic-
International-Renaissance-Mannerist-Baroque) forms. I argue that the
renascence occurred only in a hesitant and piecemeal way in England,
now touching form but not subject, now subject but not form, affect-
ing a work here, an artist or patron there, a whole genre only now
and then, and a whole art like painting or the drama only after a long
period of exploration and preparation. My position is that the Tradi-
tional style of the fifteenth century retained great vitality in most of
the arts throughout the Tudor period, so that nothing resembling the
High Renaissance in quattrocento Italy occurred in England until Stuart
times. I also attempt to analyze the particular qualities of that style and
to account for its endurance in the period. I accept Sypher's addition to
the lexicon of Tudor arts criticism of the terms *Mannerist* and *Baroque,*
but with extensive reservations that proceed from a sense of style as
determined by practical as well as esthetic and psychological consider-
ations—that is, by factors like crafts practice and the need to satisfy the
desires of patrons.

In my second line of argument I assign much more importance than
has hitherto been customary to the practical and fantastic strains in
Tudor art. I try to show how the Grotesque mode—closely linked with
the imagination by the theorists and artists of the period—was both
more extensively used and more significant than has been recognized,
and I begin here to explore some ways in which Tudor artists used the
Grotesque to relieve or counteract the professional and personal pres-
sures of life under the Tudor establishment. I also try to show, first,
how popular attitudes and crafts practices affected the idealistic main-
stream by resisting change, and then how significant changes in impor-
tant practical areas of sixteenth-century English life induced esthetic
changes to whose stylistic manifestations I assign the term *Demotic*.

This enterprise has required careful reconsideration of the critical
methods used by Sypher and other predecessors. Interarts criticism may
properly be said to have begun during the period covered by this book,
when the common rhetorical bases of literary, musical, and visual arts
theory promoted the *paragone,* the debate about the relative value of
the various arts, and when the Horatian tag *ut pictura poesis,* as well as

vernacular offspring like "speaking picture" and "visible poem," implied that the esthetic circuits connecting the sister arts were both open and reversible. By the mid-eighteenth century, it had become routine for critics to see *The Faerie Queene* as a gallery of pictures or a Gothic cathedral, or to give *King Lear* the character of a mossy ruin. So severe was the check administered to this facile analogizing by G. E. Lessing's *New Laoköon* (1766), however, that although writers addressing popular audiences have freely crossed the borders, those more sensitive to theoretical issues have moved warily, and often turned back.

Still, the urge to connect is apparently irresistible. During the last century, it has tended to operate over a field opened up by Heinrich Wölfflin. Like other art historians he was extremely conscious of questions of style and sought to grasp stylistic elements that would allow him to draw the scattered array of individual artists and works into unified configurations. His concept of the *Geistesgeschichte,* the unifying essence of a historical period, was easily extended from the visual arts to literature; under it scholars trained some as literary historians, some as art historians, some as cultural historians, have produced many stimulating works. (For a quick survey see the Bibliographical Note.) But like the Leigh Hunts of the earlier age their connections have sometimes been silly—the statement, for example, that *The Merchant of Venice* has a diagonal rather than a horizontal or vertical construction and is thus Baroque (or Mannerist, or merely late Renaissance), or that "L'Allegro" is "linear" while *Paradise Lost* is "painterly."

This sort of reductionist botanizing provoked a magisterial rebuke from the most distinguished historian of criticism of our time, René Wellek (1941, [with Warren] 1956). He was troubled by the difficulties of finding valid connections between the visual and verbal work of those few artists—Michelangelo, Blake, Rossetti—who have succeeded in both media, and by the fact that verbal and visual arts do not develop at the same rate in a given place, so that it is often difficult to connect developments in the arts with philosophy or historiography. Finally, however, he rested his skepticism on his conviction that we cannot deal with two or three arts at a time because our understanding of the individual arts is so imperfect: "Only when we have evolved a successful system of terms for the analysis of literary [and presumably also visual] works of art can we delimit literary periods" (1941, 62). A neighboring position was taken (though subsequently modified) by Svetlana and Paul Alpers (1972), respectively authorities in seventeenth-century art and sixteenth-century literature. They argued that the aims and meth-

ods of the two disciplines, as currently practiced, are divergent, and that scholars best serve their own interests by attending to their own particular tasks.[3] Richard Wollheim proposes that all attempts to transfer concepts of style from art to art run "grave risk of falsehood, and possibly nonsense," because style exists essentially in the mind of the artist and hence properly governs only his or her own work (Lang 1987, 186). And from still another angle, James F. Merriman has assailed the thoroughly unscientific character of the *analogies, comparisons, parallels, correspondences,* and *counterparts,* that are the key terms of most interarts criticism (1972–73). Not until we have identified some fundamental elements, he says, such as contrast, repetition, balance, disclosure, and so on, then devised unambiguous methods for finding and measuring them, then used the data so derived to establish reliable norms, will we be able to make meaningful interarts comparisons.[4]

The positivistic disposition of these critiques exposes some very real problems, even as it suggests ways to solve them. The concept of *Geistesgeschichte,* for instance, has invited critics like Sypher to ignore hard questions about the means by which forms and images were transmitted from artist to writer, writer to artist. Study of the visual arts of the renascence has largely meant study of Italian artists and works; this emphasis has carried over into interarts analysis in the face of the fact that most northern writers—and especially English writers—had little direct experience of the southern works. By the same token, the relationships between the arts of England and of northern Europe, especially the Low Countries, are just beginning to be studied in detail. The earlier concentration of art historical interests on the so-called major arts—painting, sculpture, architecture—distorted understanding of a period when the decorative arts and especially the ephemeral arts of masques and entrees and entertainments not only absorbed a great deal of artistic energy, including the energy of major artists, but also often brought artists and writers into close working conjunction.

The connections between the arts in Tudor England that ought to be least problematic turn out to be disappointing. Few surviving sixteenth-century English pictures, either paintings or prints, illustrate literary subjects. When sixteenth-century English writers mention the visual arts, it is almost always in highly general terms; scarcely ever do they write about particular artists or works, and their treatment of the visual arts is likely to strike us as thoroughly unsophisticated.[5] But their cross-references do direct our attention to a value of interarts criticism

scanted by positivistic skepticism. Philip Sidney and others understood that "a speaking picture" was more likely to fix a point in the memory than either a mute painting or a blind poem by itself. The same heuristic function can be served by interarts criticism. In a fundamental sense all scholarship and all criticism are ana-logical, that is, based on the identification and organization of particular features, taken from their contexts, juxtaposed with similar or contrasted features taken from other contexts. We use analogy to help us (and the urge toward metaphor is significant) grasp things, get a handle on them, come to terms with them. In particular, we use analogy to express the unfamiliar and the unique.

But those are the very qualities inherent in the materials with which scholars engaged in interarts comparisons are trying to deal. The visual and verbal arts of the sixteenth century in England are alien to us by virtue of time and cultural change. They interest us, in part, because they are alien; hence we do not exactly wish to dissolve the strangeness, only to find ways to make sense of it, to connect it with our own experience. Those same works, though they may share generic and other features with other works, become valuable to us as we come to perceive how they differ, not only from works of our time but also from each other. Each process can be clarified for us by analogy, comparison. And as many a humanistic text will show, the analogic activity also helps us to *learn* the object (whether visual or literary), by supplying additional hooks with which the work may be bound into the memory. Rosemond Tuve observes that a label like Mannerist or Surrealist can be "a provocative term used by knowledgeable critics to suggest relations" (quoted in Passmore 1972, 586). In effect, the use of such a term summarizes the scholarly debate over its meaning carried on up to the date of the work, and hence has an important allusive effect. Alastair Fowler reminds us that we can only perceive the novel and unconventional by contrast with the familiar and conventional (1972, 488). This is not to say that the skeptics' strictures are not valid; in particular, it is not to deny that the kind of formulaic oversimplification that reduces the art of a whole age to five or six terms like *Grotesque* or *Demotic* is likely to teach bad lessons. Wellek, in fact, accepts that real relations between the arts exist and can be studied, but only according to a "complex scheme of dialectical relationships which work both ways, from one art to another and *vice versa,* and may be completely transformed within the art which they have entered" (1941, 61). Karl Kroeber offers a stimu-

lating phrase: a major period like the Romantic age or the renascence is "a coherence of alternatives . . . ; to understand it at all is to understand an indeterminate, even contradictory, phenomenon" (1975, 9).

In what follows, then, I have tried to carry through some implications of the foregoing. The critical method is distinctly eclectic; I have borrowed from my predecessors now one analytical program, now another, including several of the approaches suggested by Wellek, Merriman, and others, such as attention to socioeconomic context, longitudinal study of particular features, analysis in terms of "forms of the mind," consideration of artists' effect on the "visual horizons" of writers. Most recent scholarship in this area concentrates on iconography. The approach has greatly enriched our understanding. But precisely because so much has already been done I here touch on iconographic issues only in passing, choosing to emphasize instead what might be called psychological matters. I have also made pragmatic use of what seem to me useful elements in postmodernist theory.

The relationships presented and explored are of several kinds. Some are quite direct and as it were documentary—explicit comments by authors about art and artists, treatment in two or more media of the same subject, and so on. Some devolve from relatively rigorous arguments or are supported by a range of informed opinion wide enough to seem persuasive. Some are looser, more purely inferential, even analogical, such as the relationships between architectural and literary structure that I will propose in chapters 1 and 7. But I have striven to base such relationships on the kinds of common ground represented by common educational experience or economic pressures demonstrably felt across many disciplines. Since I share Wellek's and Merriman's concern with the validity of interarts analogies, I have looked for genuinely comparable features. The elements suggested by Merriman (following Kenneth Burke)—repetition, contrast, and so on—turn out on further consideration to be the elementary places of traditional rhetoric. These lay at the foundation of a renascence education; it has hence seemed to me appropriate on historical as well as theoretical grounds to investigate them.

The overwhelming problem in writing the book has been organizational: the material is both voluminous and highly various, covering dozens of artists in many media across the whole sweep of the sixteenth century and beyond, so that setting paths and fences has been difficult. The general outline begins with a discussion of the Traditional style. There follow chapters on renascence and Renaissance, on emblems and

programs, on patronage, on visual and literary grotesquerie, on land-scape, on architectonic structure, on the autonomous artist, on Mannerism and the Demotic, and finally on self-consciousness. Since each of these chapters centers on a successively later point in the sixteenth century, the topics constitute a chronological sequence. The structure must be loose. Most chapters treat early and late materials, both because the different modes and styles tended to operate throughout the period and because such cross-references help unify the book. I have not hesitated to follow lines of development past Elizabeth into Jacobean and even Caroline times in order to reach what seems to me some logical culmination, and to treat as "Tudor" the Stuart output of artists who reached adulthood before 1603. There is thus a good deal of chronological overlap, and many features appear and reappear as different emphases reveal different relationships. But the chapters are not meant to be read as independent essays; there is a developing skein of argument, which I attempt to knit up in the final pages. At many points I have been concerned to illustrate what I take to be typical Tudor arts practices with references numerous and various enough to suggest ubiquity; readers who do not share my pleasure in catalogs are invited to skip.

In the end, the book constitutes an approach to a sixteenth-century English esthetic, one that tries to take some account of the whole range of phenomena in the literary and visual arts of Tudor England, both practical and theoretical. Such a work unavoidably involves reductive oversimplification: *caveat lector*. In any case, no grand scheme was in my head when I started out, and it is my sense that as I found most pleasure, so readers may find most profit, in the various particular relationships between the palaces and plays, the pictures and poems, turned up in the course of the study. When all the talk about method is over, it is finally the application of whatever principles emerge to particular works—and for particular readers—that matters: "And of this book this learning mayst thou taste."

I

Plane Style: The Tudor Art of Surfaces

For the most part, Tudor art is dominated not by the Renaissance elements that have claimed the attention of most twentieth-century critics but by the images and forms of what I will call the Traditional style. Tudor arts practices were deeply conservative, partly because of the way the arts were taught and learned, partly because the ideas of the more important patrons rested on a deeply conservative sense of what art was and was supposed to do. The tradition so sustained, I will argue, has three distinctive qualities: it is *epideictic,* designed to bestow honor; it is literally or figuratively *planar,* two-dimensional; and it is *paratactic,* built up by the serial addition of elements of relatively equal importance, rather than by the formal as well as the logical subordination of some elements to others.

To account for English resistance to the esthetic changes that affected Italy, France, Spain, and the Low Countries so much more rapidly and fully, let us concentrate on two factors. The first is practical and arises from the fact that most of those crafters who did the work—not only the "mechanicals," in Shakespeare's word, but also the gentlemen who hired them when those same gentlemen sang love songs to ladies, and the ladies who embroidered as they listened to those songs—were trained in the apprentice system by masters so trained, and hence tended to perpetuate old forms. Indeed, the retrospective esthetic force of crafts practice in all the arts can hardly be underestimated; it meant, among other things, that much of the innovation that did appear was the work of foreign crafters, especially from the Low Countries.

A second conservative factor was the central importance in Tudor thought of the concept of order. Philosophically, the concept descended

to the Tudors from Aquinas and the other scholastics, and beyond them from Aristotle, whose works continued to dominate instruction in the universities throughout the century, and thence to infiltrate the educational system from top to bottom. The concept was fostered not only politically but also esthetically by the concentration of cultural as well as political authority in the royal court. As we will see, a concept of order, and especially the kind of order that entails predictability, characterizes the form as well as the content of the Traditional strain in Tudor art.

Both crafts inertia and the commitment to order are well illustrated by the development of Tudor architecture. Since almost no churches were built, nor were any other structures "public" in our modern sense, our concentration must be on domestic architecture.[1] There was a major building boom during the sixteenth century, but crafts traditions, slow to change, ensured that the ordinary houses of tradesmen and farmers were not in fact very different from those that ordinary people built in the previous or the succeeding centuries (Airs 1975; Pevsner 1960).[2] Hence we must concentrate on the large houses of the gentry and aristocracy. Manor house architecture had begun to alter significantly during the fourteenth century, as changing social and military practices removed the necessity for fortification. But the living quarters retained the traditional format of common hall in the middle, kitchen and offices on one side, and solar (common term for the suite of bedroom, closet, and one or more parlors constituting the private lodgings of the owner) on the other. The ensemble articulated the social order through a sequence of spaces, from the elevated solar and dais, through the hall and its screen, to the offices, which usually occupied the lowest ground on the site and in some notable cases were even dug below ground level. But there was no effort to accommodate the hierarchy within an esthetically unified whole; each element expressed its unique function in its unique external form. During the sixteenth century a few new features were often added—notably the long gallery —and the private quarters, with their parlor or great chamber or withdrawing room, grew larger and more opulent, while the hall began to grow relatively smaller. Yet the format remained the same, and the history of sixteenth-century domestic architecture in England is very largely the history of an effort to accommodate the old functional layout to the demands of newer esthetic values. The process is epitomized in the black-and-whites of Cheshire and Lancashire, houses like Little

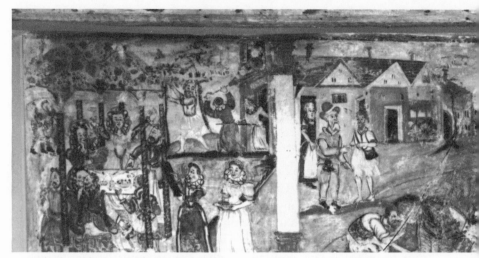

1. Artist unknown, *The Prodigal Son* (late sixteenth century), mural painting. Knightsland Farm, Potters Bar, Herts. Photo: Royal Commission on the Historical Monuments of England.

Moreton and Speke, moated, half-timbered, decorated on the outside with motifs dating back two or three hundred years, yet striving for fashion on the interior, and at Speke including some of the finest late Renaissance wood and plaster craftsmanship to be found anywhere in northern Europe.

An even more accessible (but also more vulnerable) Traditional art was that of mural painting. Most medieval and early Tudor Englishmen who could afford it painted the interior walls of their houses and churches, at the very least with ornamental patterns, at best with scenes from the Bible, the lives of saints, history, and romance.[3] Of the thousands of square yards of wall so bedecked, virtually all have fallen victim to iconoclasm and changing tastes (though new techniques of conservation are restoring widespread samples, if they are only spectral reminiscences of the original splendor).[4] A great deal of medieval work apparently still remained at the end of the century; the wall paintings Shakespeare refers to at several points all seem Gothic in subject matter, if not necessarily style, and the representation of the Last Judgment that was the principal ornament of the Guild Chapel in Stratford was not

defaced until after 1563 (Fairchild 1972, 132). Moreover, new work in the old manner continued until near the end of the period; the painting of the Prodigal Son at Knightsland Farm in Hertfordshire, although the figures wear Elizabethan dress and the picture is framed by painted Corinthian columns, has the linearity of style, ignorance of principles of perspective, and representation of several different episodes from the same story within the same visual space typical of Traditional narrative painting (fig. 1). Only in decorative painting did Renaissance grotesquerie, which did not require mastery of the new pictorial techniques and which had strong affinities with an important medieval strain, signal a strong Continental impact.

The same persistence can be observed in the book arts. Protestant iconoclasm officially wiped out the market for religious pictures (and doubtless at the same time helped to promote the vogue for portraits). In fact, the established taste for religious illustration continued to be met by Bibles and other religious books throughout the Elizabethan period; on the whole these attained levels of sophistication well above the average for Tudor decorated books (figs. 2, 3). De facto Protestant

The seconde par=
te of the olde Testament.

The boke of Josua.
The boke of the Judges.
The boke of Ruth.
The first boke of the Kynges.
The seconde boke of the Kynges.
The thirde boke of the Kynges.
The fourth boke of the kynges.
The first boke of the Cronicles.
The seconde boke of the Cronicles.
The first boke of Esdras.
The seconde boke of Esdras.
The boke of Hester.

2. Bible, Coverdale translation (1535), title page, part 2. Reproduced by permission
of the Huntington Library, San Marino, Calif.

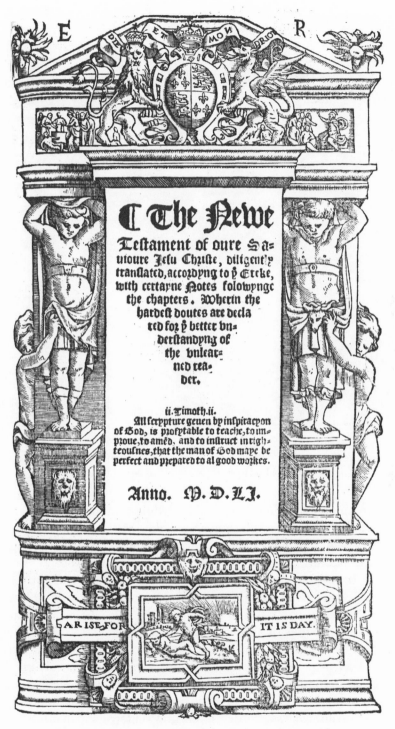

℩ The Newe
Testament of oure Sa=
uioure Jesu Christe, diligently
translated, accordyng to þ Grcke,
with certayne Notes folowynge
the chapters. Wherin the
hardest doutes are decla
red for þ better vn=
derstandyng of
the vnlear-
ned rea=
der.

ii. Timoth.ii.
All scrypture geuen by inspiracyon
of God, is profytable to teache, to im=
proue, to amēd, and to instruct in righ=
teousnes, that the man of God maye be
perfect and prepared to al good workes.

Anno. M.D.LI.

ARISE FOR IT IS DAY.

3. Bible, New Testament, Taverner translation (1551), title page.
Reproduced by permission of the Huntington Library,
San Marino, Calif.

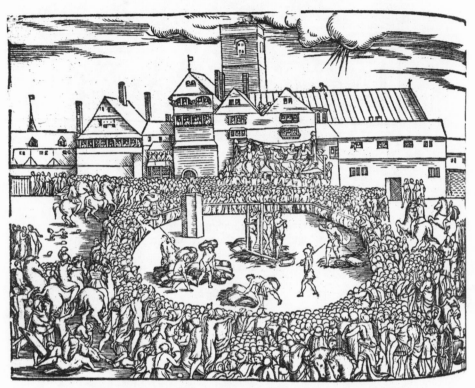

4. John Foxe, *Actes and Monuments of the British Martyrs* (1563), "The Martyrdom of Ann Askew," wood engraving. Reproduced by permission of the Huntington Library, San Marino, Calif.

hagiography, in the form of the many editions of John Foxe's *Actes and Monuments,* was richly illustrated, and although their subject matter is gruesomely repetitious, the woodcuts are reasonably sophisticated in their rendering of both space and the human form (fig. 4). But the early Tudor practices of manuscript illumination and book illustration, virtually all based on French and Flemish models, virtually all International in style, continued to be exercised on official documents and in ornamental books of all kinds. Renaissance influences were strongest in borders, initials, and ornaments (for which the blocks seem often to have been acquired at second hand). But in type style, layout, and illustrations, a combination of chauvinism and crafts inertia was strong, so that not until toward the end of the period did Renaissance motifs begin to dominate. Even so, the development was more rapid in prints than in paintings, since many more books than painters or their works crossed the Channel (Hind, Corbett, and Norton 1952–55; Hodnett 1973). [5]

We can read the same story in literature. The continuing popularity and authority of medieval works—at least sixteen editions of various works of Chaucer during the century, at least twenty-one of Lydgate—kept medieval models before other writers' eyes. In two important genres, the lyric and the ballad, the transmission both of whole works, whether popular or learned, and of the principles of their construction from master to student, ensured continuity in the way crafts practices assured it in the visual arts. English writers at the beginning of the century—Skelton, Barclay, Hawes—continued to work in familiar medieval genres, such as the ballade, the allegorized dream vision, the complaint, and in familiar forms such as rime royal and decasyllabic couplets. C. S. Lewis seems to be correct in arguing that renascence influences in British literature in the early Tudor period must mainly be sought north of Tweed (1954). In England, medieval themes and forms prevailed in the larger works well on into the century. The *de casibus* notion of tragedy and the predominant rime royal in *A Mirror for Magistrates* (1555) link it more closely to Chaucer's *Monk's Tale* than to Chapman's *Bussy D'Ambois* (1604). Morality plays, of course, continued to be written and performed until the early seventeenth century. Add to these holdovers the more conscious gothicism of Sidney's *Arcadia* and Spenser's *Faerie Queene,* and the persistence of Traditional attitudes and imagery in love lyric and satirical pastoral, and you have a solid course of medieval masonry at the foundations of sixteenth-century English literature.

The art so determined owes much to some characteristics carried over from the Middle Ages. These derive from a conception of art as the public expression of conventional ideas and values. They include a fondness (not to say mania) for ornament (applied to rule and hence making regular patterns), a commitment to *copia,* a habit of aggregative structure in which individual items nevertheless remain discrete, and an iconic turn of mind.[6] All are appropriate to a style determined by a concentration on *surfaces,* in both concrete and figurative uses of the term. And all belong to an esthetic that works by satisfying established expectations. The definitive image is perhaps that special room that every prosperous sixteenth-century Englishman added to his old house or built into his new one, a long, narrow room marked off at large intervals by windows and at smaller intervals by the recurrence, both vertical and horizontal, of wainscoting, on which, in turn, hung a stately procession of portraits—not identical, of course, but similar in style and composition. The correspondence is neatly marked by the title of a typical Elizabethan work of literature, *A Gorgeous Gallery of*

Gallant Inventions (1578), which carries out its titular metaphor in the figures of its commendatory sonnet (by Anthony Munday) and in the lack of formal or substantial connection from one poem to the next.

As one passes through these galleries, the thing to note is their systematic character, their predictability. A great deal of it was achieved by parataxis, the application of relatively simple, freely repeatable patterns.[7] We can begin with verse, part of an anonymous "Comparison of Life and Death" from Tottel's *Songes and Sonettes* (1557):

> The pleasant years that seem so swift that run,
> The merry days to end so fast that fleet,
> The joyful nights of which day daweth so soon,
> The happy hours which mo do miss than meet,
> Do all consume as snow against the sun;
> And death makes end of all that life begun.
> (Rollins and Baker 1954 [hereafter R & B], 207)

This is the stuff of a thousand poems from the middle third of the century, conventional phrases and ideas ordered into strict iambs by means of pointless inversion, imprecise diction, padding out with redundant particles and auxiliaries, with both alliteration and rhyme as obvious repetitive devices. That neither thought nor language shows any particular originality or novelty strikes us as a defect, of course. But it seems to have been a positive principle to Englishmen of the period. (Indeed, even in our post-Romantic age, with its emphasis on the esthetic value of novelty, most people derive pleasure from the repetition of familiar materials, as popular television, popular music, and the programming of "classical" music in concert halls and on radio stations indicate.)

Since the poem does not try to imitate life by imitating its actual sensory qualities, but rather tries to imitate the art that has preceded it, and only beyond that art a Nature radically abstracted and organized, it calls attention to its own artifice, especially by means of grammatical inversions and other devices indicating that the order of words is determined by metrical considerations and not by the patterns of normal speech. Indeed, the concepts and the ornaments all descend from medieval traditions, just as the elements of Tudor interior decoration do. Decorators of the Middle Ages perhaps applied their patterns more spontaneously and freely.[8] In Tudor work, as J. H. A. Gotch has indicated, we begin to be more aware of an element of conscious design applied to the segments of the whole (1928, 124). But Eric Mercer has

5. Architect unknown, Longford Castle, Wilts. (1580), facade. Photo: Royal Commission on the Historical Monuments of England.

determined that the main item in the sixteenth-century royal accounts of payments for decoration continued to be for patterned painting, charged for by the yard and laid on anything that could be reached with a brush (1953, 151–52).[9] Patterns began to be applied during as well as after construction. Diaper work, in which a checkerboard or diamond pattern was made by contrasting the blue-black of so-called burned brick with the red of normal brick, was commonly used in houses throughout the sixteenth century, including Hampton Court. At Longford Castle, Wiltshire, home of Sir Thomas Gorges, white limestone contrasts with dark flint in a striking pattern of linked lozenges running completely around the house (fig. 5). The same sort of geometric regularity, in which uniform modules are repeated until the space is filled, characterizes the Tudor wainscoting that remains the principal attraction in many English rooms, whether the simple rectangles formed by panel and molding or the more complex but still predictable repetition of linenfold. Similar effects are achieved by painting on plastered walls. And the immense areas of molded and painted plaster and carved slate on the walls of Nonsuch only brought the principle to some kind of climax.

Even more than in medieval work, such patterns seem to be a principle of Tudor design, not by-products of the crafts procedures in-

volved. The builders of Romanesque or Gothic churches made all the arches constructed during the same stage of building identical, to facilitate the cutting and setting of the stones. But when building was resumed after a hiatus—adding a choir to an existing nave, for instance, or a lady chapel to a choir—the new intervals were almost always different. Or consider the contrast between a typical leaf of an illuminated manuscript, especially the fluency and freedom of the borders, and a typical Elizabethan title page, usually made out of rectilinear elements in pairs. In either case, symmetry—balance across junction—is more likely to occur in Tudor than in earlier work. And as David Summers has shown, symmetry is a decisive quality in an art attempting to bring experience under rational control, from disorder into method (1982).

Both medieval and Tudor works, however, are likely to be built up by accumulation, *amplificatio,* by serial assemblages of discrete items. What happened in England in the sixteenth century was that the late medieval enthusiasm for *copia verborum* was extended from language to every aspect of culture, and the age's various recoveries and discoveries meant the unsealing of great new image hoards.[10] With special respect to literary style, the tendency displays itself early on in aureation, the accumulation of synonyms. Later, as the repertory of formulas and figures expands, it manifests itself in *enargeia* as well as *copia verborum.* Tudor authors love lists, of whatever length: the enumeration of particulars is their basic "descriptive" technique; thus Thomas Tusser recalling his student days or Thomas Lodge invoking a *locus amoenus:*

> O painfull time, for every crime,
> What toesed ears, like baited bears!
> What bobbed lips, what jerks, what nips, what
> hellish toys!
> What robes, how bare! What colledge fare!
> What bread, how stale! What penny ale!
> Then Wallingford, how wart thou abhorr'd of silly
> boys!
>
> (R & B 285)

> O shady vales, O fair enriched meads,
> O sacred woods, sweet fields, and rising mountains,
> O painted flowers, green herbs where Flora treads,
> Refresh'd by wanton winds and wat'ry fountains.
>
> (R & B 239)

In both these pieces, anaphora is as conspicuous as catalog, and complements the underlying grammatical pattern with phonological predictability, as the moldings at the edge of wainscoting emphasize the regular dimensions of the panels. In both literature and architecture, we find the materials of art regarded as items in a warehouse, able to be used in many contexts, transferable not only between works but also often between media—and typically arrayed, with other items of the same type and value, to form a period or block, itself then strung together with other blocks to form an extensible series. Thus Lodge might replace his vales with glades, his meads with leas, reduce the list to three items or expand it to thirty, and the stanza would remain at its conceptual core the same. The process occurs on a larger scale with whole books. Elizabethan publishers routinely reissued popular works several times, augmenting each new edition by adding new items of the same type. It happened to Tottel's *Miscellany,* to *A Mirror for Magistrates,* to Foxe's *Actes and Monuments,* to works by individual authors like Tusser and even Drayton. An analogous practice treated the Bible not as a unified whole but as a collection of works—Old Testament, Psalms, Proverbs, Apocrypha, Gospels, Epistles, Revelation (each with its own title page)—often augmented by other units (metrical psalter, prayer book, genealogy) and with initials and other ornaments varying in style, size, and quality from section to section and page to page.

Copia imaginis, an unbridled plenitude of figurative items, also characterizes the visual arts.[11] Items from the natural world constitute the most numerous class. Embroideries, like some of those attributed to Bess of Hardwick and her royal prisoner, Mary, Queen of Scots, were often made over patterns taken from printed bestiaries and herbals; a few of the paper tracings, pricked for transfer, survive.[12]

It is appropriate here to repeat that the ornamentation of surfaces did not begin with the Tudors; we have seen that most of the decorative traditions in sixteenth-century England were carried on from late medieval beginnings. Nor was it restricted to England. During the late fifteenth and the sixteenth centuries, all over Europe, new wealth meant new houses to adorn, and new additions to older ones, and funds for the redecoration of existing buildings, on the outside, now, as well as the inside. The result was an outburst of ornament. Compton Wynyates, Warwickshire, built around the turn of the sixteenth century, has forty-eight chimneys: the brickwork is fluted, spiraled, checkered with such prodigal invention that no two are alike; the lack of repetition itself becomes a repetitive principle. At about the same period, the soaring

gatehouse at Layer Marney was richly adorned with terra-cotta tiles in an assortment of quattrocento motifs: the old idea of *tower* given a fresh statement. Throughout the period, the vertical surfaces of furniture —headboards, chairbacks, cabinet doors and sides—were elaborately carved or inlaid. So were doors, chimneypieces, and especially the hall screens that constituted the main decorative element in the principal room. Ceilings were first coffered or ribbed, then later, as the secrets of Italian stucco work crossed the Channel, given figural treatment, with portrait roundels at Montacute, heraldic birds at Losely Park, roses at Burton Agnes, grapes at Speke, and emblematic scenes at Blickling. Similar treatment was accorded friezes and overmantels, with a great deal of individual variation—an exemplary warning against sexual role reversal at Montacute, an allegory of the abandonment of the active for the contemplative life at Bucklands Abbey, a moralized emblem at Little Moreton, a scene from Ovid at Hardwick.

The tendency involved not just architecture and furniture but smaller objects as well. There was a great vogue for decorative earthenware imported first from Italy, later from the Low Countries (Caiger-Smith 1973). Sand molds for fire screens produced low-relief designs ranging from simple stars and fans to emblematic images of considerable sophistication. The handles of knives and fans, the hilts of swords, and the stocks of guns were etched, carved, inlaid, bejeweled. Tudor women spent a great deal of their time embroidering bed hangings, table runners, even codpieces, to say nothing of skirts, sleeves, caps, handkerchiefs, and christening gowns. Pattern books imported from the Continent or printed in England, such as Thomas Geminus's *Morysse and Damashin* (1568), supplied models. Nothing that could be decorated went undecorated as long as the time and money held out.

I think it essential to observe that both seriation and *copia* belonged to the fundamental apparatus of Tudor education, and hence acquired the force of authority as well as habit. Transferability, discreteness, independence of context, were taught from the very beginning by the scraps of Latin, not composed for the occasion but taken out of context, that illustrated the various points of grammar; they were taught again in the published or manuscript florilegia that supplemented the grammar text, and yet again in the commonplace book, the student's own florilegium. Within the limits of decorum, any image could go anywhere. A similar message was conveyed by the traditional procedures in which any image belonged simultaneously to many symbolic systems, so that the doctrine of correspondences, the typological in-

terpretation of Scripture and history, the four-level reading of Scripture and allegory, the linkages within the Great Chain of Being, all reinforced the belief that while different images might have different ontological or moral values, their esthetic values were identical: any one was potentially as useful as any other in any given place (in both the ordinary and the rhetorical senses of the word). These habits both fertilized and were in turn fertilized by the encyclopedic tendencies of a newly pluralistic northern European culture, in which the infusion of fresh intellectual and economic energies into existing forms produced a paroxysm of world atlases, polyglot Bibles, anthologies of all kinds, herbals, bestiaries, topographies, books like Foxe's *Actes and Monuments, A Mirror for Magistrates,* Camden's *Brittania,* Meres's *Palladis Tamia,* paintings like the funeral portrait of Sir Henry Unton, buildings like Nonsuch, Theobalds, or Knole.

Most of these works share the same rhetorical impulse: they *celebrate* something. It might be the virtues of plants, in an herbal, or the beauties of cities and countries, in an atlas. It might be the achievements of travelers or the sacrifices of martyrs, the works of a single man or the works of God. In each case, the mode—and its attendant techniques— is the most comprehensive of the three rhetorical modes, the epideictic, the rhetoric of praise and blame.[13] For our purposes, the most striking group of Tudor epideictics comprises those thousands of portraits that still soberly line the walls of English houses and museums. Large or small, skillful or clumsy, those pictures exploit a small, fixed, and hence predictable set of poses, costumes, even colors. Such limitations, it seems to me, are indeed common to all epideictic art, verbal as well as visual. All the young men in the miniatures tend to look alike, just as all the emperors and patrons and bishops of Latin panegyric seem to share the same qualities of magnanimity, heroism, and moral virtue, and just as one Petrarchan lady tends to be described, and apparently to act, very much like another, even while her nonparticularized Petrarchan admirer is sounding and feeling much like all the others. Epideixis—public praise—typically means bringing the particular subject into registration with an established model whose significant attributes then become normative.[14] Within the category, novelty consists only in possessing an unusually large share of the desirable qualities. And the inverted epideictic, of ugly women and craven, mean-spirited men, is just as conventional as its positive counterpart.

An important characteristic of the Tudor esthetic appears here: *the significance of any given image is likely to be determined by reference to a norma-*

tive program or schema outside the work itself. And part of the pleasure to be drawn from such art comes from being in on the game. We know what it means, we know what should come next, we feel that we are in some sense joint authors of the work. If that is the case, however, the materials are not strictly the artist's, and not strictly the reader's or viewer's, but have a quasi-independent existence, as of courtiers waiting in an anteroom to be turned productive within the structure of the court (Kemp 1977, 357–58). What especially interests me about such materials is their transferability, the ease with which they change livery. Like the ornaments of Tudor decor, they appear singly, or in endless combinations that are not in fact in their overall effect very different one from the next, in large works and small, urban (or urbane) and rural (or crude), in assorted media. The top-to-toe *descriptio puellae* appears in sonnets and plays, in pastoral, in romance; it can be adapted to real or imaginary letters and turned without much difficulty from one valence to another by the simple negation of conventional terms ("My mistress' eyes are nothing like the sun"). The natural images embroidered on Elizabeth's gowns turn up again in *Euphues*.[15]

These matters invoke the concept of the garment of style, of rhetoric as the invention and application of ornament. George Puttenham's formulation in *The Arte of English Poesie* is familiar but worth quoting again: "This ornament we speak of is given to it by figures and figurative speaches, which be the flowers as it were and colours that a Poet setteth upon his language by arte, as the embroderer doth his stone and perle, or passements of gold upon the stuffe of a Princely garment, or as th'excellent painter bestoweth the rich Orient coulours upon his table of pourtraite" (G. G. Smith 1964, 1:143). If Puttenham really knows anything about painting, he is saying that even the most basic materials of the artist's medium in effect ornament, rather than express, the underlying idea. Yet there is an important implication that the apparently superficial application of gold thread to cloth or paint to panel produces an object ("a Princely garment") that is fundamentally, not superficially, different from the unadorned thing from which it began. Lear will be ornamented, as it were, with a hundred knights; take away these "additions to a king" and he becomes a political nothing. Historically, the deposition of Richard II was accomplished by various political and legal procedures. To Shakespeare the artist, the deed is done when Richard puts off his royal attributes—crown, mace, orb—and smashes his *image* to the floor.[16] According to such principles, the conventional materials—the sententia, exempla, even the meter and rhyme

—of poems like Googe's "Epitaph on the Death of Nicholas Grimald" or Lord Vaux's "Of a Contented Mind" (I take examples more or less at random from a convenient anthology) are ornaments. Hence even the Plain style was decorated:

> By heaven's high gift, in case revived were
> Lysip, Apelles, and Homer the great—
> The most renowm'd, and each of them sans peer
> In graving, painting, and the poet's feat—
> Yet could they not, for all their vein divine,
> In marble, table, paper more or less,
> With cheezel, pencil, or with pointel fine
> So grave, so paint, or so by style express
> (Though they beheld of every age and land
> The fairest books in every tongue contrived
> To frame a fourm and to direct their hand)
> Of noble prince the lively shape descrived
> As, in the famous work that Aeneids hight,
> The namecouth Virgil hath set forth in sight.
>
> (R & B 205)

Vergil, says Googe (himself borrowing tropes that Joachim du Bellay had previously used to honor a woman), has constructed the normative image "of noble prince" (Prescott 1978, 42–43). Other artists, in their several media (which Grimald considers interchangeable—again no sense that changing the medium changes the message), can only try to "frame a fourm" using the particular ornaments of their own art. Their task is not to devise a new idea, but to construct an outside—a speaking picture, in Sidney's phrase; a garment, in Puttenham's—for one that exists already.

Neoclassical critics ask that works be constructed from scratch, like machines; romantic critics that they grow from seeds, like trees; modernist critics that they flow from the depths of minds, like dreams. All three traditions have tended to scorn art produced by applying decorations to surfaces. But all share a deeper commitment to the concept that form ought to follow function. And if the function of art is epideictic, it will perforce work from the outside; it will deal with what is publicly on view or with those private qualities that accord with publicly accepted values. The idea may lead us toward a reassessment of both the character and the quality of Tudor art.

A good place to start is with architecture. During the sixteenth cen-

tury, English domestic architecture turned itself inside out (Girouard 1959, 216; 1963b, 37; Mercer 1962, 9; Pevsner 1960).[17] The medieval manor house had been conceived as a place of refuge, a container; it was built around a court, onto which its various doors and windows chiefly gave, and its exterior was a defensive rampart against human and natural foes. With the decay of feudalism and the corresponding shift from military to economic power as the agency of social discrimination, the house became a means for communicating economic status; it opened its doors and windows to the world, and an elaborate facade, incorporating the latest fashions in architectural decoration, supplemented a large retinue as the medium by which landowners or wealthy city merchants expressed their economic and social superiority. We are talking about a politics of imagery. It was just at the turn of the sixteenth century that Henry VII, using architecture to express his new authority, built Richmond Palace—in its time, the rival of all but the most magnificent palaces across the Channel. His son was assertive in architecture as in other things; he constructed or made extensive additions to palaces at Eltham, Richmond, Hampton Court, Whitehall, and especially Nonsuch, which established architectural standards on a royal plane (fig. 6). By a trick of fate, these stone boasts illustrate a favorite literary *topos* of the age (observe the seriation):

> High towers, faire temples, goodly theaters,
> Strong walls, rich porches, princelie pallaces,
> Large streetes, brave houses, sacred sepulchres,
> Sure gates, sweete gardens, stately galleries,
> Wrought with faire pillours, and fine imageries,
> All those (O pitie) now are turned to dust,
> And overgrowen with blacke oblivions rust.
> (Spenser, *Ruines of Time* 92–98)[18]

The same fate overtook most of the other prodigy houses of the age. Somerset House, Leicester's Kenilworth and Leicester House, Hatton's Holdenby, Burghley's Theobalds, all have fallen to fire, the Commonwealth, or simple desuetude. All were built, however, to perpetuate their builders' fame, and a few survive: Howard's Audley End (though much diminished), Sackville's Knole, Robert Cecil's Hatfield House. And the autoepideixis they proclaimed extended beyond architecture into all the other expressive modes. The same courtiers dressed themselves in elaborate, expensive clothes, feted and were feted with elabo-

rate, expensive shows, and patronized scholars, poets, and artists to paint them, praise them, and ornament their households.[19]

This penchant for display, which in proportion to their means affected ordinary knights and burghers as well as great magnates, no doubt reflects a fundamental economic change, the development of a considerable and growing pool of liquid capital, wealth beyond a sustenance level available for consumption. But a general esthetic characteristic seems to mark the economic change. The "new" style in sixteenth-century English architecture was essentially (and literally) superficial: it consisted largely in the application of the principle of symmetry to the plane of the facade, leaving the spatial organization of the interior largely unchanged. From about 1530 onward virtually every substantial Tudor house exhibited this feature. Indifference to three-dimensional considerations also informed the surprising failure of English painters to learn (or at least to apply) the principles of illusionistic perspective, and the tendency even of foreign artists like Holbein and Eworth to relinquish perspective as an important device in their English work.[20] Moreover, English painting techniques throughout the period were, in Wölfflin's terms, linear rather than painterly. Ellis Waterhouse calls sixteenth-century English portraiture "flat" (1978, 19). Similar statements have been made about things as diverse as ceilings, chimneys, staircases (Adams-Acton 1949, 77; Sekler 1951).[21]

It would not be right to call Tudor art merely superficial; it has its own profundities. But it would not be far wrong to call it an art of surfaces. If sixteenth-century English people encountered pictures, they were likely to be woodcuts or engravings in books.[22] For our purposes, it is important that in the print media literature and the visual arts come closest together, occupy the same space and often within it work toward the same ends in their different ways. It is even more important that the print techniques and especially the woodcut techniques that dominated English printing throughout the sixteenth century produced linear, surface-bound pictures.

Similar conditions applied to another art form that achieved wide currency during the period and that served as a vehicle for the spread of emblematic and other images, the tapestry. On grounds of fashion, comfort, and convenience, tapestries took over from mural paintings as the wall decoration of choice in comfortable English houses from the mid-century onward. The English climate had never been very hospitable to fresco; the popularity of tapestries may also have benefited

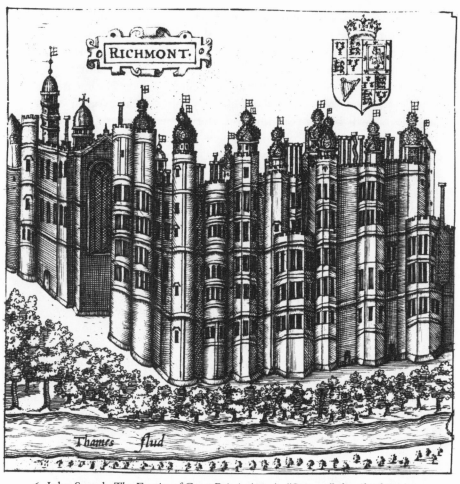

6. John Speed, *The Empire of Great Britain* (1611), "Surrey," details showing
Richmond Castle (*left*) and Nonsuch Palace (*right*). Reproduced by permission
of the Huntington Library, San Marino, Calif.

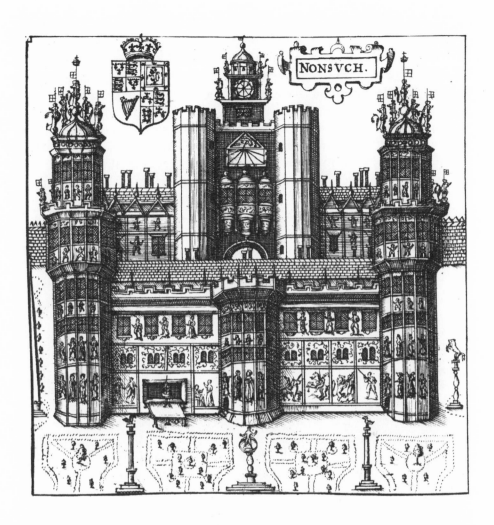

from the tendency to apply Protestant iconoclasm less rigorously to utilitarian than to purely ornamental items. Whatever the cause, the enthusiasm was great. Those who could afford them bought and hung important tapestries in all their public and their most important private rooms (see W. G. Thomson 1973, 239–76).[23] Those who could not (and this included tavern keepers as well as private citizens) bought cloths painted with the same kinds of designs. It is thus understandable that many of the most important iconophrastic passages in Elizabethan literature and especially in Spenser describe tapestries rather than paintings.[24] Moreover, most of the paintings to be seen in the England of Edward, Mary, and Elizabeth were portraits; pictures in which opportunities to use space significantly might arise—episodes from the Bible and classical literature, representations of hunting, farming, gardening, and other domestic activities—were much more likely to occur in prints, and in the tapestries and other woven objects based on them, than in paintings.[25] This meant, however, that ordinary Englishmen met both emblematic and scenic images in media distinguished by their planar characteristics. Prints and tapestries emphasize the surface because of technical qualities of the methods by which they produce images. We also perceive them as flat on the basis of tactile as well as visual experience. Most of us do not handle paintings much, but we handle paper and cloth all the time, and we know them as materials that present themselves in two dimensions. Tapestries, moreover, specifically exist to adorn surfaces.

The prevailing superficiality (if I can use the term in a purely descriptive and noninvidious sense) of the visual tradition certainly contributed to the remarkable absence of spatial depth in Tudor portraiture. There were other factors. Genetically, the work derives initially from Burgundian models and later from work by Holbein, Bronzino, and Antonio Mor, who had already for their own reasons begun to forfeit the illusion of spatial depth so diligently sought by earlier Renaissance artists (Strong 1969b, 8) (see Mor's portrait of Mary I, fig. 7). The development certainly owes a great deal to the purposes for which portraits were commissioned and hung; we will see later how their emblematic or iconic nature, calling up the role, the idea, more than the person, pulls the quality of the painting away from naturalism and hence away from naturalistic devices like perspective.[26]

An implication of this development is that much more even than the typical Renaissance easel painting, Elizabethan portraits were conceived as pictures completely freed from any particular architectural context.

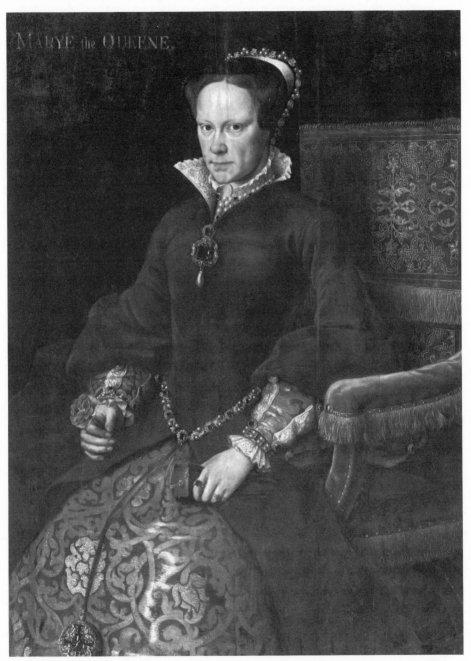

7. Antonis Mor, *Mary I* (c. 1555). Isabella Stewart Gardner Museum, Boston.

Since they did not need to seem to be windows into an artificial space, they could come and go. Portability is the special virtue of the one representational form in which English artists are agreed to have produced work of international quality, the portrait miniature. Elizabeth had a special traveling case, in construction very like the little traveling shrines and altars of Catholic Europe, in which she could carry several favorite miniatures with her when she went on progress. Miniatures not only are flat objects, able, like a print, to be held in the hand, but also are painted (until the change of style at the turn of the seventeenth century) in a linear manner against backgrounds that, being featureless, are also dimensionless.

Here and elsewhere, the principle is the same: the epideixis, the setting off, of house or garment or person by ornament encadred within uniform framing devices. The full richness of Elizabethan ornamentation appears only in something like the so-called ballroom at Knole, completed by Thomas Sackville, earl of Dorset, at about the transition point from Tudor to Stuart rule (fig. 8). It has a plaster ceiling with fleurs-de-lis, holly sprays, festoons, and the Sackville leopards; a carved frieze of gryphons, mermaids, satyrs, harpies, flowers, and more leopards (in repeating segments); paneling divided into sections by elaborately floriated pilasters with masks at their capitals; and an inlaid marble chimneypiece that seems at first glance to be decorated with lozenges, dentils, and other relatively plain patterns, but turns out on a closer inspection to include flowers, fruits, goblets, candelabra, birds, and putti—the whole apparatus of Renaissance grotesquerie. And there seems to be no reason why the subsets of decoration could not be indefinitely repeated, augmented with others, or diminished.

What this room is telling us is that the contradiction between the principles of plenitude and predictability is only apparent; both arise from the same underlying esthetic assumptions. It is important that the plenitude can be reduced to method, regimented, made predictable, by encapsulating the individual figures in all their variety within geometrically determined frames, and by seeking symmetry wherever possible. It is even more important that the relationships thus determined are purely arbitrary, juxtapositional, paratactic, established by the application of some principle external to the objects themselves rather than by any intrinsic genetic or associational bonds (as quantitative meter was applied to English language or classical pilasters to English architecture).[27] Indeed, the relationships among the various patterns in most Tudor art are equally adventitious; the geometric principle that governs

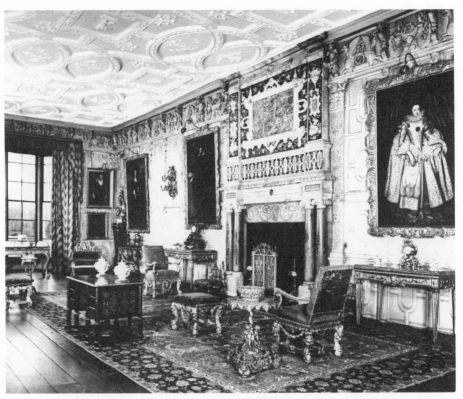

8. Architect unknown, Knole Park, Kent (c. 1603), the ballroom.
Photo: The National Trust.

any given set rules only to the edges of its own particular surface. Thus in the room at Knole, the wainscoting is divided vertically into four rows of identical panels, with a horizontal band further making two groups of two. The individual units of the frieze all contain a pair of identical but reversed images. The rhythm of the woodwork is thus duple. But the organization of the chimneypiece, though it has some doublets in it, is basically triple. The ceiling is seven units long, five wide; where both the chimneypiece and the paneling feature lozenges and rectangles, the ceiling ribs form circles and squares. Nor do the subsets correspond in size, either directly or proportionately; hence the joints between the units at the edges of the surfaces only occasionally correspond. The net effect is one of local unity, overall discontinuity, in radical contrast to the effect of the equally (though more subtly) elaborate interiors of Robert Adam, in which each individual item is

related in interval, scale, even color, to all the others in the room, and in which the whole has been conceived as a three-dimensional unity (Allen 1937, 1:12).[28]

It will be instructive to look from this room toward another of Sackville's works, the induction he wrote forty years earlier for the third edition of A Mirror for Magistrates (1563). The poem is a notable instance of *copia;* in effect it takes a passage of some 50 lines in book 6 of the *Aeneid* (268–316), describing Aeneas's passage through Hell Mouth and across the Styx, and amplifies it about tenfold, into a piece of 553 lines in seventy-nine rime royal stanzas. In the process, Sackville turns Vergil's 6-line evocation of the forest at night, with references to Jupiter, Dis, and the moon, into a 70-line introduction to a nocturnal dream vision, supervised by Saturn, Boreas, Venus, Hermes, Mars, Virgo, Thetis, Scorpio, Sagittarius, the Bear, Phaeton, Titan, and Cynthea. The mantle of pathos with which Vergil invests the entire episode is folded here around the allegorical figure of Sorrow (fifteen stanzas of description, complaint, and narrator's reaction). Most significantly, the nine lines of Vergil's catalog of personified sorrows— Luctus, Curae, Senectus, Metus, and so on, some only named, a few presented with an epithet—expand under Sackville's pen into 294 lines of detailed description. The lists are not quite identical. Although every Vergilian item but one has a Sackvillian counterpart the order is quite different.[29] Neither list betrays any apparent principle of sequence— causal, for example, which would place Dread before Famine and Death after War. Yet while the lack of logical sequence is appropriate enough to the Vergilian crowd, through whom Aeneas must push to get to Charon's boat, it seems much less natural in Sackville's vastly more leisurely account: that is, it seems to have the same arbitrary quality we saw in the juxtaposition of elements in the decor at Knole. In both cases, we are dealing with an art in which the individual item—the pilaster, the unit of paneling, the metrical foot, the allegorical figure —is considered independently rather than in subordination to some integrated whole.

As at Knole, indeed, each item in the poem is spatially discrete, and the units can be counted in simple integers. Sackville's versification, both in this induction and in the two acts (4 and 5) he wrote for the first regular English tragedy, Gorboduc (1561), is by the standards of the period fluent and versatile:

> By him lay heavy Sleep, the cousin of Death,
> Flat on the ground and still as any stone,

A very corps, save yielding forth a breath;
Small keep took he whom Fortune frowned on
Or whom she lifted up into the trone
Of high renown; but as a living death,
So, dead alive, of life he drew the breath.

<div align="center">(R & B 281–87)</div>

In contrast to most of his contemporaries, Sackville apparently understood the expressive possibilities of metrical inversion and substitution (first and fourth lines), enjambment (fifth and sixth lines), and variable caesura. Sackville's part of *Gorboduc* exhibits considerably more metrical freedom than Thomas Norton's, and Sackville is much more likely than Norton to enjamb and to end a clause in the middle of a line. Still, the great majority of lines in the poem are regular and end-stopped. And Sackville strictly respects the boundary of the stanza, the basic geometrical element. Not only are all seventy-nine stanzas of the poem end-stopped, but in all but one case the division between stanzas corresponds to a change of subject or aspect. (One transitional stanza [lines 246–52] has Revenge, the subject of the preceding stanza, in its first line and Misery, the subject of the following stanza, in its last line.) The result is a great sense of stability, which is further enhanced by the uniformity of emotional temperature and pressure throughout the work; no changes in tone break the stately gloom. The expectation, once set, is repeatedly satisfied.

Certain features of the poem strike us as arbitrary, though not exactly surprising. It is not clear why Malady is worth only one stanza while Old Age gets six. The iconophrastic description of War's shield, conflating Vergil's accounts of the arming of Aeneas in book 8 with the depiction of the Fall of Troy on the doors of Carthage's Temple of Juno in book 1, is not only different in kind from the other descriptive passages in the poem but also much longer (eleven stanzas) than any other segment. By contrast, the introduction of Henry, duke of Buckingham, whose tale follows the induction in the *Mirror,* seems to modern readers curiously brief, even perfunctory.

Both the form and the content of this art convey order, stability, control. It exhibits the qualities summarized in one word by Chaucer's Wife of Bath: *authority*. That is, it represents views thoroughly consonant with those held by the established institutions of its time, and it carries forward the forms and procedures, by and large, of its most honored predecessors. Similar qualities govern John Lyly's *Euphues*. Lyly published it late in 1578; he was twenty-five or twenty-six years old, a

few years out of Oxford, in the third generation of a family of notable humanists, at a point where his own career had seemingly stalled. In the grand humanistic tradition, the book was a device whereby an aspiring young scholar hoped to attract the patronage of powerful men (Hunter 1962, 49–69). I would like to suppose it more than just quibbling to say that the characters, setting, and sentiments of *Euphues* are two-dimensional (not to say superficial). Neither the people nor the places are particularized beyond the most conventional attributes (young, comely, rich, appropriately educated). The narrative framework is slight and utterly predictable and serves mainly to stretch the web of sententious rhetoric of which the work is mainly composed. Since the moment of its publication, *Euphues* has been chiefly admired (and condemned) for its style. In his dedication to Lord Delaware, Lyly insists on the plainness of his "simple pamphlet." But he goes on to illustrate (read "decorate") the claim with a whole string of proverbs and similes, each saying the same thing in different if not particularly fresh words:

> Though the style nothing delight the dainty ear of the curious sifter, yet will the matter recreate the mind of the courteous reader. The variety of the one will abate the harshness of the other. Things of greatest profit are set forth with least price. When the wine is neat there needeth no ivy-bush. The right coral needeth no colouring. Where the matter itself bringeth credit, the man with his gloss winneth small commendation. It is therefore, methinketh, a greater show of a pregnant wit than perfect wisdom in a thing of sufficient excellency to use superfluous eloquence. We commonly see that a black ground doth best beseem a white counterfeit. And Venus, according to the judgment of Mars, was then most amiable when she sat close by Vulcanus. If these things be true which experience trieth—that a naked tale doth most truly set forth the naked truth, that where the countenance is fair there need no colours, that painting is meeter for ragged walls than fine marble, that verity then shineth most bright when she is in least bravery—I shall satisfy mine own mind, though I cannot feed their humours which greatly seek after those that sift the finest meal and bear the whitest mouths. It is a world to see how Englishmen desire to hear finer speech than the language will allow, to eat finer bread than is made from wheat, to wear finer cloth than is wrought of wool. (1964, 4–5)

Lyly does confine himself to a middle-style level of diction and to a relatively simple syntax, and the passage is somewhat less carefully measured and balanced than many he puts in the mouths of his characters in the tale proper. Even so, a passage decrying ornament is full of ornaments. Lyly has ransacked an uncommonly well-stuffed commonplace book to find eleven ways to say that plain words most effectively express truth and four ways to ridicule the contemporary taste for verbal and other finery. How well he himself satisfied this taste is clear from the enthusiastic reception given the book: seven editions in the next nine years, an equally popular sequel, half-a-dozen imitations with subtitles like *Euphues His Golden Legacy* (Lyly 1902, 1:100–104, 148–50; see also Hunter 1962, 279–89).

The special richness of the work, more pervasive and ultimately more appealing than the famous similes, grows from its figures of repetition. Some are quite obvious: *style-delight-ear-curious sifter / matter-recreate-mind-courteous reader*. Some are subtler, like the string of long *e* sounds that runs through the passage: *reader, least, neat, needeth, see, beseem, Venus, she, these, be, need, meeter, feed, seek, meal, speech, wheat*. These structures (especially within sentences or clauses) are symmetrical: *pregnant wit / perfect wisdom; black ground / white counterfeit; Venus / Mars / Vulcanus* (or, more subtly, *Venus / judgment / Mars / most / amiable / Vulcanus*). They thus exhibit the most salient feature of Tudor architectural and other designs. That principle has the virtue of being easy to see and understand: we take it in at a glance, at a single hearing. Symmetry of a local kind also appears in the speeches, meditations, and letters of which *Euphues* chiefly consists. Eubulus speaks, Euphues replies; Lucilla broods about Euphues, then Euphues broods about Lucilla; Philautus writes a two-page letter to Euphues, and Euphues responds with two pages of his own.

This kind of control tends to operate only locally. The narrative portion of the book indeed has an overall symmetry that I might graph as follows: E EP PLE ELP PE E. (Euphues comes from Athens alone; Euphues and Philautus become friends; Philautus and Lucilla are lovers with Euphues as jealous observer; Euphues and Lucilla are lovers with Philautus as jealous observer; Philautus and Euphues become friends again; Euphues returns to Athens alone.) But the book does not stop with the narrative (which, like the facade of an Elizabethan house, is more regular than its hindparts). Indeed, the narrative occupies less than half of the book. Added on at the beginning are one dedication to Lord Delaware, another to the Gentlemen Readers. Added on at the end are

more emblems: Euphues' Cooling Card for Philautus, an Apology to the Grave Matrons of Italy (both, since they deal with love, springing quite directly out of the narrative), Euphues and his Ephebus (a discussion of education rather less closely related to the story), Euphues to the Gentleman Scholars of Athens (only distantly attached), Euphues and Atheos (a dialogue on religion, even more distantly attached), and seven assorted letters (a couple concerned with characters and events in the narrative, the others not). To the second edition (1579) Lyly affixed an address to the Gentlemen Scholars of Oxford. Then he built a sequel, *Euphues and His England* (1580), itself made of three dedications; a narrative full of interpolated conversations, observations, meditations, and letters; a description of England; a Latin poem; and two more letters. By 1581 the original tale, seventy pages or so, had grown to a book of nearly five hundred pages. The process, though much swifter, closely resembles the additive process that produced Haddon Hall or Penshurst.

Euphues goes unread; we made fun of it in my student days, and a prominent anthology of Tudor literature finds that a single page of this enormously successful and influential work will suffice for the twentieth-century reader. But perhaps we go at it the wrong way. Our devotion to integrated structure drives us through a work in search of an overall design; failing to find such a thing in *Euphues,* we turn the pages ever faster, begin to skip words, lines, whole pages, whole gatherings, whole epistles. In the process we lose the chance to experience the true nature of the book, which inheres in its particular sentences. It might be instructive to hear it read aloud by a skillful performer of prose while seated in the gallery of an Elizabethan house. Other Tudor works have fallen into similar disfavor. We admire gnarled Wyatt better than smooth Surrey, find the crude narrative gusto of the illustrations to *Actes and Monuments* more satisfying than the competent but conventional formal portraits of the same martyrs.

But this additive kind of art has its special virtue: it brings the individual feature into brilliant individual focus and can hence produce responses of great local intensity. Shakespeare's Henry VI plays, by comparison with his later works, lack design; they are episodic, monotone. How astonished we were, then, to discover through the Royal Shakespeare Company productions of 1977 how brilliantly they play in the theater: one incandescent moment after another, like a string of fireworks. Marlowe's *Tamburlaine* has some of the same qualities, and Sir Peter Hall has written eloquently about the richness he and his actors found in it as they began to work.[30] This kind of structure appears in

many Elizabethan plays, especially those in which the native tradition appears most fully to dominate over classical or Continental models— Marlowe's *Dr. Faustus* as well as *Tamburlaine,* pre-Shakespearean historical plays like *The Famous Victories* and Peele's *Edward IV,* episodic comedies like *Friar Bacon and Friar Bungay. Tamburlaine* (especially pt. 1 c. 1587) is prototypical. The stated ground moves here and there throughout Asia, but the scene is always the same, the field of battle, and though the participants change, the action is always Tamburlaine's triumph over men in part 1 and his defeat by death in part 2: variations on a theme. [31]

We have begun to follow the process by which a greater degree of temporal, spatial, and formal integration comes to be characteristic of English art. But we should note that reminiscences of nodal structure survive in *Love's Labours Lost, Titus Andronicus, Richard III,* and the principle recurs quite purely in *Bartholomew Fair* (1614). As a dramatic work, Jonson's play unrolls in time, of course, and to the extent that it has a plot in which events are causally and hence temporally sequential, its organization as well as its presentation is diachronic. But to the extent that it is an anatomy of folly, a gallery of satirical images, it is conceptually synchronic. (Perhaps the use of this Traditional structure explains why Jonson excluded the play from his neoclassical *Works* of 1616.) Synchronicity is a striking feature of a large and important class of European paintings and prints, pictures that represent several different episodes of a narrative sequence in a single pictorial space. The practice was carried over from the early Renaissance period.[32] Even in a work as late as Harington's translation of *Orlando Furioso* (1591), the engravings (copied from an Italian source) all contain scenes from several different episodes of each canto, set in a single landscape according to a general principle that puts events from early in the canto in the foreground and those later at a greater apparent distance. Since the poem roams the known world, however, the procedure means putting in sight of one another actions that are said to be occurring thousands of miles apart (fig. 9).

This kind of visual synchrony crosses over into the diachronic mode of literature in iconophrastic paintings like that described in *The Rape of Lucrece* (lines 1366–1456) and especially in the scene added to the 1602 edition of Thomas Kyd's *Spanish Tragedy* (3.12.70–161), in which the mad Hieronimo tells Bazardo the painter to represent in a single piece six different stages in the melancholy history of the family, from its initial happiness through the son's murder to the father's revenge. The passage is a remarkable blend of symbolic elements such as the stan-

9. Ludovico Ariosto, *Orlando Furioso,* trans. Sir John Harington (1591),
copper engraving. Reproduced by permission of the Huntington Library,
San Marino, Calif.

dardized postures that will convey family relationships, or the clouds, owls, and toads that will convey horror, and of naturalistic elements like the vivid description of the murdered youth, "hanging, and tottering, and tottering as you know the wind will weave a man" (1967, lines 144–45). Representation of such motion is, strictly speaking, out of reach of the painter's static and fundamentally synchronic art, though perhaps, in skilled hands, not of its power of suggestion. Some of Hieronimo's instructions seem to lie wholly beyond attainment, however; he requests that the painter paint groans, sighs, doleful cries, speech, the sounds of bells and owls: a speaking picture, indeed, whose context raises the nice historical question whether the esthetic confusion expressed here arises from the old man's distracted state, or from the healthy inability of the poet to sort out competing esthetic strains in a time of transition, or from the poet's desire to make an implicit contribution to the *paragone*.[33] In any case, this kind of iconophrasis continues to appear in English literature at least as late as 1656, when Abraham Cowley describes in his *Davideis* a painting shown to the young king setting forth in its various parts the whole history of Lot (3.204–68).[34]

More generally, however, synchronicity of conception if not of execution may be discerned in much Tudor writing. The complaint tradition, for example, in its several modes—Petrarchan lament, quasi-satiric social observation as illustrated by Skelton's *Bowge of Court* (1498) and Gascoigne's *Steel Glas* (1576), and even the railing satire of Hall, Marston, and Donne in the 1590s—depends for much of its emotional force on the fact that the situation that has provoked the poet to utter his woe or vent his spleen is perceived as not only unchanging but unchangeable. These poems are all constructed on the principle of modular parataxis, as lists of items and factors all having about the same degree of importance in the total situation. Moreover, the items are typically treated in their relations not with each other but with the speaker of the poem, who sits, as it were, at the center of a circle of assailants or sorrows, or, if he moves, moves along a line, around the railing of a ship like Drede in Skelton's *Bowge,* or along a London street like the raving persona of Marston's seventh satire (1599).

Indeed, the lack of evident internal coherence—of sequence determined through causal or other relations of interdependence—by expressing structurally a world beyond the artist's control amplifies the sense of futility and dismay that is the chief mood of these works. And if a logical principle can be discerned, it is likely to be very conventional and hence to imply timelessness, generality, to suggest that the

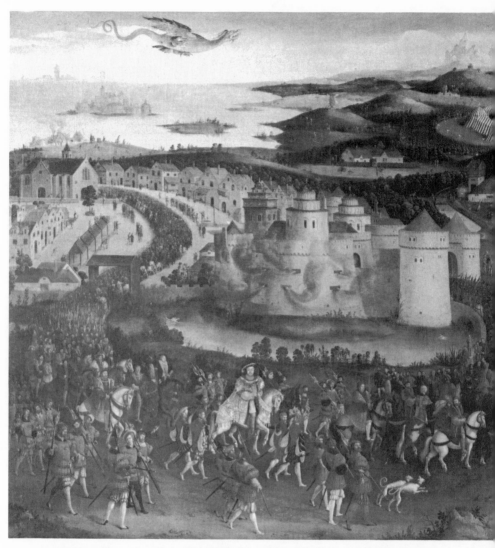

10. Hans Roest (attrib.), *The Field of the Cloth of Gold* (c. 1520). The Royal Collections, Hampton Court. Photo: William Cooper. Copyright reserved to Her Majesty Queen Elizabeth II.

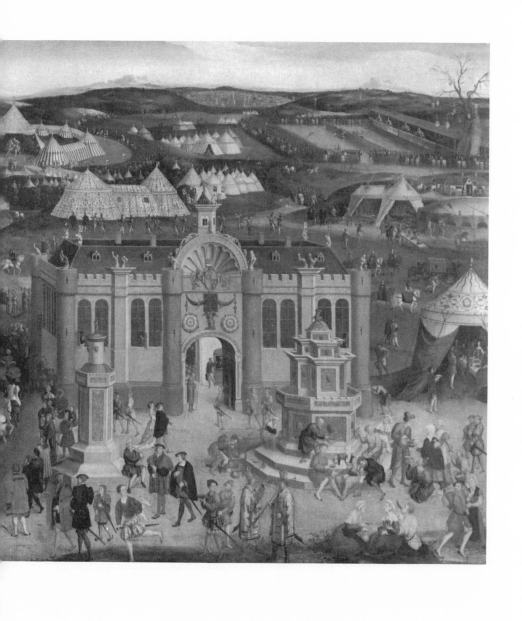

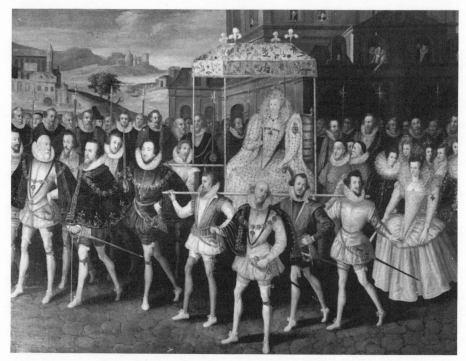

11. Robert Peake (attrib.), *Elizabeth I Carried in Procession* (c. 1600). Private collection. Photo: Percy Hennell.

source of the poet's discontent (or delight, in the poetry of praise) is built into the very fabric of the world; examples are the social hierarchy in Gascoigne's *Steel Glas,* which moves (with many digressions and returns) from rulers through nobles and clerics to common folks, and the rigidly formulaic top-to-toe sequence of the items in the *descriptio puellae* at the center of so many lover's complaints.

These and many other works of sixteenth-century English art share a deeply ceremonial character. An important group comprises ceremonial processions of the kind that were an important feature of European public life throughout the Middle Ages and the renascence and that often appear in paintings either as the main subject or as part of the ground; significant English examples include the picture of the Field of the Cloth of Gold now at Hampton Court (fig. 10) and a painting long known as *Queen Elizabeth in Procession,* which shows Elizabeth in a canopied chair and a large retinue of courtiers processing past some remarkably classical buildings, with an extensive landscape beyond (Strong 1977, 17–55) (fig. 11).[35]

The mixed-media events of which such processions were a part often had literary components ranging from songs and speeches in the ceremonial entrees and progresses to entire (if slender) plots and dialogue in the masques. Across the very vague line that separates courtly entertainment from drama per se, we find that plays in the older native tradition often have a generally ceremonial character (as befits their ultimate liturgical origins) that almost as often expresses itself in processional forms. *The Castle of Perseverance* (c. 1425?) has Mankind, not James Stuart, as its focal point, but the movement of action from mansion to mansion is structurally identical to the king's progress from arch to arch, and both the emblematic speakers encountered at each stage and the sentiments they express are, allowing for a general shift of emphasis from sacred to secular, closely akin. In later work like Redford's *Wit and Science* (c. 1530) the focal point, Wit, tends to be relatively static at the center of the stage, with other figures advancing on and retreating from him, often in processional groups, like the foursome Honest Recreacion, Cumfort, Quycknes, and Strength, who enter in a line, gather around him kneeling, and sing a complicated song (J. Adams 1924, 329). Among the plays written for the professional theater, *Cambises* (1569) still has this structure, and recollections of it appear in the procession of Vices in *Dr. Faustus,* in the pageant of the Worthies in *Love's Labor's Lost,* and indeed (with new influences from the enthusiasm for court entertainments after the accession of James I) in *The Tempest* as the Neapolitans and Milanese advance toward their meetings with Prospero under the direction of Ariel as grand marshal.

Let us summarize. Earlier Tudor art, whether visual or verbal, springs from motives of self-advertisement, display, honor. It is an art of surfaces rather than volumes, in which emphasis falls on ornament rather than structure—in which it could be said that ornament *is* structure. It goes in for *copia*. The characteristic organization depends on aggregative repetition, within but not typically between the larger units, of discrete items. These items are sometimes simple figures producing purely decorative patterns, sometimes imitative objects with assigned ethical values, that is, icons. In either case they can be readily freed from their particular context and shifted to another, even moved from one medium to another. Ideas, forms, and images tend to be readily apprehensible and comprehensible, familiar, predictable, to satisfy rather than to violate expectations. The elements of this Tudor esthetic mostly descended from medieval sources. But they were amplified and confirmed by the characteristic procedures of Tudor education.

Perhaps, with proper attention to the real nature of earlier Tudor art,

taking it on its own terms rather than those borrowed from our study of the Italian Renaissance, we might learn how to respond to it. Yvor Winters has argued fervently in favor of the continuing *moral* value of Plain-style Tudor poetry (1939). That moral value kept such art aligned with the interests of the Tudor establishment, with its emphasis on order and control. But the art professed to delight as well as to instruct, and much of it (including much scorned by Winters as insufficiently grave) still can please. So can the paintings (mostly grave enough for the wintriest critic), whose subjects wrote or received the poems, and the houses they lived in, and the clothes they wore. And though like those houses the resulting work might not suit us (unmodernized) for every day, it has great charm. Because it is constructed according to principles of discontinuity and aggregation, its addenda divert but do not surprise. It sets up some rhetorical and ethical expectations (to a large extent by appealing to substantial existing traditions) and then satisfies them. In the end, it epitomizes an art of display, carried out through the copious ornamentation of surfaces by predictable, patterned, aggregative repetition of discrete elements, focused on iconic images of established significance: the Plane style of sixteenth-century England.

2

The First and Chief Grounds:
The Renascence in England

The habit of calling this period "the English Renaissance" and the tendency to discuss and evaluate Tudor works of art according to principles based on a special admiration for works of art in the Renaissance style are largely inappropriate. The customary labels and ratings, if nothing else, tend to turn English culture of the period into a projection or substation of Continental (and especially Italian) culture, and hence to distract attention from or lower our estimation of some important indigenous elements in Tudor works.[1] Traditional subjects, attitudes, forms, and styles endured; they even dominated the English arts through most of the Tudor period. Yet the history of that art is finally an account of an advancing and ultimately triumphant classicism.

Renaissance elements entered English culture in large numbers and in many forms, of course, from the time of Edward IV on. Henry VII invited Polydore Vergil to celebrate his achievements in language, and Pietro Torregiano came over late in the reign to model his royal patron's bust in terra-cotta and to design for him a tomb that is the first full expression of Renaissance ideals in the visual arts in England. Wolsey summoned Italian craftsmen to decorate the essentially medieval facade of Hampton Court with terra-cotta rondels of Roman emperors. In addition to such well-known literati and artists as Desiderius Erasmus, Hans Holbein, Federico Zuccaro, Giordano Bruno, hundreds of anonymous stucco workers and woodcarvers and silversmiths crossed the Channel, bringing new ideas and new styles and skills with them, some only as visitors, others as immigrants to make their permanent homes in England. English buyers imported prints, tapestries, majolica ware, armor and weapons, jewels. English travelers returned from the Continent with their heads full of words and images, their luggage full

of books and pictures: Wyatt, Surrey, and Sidney in literature, John Shute and Inigo Jones in architecture, and Nicholas Hilliard in painting are only the best-known names—along with Sir Thomas More, whose work constituted a kind of one-man renascence but who, because he had so little demonstrable influence over his immediate successors and therefore must be considered a kind of sport, does not figure very largely in these pages (see the Appendix). English writers imitated their Continental counterparts by imitating classical models.[2] The chronicle of that second Conquest has been told too often, and too well, to need repeating here.

Still, Renaissance ways of seeing and doing things affected the arts in England only locally, piecemeal. We have already considered the persistence of Traditional forms. Throughout the period, influences from Burgundy early on, from France and the Low Countries later, were as strong as or stronger than those from southern Europe, and although they sometimes passed along Italian Renaissance images and practices in a relatively pure form, northern artists as often gave them a particularly northern turn, so that, for instance, Dutch or Flemish painters or English painters trained by them used a system of perspective that, since it placed the viewing eye in the plane of the picture rather than at a distance in front of it as the Italian system did, produced effects somewhat different from those of their southern fellows (S. Alpers 1983). The aniconic tendencies of the Reformation resisted innovation in the mimetic arts directly by destroying much art (mostly Gothic and Traditional, but doubtless including some Renaissance work).[3] It drew many of the period's most gifted people into theological and controversial activities (although it must be said that the same energies invigorate works like Foxe's *Actes and Monuments* and Spenser's *Shepheardes Calender* and *Faerie Queene*) and by inhibiting commerce with Italy and Spain denied to both artists and patrons direct experience of the most potent Renaissance models.

Widespread revolutions in taste are likely to occur when a politically and socially dominant figure or group—a monarch, a pope, a popular president—asserts decisive esthetic leadership. Under the Tudors and Stuarts, such leadership was exercised by the just-crowned Henry VII, the young Henry VIII, the Seymour group who controlled the kingdom in the name of Edward VI, and the corresponding group around Henry, Prince of Wales, and later around the young Charles I. Elizabeth I, however, built no palaces, founded no colleges, commissioned portraits of herself only at two brief periods in her long reign (and

when she did admit painters, insisted that all the pictures of her should conform to a single type). Royal patrons set the style; their tastes spread rapidly to the members of the court and beyond. In the absence of such leadership, esthetic influence was dispersed among the great courtiers—Leicester, Hatton, Cecil—who built and decorated and furnished huge mansions, and set to work in them not only painters and plasterers but also poets and playwrights. They were perforce, as Eric Mercer has said, "dabblers in Renaissance arts" (1962, 57). Some very pure Renaissance work was produced, such as the Gate of Virtue Dr. John Caius built for his new Cambridge college in 1565.[4] But other patrons commissioned work in other styles.

For the most part, then, Elizabethan art shows a mixture of styles, in which heterogeneous Renaissance motifs, often derived from their Italian prototypes via French, German, or Flemish intermediaries and given a distinctly northern character in the process, are freely applied to Traditional structures using traditional materials. Indeed, it has been claimed that the principal esthetic influence on English art of the 1580s was not Renaissance but Gothic. Some architectural historians are now arguing that the strong vertical emphases in the facades and decorations of English buildings from beginning to end of the sixteenth century only continue the dominant characteristics of Perpendicular Gothic (Drury 1980, 19). According to Sir Roy Strong and others, a fervent longing for the simplicity of the good old days, and a cultural chauvinism that associated English artistic glory with the country's period of maximum political importance, called forth the chivalric trappings of Sidney's revised *Arcadia, The Faerie Queene,* the Accession Day tilts, the pinnacles and battlements of Burghley House and Wollaton, and the English history play (Bender 1972, 146–48; Buxton 1965, 53–54; Esler 1966, 108–10; Girouard 1963b, 23–39; Mercer 1962, 4–5; Strong 1977, 129–62).

More deeply, indeed, I would argue that the Gothic revival in sixteenth-century England was itself a renascence phenomenon, because it meant treating the medieval past, like the classical past, in a self-consciously historical way, as something discontinuous from the present to which the present might consciously return for ideas and images. And what one returns to, one can also turn away from. For the revival was a kind of last gasp (at least until the later eighteenth century). Sidney and Spenser, Burghley House and Wollaton, even Shakespeare's *Henry V,* claim to derive their design, as well as their ornament, from the classics. But they only led the way in a development that

continued through the last decade of Elizabeth's reign and came to a climax under James I. All kinds of ancient constraints were relaxed in the 1590s, as though the country were readying itself for a change of taste. With the accession of the new king came what can perhaps most properly be called the English Renaissance. "For the first time there were wide classes who had both the classical heritage—something more than a tendency to follow other men's fashions in copying classical motifs— and the necessary leisure to indulge a deep interest in Renaissance art" (Mercer 1962, 8). The most significant phenomenon may have been the emergence of the serious collector, interested in acquiring classical and renascence statues and paintings for esthetic as well as ethical or dynastic reasons, men like the earls of Arundel and Somerset and the duke of Buckingham. As milestones marking the point at which the transition to renascence classicism seems assured, I would select the folio *Works* of Ben Jonson and the decisively Palladian house his associate and sometime enemy Inigo Jones began to build for the queen at Greenwich, both of 1616.[5] *Hic opera, hic labores sunt.*

To the extent that the renascence came to England, it came as a direct result of a conscientious management of educational theory and practice.[6] Most of the notable humanists under the two Henrys were either educators themselves or closely associated with educational institutions—Grocyn, Linacre, More, Colet, Lyly. Hence the most significant products of the early renascence in England were men, not marble. Henry Tudor brought with him when he landed at Milford Haven a conviction that a successful state required the services of a humanistically educated bureaucracy. Initially, classical education was primarily aimed at sons of the middle class, men like Skelton, Wolsey, More, Cromwell. In securing power and making up the decimations of the Wars of the Roses, however, the Tudors extended the new education to the new aristocracy, too. The process spread potential susceptibility to renascence ideas across a wide segment of society.

It will be useful for our purposes to examine the fruits of that education in terms of two of its most fundamental characteristics. The first of these is the centrality of the doctrine of imitation.[7]

Nothing could indicate more clearly the profound connection between renascence ideas and the cultural establishment than this doctrine, which by stamping all the members of the dominant institutions with the same dies—that is, texts—sought to make them intellectually as uniform as the coins of the realm. But the procedure also offered much to the individual. To the people of a period that looked to classi-

cal and biblical culture as the twin hopes for renewed life in this world as well as the next, imitation gave practical means for expression. By tracing the work of the great spirits of the past, and closely following every gesture of thought and word, the humanists sought to become like their models. Yet in fact, the national absorption with a relatively small number of religious and political issues tended in England to confine the imitation to a relatively narrow band of subjects and forms. Diplomatic correspondence, history, education, and controversial theology were the areas in which Tudor humanists exhibited their mastery of classical grammar and rhetoric; not until the latter part of the century did conditions allow a real efflorescence of belletristic writing.[8] In the mid-century, the drama of Nicholas Udall and John Bale was written for school or university, that of Thomas Sackville and Thomas Norton for the Inns of Court; these works were pervasively didactic in both content and form. The first of the classical genres to be imitated in English, the pastoral, was in Alexander Barclay's hands (c. 1515) so moralized and allegorized that it seems to owe more to Lydgate than to Vergil. The "literary" literature we know best, the lyrics and satires of Skelton and Wyatt, the Petrarchan sonnets of the Tottelians, has a moral intensity that bespeaks Flemish as much as Italian influences (Kipling 1977, 141); this is, in any case, a highly private, highly local kind of work, written by a few courtiers for a few other courtiers, not something fired by renascence enthusiasm for spreading the good things of the past abroad (Kipling 1977, 141; Mercer 1962, 5). Still, the drive toward a classically educated aristocracy did eventually begin to spin off literary by-products. Wyatt translated Seneca, and in his satires made contact through the Italian Alemanni with Horace. A brighter beacon yet was lit by Henry Howard, earl of Surrey, whose partial translation of the *Aeneid* (c. 1538) I would call the first unalloyed expression of the renascence impulse in English literature. It is not surprising that his funeral portrait (c. 1548), by Guillem Scrots, shows him leaning on a classical monument surrounded by putti, masks, urns, and a pair of half-clad young people making up a Mannerist ensemble more liberally antique than anything in English painting to date (fig. 12).

A similar sense of freedom marked the most thoroughgoing imitation of Renaissance art forms before the coming of Jacobean neoclassicism, in the activity of the Seymour circle under Edward VI. Like his father's forty years earlier, the young king's accession set off a flurry of progressive arts activity. The process is most clearly discernible in architecture, and especially in the work of a particular group of en-

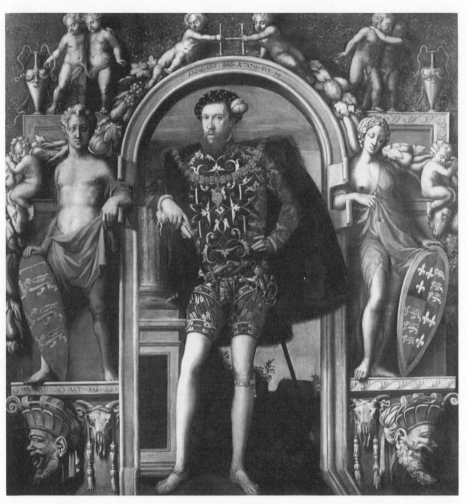

12. Guillem Scrots, *Funeral Portrait of Henry Howard, Earl of Surrey* (c. 1548). National Portrait Gallery, London, on loan to Arundel Castle, Sussex.

thusiasts. Of all the major visual arts it is the most purely formal and thereby the least doctrinal. It was the only art to receive official attention in the course of humanistic education; and from classical tradition, from the medieval responsibility of knights to look to their fortifications, and from the fact, as true then as now, that a man leaves a record of his personality in the house he builds, architecture remained a legitimate focus for a gentleman's energy throughout the century.[9] Economic expansion and the resulting monetary surplus had unleashed a major building boom after the accession of Henry VII; his extensive renovations to Richmond, Eltham, Greenwich, Hampton Court, and Whitehall set the example for the remodeling of older houses and the construction of new ones. Henry VIII's Nonsuch, emulating the splendid works of his rival François I, set off another flurry. Nowhere was the commitment to Renaissance ideals clearer, however, than among the circle that gathered around Edward Seymour, earl of Hertford and duke of Somerset. The group included Seymour's brother Thomas, his erstwhile crony and later enemy John Dudley, Sir William Cecil and Sir Thomas Smith, who would survive the turbulent fifties to become important courtiers under Elizabeth, and Sir John Thynne, who made money. The intellectual focus seems to have been Sir William Sharington, though the widely learned Smith, notwithstanding his youth, must have made important contributions. The group was, then, a kind of academy, like those that had begun to flourish in Italy, France, and the Low Countries, not perhaps formally constituted as such but engaging in similar work.

Like the surge toward Protestantism that was the Somerset circle's other great legacy, the new esthetic energies began to dissipate with the deaths of first Somerset and then Edward, though Smith continued to bring in new ideas and forms until his death in 1577, and Cecil was hospitable to the Mannerist phase of the renascence at Burghley. The group's most prominent monument, Somerset House in London, was destroyed during the American Revolution (1776–84).[10] Some of the smaller houses—Lacock, Hill Hall, Sudely—remain, more or less extensively altered to accommodate subsequent changes in taste and way of life.[11] The best-known survivor is Longleat; though its interior is almost entirely work of the nineteenth century, the exterior remains very much as Thynne built it over a period of more than thirty years (Girouard 1959, 200–222) (fig. 13). It is quite unlike any other English house of the period in two major respects: first, in that it is a nearly square house, built around a pair of courts, and second, in that all four

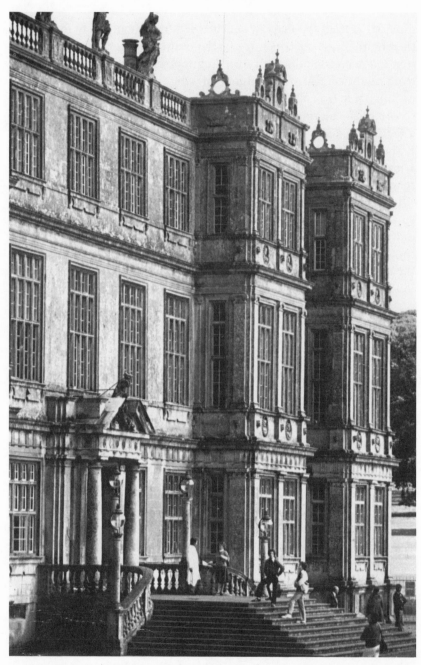

13. Architect unknown, Longleat House, Wilts. (1547–80), east front.
Photo: David Evett.

of its faces are treated as, in effect, of equal visual importance. Thus the house is one of the very first English instances of an architecture in which the design—the element conceived in esthetic as well as practical terms—is carried into three dimensions. As Eric Mercer says, it is as though an Italian Renaissance townhouse (albeit with Perpendicular Gothic overtones) were set down in the English countryside (1962, 33; see also Bradford 1981, 9–18).

This is especially the case because the decoration of those facades is based on a systematic application of classical pilasters. The fact brings us to one of the most interesting people in the Somerset group, John Shute. A member of Edward Seymour's household, he was dispatched to Italy (Reformation or no Reformation) to study classical and Renaissance architecture firsthand. And when he came back, beyond such influence as he may have exercised over the building programs of the group, he wrote what was not only the first book on architecture written in England, but the only theoretical work on any of the visual arts published in England before the very end of the sixteenth century. [12]

The First & Chief Groundes of Architecture (1563) strikes a modern reader as a curiously deficient introduction: academic, if you will, rather than practical, and oddly out of balance (especially in comparison with Vitruvius). After a brief opening, which says a few things about site selection and a few more, very general, about construction, it devotes most of its attention and all of its diagrams and drawings to the classical orders (fig. 14). There is nothing in the book about the proportions of rooms or the efficient and pleasing use of space and materials. But that is because those things were the province of the builders. Builders, and building, were English, and had been for years. But architects, and architecture, were classical; the words first occurred in English (at least in print) in Shute's book.[13] He was imitating Vitruvius, *De architectura* (as mediated through Vignola and du Cerceau). And he was imitating what was, for an Englishman, imitable. In Italy, where church building went on throughout the fifteenth and sixteenth centuries and where the summer sun still shone hot and bright, the formats of classical temple and colonnaded atrium could be adapted to the liturgical and domestic needs of contemporary people—heuristic imitation in architecture. The Tudors built no churches, however; and though it was apparently tried out at Longleat, Cecil's Burghley, perhaps Somerset House in London, and a few other places, the atrium proved impractical in the misty north. Classical columns and pilasters were another matter. They were distinctively, decisively different from Gothic columns

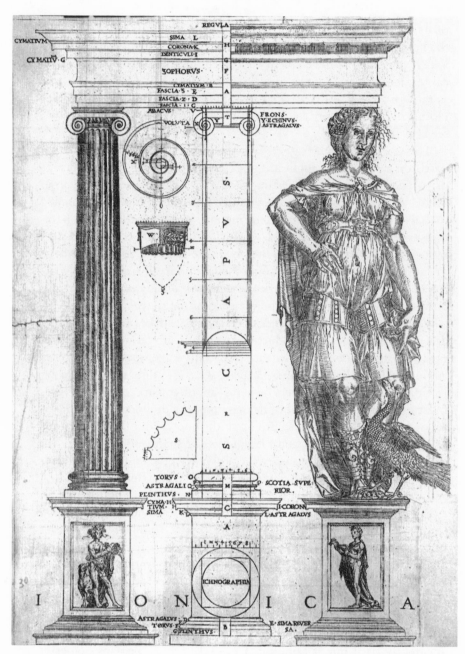

14. John Shute, *The First & Chief Groundes of Architecture* (1563) wood engraving. The British Architectural Library, RIBA, London. Photo: Geremy Butler Photography.

and pilasters, and they were readily adaptable to English structures. No other surviving Tudor building used them so extensively as Longleat, but they appear on the entrance or courtyard front of dozens of other houses, especially on the porches and frontispieces that, throughout the period, carried most of the external ornament on most English buildings (Mercer 1962, 73–75).[14] So readily imitable were they, in fact, that they could be broken quite away from their original structural function and applied in a totally decorative way as window mullions and even (at Burghley and Lacock in particular) as chimneys, transferred from architecture to sculpture as elements in literally thousands of funeral monuments, and rendered in two dimensions as the framing elements in many a title page.[15]

In the same way, the most readily imitable elements in classical literature were first indentured to English masters. The renascence spirit in England began to express itself long before the beginning of the sixteenth century through aureate diction and the free use of classical allusions; both depended largely on authors—Ovid, Vergil, Cicero—who were read throughout the Middle Ages. Still, these borrowings appeared in forms either medieval (dream vision, ballade) or ultimately classical but already adapted to modern use (letters, biography and chronicle, sermon) (Bush 1963, 3–45). As we have seen, the first conspicuously classical poetic genre to find a vernacular voice in England was the pastoral, in Barclay's heavily Traditional *Eglogues* (c. 1515), presumably because the *pastor/pastor* pun and the tradition of allegorical application satisfied demands for didactic gravity. The verse epistle (Wyatt's "Mine Own John Poins," which also incorporates an Aesopian fable) seems to have come next, and the epigram. Among the larger forms, the drama, especially comedy, appeared first, fostered by the taste for interludes as domestic entertainment, by the demand in schools for corporate entertainment, and by the fact that Terence led off the sequence of Latin authors in English school curricula throughout the century (Baldwin 1944, 1:102). The didactic treatise à la Vergil's *Bucolics,* Ovidian epyllion and elegy, and formal satire followed. The more specifically Greek genres—romance, ode, tragedy—waited for the last decades of the century, and no deeply classical English epic appeared until the renascence was virtually at its end.

Inspected more closely, the process, overall, is like the process in architecture. A classical element—putti and shell cresting or aureate diction, an order of columns or the fiction of a lovestruck shepherd —was imitated, at first quite self-consciously, and put to use in some

otherwise English and often essentially medieval piece of work. In time, however, the Mediterranean item became more at home in the new intellectual climate, more fully assimilated.[16] Practically, what happened was that the mason borrowed not from Vitruvius but from an earlier borrower from Vitruvius, the writer not so much from Vergil as from Mantuan and Barclay and Spenser. The item continued to be identifiably classical, but it lost its purity because it had participated in the general drift from the occasional classicism of the Middle Ages through the intense classicism of the Renaissance to the habitual classicism of the renascence.

Some implications of this process will be taken up in subsequent chapters. For the moment, however, it is imperative to notice another, in some ways more fundamental, effect on English culture of the renascence. Like the concept of imitation, this is rooted deep in the educational system, and we can likewise approach it through a consideration of architecture. The enthusiasm of John Shute and his noble patrons for the classical orders is apt to seem odd to us (although we should remember that mastery of the principles of those orders was an essential part of the training of architects until very recently). I earlier explained it on the practical grounds that the orders were the feature of classical architecture most readily applicable to English uses. Beyond that, we may sense the delight that people feel when they are inducted into a mystery (in its occupational sense), with its attendant jargon; to a nation in love with words the appeal must have been strong:

> Of this goodly stone were exact two litle halfe pillers, chamfered with their bases, holding up a streight Sime, with a gule and adiected denticulature & cordicules, or worke of harts, with their chapters under a Trabet, Zophor and Coronice, over the which was a trigonall conteined, in the fourth part of the stone smooth and plaine without any workemanship in the table thereof saving a litle garland, within the which were two Doves drinking in a smal vessel. Al the space unspoken of inclusive was cut in and evacuated, betwixt the Pillers the Gulature and overthwart Trabet, did containe an elegant Cigrued [sic] Nimph. And under the Syme was another quarter wrought with Thors, Torques, Ballons and a Plinth.

This is Francesco Colonna's *Hypnerotomachia,* in the English translation of 1592 (1969, 32–34); most of the strange words (the passage makes better sense in conjunction with its accompanying woodcut) entered

English in Shute's *First & Chief Groundes*.[17] This innocent pedantry re-appears in the speeches of Holofernes, Mercutio on the terms of fence, Touchstone on giving the lie, Polonius on the kinds of plays.

The important point about the jargon, however, is that it bespeaks a systematic body of lore, depends on an essentially academic approach to the subject.[18] From Shute's text and others, it is clear that to human-istically educated architects and patrons (though probably not to build-ers and masons) the appeal of the orders was ultimately intellectual and depended on their having, in addition to a complicated termi-nology, a coherent basis in mathematics. Vitruvius had set forth the formulas by which the ratios of base to column and column to archi-trave, of molding to capital and triglyph to entablature, were to be calculated. As Rudolph Wittkower has demonstrated, the mathemat-ics made architecture humanistically respectable by connecting it with other intellectually significant traditions (1965, 89–135).[19] It also related architecture to the other major arts. In sculpture, mathematics applied through the anatomical ratios based on the head, of which Da Vinci's is the most familiar expression. In painting, the relevant procedure was that most uniquely Renaissance development, vanishing-point perspec-tive, which, as explained in Alberti's *Della Pittura,* was an essentially geometrical procedure based on similar triangles (1966, 52–59). What we have in all three cases is not a crafts practice based on rules of thumb (although all three, as it turned out, needed minor modifications ac-cording to situation in order to satisfy the eye). Nor is it a purely symbolic construction based on a priori ideas about the way things in the universe ought to go together. Instead, it represents the familiar renascence mixture of *ethice* and *practice:* codifiable systems, based on experience ("imitation," if you will), rationalized, and presented as on the one hand literally fundamental—that is, intimately bound up with the primary laws of creation—and on the other, applicable to an endless variety of practical situations. Michael Baxandall has shown how they share these characteristics with the principles of renascence rhetoric, and hence with the basic procedures of renascence education (1971, 129).

The usual sixteenth-century term for such systems is *method;* it is interesting to see how the word enters English as a medical term dur-ing the glory days of humanism (the first *OED* reference is 1541), is taken up by rhetoricians, then spreads rapidly to the other arts and sci-ences (Gilbert 1960; Howell 1961).[20] This is the period when systematic or methodical procedures begin to appear in English visual arts and literature; we might say that at this point the renascence as a way of

thinking, as well as a body of thought, really begins to have an effect. The specific system of the classical orders did not cross the Channel until after 1550, the anatomical ratios later yet. For reasons that no one has satisfactorily explained, the system of vanishing-point perspective remained a mystery sealed off from most English artists until the seventeenth century. Holbein understood the principles, although most of his English works employ a relatively shallow field (the largest of them, the Whitehall portrait of Henry VII, Henry VIII, and their wives, had an apparent depth of only eight or ten feet, if we can trust the surviving copies). There are a few mid-sixteenth-century pictures in which space is treated with some skill; they almost all turn out to have been executed by traveling artists from the Continent. But English artists, and most Continental artists who took up residence in England, even when skilled in the delineation of the human figure, handled space as though their heraldic concerns forced them to paint in gauntlets. At the very end of the sixteenth century, we find Rowland Lockey and Robert Peake exulting in their discovery of the rather rudimentary spatial devices that had exhilarated Uccello 150 years earlier, as if every hack painter in Italy had not in the meantime mastered vastly subtler tricks of perspective (figs. 15–19).

After all, England already had its own esthetic systems, with their own underlying principles. In painting, as has already been suggested, there grew up a formula for successful portraits, involving a small number of poses, the prescription of certain symbolic attributes and features of costume, even a repertory of facial expressions and positions of the hand. A more interesting thing happened in architecture. Medieval domestic architecture had been functional; the exterior appearance of a structure was determined by its internal uses. Hence in a typical fifteenth-century English manor house, the hall is large, to accommodate many feeders, and high-ceilinged, to carry smoke and noise up from the table, with windows that often rise the equivalent of two stories to light the large, crowded room. At one side the kitchen, too, is high, to carry off the smoke, but smaller and with windows well above the floor because the ground-level walls are occupied by cupboards, ovens, and so on. On the other side, the solar typically has two stories, not one, with a parlor below and the private bedroom above. The hall was not only the largest room in the house but (at least during the first part of the period) the ceremonial center as well. Traditionally, its entrance was at the end closest to the kitchen, into a kind of corridor created by a screen (usually of wood) that shut out the draft, cut

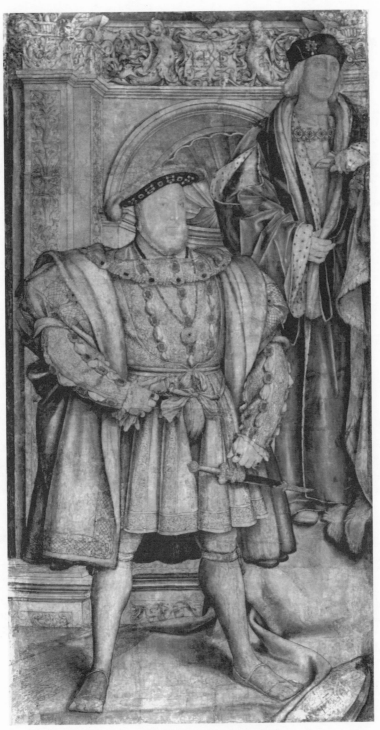

15. Hans Holbein the Younger, *Henry VII and Henry VIII* (1537), cartoon. National Portrait Gallery, London.

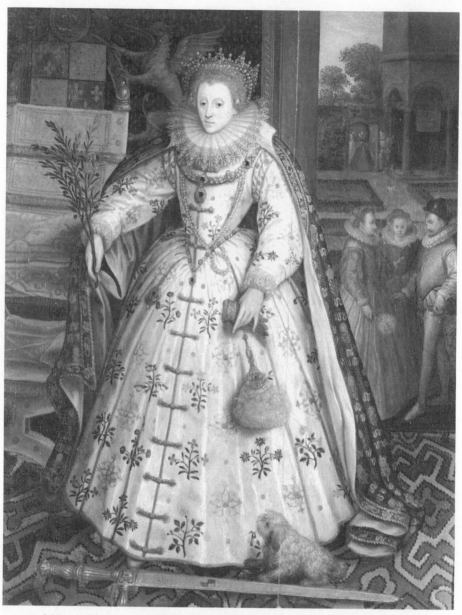

16. Marcus Gheeraerts the Younger (attrib.), *Elizabeth I* (the Welbeck Portrait, c. 1590). From a private collection. Photo: Layland Ross.

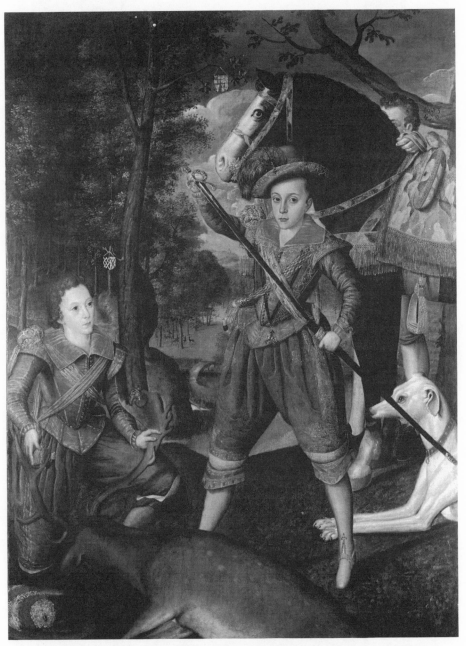

17. Robert Peake, *Henry Prince of Wales and Sir John Harington* (1603). The Metropolitan Museum of Art, New York, purchase, 1944, Joseph Pulitzer Bequest.

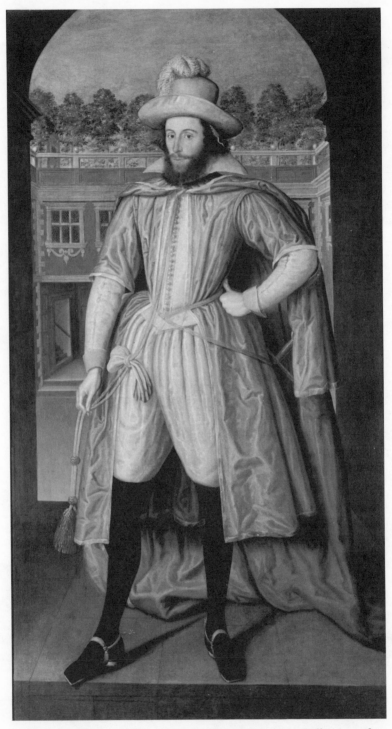

18. Robert Peake, *William Pope, Earl Downe* (c. 1605). Collection of
Viscount Cowdray. Photo: Courtauld Institute of Art.

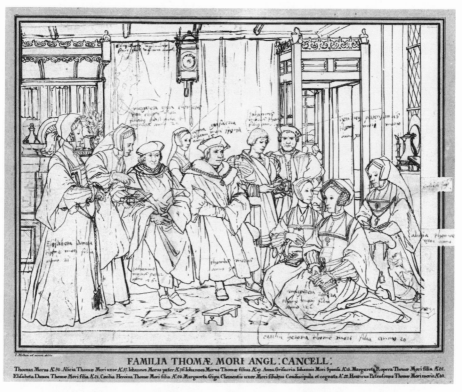

FAMILIA THOMÆ MORI ANGL: CANCELL:

Thomas Morus Æ.50. Alicia Thomæ Mori uxor Æ.57. Iohannes Morus pater Æ.76. Iohannes Morus Thomæ filius Æ.19. Anna Grisacria Iohannis Mori Sponsa Æ.15. Margareta Ropera Thomæ Mori filia Æ.22. Elisabeta Damen Thomæ Mori filia Æ.21. Cecilia Heroina Thomæ Mori filia Æ.20. Margareta Giga Clementis uxor Mori filiabus Condiscipula et cognata Æ.22. Henricus Patensona Thomæ Mori morio Æ.40.

19. Hans Holbein the Younger, *Sir Thomas More and Family* (preliminary drawing, c. 1526). Öffentliche Kunstsammlung, Kupferstichkabinett Basel.

off the noise, smoke, and odors of the kitchen, and incidentally supplied a large surface to decorate with carvings. At the other end, the dais, with its bay window, accommodated the lord of the house and gave access to the private apartments beyond. Such an arrangement is effectively asymmetrical (especially the position of the entrance, which will normally be the most assertive visual feature of the exterior). The format produces that picturesque irregularity commonly if inaccurately identified as "Tudor." It can be seen in places like Penshurst, Haddon, Broughton Castle; it is perhaps most easily visible in the ruins of Kenilworth, where the ravages of time and war have reduced a splendid castle to its bare bones. And because the only principles involved are custom and expedience, such houses comfortably accepted additions and changes (fig. 20).

Around the turn of the sixteenth century, however, the first generation of humanistically educated builders began to apply to their houses

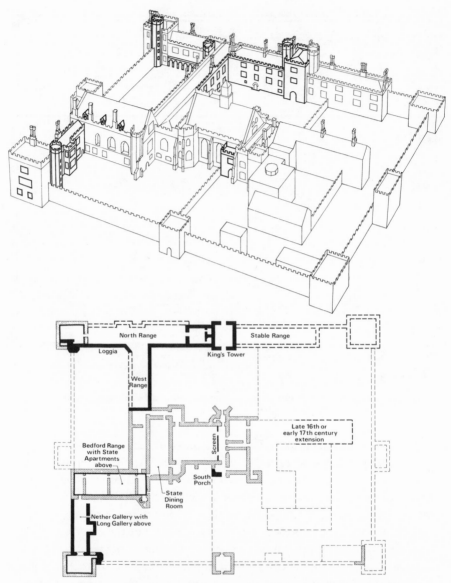

The labels in the image read:

North Range

Loggia

West Range

King's Tower

Stable Range

Bedford Range with State Apartments above

Screen

Late 16th or early 17th century extension

South Porch

State Dining Room

Nether Gallery with Long Gallery above

20. Architect unknown, Penshurst Place, Kent (c. 1580), reconstruction.
Reproduced by permission of Marcus Binney, O.B.E.

an elementary esthetic principle, the principle of external *symmetry*. (The word itself first occurs in Shute's *First & Chief Groundes* of 1563, though the *OED* glosses it as "proportion.") Wölfflin insists on underlying symmetry as a profound characteristic of Renaissance art (1950, 126). It would be silly, of course, to pretend that symmetry does not occur, often, in medieval art and architecture. But there it is likely to arise from structural considerations (as in the arches of a Gothic cathedral) and to yield when possible to other imperatives (as in the assymmetrical towers of Nôtre Dame de Chartres). Renascence symmetry, by contrast, dominates over structural and other considerations wherever possible. The process began with large courtyard houses like Thomas Bourchier's Knole (1480s) and Wolsey's Hampton Court (begun 1515). The main blocks of these structures followed medieval practice. But lodgings to accommodate the enormous retinues of these ecclesiastical princes (Wolsey's at his apex numbered more than four hundred) were constructed first in wings brought forward from the main mass of hall, offices, and solar, then in a range across the front of the courtyard so formed (fig. 21).[21] Since the rooms could be small, and since they all had the same function, it was convenient to make the range symmetrical and satisfy a taste that the builders presumably saw exemplified in the new architecture of Italy and France, in its turn animated by the precepts of Vitruvius and the practice of Greece and Rome. The same principle appears in Henry VIII's great palace of Nonsuch (begun 1539), which in this respect as well as others differs from his father's chef d'oeuvre, Richmond, of forty years earlier (fig. 6). Whether through adoption of the abstract concept of symmetry or through imitation of the works of influential men or both, the style began to be applied to structures too modest to sport a front dormitory range, that is, to the main block itself.

Thus from about 1530 onward, virtually all of the hundreds of substantial houses constructed during the great Tudor building boom were given symmetrical facades (figs. 22, 23). The change represents the dominance of Idea over Experience, of abstract principle over practical expedience, for the actual application made real problems for the builders. Neither the hall nor the kitchen fit comfortably into the new regime: the vertical character created by their need for higher ceilings than the other rooms struggled against the essentially horizontal disposition of the symmetrical concept; a doorway into the screens passage could not occupy the central position that symmetry seemed to call for; and the staircase required at the solar end but not necessarily at

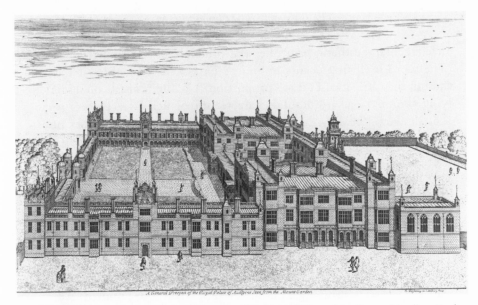

21. Henry Winstanley, *A General Prospect of the Royal Palace of Audleyene* [Audley End, Essex] (1676), copper engraving. Essex Record Office, Chelmsford.

22. Architect unknown, Bramshill House, Hants. (1605–12), facade. Photo: Royal Commission on the Historical Monuments of England.

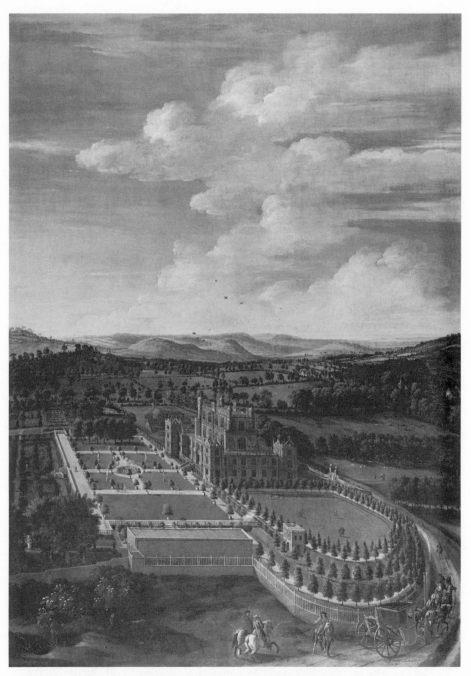

23. Jan Siberechts, *Wollaton Hall, Notts.* (1697). Yale Center for British Art, Paul Mellon Collection, New Haven, Conn.

the screens end demanded not only addditional space but a unique and hence assymetrical pattern of fenestration. [22]

Under the Stuarts, the problem went away. Two causes may be noted. The first, and doubtless more efficient, was a change in social patterns, through which the master of the house stopped entertaining all comers in his hall and retired with his special guests to a private dining room (McClung 1977, 28–38). The effect was to downgrade the importance of the hall, thus left to the servants.[23] The second cause, though perhaps less practically significant, is more germane to our present concerns; I mean what might be called the Palladian principle, the extension of symmetry as a principle to interior layout as well as exterior facade (Pevsner 1960). Only a hall whose axis was the axis of the house, and whose function was to allow communication with the outside and between the two halves of the building, could meet that demand. The result was that the hall became only an elaborate entrance, containing the main staircase, as at Blickling, Norfolk (1616). Until this transition occurred, builders had to exercise their wits. [24]

As David Summers has shown, the kind of planar symmetry represented by Tudor facades expresses more than an abstract commitment to method. The plane draws any images it contains into a formal and explicit relationship; it thus "absolutely qualifies images and is a major condition of making visible their meaning." Within the plane, symmetry establishes "relations of hierarchy" that further qualify the meanings of the images, especially by assigning highest value to whatever occupies the center (1982, 303, 305). Tudor devotion to symmetry thus encouraged a movement away from the modular parataxis of the Traditional style toward the hierarchizing systems of renascence art, although the two could remain compatible in any case where the artist declined to fill the center. And the hierarchies thus articulated drew on notions of authority, not only esthetic but also social, political, and economic, even as it reasserted them.

We will explore the implications of this development later. For now, let me note that here we find some further connections between visual and verbal art. We have followed a process whereby an esthetic concept, based on classical sources, adopted as renascence dogma, was applied to a somewhat intractable native tradition until a point was reached where, the concept having been somewhat modified and the native tradition subdued, the struggle ceased, and the synthesis thus achieved became normative. Such a process had its literary counterpart in the development of modern poetic meter.[25] In Italy and France the move-

ment started from a basis of secure and as it were Gothic vernacular achievement (Dante and the *romanciers*). By early in the sixteenth century Sannazaro and Ariosto were ready to assert freedoms amounting almost to license; their successors, Tasso, Guarini, Marino, crossed the line into Mannerist exploitation of metrical resources as ends in themselves as well as means of expression, using the tradition as a kind of trampoline above which they could perform their elaborate metrical tricks.

In England the process was complicated, but also encouraged, by the linguistic changes of the fifteenth century, which had the effect of cutting renascence poets off from the accomplishments of Chaucer. What look like two sets of forces can be seen at work striving to impose order on the muddle exemplified in the metrical incompetence of Hawes, Barclay, even Skelton, at the beginning of the century. One of these was the content but also the style of renascence education. It shows most clearly in the enthusiasm for classical versification of Sidney, Spenser, Harvey, Dyer, and Campion. Like other features of the English renascence, this appeared relatively late in the century. The heavily ethical and political bias of Tudor educational policy and practice had allowed little scope for belletristic concerns with subtleties of versification. English cultural modesty meant that the slavish replication that Thomas Greene has termed "sacramental" imitation of the important classical forms (1982, 38) came slowly (if at all—whether because of temperament or only incompetence, we do not find in England such egregiously pedantic Ciceronianism, for instance, as in Italy). Hence most English verse written prior to the 1570s belonged to a comfortably secure local tradition. The enthusiasm for classical meters, when it did well up, has puzzled historians, because it seems so obvious to us that English was and is phonologically unsuitable. But as Derek Attridge has shown, the phonological problems, the actualities, were at least initially irrelevant (1974). What mattered was the *method,* the application (as with the Vitruvian orders) of an abstract scheme imitated from classical models to the vernacular materials. Indeed, Puttenham, whose *Arte of English Poesie* is an early attempt to deal with the development in theoretical terms, connects poems with pillars, "a figure among all the rest of the Geometricall most beawtifull" (2.12, in G. G. Smith 1964, 2:100; cited by Ing 1968, 63).[26]

The crucial figure, however, is Sidney. Like John Shute in architecture before him, he seems to have set out quite consciously to improve English poetry through the imitation of a classical method. Like

Shute's, the work he produced may at first seem curiously narrow in its scope: a few dozen poems, virtually all on love, virtually all distanced from his own life by the interposition of a persona, in which his deep concerns with politics, religion, friendship appear only in passing. As William Ringler says, "he devoted his attention more to manner than to matter. . . . So he set out to be a Daedalus to his countrymen, to teach them the rules of right writing, and to provide them with models to follow" (Sidney 1962, lii).[27] But he experimented incessantly with manner in the areas of versification and rhetoric (as well as of some organizational principles, which I will consider more fully in chapter 7), on the basis of what seems on the evidence of *The Defence of Poesy* to have been careful study of classical and Continental work. Like Shute's orders at Longleat, Sidney's most methodically classical poems appear as ornaments on a large work in a form that mixes Traditional (romance) and Renaissance (epic, pastoral) elements, the *Arcadia* of 1580–85 or so. The pastoral interludes and occasional lyrics in that heroic romance, both those in quantitative verse and those (more numerous) in rhymed accentual verse, show demonstrable debts to Theocritus, Moschus, the Anacreontea and the Greek Anthology, Vergil, Ovid, Horace, and Catullus among the ancients, and to Petrarch, Boccaccio, Mantuan, Bembo, Sannazaro, Erasmus, Montemayor, and Gil Polo among the moderns. Yet Sidney integrated the borrowed materials fully into the structure as well as the texture of his own highly original work, just as Longleat does not in fact resemble any particular model. By contrast the imitators of *Arcadia* tended both to imitate their model quite closely (especially with regard to plot and character) and, where they did go off on their own, to write long interpolated speeches that in effect turned back toward the ethical and rhetorical emphases of earlier humanistic classicism in England.

This only reminds us, however, that not many artists are really ready to take up their work on the basis of a closely reasoned esthetic. Sidney's concept of meter is very different from the experiential, craftsman's basis of traditional lyricism; I do not suppose that the Plain-style makers of early Tudor England had to count syllables and accents any more than do the young guitar players of present-day Liverpool or Nashville. And this experiential component fed a much more widely significant metrical development, the so-called Petrarchanism of the Tottelians. Surrey and Wyatt went to the Continent and found that among the members of the socially appropriate set, Petrarchan sonneteering was all the rage. They brought it back. What they brought back was an

assortment of motifs and images not unlike the quattrocento decorative motifs concurrently being applied to English buildings. More important than the imagery, however, was the idea, in vernacular as well as in classical prosody, of strict form, comprising rhyme scheme, corresponding logical structure, and meter—in short, the *method*. (The analogy of architecture, putting the general idea of symmetry, which could affect Traditional buildings profoundly, over against the explicit formulas of the orders, which could be applied to surfaces without much affecting structure, remains persuasive.) That it was an idea, not a set of formulas, is shown by the swiftness with which Surrey was able to adapt the Petrarchan model to English needs, so that octave and sestet became quatrains and couplet, and the Italian and French eleven-syllable line, with elisions, became the English decasyllabic—and not the decasyllabic only, but with alternating stresses—which could in turn be applied to standard English lines of other lengths to produce fourteeners and poulter's measure. It is the *idea* of meter, of an abstract pattern to which the actual structure must be made to conform, that accounts for the stern regularity of mid-century verse, and it is the general openness to and enthusiasm for ideas of this kind that accounts for the rapidity with which the practice spread, so that by 1560 or so any English poet of any talent and seriousness whatever could manage the regular alternation of stressed and unstressed syllables, just as any English builder could construct a house with a symmetrical facade. [28]

Where the approach by way of visual arts helps us, then, is by indicating that the rhetorical practices of the Tottelians result not from incompetence or ignorance but from the methodical application of an esthetic principle. Our eyes are likely to prefer early Tudor irregularity to late Tudor symmetry, as our ears may prefer the groping rhythms of Wyatt's sonnets to Surrey's unfaltering iambics. But to Elizabethan auditors the application of a principle of regularity per se seems to have afforded great pleasure, of a kind similar to that which they apparently drew from hieratically rigid portraits, featuring strong chiaroscuro, or from the incessant repetition of a few well-established devices in the design of title pages. A further instance occurs in euphuism, as practiced not only by John Lyly but also by many of his contemporaries. Morris W. Croll shows us that the special artifice of Lyly's style lies not so much in the incessant similes from natural history as in the incessant schematic figures, especially isocolon (identity of length between one rhetorical unit and the next), parison (identity of parts of speech), paramoion (identity of sounds), and chiasmus (repetition with inversion of

order) (Lyly 1964, xv–xvi): "But were it not, gentlewomen, that your *list* stands for *law,* I would borrow so much *leave* as to *resign* mine office to one of you, whose experience in *love hath made you learned* and whose *learning hath made you so lovely;* for me *to entreat of the one, being a novice,* or to *discourse of the other, being a truant,* I may well make you *weary* but never the *wiser;* and give you occasion *rather to laugh at my rashness* than *to like my reasons*" (Lyly 1964, 34–35). Alliteration was, of course, the organizing principle of the most traditional English verse; homoioteleuton (repeating endings) and isocolon help organize most of the great body of medieval Latin verse. What is distinctive and rather new in Lyly's prose is the application of these devices to produce balance across juncture, that is, symmetry. These figures mostly have the form *AA,* sometimes *ABA* or *ABBA.* They are symmetrical to the point where in most cases it would not matter to the sense of the passage if the order of the paired elements were reversed. And they throng in such plenitude through the pages of late sixteenth-century prose and verse alike that we may welcome the relief from predictability afforded by the lack of apparent plan in matters of overall structure.

In time, of course, ideas in their pure form lose their novelty, and other conditions obtrude. Renaissance painters tinkered with the strict mathematical principles of perspective in order to please the eye, then went on in the Mannerist phase of the renascence more largely conceived to use the idea of pictorial space in negative as well as positive ways, rejecting or distorting strict perspective in order to stimulate their viewers. For three or four decades English poets experimented with the idea of meter, adapting or inventing rhyme schemes, trying out trisyllabic as well as disyllabic feet, in lines of various lengths, on a widening variety of subjects. Then Gascoigne and Sidney came along and showed how meter, used mimetically (Suzanne Woods's term), could be a means rather than an end; from the mid-1570s until the beginning of the next century English versification, like English architecture, was dominated by practice, until a new wave of classicism accompanied a new ruling house.

We will look at these developments again. For now, however, let it be noted in summary that they are only further illustrations of a general pattern in which renascence images and forms, entering the culture through classical education or the imitation of Continental models, starting with the works of men of wealth and power, serving the needs and inculcating the values of such men, but percolating down to the gentry and the mercantile classes, were applied to existing native tradi-

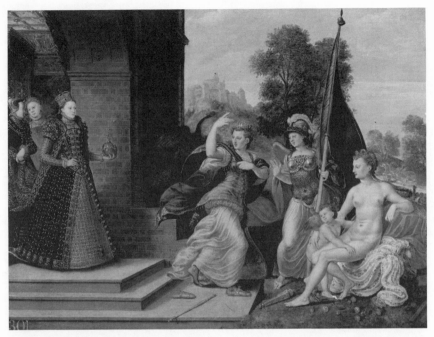

24. Monogrammatist HE, *Elizabeth and the Three Goddesses* (1569). The Royal Collections, Hampton Court. Copyright reserved to Her Majesty Queen Elizabeth II. Photo: A. C. Cooper.

tions, at first awkwardly and then more naturally, until some kind of satisfactory composite work emerged. The mixture shows up in something like the painting *Elizabeth and the Three Goddesses* (1569), a curious blend of classical and medieval elements; in something like Wollaton (1580–88), a medieval castle built in a classical idiom; in something like the tomb of Sir Thomas Gresham (c. 1580) in St. Helen's, Bishopsgate, an elegant classical sarcophagus sporting a huge heraldic shield in high relief (figs. 23–25). It shows up very clearly in the Grotesque decor that was ultimately the most widely applied Renaissance strain in Tudor visual art. The mixture is obvious in *The Faerie Queene* but appears also in Thomas Nashe's *Unfortunate Traveller* (1594), whose form comes from Apuleius (with some help from *Lazarillo de Tormes*) but whose contents—jests, scraps of romance, cautionary exempla, fabliaux, *de casibus* tragedies (of rogues, not kings)—are mostly things that would be perfectly at home as Canterbury tales. The elements are disparate, of mixed ancestry. But the very mixture gives strength to the whole, as

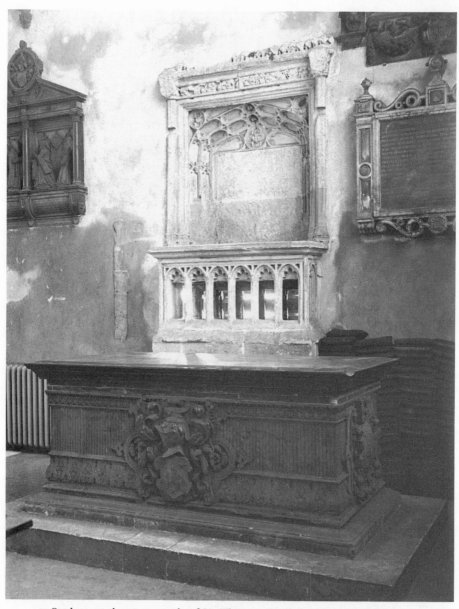

25. Sculptor unknown, tomb of Sir Thomas Gresham (d. 1579), St. Helen's, Bishopsgate, London. Photo: Royal Commission on the Historical Monuments of England.

the qualities absent in one strain are supplied from another and the at-tenuation of force caused by the inbreeding of successive imitations is defeated by fresh if coarse blood. For all the undeniable authority of classical models both visual and verbal, it is just such stylistic mongrels that ultimately prove to be the most satisfying Tudor works of art.

3

Emblems and Programs

I have been arguing, in effect, that Traditional and renascence styles differ in structure more than in content; the differences are, so to speak, matters of syntax more than of lexicon. One is *paratactic,* constructed by stringing together units of equal importance; the other is *hypotactic,* constructed by subordinating some units to others in complex hierarchical arrays. In sixteenth-century England, both styles made extensive use of images employing both words and pictures to convey the same (or at least very similar) messages. And in both styles complex ensembles were often organized according to a *program,* which in this sense is a prescription, usually drawn up by a scholar, usually working in close consultation with a patron, setting forth the ideas of a proposed work, listing the images with which the artist is to express them, and imposing not only subject matter but often material, scale, and overall style as well. The procedure unites what happens when a patron speaks directly to a craftsman, asking for such-and-such an image to be placed in such-and-such a spot, with what happens when an illuminator or engraver sets out to illustrate a book. Programmatic art normally depends on a great community of attitude and experience between artist and audience. In medieval art, that community was expressed through a large inventory of highly conventional images, derived from biblical and classical sources and repeated in many contexts and in all the verbal and visual media. Both the traditions and the particular images were carried forward to the renascence period, augmented, codified, and given new philosophical authority by the neoplatonic and hermetic strains in fifteenth- and sixteenth-century European thought. Such images have gone by a variety of names—symbols, icons, hieroglyphs, *imprese*—but for the duration I will use a term brought forward by both Tudor usage and much recent scholarship, *emblem.*[1]

Because the semantic aspects of emblems have been amply treated in dozens of recent works, my particular concern will be with what might be called their syntax: the characteristic relationships among them. As we will see, emblems are aggregative images, built up from one or more independent, conceptually discrete signs or symbols. In an art based on them, structure tends to be imposed on the artist by the nature of the material, by the situation, by previous works of the same kind, by accidents encountered in the course of construction or decoration or writing—in short, by external factors of all sorts. The area over which an artist can be seen to be exercising control is what I have been calling the surface, the portion of the work immediately under the artist's hand and eye.[2] The Tudor architect seems to have seen the two-dimensional facade but not necessarily the three-dimensional layout (which, as we have learned from Penshurst, was likely to develop as the needs and resources of the family developed, through decades). And he saw the facade as an aggregation of elements—door, windows, columns, balustrades—each with its own stylistic and symbolic logic. The Tudor poet, following Ovid (and Chaucer), cataloged the trees rather than mapping the forest, and when a sixteenth-century Englishman designed a forest (or at least a garden) he did so in incremental units, usually squares, of uniform size and shape. If an idea kicked up in the course of a discussion suggested, and the printer allowed, Lyly would add to his narrative a letter, then another, then a third. If the Oxonians in his audience took offense at his account of Oxford, he would add an apology (but not rewrite the offending section). If his readers called for more he gave them more. When an anonymous artist set out to memorialize Sir Henry Unton he divided his panel into halves, with the right side, relatively light in tone, devoted to images from his life, and the left, relatively dark, to images of his death (Strong 1977, 84–110) (fig. 26). Beyond that point, however, he seems to a modern eye to lose control. Because there are many more images from life than from death, they are painted to a smaller (but by no means uniform) scale; the episodes are treated as discrete places (in both the spatial and the rhetorical sense), though the domestic events are roughly confined within a house (as the funeral in the other half is placed within a church) and the public acts laid out along a highway of life, which is awkwardly squeezed in as the available surface allows. Since the picture is a funeral picture, the portrait per se lies in the left half—where it unbalances in terms of actual visual effect the conceptual symmetry of the plan. It is not just the crudeness of execution that distances this work from Con-

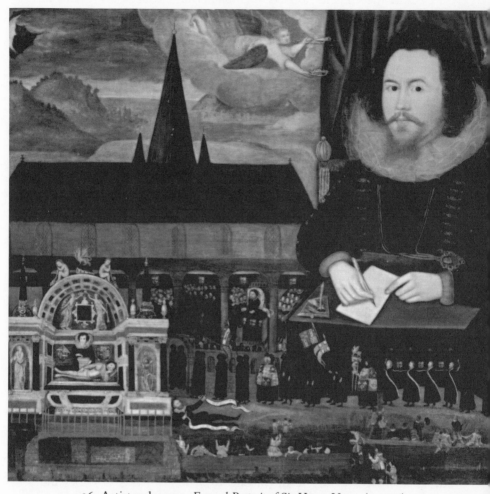

26. Artist unknown, *Funeral Portrait of Sir Henry Unton* (c. 1596).
National Portrait Gallery, London.

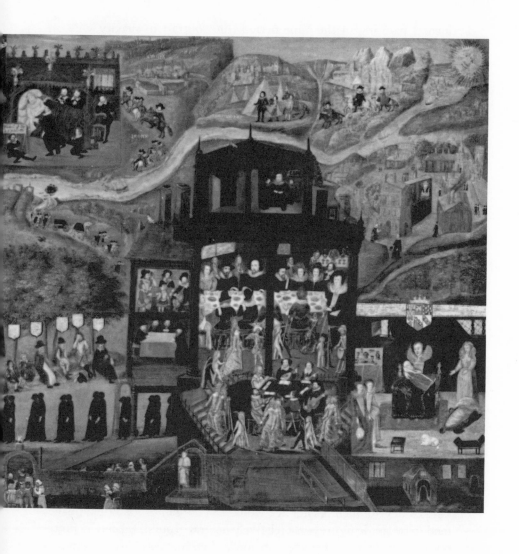

tinental painting of the same period (the contrast in suavity with an earlier portrait, presumably painted to celebrate Unton's knighthood, is striking), but also the assumptions about how works of art might be constructed and, beyond that, deeper assumptions about their functions in the world.

The paratactic style of works like the Unton piece, the style of the Bible and the primitive epic and romance, contrasts with the hypotactic style of literary epic and romance. Parataxis works by sticking bits and pieces together. They may be identical or only similar or quite different, but they are all conceived as having equal value and significance: they occupy the same conceptual plane, so to speak. Hypotaxis works by subordinating some things to other things, in both form and value: they occupy different planes. The great example of paratactic construction in literature is a chapter from the Book of Numbers. The great example of hypotactic construction is any Ciceronian period. From the visual arts we might adduce the Bayeux tapestry and Michelangelo's Sistine Chapel ceiling. In an age that taught its writers to write by close imitation of Cicero, Vergil, and the other authors of the Roman summertime, such periodicity as the syntax of early modern English would allow was a common feature of English style. In the visual arts, the commitment to symmetry gave a conscious precedence to visual over practical considerations. Yet whatever complicated subordination More, Surrey, Jewel, Lyly, or the architects of Nonsuch, Parham, or Knole might have achieved within a single sentence or a single facade, I have already demonstrated that the underlying principle of esthetic construction in the arts of mid-sixteenth-century England was mostly paratactic.

Such art expanded by accumulation, *amplificatio,* rather than by the kind of development a later age would call "organic." Its visual images tend to be single figures on a relatively neutral ground, related by juxtaposition; its literary characters are most often solitaries, lovers bemoaning the coldness of their mistresses, courtiers cooling their heels in a perpetual anteroom of unfulfilled anxiety, mourners grieving a death. In Sackville's induction to *A Mirror for Magistrates* (1563), none of the personages—the dreamer, Sorrow and the dozens of other personifications, the doleful Buckingham—has more than an accidental relationship with the others. And the work's lack of any clearly focused center of attention (Buckingham appears suddenly toward the end without any particular preparation) seems to represent a literary equivalent of the diffusion typical of many Tudor paintings, prints, even buildings. The

distinctively Tudor room is the long gallery (which goes nowhere in particular) constructed of any number of identical bays; though houses were symmetrical, their doorways were more often than not off-center, balanced by the bay window of the hall dais, and the most elaborate gateways to mansions and colleges typically opened only onto a court itself entered by half a dozen doorways. The principle can even be extended to the visual dimensions of religion and politics. The aniconic, verbal emphasis of the Reformation displaced attention from the altar, which was fixed and focal, to the pulpit, which in effect moved with the preacher. Indeed, the most important pulpit in England was not at the apex of some commanding set of sight lines but tucked rather inconspicuously into a corner of Paul's Yard. The Elizabethan court was peripatetic—the annual royal progress marked only its most active period—and the sovereign herself not only kept no settled throne in a settled palace but within her assorted places of lodging (as often as not, somebody else's house) came, went, appeared and disappeared, in a Protean variety of masks and roles.

Full analysis of the origins of such a complex and ubiquitous phenomenon is not possible. I would, however, call attention to three factors. One was essentially philosophical: an esthetic attitude in which art conceded the irresistible flux of the phenomenal world by abjuring closure. Such an attitude had been carried over from the medieval past. It was predictable in a culture to which the Day of Judgment remained an imminent possibility. It was also the probable attitude, since most of the world's esthetics have been of this type (only recently have comparative studies forced us in the West to recognize that the expectation of closure, dominant in classical art and revived and developed from the renascence to our day, is relatively uncommon). A second factor was essentially religious, the consequence of positing this world as only the phenomenal expression of a noumenal reality beyond and around it, an attitude likewise medieval in origins but amplified by renascence neoplatonism. A third was essentially political, a definition of the artist as merely the agent of superior spiritual, temporal, or intellectual authorities.

The consequences of an esthetic system free of our insistence on closure we have already seen: *amplificatio* and *copia*. They were in various ways encouraged by the second factor, the definition of the phenomena of the world as iconic expressions of higher truths. In this connection, the etymology of the word *emblem* comes to bear. As Whitney put it, "The word is as much to say in English as To set in, or To put in:

properly meant by such figures or works as are wrought in plate, or in stones in the pavements, or on the walls, or such like, for the adorning the place" (1586, 4r). The passage directly ties emblems to the architectural decor we have been concerned with, but it also brings out the disposition of the emblematic mode toward discontinuity. Angus Fletcher has a significant observation on the issue: "Allegorical painting and the emblematic poetry that takes after it . . . present bits and pieces of allegorical 'machinery,' scales of justice, magic mirrors, crystal balls, signet rings, and the like. These devices are placed on the picture plane without any clear location in depth. Their relative sizes often violate perspective (they are often out of proportion), and at the same time they preserve their identities by being drawn with extremely sharp-etched outlines" (1964, 87). [3]

The proposition (and it has been a datum of much recent scholarly work on the period, in both art history and literary history) is that sixteenth-century Englishwomen or men read the world as a catalog of signs, icons, emblems. Objects and events they saw as local manifestations of cosmic truths; they valued particulars chiefly as the sensible ends of generalities. And one of the important implications of *ut pictura poesis* is that as symbols, visual and verbal images work to the same purposes: "pictures are the age's way of conceptualising abstractions" (Orgel and Strong 1973, 1:3). [4] Yet such pictures normally depend upon verbal antecedents, as we can see from the fact that a book apparently so close to the visual as Abraham Fraunce's *Insignium armorum, emblematum, hieroglyphicorum, et symbolorum, quae ab Italis Imprese nominatur, explicatio* (1588) has no illustrations. Neither does Linch's translation of the *Imagini* of Cartari, *The Fountains of Ancient Fiction* (1599). [5]

But as Fletcher suggests, the art that rests upon such assumptions will tend to be paratactic: aggregative, disjunctive, even visually incoherent. As long as artists are looking through their images to the ideas beyond them, the images themselves will appear mutually discrete, and their relationships will be governed by noumenal relationships among the ideas rather than phenomenal considerations such as spatial proportionality: they will all occupy the same conceptual plane. [6] (Consider the pictures that illustrate the dictionary or the Sears catalog.) Indeed, when complex aggregates of symbolic forms are brought together into configurations that come too close to imitating familiar complex phenomena—specifically, into stipulated spatial relationships —as when the digestive and sensory and mental and other functions of the human body are imaged as the various rooms and towers of

the Castle of Alma in *The Faerie Queene,* the result may be ludicrous. Moreover, the artists will tend to represent the physical image in ways determined by the idea beyond the visible surface. The portraits and epideictic poems representing the aging Elizabeth seem to us to bear little resemblance to the temperamental old woman discernible in history, but to the Elizabethans that did not matter. They preferred rather to have the expectation set up by their idea of her role satisfied than to be surprised by facts.

The point may also help account for the planar character of Tudor art. Comments about art in Tudor books almost always commend the power of the artist to represent reality; over and over again somebody gasps in astonishment because such-and-such a picture is more lifelike than the original. Yet when we moderns turn from these remarks to actual English pictures and statues of the period, we must be puzzled. For by and large, they fall far short of their Continental cousins in the department of illusionistic magic. The skillful imitation of surfaces was carried over from the International Style background; lace and brocade, the sheen of a pearl or the luster of an eye, are usually well painted. But the modeling of faces and bodies, the placement of figures in space, the handling of architecture and landscapes, normally appear crude to our eyes. Even such an admirable workman as Nicholas Hilliard ordinarily avoided particularized settings and figures painted more than half-length. We are always being reminded that we are looking at a two-dimensional object. To some extent, we may attribute this contrast between Tudor statements and Tudor practices to a lack of real visual sophistication; most of us will have heard a naive viewer enthuse about the representational power of some incompetent daub.

It helps here to remember again that Tudor definitions of reality emphasized ideas. Warts and whims were no part of *queen* abstractly conceived: artists sought to represent the idea of the queen and not what she was. In Elizabethan portraiture the personage is typically painted without much expression in a static pose, dressed in a costume whose fabric and style, jewels and accessories, all express some element of role or station. If the figure is shown seated, the chair and canopy are likely to include symbols of authority or rank or genealogy. If the subject occupies a defined space, the furnishings and architecture normally convey specific meanings about family (a coat of arms) or occasion (a battlefield tent). The portraits often bring out to the point of exaggeration qualities of what we would call role rather than personality— Lord Burghley as Statesman, Sir Thomas Lee as Soldier, Lady Dacre as

Grieving Mother (figs. 27, 28). Thus the Lothian portrait of Donne is "an 'icon' of Donne as a 'humorous,' melancholy poet," and no more represents the whole of the man than does the poetic persona, of which indeed the painting is a visual counterpart (Chambers 1971, 29–30; see also Hunt 1978, 214; and Leslie 1985, 24–25) (fig. 29).[7] Nor were individual emblems the peculiar property of any person or institution. Individual emblems, of course, were widely copied, not only from one book to another but also from books to other media. As in any other imitative tradition, the quotation did not need to be direct. European families with any pretensions to gentility had their genealogy drawn up, engrossed on vellum, and available for display; the typical format involved a secular adaptation of the Tree of Jesse motif, with the arms of the various branches of the family hung on various branches of a flourishing tree (often shown springing from the recumbent body of some ultimate ancestor). But a virulently antipapistic English manuscript illustrates the pedigree of Philip II of Spain with leafless trees, whose only fruits are swords (Eton College MS 164, 70–71). The Protestant poet Spenser will borrow images from the Catholic poet Tasso without embarrassment, and the papal crown has a very different moral valence in Protestant than in Catholic art. In other words, the particular emblem usually has no particular ideology or other bias.

The generalizing and abstracting power of the emblem appears to stand to the content of images as the generalizing and abstracting power of ratios, meter, and other patterning methods stands to architectural, pictorial, and literary content. But within an emblematic conception of art, it is important that the artistic surface not become too substantial, too tightly organized, too firm, that it not begin in its coherence and completeness and multidimensionality to compete with the real world. If the eye stops there, rather than passing through to the idea beyond, it becomes an end rather than a means (as the Puritans understood). It is not only because of characteristics of the print medium itself that the earlier emblem books (especially Alciati, the most popular) employ a very purely linear technique. The figure, isolated on the page, further isolated within the page by a frame, presented with little or no modeling against a minimal background or no background at all, is by such technique almost totally freed from any particular context. Since it is the emblematic contributions the particular constituents make to the whole that matter, and not their physical interrelationships or their evocation of a particular place, they do not need to be painted in a

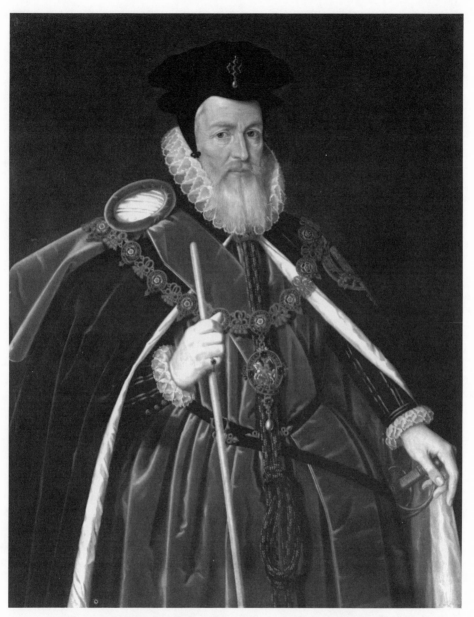

27. Marcus Gheeraerts the Younger, *William Cecil, Lord Burghley* (c. 1570). National Portrait Gallery, London.

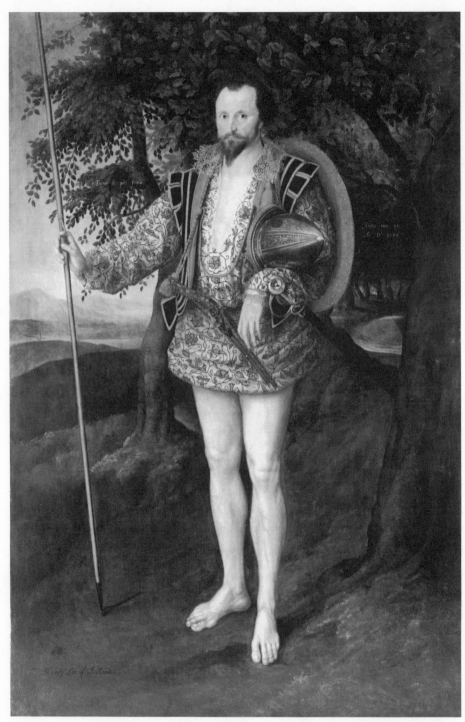

28. Marcus Gheeraerts the Younger, *Sir Thomas Lee* (1594).
The Tate Gallery, London / Art Resource, N.Y.

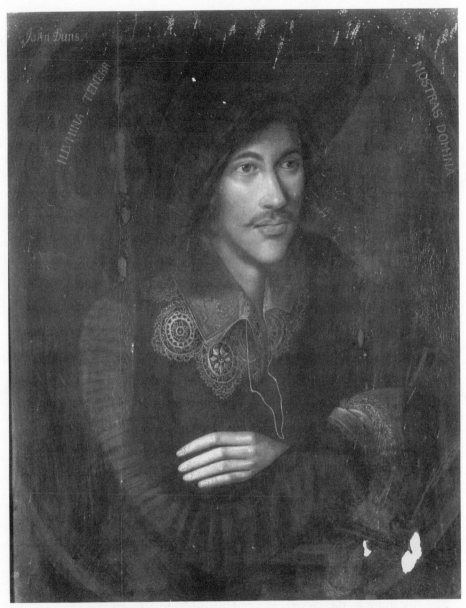

29. Artist unknown, *John Donne* (the Lothian portrait, c. 1595). In a private Scottish collection. Photo: Scottish National Portrait Gallery, Edinburgh.

spatially sophisticated manner; they can all be seen to occupy the same visual plane as they occupy the same plane of significance.

All these points are well exemplified in the work of Nicholas Hilliard, who in these as well as some other respects can be taken as the prototypical Elizabethan artist.[8] At first glance, it looks as if Hilliard's training and artistic allegiances ought to have encouraged him to develop the representational skills of his counterparts across the Channel. He claimed that he founded his art in study of the greatest available model for English painters, Holbein, and he sought additional sophistication at the court of France, where he seems to have had ample opportunity to observe work exhibiting the full technical achievement of renascence art, as well as to pick up more tricks of the limner's trade.[9] But Hilliard began as a miniaturist, and a miniaturist he remained. And the conceptual bases of the Tudor miniature were antagonistic to techniques intended to locate the subject in a particular space. It is not just, as noted above, that miniatures could be held in the hand and thus gave tactile evidence of their two-dimensionality. Nor is it just a matter of size—Hilliard's pupil, then rival, then successor, Isaac Oliver, produced much more spatially accomplished work on the same scale. But for Hilliard, Oliver, and their clients the miniature was explicitly an icon, a sign, the present or phenomenal emblem of the ideal subject.[10] Moreover, the miniature typically represented the subject idealized as the embodiment of a particular character or role, as sovereign or parent or (most commonly) lover, attired in an appropriate garb (for lovers, some degree of deshabille), accoutred with appropriate symbolic attributes (for lovers, flames or clouds) (figs. 30, 31). Under these circumstances, a good likeness was wanted, one that gave a strong sense of personality. So was the skillful depiction of attributes such as costume or badge. But illusionistic representation of a specific setting would be undesirable because it would run counter to the purpose of the piece, which was not to fix the viewer's memory or anticipation of the subject in some particular moment but rather to provoke contemplation of the subject's meaning to the viewer. Hence Hilliard had no motivation to learn the devices of illusionistic perspective, and on the very rare occasions when the iconography of a piece called for something more spatially complex (most notably, in his portrait of Henry Percy, earl of Northumberland), he lacked the necessary skills (fig. 32).

At issue in Tudor art, then, is a repertory of specific images, but also and perhaps more centrally an emblematic habit of mind, carried over from the medieval past, infused with new energies by the study

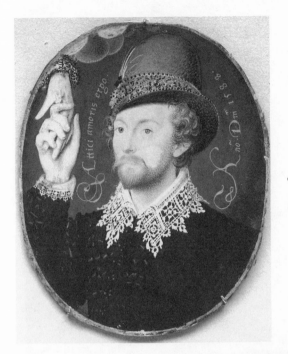

30. Nicholas Hilliard, *Lord St. John of Bletso* (c. 1586). Reproduced by courtesy of the Board of Trustees of the Victoria and Albert Museum, London.

31. Isaac Oliver, *Unknown Man* [in flames] (c. 1600). Reproduced by courtesy of the Board of Trustees of the Victoria and Albert Museum, London.

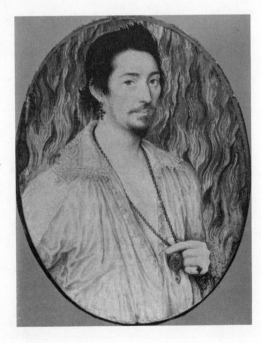

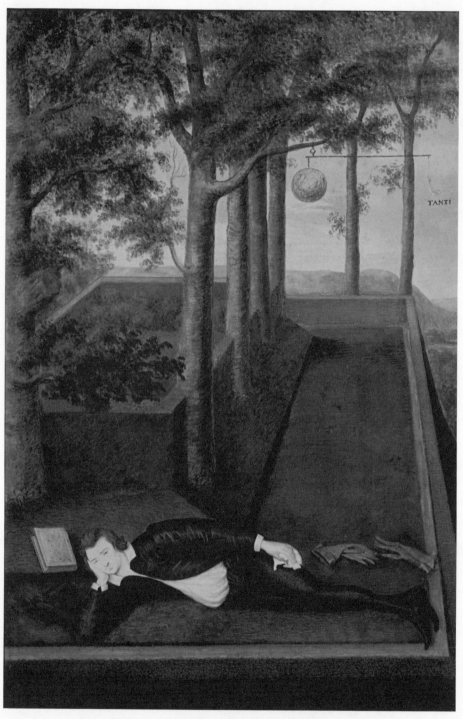

32. Nicholas Hilliard, *Henry Percy, Ninth Earl of Northumberland* (1590–95).
Rijksmuseum, Amsterdam.

of the classics and of collections of adages and proverbs, inculcated both didactically and experientially from childhood on, and eventually affecting every part of life. Among the most interesting buildings of the Elizabethan period is that built at Lyveden in Northamptonshire by Sir Thomas Tresham. Between the Old Building he had inherited and the new one he put up in the late 1590s, he laid out an elaborate set of symbolic gardens. A series of terraces rose to an orchard, beyond which was a moated garden with artificial mounts at each corner. This in turn enclosed a square terrace on which Tresham set out to build his New Bield, as it is called. The sequence represents from one angle a symbolic return back through the states of history to the first garden, with the New Jerusalem beyond, from another a movement from Eden to Gethsemane to Calvary. And the garden lodge is a building in the shape of a cross, its proportions and openings worked out in terms of the mystical numbers 3 and 7 and its decorations consisting of emblems and mottoes on the subject of Christ's Passion. This structure is, of course, carried out in three dimensions. But the governing concepts are linear (historical sequence) or planar. The house is equally cruciform whether two feet or two miles high; Tresham died before the building could be completed, but as a symbol, it probably works better without roof and interior partitions than with them. The whole thing is a complicated architectural allegory (Stean 1977, 397–400).[11] The literary equivalent is the five-pointed lodge of Basilius in Sidney's *Arcadia* (1917–26, 1:91).

Shaped houses and gardens recall shaped poems, like those in the form of a crowned pillar and a pyramid presented to Elizabeth during the royal progress of 1590 (Ing 1968, 88; Nichols 1966, 3:51–52; G. G. Smith 1964, 2:100–101). Such poems very often appeared at the beginnings of things—as entry points. But in a sense all emblems are entry points, to a world higher and more orderly than this one. The point is well made by the title pages of books, which grew increasingly elaborate throughout the period and which from an early date were often based on architectural images. (Note how the verbal elements insist on the two-dimensionality of the sheet no matter how virtuose the cutter's work on the encadrement [figs. 2, 3, 33]). Title pages serve to remind us that for all their adaptability to garden plans, topiary, embroidery, majolica ware, plaster, and even marzipan, emblems mostly went about in print, and not just in emblem books per se, or in single leaves from such collections, but in printers' badges, decorated initials, and borders and as elements in or parts of the frames around scenic pictures, portraits, maps, architectural and mechanical diagrams, and so on. Such

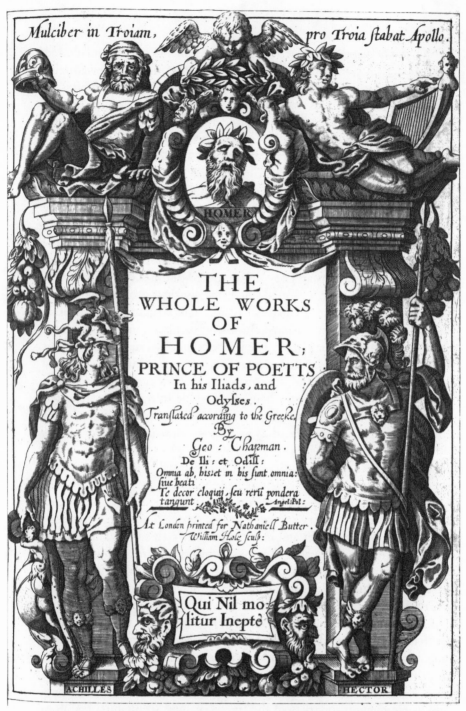

Mulciber in Troiam, *pro Troia stabat Apollo.*

HOMER

THE
WHOLE WORKS
OF
HOMER;
PRINCE OF POETTS
In his Iliads, and
Odysses.
Translated according to the Greeke.
By
Geo: Chapman.
De Ili: et Odill:
Omnia ab. his:et in his sunt. omnia:
siue beati
Te decor cloquij, seu rerū pondera
tangunt _____ Angel:Pol:

At London printed for Nathaniell Butter.
William Hole sculp:

Qui Nil mo-
litur Ineptè

ACHILLES HECTOR

33. George Chapman, *The Whole Works of Homer* (1616), title page. Reproduced by
permission of the Huntington Library, San Marino, Calif.

emblems serve equally well both the visual and the verbal rhetoric of the time; in either case they set objects imitated from experience—portraits, maps, *descriptionis loci,* love stories or recipes for making beer—in the ethical context demanded by the intensely ethical bases of English humanism.

Symbolic architecture, shaped poems, and emblematic entry points are ubiquitous in those important focuses of Tudor arts activity, royal progresses and processions. Such occasions, inherently linear and aggregative, brought forth paroxysms of emblematic activity. Analysis of the ceremonies recorded in Nichols and other sources would turn up a good deal of repetition but still the appearance of literally hundreds of devices in dozens of formats and contexts, from an isolated figure dressed like a wild man leaping out from behind a tree to recite a commendatory poem (itself full of emblematic images) to such an elaborate set piece as the four-day entertainment offered to Elizabeth at Elvetham, Hampshire, by the earl of Hertford in September of 1591, which involved the construction of an artificial lake and the enactment of half a dozen allegorical episodes by hundreds of costumed figures (Bergeron 1971, 57–61; Nichols 1966, 3:101). For our present purposes, the most informative events were the royal entrees, such as those that made part of the coronation activities of both Elizabeth, in 1558–59, and James I, in 1603–4. Such entries involved the construction of decorated archways, pierced for the royal passage but overwhelmingly frontal and planar in their visual effect, each carrying anywhere from two or three to two or three dozen individual emblems (Bergeron 1971, 65–89). Thus in the Jacobean entry of 1604, the New World arch in Fleet Street, centering on a moving globe, presented the figures of Astraea or Justice, Virtue, Envy, the four Cardinal Virtues, the four Kingdoms (England, Scotland, Ireland, France), the four Elements, the Estates of the Land—thirty-four figures in all, together with assorted animals, plants, pyramids, columns, and trophies. Yet for all its complexity, it would not take much to turn William Kip's engraving of this structure into the title page of a book (fig. 34).[12]

Such spectacles typically involved several dozen characters, divided between idealized and grotesque figures (more precisely, one group idealized upward, the other downward). The tradition appears most clearly in the masques, where the two groups appeared separately (masque and antimasque), each conveying half of the world, as it were. The spectacle incorporated the duality expressed in the static emblems of the print media, between a corrupted phenomenal microcosm and

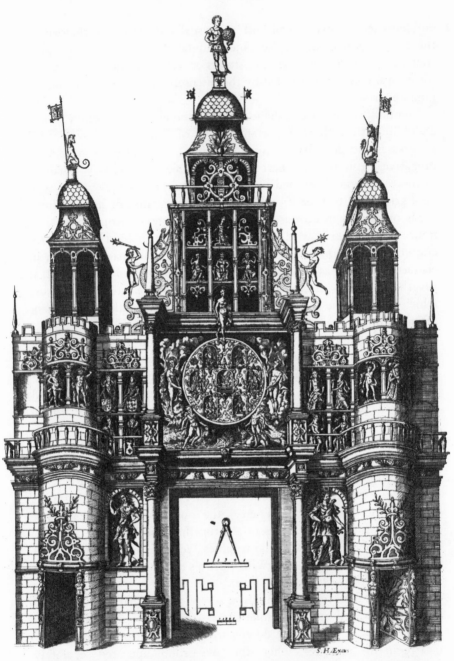

34. Stephen Harrison, *The Arches of Triumph* (1604), "The New World Arch," engraved illustration. Reproduced by permission of the Huntington Library, San Marino, Calif.

a purified noumenal macrocosm. Whether in print or in action, the modes are in tension, even conflict. To the extent that they can be resolved, the resolution must occur not so much in the works themselves as in the mind of the reader or spectator (in the case of the masque or royal entree, in the unifying figure of the monarch).

What is implied is that the work is not itself a complete image (*imago*) of the idea—of Justice, for example—but rather a set of materials for constructing such an image. The materials are likely to be familiar. They will almost always include, first, a number of propositions, then a number of individual emblems (some single and unequivocal, some multiple and ambiguous, some discrete, others composed), and finally a narrative or other framework that identifies the anticipated audience, attracts and stimulates that audience, establishes a sequence, and supplies a context for interactions among the individual emblems. In the proem to book 5 of *The Faerie Queene,* Spenser submits Justice to analysis, sketching its nature and history in the world, mostly by contrasting the actual present with an ideal past and placing the rectified ideal in the bosom of the queen:

> Dread Soverayne Goddess, that doest highest sit
> In seate of judgement, in th'Almighties stead,
> And with magnificke might and wondrous wit
> Doest to thy people righteous doome aread,
> That furthest Nations filles with awfull dread . . .
>
> (St. 11)

In the arts, however, the analysis is expressed in concrete symbols rather than abstract words. Thus the individual episodes of book 5 illustrate in narrative and descriptive terms Justice's roughness, vulnerability, source in the very nature of the world, and so forth. Another illustration of the practice is afforded by the funeral portrait of Sir Henry Unton, whose assorted images drawn to several scales and scattered across the painting according to intellectual, not visual, principles memorialize Unton's life not just as a set of events but as events treated in terms of a dialectical analysis, which develops particular images of this man and his work by reference to traditional treatment of a gentleman's roles (the dramatic counterparts of verbal tropes) as scholar, husband and father, host, and diplomat (fig. 26).

The process corresponds on an esthetic level with the analytical process inculcated in the third stage of renascence education, dialectic. The significant terms are defined and then broken down into qualities and

effects by the application of the logical topics. In the visual arts, in fact, in the construction of a visual program, the process was commonly divided between two or more people. A humanistic scholar—that is, an artisan of the intellect, trained both in dialectic and in the invention of rhetorical figures by which to express his concepts—would carry out the analysis, draw up the list of emblems, establish the sequence, and work out some of the more important interactions. The program thus constructed would then be turned over to the artisan of the visual, the painter, sculptor, plasterer, weaver, for execution. (It should be noted that some artists acquired by study and experience license to devise their own programs, or at least to determine on their own many of the details, and that certain highly conventional images were apparently so familiar that knowledge of them was taken for granted.)

A number of such programs, both Continental and English, survive. There is in the British Library a particularly interesting set of late sixteenth-century English instructions for elaborate allegorical paintings, mostly by the same author, who seems in this instance also to have been the patron (Brit. Lib. Sloane MSS 1041, 1062, 1063, 1082, 1096, 1169; Harley MS 6957). Most of these are addressed to a particular painter. They give detailed instructions concerning color, relative size, spatial relationships, and other practical matters. The governing criteria are mainly emblematic: the writer stipulates that a given figure be placed high or low in the picture to indicate whether the figure is triumphant or cast down, sets virtuous images at the right and wicked ones at the left. Most of the more purely esthetic decisions are left up to the painter (although the writer has a powerful and typically Tudor commitment to the ideal of symmetry, and repeatedly asks that figures be set to balance one another). The surviving manuscripts include lists of the mythological beings, personified abstractions, and historical personages (including Sir Thomas Gresham, Sir Nicholas Bacon, the archbishop of Canterbury, assorted Greeks and Romans, and the Great Turk) who are to be depicted and the legends, labels, and sentences associated with them. They betray their inkhorn origins by occasional bursts of theory, as when big gobs of cosmology are mixed in with the practical instructions for representing a tempest, by unnecessary explanation (a long statement of "The Morall of the Tempest" in the most intemperate, controversial manner), and by a habit of documentation ("*q l in vergilio aeneidos*" following an instruction to the painter to put patches of snow near the top of Mt. Etna). So full are they that they would, if cast into verse with a few omissions and embellishments,

produce allegorical poems. It is a great pity that the pictures (if they were ever executed) have disappeared.

A more elaborate undertaking, like the entry of James, called for a more elaborate program. In this instance, the primary sources (that is, the manuscripts) have not survived. What we do have are published texts of the speeches and songs and verbal descriptions of the arches, together with some information on participants and procedures, and a set of engravings (figs. 34–35). (Much less information survives for the corresponding entrees of Mary in 1554 and Elizabeth in 1559 [Bergeron 1971, 9–22].) Although these materials raise as many questions as they answer, they do provide us with the fullest available account of one extensive mixed-media event of the period, at least until we reach the masques of Jonson and Inigo Jones a few years later (Dekker 1955, 2:229–309; Jonson 1941, 7:83–109). It was a considerable enterprise. The city merchants elected a committee of sixteen, including four aldermen, to supervise the project; they were assisted by a clerk and two flunkeys, a clerk of the works, and more than two hundred workmen (Dekker 1955, 2:303). Presumably the businessmen took care of practical matters—money, materials, manpower, local arrangements, security. Artistic direction was apparently divided among the poets Ben Jonson and Thomas Dekker (with some help from Thomas Middleton) and the artificer Stephen Harrison. Just how the process worked is impossible to know, but the published texts support some speculation. Dekker suggests that the initiative lay with the writers rather than the visual artist: "Imagine, that *Poets* (who drawe speaking Pictures) and *Painters* (who make dumbe Poesie) had their heads and hands full; the one for native and sweet Invention: the other for lively Illustration of what the former should devise: Both of them emulously contending (but not striving) with the proprest and brightest Colours of Wit and Art, to set out the beautie of the great Triumphant-Day" (2:257). The suggestion is supported by the plethora of learned quotations and marginalia in Jonson's text. Yet Dekker also states that Harrison "was the sole Inventor of the Architecture" (2:303). A reasonable supposition, and one that falls in line with what we know of similar spectacles on the Continent, is that Jonson and Dekker drew up inventories of figures (including information about their characteristics, costumes, and attributes) and inscriptions, together with some general principles of organization, which Harrison then translated into two-dimensional drawings, then plans, and finally three-dimensional structures (whose visual effect, as stated earlier, was really planar).

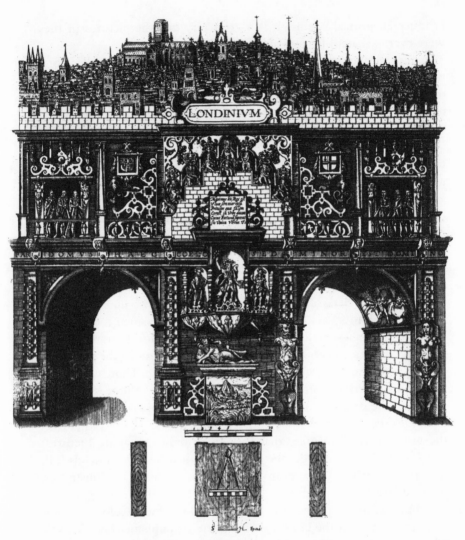

35. Stephen Harrison, *The Arches of Triumph* (1604), "Londinium Arch," engraved
illustration. Reproduced by permission of the Huntington Library,
San Marino, Calif.

The results are a *mélange de tout:* dozens of symbolic figures (classical divinities, personified places and ideas, legendary and historical personages); further dozens of more generalized putti, satyrs, herms, masks; dozens of symbolic and decorative objects (columns, pilasters, obelisks, cupolas, corbels, pediments, stairways, balustrades, lozenges, swags, flags, niches, curtains, windows)—all the paraphernalia of late sixteenth- and early seventeenth-century European decor. If we include the arches contributed by the Dutch and Italian merchants (independent contributions, it would appear), the styles range from a relatively direct (but still mannered) classicism, through Gothic Revival, to the heaviest and most self-conscious imaginable northern European Mannerism. Academic classicism is thickest round the Dutch and Italian arches (where the speeches were given in Latin, not English) and the two arches supervised by Jonson (both liberally adorned with Latin inscriptions). Dekker's are more merely visual. Indeed, he comments rather acerbly on those who "make a false florish here with the borrowed weapons of all the old Maisters of the noble Science of Poesie" and who would clothe an allegorical figure in "many paire of Latin sheets . . . shaken and cut into shreds" (2:254–55). Dekker may well be jibing at Jonson here (a point to which we will return in a moment). He goes on to aver that "we come not now . . . to Play a Maisters prize" in a competition among scholars; rather, "the multitude is now to be our Audience, whose heads would miserably runne a woollgathering, if we doo but offer to breake them with hard words." Even the king should not be "wearied with tedious speeches"; hence many of those written and printed by the poets "were left unspoken" (2:303). Is there an implication here that the individual emblems needed no verbal gloss? Such a view would only represent the durability of an idea running far back into the Middle Ages, when the church was accustomed to speak to its illiterate flock through visual images—painting, sculpture, stained glass. But Jonson, seemingly concerned to defend his more deeply scholarly schemes, retorted that they were meant for "the sharp and learned" (including especially his well-informed sovereign, to whose view these works especially addressed themselves); others could admire the pretty things and be satisfied.

What is most certain, and certainly most important for our purposes, is that here, as late as 1603, in a work at least partly supervised by the most thoroughly classical writer of the time, only the most rudimentary principles of theme or design can be seen to govern the relationship among these several arches and the speeches uttered from them:

the paratactic disposition remains in force. It could perhaps not have been otherwise, because circumstances did not permit control by a single supervising intelligence. The Dutch and Italians worked separately from each other and from the English. The two English poets had been sworn foes since the War of the Theaters, and neither's text mentions the other's name, though Dekker does describe Jonson's work as fully as his own. In any case their divergent views on the appropriate application of learning would have made real collaboration difficult. Poetic rivalries aside, Harrison's engravings differ from Jonson's and Dekker's descriptions in ways that imply that he had his own ideas on many points. (Like other artist executants, he presumably made up for the formal authority assigned to the verbal programmer by getting the last, practical image.)

Jonson's text, indeed, sets up some kind of hierarchical integration as a necessary quality in elaborate compound images such as these arches:

> The nature and propertie of these Devices being, to present alwaies some one entire bodie, or figure, consisting of distinct members, and each of those expressing it selfe, in the owne actiue sphaere, yet all, with that generall harmonie so connexed, and disposed, as no one little part can be missing to the illustration of the whole: where also is to be noted, that the *Symboles* used, are not, neither ought to be, simply *Hieroglyphickes, Emblemes,* or *Impreses,* but a mixed character, partaking somewhat of all, and peculiarly apted to these more magnificent Inventions: wherein, the garments and ensignes deliver the nature of the person, and the word the present office. (7:90–91)

According to Sir Roy Strong, Jonson is paraphrasing the *fons et origo* of renascence hypotaxis, Alberti, who in turn was following Vitruvius (1983, 70). And within the single arch, the prescription may apply; if we take Jonson's list of the ideas for the Fenchurch arch ("the very site, fabricke, strength, policie, dignitie, and affections of the Citie" [7:90]) as definitive rather than suggestive, one or more features of the arch clearly correspond to each idea, and vice versa.

Still, the visual organization is less coherent than the verbal scheme. In the Londinium arch, intellectually and visually, Monarchium Brittania is served by Theosophia at her feet, and together they rule Genius Urbis, below them, who in turn dominates the recumbent Tamesis with the help of Civil and Military Authority (fig. 35). Intellectually, London ought to be dominated just as Tamesis is. Visually, however, the forty-

five-foot long topographic representation of London across the top of the arch dominates everything—is, indeed, if Harrison's pictures can be trusted at all, the most striking image in the entire spectacle. And whatever hypotaxis may occur in any single arch or speech, there is not much intellectual or formal development from one part of the spectacle to the next—no compelling reason, for instance, why one arch should precede or follow another in the sequence. The Londinium arch, to be sure, makes an irresistibly natural entrance point. It would no doubt have been inappropriate for the two "strangers'" arches to come first or last, and the Garden of Plenty arch, with its bucolic rather than heroic imagery, would have made an unlikely conclusion. But there seems no reason for the Italians to precede the Dutch (or the other way round, either), or for Dekker's Nova Arabia Foelix to come ahead of his conceptually similar New World arch; and either would have served as well as Jonson's Temple of Janus to close the series. Not that it exactly did: for by a development very similar to the growth of *Euphues,* the procession continued on into the Strand, where it found not an arch but a pageant, also written by Jonson, perhaps at the last moment (7:106–9).

I have not been quite fair. There are recurrent motifs and topics: James's arrival as the culmination of the city's history, a contrast between old and new, peace, the four kingdoms, virtue and prosperity overcoming vice and danger. But these mainly arise from the well-established patterns of meaning that developed through a century of royal entrees all over Europe, and confirm my earlier observation on the ease with which emblems move from one context to another. More significant is the link that Jonson established between his two arches by having Genius Urbis speak at both of them. It is noteworthy, however, that the bond is verbal, not visual, especially in connection with the very interesting distinction he draws between "garments and ensignes," which "deliuer the nature of the person" and "the word," which conveys "the present office" (7:95). In the long run, this distinction turns into Lessing's division of the arts, for *present* implies time and change, dynamic versus static, and so on. In a shorter run, the distinction looks forward to the more fully integrated emblematic art of the masques that Jonson was to devise with and without Inigo Jones and that make much fuller use of sequence as an expressive device than do the emblematic arches and speeches of the royal entry. For the moment of 15 March 1603, however, the comment takes us back to the notion of *program* and of the emblem as in effect a potential meaning waiting to be realized in the world by means of action.

What we meet here is the essentially literary basis of renascence visual allegory.[13] Analysis of the arches also suggests that it might be useful to think about literature itself in terms of program. In such a view, the reader stands to the writer as the painter stands to the programmer, asked to carry out the instructions first mentally, but then actively, and thus almost literally to make a picture speak.[14] (The process becomes most immediately realized in plays and in mixed-media entrees, interludes, and masques.) The concept honors the notion of *elocutio, actio* so fundamental to renascence rhetoric and hence poetic. It also helps both to explain and to justify the open-ended structure of works like *Euphues*. If the *actio* to be carried out is an entire life, then the instructions not only may but should grow ever more complex, as time, circumstance, and the knowledge and understanding of the program writer increase. How this procedure might develop in some particular works of art we will see in chapter 5. First, however, I want to shift attention from artists, devising and executing programs, to the patrons for whom the work was done.

4

The Eye of Expectation: Tudor Patronage of the Arts

The history of renascence art is in important ways a history of pa- tronage, in which the names of Gonzaga, Leo X, Charles V, and Ippolito d'Este stand next to Mantegna, Raphael, Titian, and Ariosto. Patronage as a shaping force has been extensively studied by both art historians and literary historians treating Continental works of the fif- teenth and sixteenth centuries. Only recently has English patronage of the period drawn much scholarly attention.[1] Yet it affected artists as fully. In general, Tudor patronage meant the Tudor court, and in the arts as in other matters that institution was conservative, even reaction- ary; artists warmed to its stimulation and struggled against its inhibi- tions in about equal measure. Toward the end of the century, however, changes in the economic and political climate encouraged new sources of patronage that in turn encouraged development of new matters and new manners. Since these things affected even the most independent artists, a consideration of Tudor patronage is as important as a consider- ation of Tudor education in filling out the necessary background for the work of individual artists and the development of particular styles.

Through most of our period, the initiative, and the subsequent con- trol over the subject, size, materials, even the style of works of visual art, rested (nominally in all cases, practically in most) with the patron, whether that was a monastic house building a new chapel, a city corpo- ration decorating its meeting room, or a *gran signior* ordering a portrait of his latest wife. The patron conceived the project, then sought out a painter or sculptor or builder to execute it, and though the skilled worker might well offer suggestions or even haggle strenuously over individual details, final authority, as reflected in the contracts that cus- tomarily governed these matters, always remained with the patron.[2]

Within this framework, we may nevertheless discern three broad streams of development that worked together to shift initiative, and hence authority, away from the patron and toward the artist. The first of these was the great extension of subject matters that occurred in the fifteenth and sixteenth centuries in all the arts. One factor here was the process of secularization. Virtually all medieval art is religious art. Most of it was produced directly for the church, much of it by artists who were themselves members of the clerical establishment; even the patronage of kings and dukes ran through ecclesiastical channels. The fifteenth century, however, was marked by the emergence of lay patrons (and of ecclesiastical patrons behaving more like dukes and kings than like abbots and popes) who commissioned lay works— palaces instead of chantries, portraits and secular *istorie* (Alberti's word) instead of illuminated books of hours: new kinds of pictures and statues and buildings (Levey 1967, 78). A crucial practical factor here was the increase in European economic productivity and the corresponding rapid development of a cash economy. A crucial intellectual factor was the new or revived learning. As the range of subjects increased, the opportunities for the artist to know things not known by the patron increased, particularly as artists themselves became better educated.

New books and new ideas also fed into a second area of development in the arts, a series of technical and stylistic innovations amounting to a revolution. The study of the disinterred artifacts of classical civilization put into renascence hands the round arch and the dome, the classical orders, the freestanding figure, lost-wax bronze casting, the nude, the portrait bust, Grotesque mural decor. On their own, or working up rudimentary processes imported from the East, renascence men invented or perfected oil painting, the cantilevered staircase, printing from both wooden and metal blocks, perspective (aerial and linear), tin-glaze pottery, chiaroscuro enameling, and cheap window glass. The results equipped the renascence artist with a substantially larger and more responsive battery of techniques and styles than had been available to his medieval predecessor. The process also stimulated a taste for novelty in execution as well as subject matter.

The existence of such a taste, by arousing demand, contributed to the third general development, a change in the social standing, and hence ultimately in the professional freedom, of artists.[3] They started off (and largely, to be sure, remained) artisans, craftsmen, men paid to do a job of work, who produced pictures or statues as other men produced shoes; they competed with other craftsmen for commissions; and

if they were engaged on a kind of retainer basis to serve in the household of a single patron—Mantegna in Mantua, Leonardo in Milan, or Holbein in London—they were expected to turn their hands to whatever tasks of design and decoration came along. But through the period a number of factors converged to raise the artist's status. Education and the humanistic emphasis on individual talent fostered intellectual respectability. The widened range of subjects, styles, and media, the expanding markets opened up by secularization and economic prosperity, rapid political change that entailed the need for a constant furbishing and refurbishing of political images, all stimulated competition for artists' services. Improved communications and travel spread artists' reputations and increased their mobility. A clear sign of the new status available to at least the most gifted and energetic figures appeared in the early sixteenth century when patrons began instructing their agents to acquire works of renowned artists without prior commission and without regard for subject matter, size, style: get me a Michelangelo, any Michelangelo, and hang the cost (Gombrich 1966, 110; Shearman 1967, 44). Better yet, get me Michelangelo himself, to ornament the court as both artisan and man. Only a few became what Michael Levey has called painter-princes, including Raphael and Titian. But their success reflected glory on all the rest. The net effect was to put the artists in an entrepreneurial position, from which they could actively seek patronage (even to the extent of traveling from Rome to Florence, from Florence to Fontainebleau), propose projects, expose and develop new markets for their work. A final gloss was applied in the late sixteenth century with the establishment of academies, in Florence, Venice, Paris, to which artists and aristocrats alike belonged (L. Murray 1967, 60; Yates 1947).

In this as in other matters, the process was much slower in England than in Italy. Secularization occurred early in the sixteenth century, and the technical advance began. But the artist remained subservient. To be sure, where Maximilian I had employed even Dürer as a "craftsman" (*faber*), Henry VIII contracted for Holbein's services as an "artist"; the change in terminology may have marked a change in status (Stechow 1966, 131). Holbein's successors as serjeant-painter were court functionaries on a level with the keeper of the wardrobe and the controller of the royal works. But their duties lay largely in devising and supervising the execution of routine decorations—gilding coaches and barges, putting up heraldic devices, and so on (Erna Auerbach 1954, 107). Many Continental painters came to England.[4] But they came as craftsmen, to

join the native craftsmen in a status neatly signaled in Lyly's *Campaspe* (1584). Apelles himself (than whom no painter was greater) broods on the difference in degree offered the bewitching Campaspe by his love and Alexander's: "better to sit under a cloth of estate like a queene," he reasons, "than in a poore shop like a huswife" (1924, 3.52–54).[5] Similar conditions applied to the other arts. As late as 1620 a master builder like Richard Lyminge, who supervised Robert Cecil's work at Hatfield and Sir Henry Hobart's at Blickling, was still a "mechanick," paid a weekly wage rather than a fee, and doubtless subject to on-the-spot dismissal (Mercer 1962, 54).[6] No native English sculptor of the period seems to have been regarded by himself or others as more than a master mason; no English potter, furniture maker, or silversmith found a market for his work outside his own city or town.

Only at the end of the century do we find signs that native English artists were beginning to develop an entrepreneurial stance and to cultivate new customers, both aristocratic and bourgeois, for new kinds of work. Evidence for these developments is fragmentary and scattered, not least because historians have tended to concentrate on the traditional fine arts and on major monuments. The clearest sign is the appearance in churches all over the country of figural funeral monuments to men and women we would call middle class. Most of the murals recorded by F. W. Reader and other students of Elizabethan wall painting have been found in bourgeois houses or substantial farms. We know from Shakespeare and elsewhere about the late Tudor market for both woven and painted hangings; from the coney-catching literature about the demand by young heirs for expensive clothing, swords, and other personal furniture; and from the sumptuary laws and the city comedies about the disposition of well-to-do citizens and their wives toward self-adornment. In the second half of the century some members of the middle class began to have their portraits painted. It seems probable that many of the compact city houses—and perhaps some of the country houses—in John Thorpe's collection of plans were designed for middle-class clients. And the city companies were significant patrons of the groups of artists in various media who produced entertainments and shows to mark anniversaries or installations or to greet dignitaries.

It is less clear that the increased market for the arts produced qualitative as well as quantitative changes in the work. Sir Roy Strong has suggested that the late Elizabethan vogue for the miniature had snobbish grounds, as middle-class clients began to commission the easel portraits previously restricted to the gentry; when city wives began to

order miniatures of themselves, the gentry sought refuge in the new (and expensive) styles of easel portrait of Daniel Myrtens, Paul van Somer, and eventually Anthony van Dyke (1983, 11). For the most part, however, the new clientele merely sought already fashionable kinds of work from applied arts artisans still working in the traditional way.

Unassertive craftsmen produce unassertive work. They respond to demand rather than creating it; they tend to repeat the patterns of the past using the methods of the past. And in sixteenth-century England, not much happened to arouse the sort of competition for art and artists that had energized the Renaissance in southern Europe. In particular, as we have seen, the lack of royal esthetic leadership contributed strongly to the static, even stagnant, case of the visual arts in Tudor England. Only in architecture did the royal court promote much activity, under the two Henrys. Elizabeth, although she built nothing herself, was the cause of the building of others: prodigy houses like Leicester's Kenilworth, William Cecil's Theobalds, Hatton's Holdenby, were all more or less explicitly put up as hostels to accommodate the queen and her court on progress. At the same time, the queen filled another, equally passive esthetic role, as the subject and focus of an endless outpouring of epideictic art, mostly ephemeral but some permanent, mostly mediocre but some of high quality, in all the media and forms.

At this point we find a connection to literature.[7] As we have already had occasion to observe, praise of the ruler was an artistic activity that observed no esthetic boundaries, but rather ran from relatively pure visual objects like portrait miniatures or equestrian statues (though these were likely to incorporate symbolic elements drawn from literary sources) through mixed-media events like entrees and masques to relatively pure literary objects like commendatory sonnets or odes on the occasion of this or that (though these were likely to incorporate images drawn from visual sources). And most of the literary work was done by what we might call the artisan *literatus*, the man of education but not wealth, stature, or authority, who filled some administrative slot or other at the pleasure of a king or magnate, and who like the serjeant-painter was ready to turn his hand to any task: translate an epistle of Cicero; write a Latin welcome to a visiting dignitary or a vernacular genealogy; make songs, sonnets, or interludes.

The workshop of these people was the court more generally construed—the extended household of some wealthy, powerful figure. Such households, says Lawrence Stone, replaced the monasteries and royal courts as the centers of patronage in the literary as well as the

visual arts in an "Indian summer" of the medieval tradition (1965, 520, 703). Only such figures (and they included a few women, among them Bess of Hardwick) had the wealth, the leisure, and the education necessary to assume the initiative in the commissioning of important works of art. They supervised the design and construction and furnishing of huge houses; they invited the queen to visit them and oversaw her entertainment.[8] The activity was neither universal nor steady. Individual and family fortunes fluctuated wildly during the period; the extravagant patronage of one generation might leave the next fighting for its fiscal life, or a change in royal favor wipe out an aspiring patron like Sidney overnight. Additional waves were made by religious turbulence, as Protestant iconoclasm ran counter to Protestant wealth.

Caught in the cross-chop, the artisan, visual or verbal, was now swung aloft, now hurled toward the rocks. The initial humanist impetus had promised a splendid future for the educated man, regardless of social origins, and the prodigious rises of figures like Wolsey and Thomas Cromwell seemed to bear out the promise. But sixteenth-century education fell on knights' sons and earls' sons and even kings' sons (and daughters) as well as butchers' sons, with first Henry VIII, then Mary, Edward, and Elizabeth, and finally Henry and Charles Stuart as compelling examples. By 1530 or so the success of this program of genteel education had begun to set considerable obstacles in the way of the aspiring humanist of lower- or middle-class origins. If, as G. K. Hunter has argued, Tudor literary activity was a kind of political courtship display (1962), the advantage had to go to birds who by virtue of birth and wealth were already inside the charmed circle when the contest began. Thus, through most of the century we can distinguish at least two classes of courtiers; I will call them *clerks* and *gentlemen*.[9] The model for the first group was established around the turn of the century at a point where the church still had an effective monopoly on literacy, and was set by men like Hawes, Skelton, and John Heywood; it included Grimald, Breton, and Gascoigne in the middle third and Lyly, Spenser, and Daniel at the end. These men were by and large the sons of freeholders or merchants; after Oxford or Cambridge, they became minor figures at court, maneuvering for preferment to some secretaryship or sinecure. Within the second group, Wyatt was in many respects prototypical; this category later included Sackville, Ralegh, Dyer, Harington, and Bacon. These men were given a taste of the university, a Continental tour, and a period at the Inns of Court. Then they, too, attached themselves to the court and began the struggle

for some of the spoils of a traitor's estate, or a profitable guardianship, or a piece of a state monopoly.

There were assorted differences between the two groups. One of the most visible was that the literary products of the clerical group were likely to be their primary tasks. Edwin Miller justly emphasizes the labors of second- and third-generation humanists in producing translations, moral writings, books of practical instruction on husbandry or self-defense, chronicles, polemical pamphlets, diplomatic correspondence. Under "the sustained patronage of members of the privy council," including Leicester, Cecil, and Erpingham, the most able literary men of the mid-century became "propagandists, interested in their own and the nation's welfare." The group included Golding, Googe, Hall, Phaer, and Turbervile.[10] In general, Miller insists, "utilitarian writers" fared better than belleslettrists (1959, 103–36). Yet for all the success of these clerks in achieving print, they knew frustration, too. For the social advantages that came with birth and wealth meant that the gentleman had a decisive advantage in the struggle for preferment; it was Sidney and Herbert, not Spenser and Donne, for whom brilliant political careers were being forecast while they were still in their early teens. Yet to a gentleman (whatever the differences in training and talent), literary work was much more likely to be or at least to be seen as a graceful accomplishment, on a par with dancing or horsemanship, in a life whose real work would be political or military. No clearer illustration of this fact could be provided than that many of the major literary talents of the period, including Thomas Sackville, Philip Sidney, John Davies, even John Donne, gave up serious literary work as soon as their mature public careers began to prosper.[11] For all that, the habits of thought, the rhetoric of humanism in the debased political sense, hung on. Hence, according to Hunter, "the Humanist dream forced the learned into dependence on a court which did not really need them," into a situation whose fullest expression is *Euphues,* "the pipe-dream of a disappointed don" (1962, 29, 61).

In the visual arts, as might be expected, the situation was both similar and different.[12] We have seen how most visual artists in England (and largely on the Continent, too) had the status of craftsmen, nor do many of them seem to have aimed higher. Lyly's Apelles in *Campaspe* and the poet-painter of Shakespeare's sonnet 24 keep a shop like any glover; John Chapman, who designed and carved fine Renaissance elements at Lacock, Dudley Castle, and Longleat, was paid by the day (Lees-Milne 1951, 55). The social distinction doubtless accompanied educational dis-

tinction; in England, by contrast with the Low Countries, the leveling power of classical learning does not seem to have been made available to many men of visual talent.[13] And while gentlemen had been poets before, there was no clear tradition of genteel artists to invite emulation. The record is muddled. Edward VI apparently received some instruction in drawing.[14] Hill Hall, which Sir Thomas Smith began to build for himself during the 1570s, was richly decorated; there is a family tradition that he painted some of the murals himself following engravings by Agostino Veneziano (Croft-Murray 1962, 1:28).[15] Sir Horatio Palavicino, born in Italy but naturalized an English citizen in 1585 and knighted in 1587 for his financial services to the crown, was said by Horace Walpole to have been an "arras painter" and "Italian architect to the Queen" (*DNB*). Sir John Harington may have drawn the illustrations on which were based the woodcuts for his *Metamorphosis of Ajax* (1596); they are amateurishly crude. Erasmus in *De recta Latini* (Stechow 1966, 123) and Mulcaster, presumably following him, in his *Elementarie* (1582, 9, 22, 58) suggest that the original humanist impulse was to include visual arts in the education of gentlemen; on the other hand, we have Henry Peacham's testimony that he was whipped for drawing in school on the grounds that it was an unsuitable pursuit (*Graphice,* 1625, 107).[16]

But even Peacham regarded his work in the visual arts as only one strand (though an important one) in his gentleman's bowstring. More substantial evidence was provided by George Gower, Elizabeth's serjeant-painter from 1579 to 1596. On his *Self-Portrait* (1579), he inscribed some Plain-style verses:

> Though youthful ways did me intyse from armes
> and vertew eke
> yet thanckt be God for his good gift, which long did
> rest as slepe
> Now skill revyves with gayne, and lyfe to lead in
> rest
> by pensils trade, wherefore I must, esteme of it as
> best
> The proef wherof thies ballance show, and armes my
> birth displayes
> what Parents bare by just renowme, my skill mayn-
> taynes the prayes
> And them whose vertew, fame and acts, have won
> for me this shield

I reverence much with servyce eke, and thanks to
> them do yield.

Gower was one of the most important Elizabethan painters—perhaps
the most important native portraitist of the century (Strong 1969b, 15–
16). His pretensions to gentility (and few other English visual artists
had any) are thus of interest. It may be to the point that he felt able
both to write a sonnet and to make a portrait of himself: the latter genre
was normally confined through most of the century to the propertied
classes. Of two other English painters of note who painted themselves
one was a man who vaunted not only his own gentility but that of his
art, Nicholas Hilliard (1981, 62). He contrasted limning or miniature
painting with the coarse work of the easel painters (including Gower,
presumably) as a genre suited to gentlemen only, and seems to have cut
a dashing figure at both the French and the English courts during the
last quarter of the century. (The snobbishness also indicates the extent
to which mere tradesmen were becoming able and willing to afford the
luxury of a portrait—how able, we can see when we find that even
Hilliard began to paint citizens' wives around 1602 [Strong 1983, 12].)
Yet there remains something raffish and presumptuous about Hilliard,
even if he managed to achieve the "courtier-artist" status discussed by
Michael Levey (1971, 117–49). (I do not know if it has been suggested
anywhere that Gower's higher social status may have accounted for
his nomination as serjeant-painter over his more talented rival, Hil-
liard.) A socially more solid if historically more shadowy figure was
Sir Nathaniel Bacon (1585–1627). A good many pictures from the hand
of this cousin of Sir Francis survive, mostly dating from the second
decade of the seventeenth century; not only are they competent pieces
of work in terms of representational skills and mastery of the principles
of renascence composition, but they rival the works of Robert Peake
in their experimentation with three-dimensional space and go beyond
his in other technical adventures. In fact, Bacon has been pronounced
the most innovative English painter of the period (Mercer 1962, 187–
89; Waterhouse 1978, 66). To these historical figures we may add one
from imaginative literature, the earl Lassingberghe, who assumes the
identity of a painter to woo a merchant's daughter in the anonymous
city comedy *The Wisdom of Dr. Dodypoll* (1599). [17]

But these noble folk are few in number, and against whatever re-
spectability may have been represented by Gower, Hilliard, and Bacon
we must set abundant testimony to the genteel scorn extended to arti-
sans of all kinds. Phoebe Sheavyn devotes several pages to documenting

the uncertain status of Tudor authors and artists (1967, 162).[18] One of
the witnesses is Sidney himself, in the *Apologie,* discussing the "hard
welcome" afforded poetry in England: "Upon this necessarily follow-
eth, that base men with servile wits undertake it: who think it inough
if they can be rewarded of the Printer" (G. G. Smith 1964, 1:194).[19]
Sidney presumably marks here the consequences of a notion endorsed
by some Elizabethans (including, in some moods, himself), and many
moderns, of the arts as ornamental adjuncts to rather than essential
features of life, and hence of artists as parasites. [20]

On purely social grounds the status of those Tudor artists who made
a living from their work was thus intrinsically problematic. Artists
were obliged to find and please specific patrons, who necessarily deter-
mined to a great extent the subject and style of the work. Sometimes
such relationships proved mutually satisfying over a period of time.
The manuscript instructions to painters in the Sloane collection of the
British Library (Sloane MSS 1041, 1063, 1081, 1096, 1169; Harley MS
3657) reveal a patron's deep respect for the abilities of an artist, which
seems to have led to a series of substantial commissions over a period
of several years, under conditions that nevertheless left the artist very
little control over subject matter, composition, or color, except at the
level of detailed execution. John Ballergons or Balechonz was hired by
Elizabeth Hardwick during her remodeling of Chatsworth in the late
1570s; she kept him steadily employed on Hardwick Old and New halls
until her death in 1608 (Girouard 1976, 22–23).

But patronage was always uncertain. The work of Nicholas Hil-
liard came into fashion in the 1570s: the portrait miniature was in great
vogue, and when he was invited to paint the queen he attracted not only
commissions from many of her courtiers but other royal jobs as well—
full-length portraits, story paintings, the decoration of royal charters, a
new design for the Great Seal, title pages for approved books. Hilliard
continued to carry out a great variety of royal and other commissions
throughout Elizabeth's reign. But he never received appointment as
serjeant-painter or any other assured court position; for all his large
output he was in steady financial trouble, perpetually appealing to the
queen and her courtiers for assistance (not least because few of them
were prompt in paying their bills, Elizabeth being among the worst
offenders). What it meant was that he had to hustle constantly. We get
a curious glimpse in one of the Sloane manuscripts (1041, 12–14); at
the bottom of an Allegory of the Tempest, which shows the queen as-
sailed by a great storm (probably an allusion to the various plots on

her life in the 1570s and 1580s), the painter is instructed to paint him-
self, labeled as Spes, kneeling, offering the queen his freshly executed
miniature portrait of her. The terms of the program make it plain that
the painting is intended to win back the queen's lost favor—perhaps
for the patron as well as the artist, for these instructions are preceded
by two pages in which the writer celebrates and bemoans his long and
devoted service of Lady Fortuna, who is clearly at this stage of the affair
frowning rather than smiling on him.

The social status of the Tudor artisan, visual or verbal, was thus un-
sure. But that insecurity was only one of several sources of anxiety.
Sixteenth-century England, after all, was a nation roiled by political up-
heavals, threatened internally by religious dissension and externally by
the menace of Catholic Europe; the corresponding but even greater tur-
bulence in the Low Countries drove to late sixteenth-century England
most of the visual artists whose names have survived. Throughout the
period, the country moved unsteadily toward monarchical absolutism,
as successive sovereigns sought to win and to keep firm control over
thought and wealth. The mechanism of royal dominance, the court,
was a kind of switching center through which the intellectual and fis-
cal energies of the state had to flow; what the court did not largely
stimulate (the visual arts, for instance) did not thrive. And the main
control device of the court was the system of patronage. By the stan-
dard of modern totalitarian regimes, the engines of repression of Tudor
political life were no doubt inefficient. But they were effective enough
(especially during the crisis periods in the thirties, fifties, and nineties,
when patronage was backed up by the threat of confiscation and de-
struction of works, fine, imprisonment, mutilation, and execution).[21]
"It is difficult for a modern writer to estimate at its full strength the
paralyzing influence of 'authority' in Elizabethan days," says Sheavyn
(1967, 39; see also Adams 1979, 5–16; Esler 1966, 10–16).[22] These con-
straints, of wealth and authority offered or withheld, violence con-
tained or released, touched courtiers at every level, from the humblest
secretary's secretary up to the Wolseys, Somersets, Leicesters, Essexes.
And the first effect of these pressures was to produce in the courtier
great caution concerning the kinds of statements he made and the kinds
of events and people he made them about. The most moving expres-
sion is the earliest, Skelton's *Bowge of Court* (1499): "Who dealeth with
shews hath need to look about." It can be argued that similar feelings
drove Spenser into allegory and Shakespeare into satirical displacement
(Adams 1977, 67–90; Sheavyn 1967, 60–61).

But a second kind of anxiety distilled from the position of the court as the center of the action, a place of intellectual and personal light and warmth where the creative spirit could receive not only material sustenance but artistic stimulation and encouragement as well. We associate brilliant artistic achievements throughout the period with brilliant courts, at Urbino, Mantua, Florence, Rome, Fontainebleau, Hampton Court, Madrid, Prague (Strong 1973; Trevor-Roper 1976). Exclusion from such centers threatened isolation, sterility, professional death. Yet such courts were also places of seduction and danger, which softened resolve, distorted values, assaulted integrity. Hence we find from one end of the century to the other ambivalent images, from "Speak, Parrot" and "Mine Own John Poins" through *The Steel Glas* and *The Adventures of Master F.J.* to *The Faerie Queene* and *Hamlet,* of courts as oases of seductive delight in the dark forests of life that, according to the situation, may either slam their doors in the face of the approaching traveler, even disgorge a band of assailants, or else invite him or her in for entertainment likely to sustain and corrupt at the same time. These images are common to romance in all periods, of course; in Tudor literature they seem to me to be echoed in many other recurrent, even obsessive, literary structures that place the speaking consciousness of the work at the edge of some kind of charmed and charming circle: the poet meets the patron at the gate, not in the private office, and the poems he offers are Petrarchan sonnets, complaint poems of all kinds, courtly fictions like *Euphues* and *The Unfortunate Traveller,* pastorals, Ovidian visions like *The Rape of Lucrece* and Chapman's *Banquet of Love,* and so on.

One feature common to most of these works is the indication that within the temple (I borrow terminology from Angus Fletcher) waits a labyrinth of conventions, rules, codes. This group of expectations brings into view a third set of courtly pressures, the insistence on an elaborate set of arbitrary gestures by which courtiers constantly enact their subservience. Raymond Southall has argued that the uniquely personal voice in Wyatt's poetry bespeaks "the clash between a desperate personal need [for the energies available only at court] and the impersonal and ceremonial forms" that were imposed on those seeking to have their needs met in a Tudor court (1973, 22).[23] Such forms emanated from the elaborate rituals danced around the sovereign in levees, audiences, processions, entrees, and banquets and infused into every sort of court activity. We encounter them most notably in sexual courtship practices (and the literature about them), legal procedures, and the forms of established religion. They must help explain Tudor court

clothes and the incredible menus of Tudor feasts. They achieved architectural expression in the hierarchical sequence of rooms in a Holdenby or Hatfield House. They fostered the "hieratic abstraction" (M. Jenkins 1947, 23) of Tudor portraiture (the work of Holbein is notably freer and more exploratory during the period of his association with the More circle than during his service to Henry VIII) and the dominance of a few highly conventional forms, especially the love sonnet, the complaint, and the *de casibus* tragedy, in English literature of the mid-century.

Consider one of the most problematic pictures of the Elizabethan scene, the painting called *Elizabeth and the Three Goddesses* now at Hampton Court, dated 1569 (fig. 24). The left side of the picture is occupied by a Renaissance porch and part of the building to which it belongs (it resembles no surviving structure); the rest of the piece shows in the background a landscape, with a high, castle-crowned hill in the middle falling away toward a wood at the picture's edge. Inside the building stand two ladies-in-waiting in court dresses. On the porch stands Elizabeth, likewise dressed in a severely cut gown, wearing a crown, and carrying the orb of state, facing but not necessarily regarding the three goddesses most familiarly grouped together in the tale of the Judgment of Paris. Juno, fully dressed in classical robes, occupies the center of the painting; she is turning away from the queen in a pose that suggests both invitation and flight. Further on is Minerva, helmed, wearing a skintight corselet. At the right is Venus, seated, nude, with Cupid beside her. (A similar structure, less strongly articulated, can be seen in the painting of the family of Henry VIII attributed to Lucas de Heere [c. 1570; fig. 36], with Mars and a man at the far left—the king's right —and Venus and the women at the right.)

The painter of this picture remains unknown, and the full meaning of its iconography undetermined.[24] At its primary level, it is surely a tribute to the Virgin Queen, England's Diana, occupying Paris's place, most beautiful, most virtuous, at once judged by the viewer of the picture and judging the classical trio herself, ready to step forward quite literally to fill the sandal left by the retreating Juno on the step and to take up the scepter that lies beside it. At another level, however, the message of the picture is, at least to modern eyes, ambiguous. Elizabeth, at the left and well off the formal center of the painting, is pale, stiff, linear, reserved, associated with art, architecture, society, order, control, restraint, and also darkness. She herself is in shadow, and her dress is black (though richly decorated); her attendants are partially concealed beyond her, and beyond them the passageway leads into

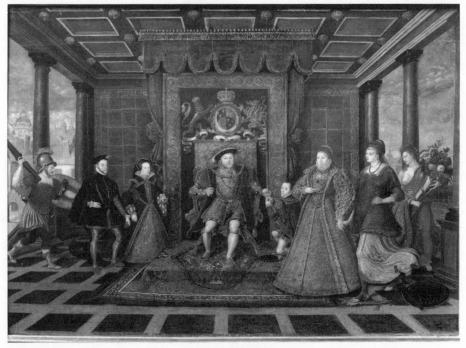

36. Lucas de Heere (attrib.), *The Family of Henry VIII* (c. 1570). Sudely Castle, Winchcombe, Gloucs. Photo: National Portrait Gallery.

the mysterious depths of the building.[25] The goddesses, at the right, dominating the picture in composition and chiaroscuro, are relatively painterly and supple, associated with nature and freedom, and bathed in golden light. Indeed, the tonalities of the painting move in a predictable sweep from left to right, from rectilinear, dark, clothed artifice to curvilinear, bright, naked naturalness. In the background, medieval Windsor Castle on the hill mediates between the Renaissance building and the timeless forest; Venus at the right is the most relaxed, Elizabeth at the left the most tense figure. In the left foreground, cut stone; in the right, roses.

We descendants of Priam, as we file past, will tend to interpret this scheme according to our own values. How Elizabethans saw it I cannot surely say. Similar ambivalences appear in that curious fragment, Ralegh's "Ocean to Scinthia." Like the figure in the painting, the figure in the poem gathers up all the virtues of all the ages:

This did that natures wonder, Vertues choyse,
The only parragonn of tymes begettinge
Devin in wordes, angellical in voyse;
That springe of joyes, that floure of loves own
 settinge,

Th'Idea remayninge of thos golden ages,
That bewtye bravinge heavens, and yearth
 imbalminge,
Which after worthless worlds but play onn stages,
Such didsst thow her longe since discribe, yet
 sythinge . . .

 (1951, 344–51)

Ralegh sighs partly because he cannot find language adequate to express his admiration, but partly because although he once knew the queen under the conditions of pastoral delight (the right half of the picture) that furnish much of the imagery of the first half of the fragment, now he experiences mainly the regal severity of her justice (the left half): "Such feare in love, such love in maiestye" (115). Both picture and poem contribute something to the current debate about the "real" values of Elizabethan pastoral, as given literary expression, for example, in the collapse of the pastoral society at the end of book 6 of *The Faerie Queene* or the withdrawal from that society of the main characters of *As You Like It,* leaving only old men, wittols, and foolish lovers behind. Within that debate, however, it is not wholly clear whether the Elizabeth of the Hampton Court painting is like Spenser's Sir Guyon, armed against the sweet temptations of the postlapsarian earthly paradise (*FQ* 2.12), or like Spenser's Sir Calidore, whose knightliness and courtliness banish pastoral beauty and song (6.10).

It is my own conviction that most Elizabethan artists (as other people would in their places) strove to have it both ways. "It is most true," Sidney says, "that eyes are form'd to serve / The inward light: . . . And yet true that I must *Stella* love" (1962, *Astrophil and Stella* 5), honoring in the sensous elements of his work, *sub specie aetatis,* the claims of the flesh, and in the intellectual elements, *sub specie aeternitatis,* those of the spirit. In any case, the ambivalence, and the anxiety, are there. The problem is indicated in the two dedications to Gascoigne's *Posies* (1575); a poet who tries to address Reverend Divines and Young Gentlemen at the same time is perhaps likely to end up talking mainly to himself—as

seems to have been the soldier-writer's fate.[26] A different set of prob-
lems afflicted Gabriel Harvey, windlassed between the dull security of
a Cambridge lectureship or country vicarage and the dangerous thrills
of a London where a whip-tongued Nashe was parked in every tavern.
Both Shakespeare and Jonson seem to express, in J. E. Bamborough's
phrase, "a genuine veneration for classical authority." But neither aban-
doned intellectual and artistic independence to enter wholeheartedly
the race for patronage. The classical model in this connection was two-
faced. Vergil had spoken for and to Augustus and been handsomely
remunerated for his pains. Spenser, following Vergil's career step for
step, got Ovid's reward instead, exile to a beleaguered compound on
the edge of a swamp.

Spenser was trying to point a new way, in his "bravado and pio-
neering courage . . . seeking out a new kind of professional dignity
through print" (Sheavyn 1967, 169). Gascoigne's dedications represent
an early attempt to span the gap fostered by the division of literary
courtiers into clerks and gents and to avoid what Richard Helger-
son calls "the bifurcated look" of the typical Tudor literary career, in
which "poetry serves the truant passion of love, while expository and
argumentative prose does the work of the active world" (1978, 904).[27]
Faced, Helgerson says, with the traditional distinction between knights
and clerks, fighters and talkers, Sidney, by means of an effort literally
heroic, sought to reconcile the modes within the mediating context of
the pastoral world. Spenser carried on this enterprise through the first
four books of *The Faerie Queene,* in which love and heroic achievement
nourish one another in the traditional romantic way. Helgerson asserts
that in the last two books, however, Venus and Mars are separated,
even divorced. The dominant figures are the grotesque Artegall and
the truant Calidore, each longing for love, each condemned to destroy.
In other words, even Spenser, the only member of his generation to
present himself unabashedly as a Poet and the only one able to fulfill the
humanist dream, because he poured his unique capacity for "harmo-
nious mediation" into the work, could not finally hold it together. It
is as though the Burghleys and Stubbeses of the world, blatant beasts,
overcame. The result was to force poets to resign their loftier offices
and don the livery of Venus again (Helgerson 1978, 893, 895, 903). No
English nondramatic poet of the reign of James I took up the epic quill.
Daniel and Drayton revised their historical poems of the nineties, but
their new works were sonnets and spun-sugar pastorals. Jonson and

his followers wrote epigrams and songs, Donne and his, songs and epigrams. The Spenserians piped and dreamed.

Forceful as it is, Helgerson's analysis (perhaps because it relies so largely on the images of themselves that the writers offer, which are predictably conservative in the sense that they tend to rely on preset categories) oversimplifies the situation. If the middle-aged Greville, Chapman, Donne, Herbert, and others were closed out of the epic, intellectual ambition speaks, all the same, in their religious and philosophical work, and in the political drama of Jonson and Chapman. Yet this work mainly carries on the didactic Traditional modes of the mid-century. Once again, we have fetched up against the deep conservatism of Tudor and early Stuart esthetic attitudes. We have seen it almost wholly ruling the work of those visual artists dependent on courtly patronage. Among writers in similar positions, Sidney and Spenser challenged but could not ultimately overcome it. Other patronees—whether courtiers like Ralegh and Oxford or clerks like Daniel, Drayton, and such lesser figures as Churchyard and Barnes, whom most of us know only as names—might use a richer, more ostentatious style than had Breton and Googe, but their genres and subjects were much the same. The most conspicuous case is that of John Davies; having captured attention with the graceful but resolutely orthodox *Orchestra* (1594), he got into serious trouble when he took a flier in the novel genre of verse satire, got back into grace by writing the verse treatise *Nosce Teipsum* and the epideictic *Hymn to Astraea* (both 1599), and then like Sackville before him abandoned poetry altogether in favor of an extremely successful pursuit of wealth and power.

Davies's career is all the more enlightening because, as Edwin Miller demonstrates, one of the themes in the railing satire of the late nineties was criticism of the patronage system for the sacrifice of self-respect necessary to thrive in it (1959, 14). The writers who took this stance belonged to one of what I see as two new groups within the general scheme of clerks and gents. In a subsequent chapter we will consider one of these groups, the entrepreneurial writers like Shakespeare who came out of circumstances similar to those of the clerks but who wrote for cash, not sinecures. The second group included, in addition to Davies, Joseph Hall, John Donne, and John Marston, and clustered around an institution, the Inns of Court, that had taken on a new importance in Elizabethan society because of the rapid development of new economic patterns. In particular, transfers of property through

cash sale, forfeiture of loan security, marriage, and royal gift became much more common and more frequent than they had been earlier; the large number of transactions required a large number of lawyers to organize them. And since the profession, even more than in earlier days, offered not only a promise of fairly rapid material rewards but the opportunity to do favors for the great persons of the court, the Inns of Court drew many of the most talented and ambitious young Englishmen of the period, including many who had no intention of practicing law but who came to meet people and acquire a certain polish, even as they got enough sense of the workings of the law to help them manage their estates. Their own abundant energies, in an institutional context that offered the freedoms characteristic of other apprenticeship states, provoked them to vie with one another in self-display. The group fostered the arts both directly, as writers, and indirectly, as patrons; among their commissions were some at least of the early works of Shakespeare (a hanger-on if not a member of the Inns, if Hotson can be believed) and (if Hotson can be believed further) the portraits of Nicholas Hilliard (1977).[28]

Literary activities around the Inns had flourished in the middle of the century. In this period, however, the spirit was largely conservative; the most celebrated products were the works of Thomas Sackville and Thomas Norton, which articulate perfectly orthodox ideals of political and ethical behavior. In the early nineties, the internal ferment set up by so much talent and ambition feeding on so many new opportunities was enhanced by a brief relaxation of external pressures, especially of censorship. J. E. Neale has called attention to the fact that nearly all the men who had advised Elizabeth through most of her reign—Leicester, Mildmay, Walsingham, Croft, Shrewsbury, Hatton, Hunsdon, Knollys, Burghley—died in the ten years from 1588 to 1598 (1958, 80). Into their places came younger men like Essex and Bacon whose political recklessness entailed a degree of esthetic open-mindedness. Hence a spirit of literary experimentation flourished in the halls of Gray's Inn and the Temple. Its special crop was the fashion for satire, but to the same period we can ascribe the post-Petrarchan love poetry of Donne and Greville.

Members of the Inns of Court group, for all their readiness to venture into tricky waters, still carried on the motives of the courtly tradition, like Sackville, Norton, and other predecessors of the mid-century. Their literary activity was certainly stimulated by mutual example and discussion, but a major aim was still to call attention to

the individual talent. All of these men projected, and most of them achieved, a career in public service; Donne and Hall became important ecclesiastics, Davies chief justice. The rest, except Marston, disappear from literary view after the burning of their books in 1599; a plausible deduction is that the poems were primarily public-relations ventures.

Right up to the end of the century, then, the traditional forms of Tudor patronage, in both literature and the visual arts, imposed largely conservative pressures on artists' work. They tended to encourage Traditional rather than innovative styles; even when the young Henry VIII or the Seymour group brought in renascence departures from the Traditional norm, they were validated not only by their classical origins but also by their long prior establishment on the Continent. Such novelties as the Mannerist fashion for full-length portraits with the head relatively small in proportion to the body, provoked by the visit to England of Ferdinand Zuccaro in 1575, were nevertheless quickly anglicized with respect to costume, furnishings, facial expression, the use of mottoes and badges—and ignorance of vanishing-point perspective in the background. Some patrons did promote new developments, such as the sophisticated decor produced for Nonsuch or the "perspective" engravings of Sir John Harington's translation of *Orlando Furioso* (1591). Such attempts were likely to be rebuffed, however. More encouraged Holbein before the artist went to work for Henry VIII. But Holbein's work for Henry is, as noted, much less stylistically free than that which he did for More. On largely political grounds, the Leicester faction supported the young Spenser's revolutionary exploitation of the pastoral tradition in *The Shepheardes Calender* (1579). He did not publish again for eleven years. The patron-author of the Sloane programs, writing in the early or mid-eighties, encouraged his artist to use devices—such as extensive nudity, landscape backgrounds, anamorphic constructions —that were by English standards of the period highly advanced. Yet the subject matter and overall design of these works remain relentlessly old-fashioned.

In all sorts of ways, that subject matter, and the subject matter of all Tudor art, expresses the authoritarian idealism of the Tudor establishment, mediating the claims of a hierarchical, paternalistic power structure through a set of authorized forms, in this case mainly Traditional, with some admixture of Renaissance elements. It is natural for political hegemonies to control the arts, and natural for them to do it through established forms that are or at least readily can be reduced to one or another kind of rational order, whether it is the symmetrical modu-

lar parataxis of the Traditional English or the Modern American style, the static hypotaxis of the Renaissance or the International, or the dynamic hypotaxis of the Baroque, of nineteenth-century academicism, of twentieth-century social realism.

It is also natural for artists consciously or unconsciously to struggle against the constraints, whether to find a way to unleash the chthonic energies of their own imaginations or simply to assert the authenticity of their own ideas and images of life over against those of the established elite. We will now look at some examples of work that reveals signs of that struggle.

5

A Violence Within:
Elizabethan Grotesques

Common sense, if nothing else, tells us that within the experience of any individual person, renascence ideals of order had to struggle against actions and emotions and events that would not readily fit the paradigms. In fifteenth- and sixteenth-century Europe, uncertainties about patronage only ganged up with political, economic, and religious upheaval and the ageless assaults of illness, accidents, and death to mock at any merely human attempt to make sense of things. Even when the system attempted to contain the disruptive elements within the paradigm by means of concepts like original sin or election, some irreducible residue of doubt, rage, despair had to remain. From within so apparently secure and stable a system of propositions and procedures as those that composed Petrarchanism, signs of such a struggle emerge. In place of a settled assurance, we find persistent anxiety. In place of a harmonious hierarchy, we find radical tension between sets of antinomies. In place of a vision of the world as established and kept in order, we find images of chance and decay. More precisely, we find that in Petrarch and many other renascence artists much of the most powerful work arises from the persistent failure of actual experience to correspond with renascence ideals. At the same time, the hegemony of those ideals, like the political hegemony that supported and was supported by them, was potent enough so that artists—even those as securely placed as Petrarch—were obliged to express their distrust in relatively indirect ways. To a surprising extent, those ways led through the serpentine complexities of the Grotesque, which gave to renascence artists as it has to artists of all places and periods a mode in which unorthodox feelings and the nonrational activity of the imagination could take form.

A Tudor epitome is furnished by the work of George Gascoigne.

Gascoigne (c. 1538–77) was a Bedfordshire gentleman who was educated at Cambridge and Gray's Inn, spent his patrimony in the usual ways, tried repeatedly and unsuccessfully to find preferment at court, married an already married woman, did time in debtor's prison, and finally sought to repair his ravaged fortunes as a soldier in the Netherlands. Throughout his career he pursued advancement through literary achievement in the established humanistic way. Gascoigne was no Petrarch; he worked often in minor forms and tended to imitate imitations rather than contending with the great classical models *mano a mano*. But even by the standards of humanistic writing, Gascoigne worked in a remarkable variety of genres, subjects, tones. He wrote neoclassical tragedy (*Jocasta,* with Francis Kinwelmershe, 1566, nominally taken straight from Euripides but actually translated from Ludovico Dolci's Italian translation of a Latin translation from the Greek); neoclassical comedy (*The Supposes,* 1566, after Ariosto's *I Suppositi*); social complaint (*The Steel Glas,* 1576); assorted pieces of versified reportage and moral observation that do credit to the tutelage of Plutarch, Seneca, and Tacitus; a moralized novella with inset verses (*The Adventures of Master F.J.,* 1573, which anticipates both Lyly and Sidney and may be said to inaugurate Elizabethan prose narrative); and a critical treatise in prose (*Certayne Notes of Instruction,* 1575, printed with his *Posies*) that is as good a practical guide to writing Traditional verse as Hilliard's *Art of Limning* is to the making of miniature portraits. After he was released from captivity by the Spanish army in 1575, he published his *Posies*. This book brings together many of the disparate strands we have disengaged so far. It is a collection of poems in many of the Traditional forms and meters—a kind of one-man miscellany. Even the appearance of the poems on the page, with their different lengths of line and stanza, their switches from roman to italic type, the patches of explanatory prose that link poem to poem, recalls the distribution of shapes in a long gallery. Like other important Tudor books, it was actually a revised and expanded version of an earlier work, *A Hundredth Sundrie Flowres* (1573); unlike the later editions of *A Mirror for Magistrates* or *Euphues,* however, the revision has more coherence than the original, which Gascoigne claimed (probably disingenuously) had been published without his authorization while he was soldiering across the Channel. Like Hilliard, then (but much less successfully), he was involved in a desperate and incessant search for patronage.

Like Hilliard's, most of his work was programmatic, work in which the conventional illustratory materials accumulated in the course of a humanistic education were laid out, as needed, to convey conventional

ideas and satisfy conventional ends, rather than to convey a unique experience or explore an unsolved problem or express a deeply personal state of mind. So the poems are begging poems, praising poems, complaining poems; each grinds its axe, and the sparks are figures of speech. It is work whose order is determined by things outside itself; although it includes passages of great coherence and formal beauty, it tends to ignore considerations of overall consistency and balance in favor of immediate emotional and intellectual impact. It reflects educational practices that treat images and ideas as discrete and transferrable, and so encourage a diffuse, paratactic style. André Chastel, seeking a phrase that will refer equally well to renascence works of art in many single and mixed media, has called this kind of work *discours figurés*.

Art like Gascoigne's does not necessarily represent a breakdown in the holistic vision sought and sometimes achieved during the renascence. Instead, it can profitably be regarded as an alternative style especially adapted to mark (though not to resolve) the junctures between different orders—ruler and subjects, court and country, ideal and real, sacred and secular, past and present—an art of meetings, exchanges, transitions. It is a mode keenly sensitive to temporal and spatial flux. It is produced by courtiers seeking preferment from their lords during those brief moments when the lords emerge into public view, by lovers vainly worshiping chaste beauty on its pedestal, by builders marking the disturbed and disturbing zone where house meets environment or floor meets ceiling, by writers deeply aware of their inability to reach the levels of assurance they found in their classical models. It is, therefore, an art full of anxiety and unresolved contrasts, though often these surround settled, harmonic nodes of assurance and delight.

When I began visiting Elizabethan houses in preparing to write this book, the first thing that struck me was a ubiquitous style of architectural decor for which nothing in my previous study had prepared me. It involved columnar forms that were naked human torsos above and tapered pillars below, faces detached from bodies, twining foliage suddenly metamorphosed into animals or tools or weapons. It seemed, and it literally was, Grotesque. The English application of a pan-European phenomenon, this Grotesque decoration furnishes an especially important and interesting illustration of the principle of paratactic diffusion. The decor involves two elements: a characteristic imagery, and a principle of construction according to which the images are linked or juxtaposed in ways that violate ordinary spatial and situational logic.

The term *Grotesque* has, of course, a general sense that has drawn the fascinated attention of many historians and critics.[1] I use it here, how-

ever, with special reference to a tradition of mural decoration widely applied in later classical Rome, revived in Italy during the Renaissance, and carried thence all over sixteenth-century Europe.[2] Like many other renascence developments, this one incorporated important medieval components; we are all familiar with gargoyles and the grinning imps of corbels and misericords, and with the fantastic creatures, humanoid and otherwise, that disport themselves among the twining vegetation of illuminated capitals and borders. Some of these images doubtless swarmed out of the primitive darkness of the northern European imagination. Others, however, had classical ancestors, who helped prepare for the day when the sharp spades of renascence antiquarians thrust the buried riches of Roman architectural decor back in the European mind again—and when the sharp eyes of scholars began to explore the verbal arcana of the cabala, the mysteries of Dionysus and Isis, and the rest of the shadowy topics on the darker side of the renascence of learning. The essentially *structural* characteristics outlined below apply equally to either renascence or medieval grotesquerie. But many specific images passed directly from classical artifacts to quattrocento ateliers and came to constitute the characteristic imagery of a peculiarly renascence kind of Grotesque decoration. By the middle of the fifteenth century Italian painters and goldsmiths were using elements of that repertory of images on candelabras and andirons and in the pilasters and other mural components of their paintings (Dacos 1969; Harpham 1982, 23–47).

The major impetus came from the discovery of the so-called Domus Aurea, Nero's villa on the Oppian Hill across from the Colosseum, around 1480. Its rooms were rich in mural decorations, the work of the celebrated painter Famulus, according to Pliny, and remarkable for their extent and richness and for their excellent state of preservation. But they also appealed strongly to Renaissance artists because their hundreds of individual images were organized and linked one to another in ways that suggested the underlying presence of some kind of unifying scheme. Because the Domus Aurea had ultimately been adapted to serve as part of the foundations of the Baths of Trajan, and its rooms therefore filled with earth, and because the buried rooms were first entered through their vaults, and only slowly excavated all the way to the floor, the early discoverers thought of the place as a set of artificial caves, or grottoes. Hence the decoration was called grotto work, *grottesca,* a name all the more appropriate because many of the images seemed to subsequent admirers to spring (or creep) from the dark places of the mind.[3]

The discovery stimulated development of a decorative style that spread all over Europe. Painters like the Italians Pinturicchio and Ghirlandaio and the northerners Frans Floris and Martin van Heemskerk came to study the Domus Aurea frescoes and imitated them in their paintings. Raphael and his atelier, led by Giovanni da Udine, brought the style to its Renaissance peak in the Vatican *logge* and the Villa Madama. Primaticcio and Fiorentino Rosso took it to Fontainebleau in the 1530s, whence it spread east, north, and west. During this period goldsmiths and potters were applying Grotesque ornaments to knife handles and faience that were then shipped to all parts. The tendency for the kind of linkage achieved in the Domus Aurea or the Vatican *logge* to break down, and for the Renaissance Grotesque to become in effect merely a source of individual images, meant that it was applicable to any surface; the list of sixteenth-century items sporting Grotesque decor is coextensive with the inventory of the possessions of well-to-do families during the period.

Renaissance Grotesque came to England when Henry VIII, emulating François I, imported artists trained in Italy to adorn his palaces; the panels said to have been painted by Toto di Nunziato (a pupil of Ghirlandaio) for the banqueting hall at Nonsuch, around 1540, are very reminiscent of Giovanni's work in the Vatican *logge* (fig. 37). The painted decor in Leemput's copy of Holbein's great fresco of the last two Henrys and their wives is richly Grotesque (David Piper suggests that it continued the actual architecture of the Privy Chamber, Whitehall), while Holbein's design for a chimneypiece suggests that the completed piece would not have been out of place in the Villa Madama (Croft-Murray 1962, pls. 103–4; Piper 1975, 77–88) (fig. 15).[4] Of Henry's great houses, only Hampton Court (largely the work of Wolsey and largely completed before the vogue for this work began) survives; Nonsuch fell back into darkness along with Somerset House, the principal Renaissance building in sixteenth-century London, and as we have seen, the Henry-Edward Renaissance was by untimely accidents cut short. But the style survived, though in a form that was anything but pure. In virtually all the English grotesquerie of the second half of the sixteenth century, the classical restraint of the Raphaelesque prototypes has gone to seed; in place of a mingling disciplined by the intellectual aims of a program, the only compositional principle seems to be the indiscriminate accumulation of forms, and the forms themselves are luxuriant but coarse (figs. 22, 37–38).[5] Moreover, the workmanship lies along a range from the sophisticated (the tapestries

37. Toto di Nunziato, Grotesque panels (from Nonsuch? c. 1540). Losely Park,
Surrey. Photo: Cleveland State University.

38. Artist unknown, Plas Mawr, Conwy (late sixteenth century), chimneypiece, plaster. Photo: The National Monuments Record for Wales.

devoted to the senses at Haddon Hall) to the primitive (the plaster over-
mantels at Plas Mawr, Conwy), from the elegant (the great chamber
ceiling at Speke Hall outside Liverpool) to the vulgar (the frontispiece
at Bramshill, Hampshire), that beggars analysis.[6] In other words, like
other Renaissance borrowings, this one was modified to fit Traditional
or Mannerist expectations and the habits and skills of English artisans.

For the present purposes, however, it will be sufficient merely to
observe that Grotesque features, singly or in groups, constituted the
most striking class of decorative elements on the possessions of well-
to-do Elizabethans—their houses, their furniture, their lingerie—and
to list some recurrent images. Perhaps the most obtrusive is the *herm*
(from Greek Hermes) or *term* (from Roman Terminus), a pillar (often
tapering toward its base) that becomes a bust (fig. 38).[7] The Athenians
set herms as mileposts and boundary markers; Elizabethans put them
to dozens of uses, on doorways, chimneypieces, and beds, as andirons,
candleholders, the handles of knives and the hilts of swords. A related
figure is the disembodied head, or *mask,* often scowling or otherwise de-
formed though often handsome enough, sometimes human, sometimes
bestial, but always picturesque. Sometimes the motifs are combined,
and a grimacing herm will have a mask in the breast or in place of the
genitals. Vegetable motifs are common: ivy and other twining foliage,
flowers, fruits, often in combinations (pouring out of cornucopias or
filling baskets), often growing on stalks that link with other images
and thus begin to realize the full spirit of Roman grotesquerie. In this
connecting function, the flora are related to strapwork, a framing and
connecting device of straight and curved lines based on the behavior of
cut leather, but like most of the imagery discussed here readily transfer-
able to plaster, wood, or paper (figs. 39–40). Both Grotesque human
figures and whole animals, of all kinds, appear. The latter had a spe-
cial appeal to Tudor decorators because they went along with the pas-
sion for heraldry; the same can be said for the bits of armor that fre-
quently appear in Grotesque decor, either alone or in trophies. Finally,
there are monsters, deformed men or beasts or several beasts at once.[8]
Typically, two or three of these things decorate a doorway or bed-
post. In a few places, doubtless only representative of many more that
vanished when their houses fell (as at Somerset House) or were re-
placed by later work (as at Longleat or Burghley), complex assem-
blies still survive. The best example is Thomas Sackville's work at
Knole, begun in 1603, which runs in various tonalities through half

The.holie.Bible.

conteynyng the olde
Testament and the newe.

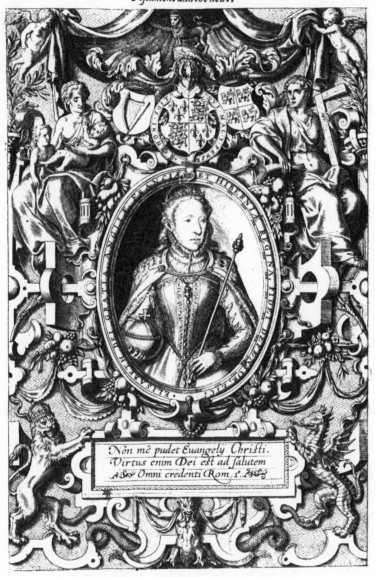

39. Bible, Bishops translation (1568), title page. Reproduced by
permission of the Huntington Library, San Marino, Calif.

40. Clément de Perret, *Exercitatio alphabetica* (1569), engraved alphabet with Grotesque border. Reproduced by permission of the Huntington Library, San Marino, Calif.

a dozen rooms. In the finest, known as the Cartoon gallery, Grotesque panels frame windows, statues, portraits, and a set of tapestry designs by Raphael that would link the English house directly to the Roman tradition except that they were not acquired until a century after the panels were painted (fig. 37). And at Knole and many other places, complex assortments of Grotesque images also occur in tapestries and embroideries, on large surfaces like the headboards of beds, and in prints of various kinds—especially in the title pages of books (fig. 33).

Abundant as these applications are, they interest me mainly because they can be analyzed, I believe, according to a few essential principles, whose generality will allow the style to be discerned in verbal as well as visual art. The first principle is a (perhaps the) principle of plenitude. Precisely this quality of unbridled multiplicity suited the Grotesque admirably to the paratactic tendencies of Tudor art considered in the previous chapters; I have in mind here not only the copiousness with

which observation and imagination could generate Grotesque images but also their independence from one another in any but juxtapositional ways.[9] Ruskin grumpily described it as "an artistical pottage, composed of nymphs, cupids, and satyrs, with shreddings of heads and paws of meek wild beasts, and nondescript vegetables" (1906, 3.3.39).

Ruskin's terms direct us to the second principle of Grotesque art, that it treats natural items in an unnatural way. It begins with close observation of the natural world; as Montaigne says, it is "the artifaction of nature" (1957, 135, "Of Friendship" 1.28). The ornamental foliage in both Gothic and renascence Grotesque is usually specific—recognizably ivy or woodbine or acanthus—and usually populated with recognizable birds and insects and flowers. The basis in nature was one matter on which all the participants in the sixteenth-century debate over the value of the Grotesque could agree (Summers 1972, 155–57).[10] But while observation and imitation of nature must always entail some sense of esthetic distance (the essence of pastoral), the Grotesque emphasizes the distance, initially by the obtrusive character of the artifice, later and more forcibly by shocking violations of natural expectation. This appears most clearly in the monsters so common in Grotesque decor, which are not radically new beings but are instead artificial combinations of natural elements, centaurs and gryphons and merpersons (Baltrušaitis 1957, 8–13). But the principle of subverted expectations is so universal as, paradoxically, to develop the very predictability we have found to be characteristic of Tudor art. Nothing ends as it starts out. A basket of fruit has a pendant bottom, which turns into a strap leading to the head of a bust; below the breast the bust becomes a pillar, from whose base foliage twines to left and right; in its branches are birds, insects, musical instruments, implements of war or farming; one tendril mutates into the beard of a leering satyr, whose horns generate a strap from which hangs a basket of fruit . . . (fig. 40). It is nature in its Protean mode, not only alien but willfully alienated.[11] It is our experienced world in a fearful guise, yet also, for all its strangeness, under control: the special control of art.

The third principle of the Grotesque style springs from the second: the items so plenteously imitated from nature are abstracted from their normal contexts. The trees that produce Grotesque foliage have no trunks, or if they have trunks, no roots, nor does the style as executed (by contrast with the rational, idealistic mimesis of Renaissance or Mannerist work) indicate that the context is there but has been screened off by the frame or by an interposed wall or curtain. More radically

yet, the style abstracts parts of normally integrated wholes, faces or torsos or tails, sometimes to leave them by themselves, sometimes to combine them with other parts to make grotesque new wholes. In any case, in most instances of the Grotesque the images are simply *there,* placed against the ground, whether that ground is plaster or paper or stone; unlike real branches on real trees a Grotesque branch has no other branches above or beside or behind it, which may help explain why the thing sitting on it is not a bird but a man or a monster: the loss of spatial context encourages the breakdown of other kinds of context.

A fourth principle, however, determines that the individual elements of Grotesque art are connected in a linear mode. Henry Peacham exhorts painters working in the mode to "observe a method of continuation of one and the same thing throughout your whole work without change or altering" (1606, 35–37). And since the source of the imagery is nature, the line is almost always curved. I have argued elsewhere, indeed, that the *linea serpentinata,* widely identified as a distinctive feature of Mannerist art, in fact characterizes the Grotesque instead (Evett 1986). The serpentine line expresses the willfulness and unpredictability, but also the continuity, of the unbridled imagination, restlessly pouring forth its images. Yet at the same time it links those images, imposes a sequence (albeit irrational), calls attention to the activity of the artist beyond the work.

The assertion of esthetic control and the linearity of its essential form entail the fifth general principle of Grotesque art. It is an art of the surface, something laid on, appliqué. The fact makes the Grotesque especially consonant with Tudor Plain-style artistic practices. The perception emerges initially from the darkness of the Roman grotto, where the designs are, indeed, painted on the wall, as well as from the painted borders of medieval manuscripts. It is not qualified, but rather reinforced, by the recognition that some architectural grotesques aspire to three dimensions: such works are virtually always engaged in a surface from which they are only partially free, whether they are the leering wittols lurking on the dark underside of choir stalls, the herms at the corners of a candelabrum or a chimney, or the masks placed as guardians above doorways. Like Enceladus in the Ovidian *locus classicus,* they are trapped in a surround from which they cannot escape. Yet although Grotesque art is confined to the surface, its effect is not to confirm the surface but to render it ambiguous, to make and unmake it at the same time. [12]

Yet another way to conceive of the superficiality of Grotesque art is

in terms of the conjunction of two or more surfaces. (A similar kind of conjunction appears to generate the literary trope.) The relation may be one of superposition; thus a monster may be explained as the coming together of part of one surface devoted to a man and part of another devoted to a horse, while the strangeness of the kind of farrago of images typical of the Domus Aurea frescoes and their descendants depends partly on the fact that each class of item (baskets of fruit, foliage, birds, satyrs) is drawn to a different scale, thus frustrating our sense of the spatial homogeneity of the plane to which they all visibly belong. Or the relation may be one of juxtaposition. In both medieval and renascence art, Grotesque decorations commonly occur at the *edges* of things: in manuscripts they fall in the margins; within paintings they appear on the pilasters and sills of the painted architecture that frames the illusionistic space; in frescoes they form the surround separating the picture proper from the rest of the wall; they are sidepieces and edgings to overmantels, panels, the covers of books, plates, skirts, gloves. Further, we know that Grotesques often mark the intersections of surfaces, or of surfaces and solids; they most frequently occur in friezes, corbels, capitals, bosses, frames, around doorways and chimneypieces.[13] As Geoffrey Harpham says, it is a "liminal" mode (1982, 14). The bordering function may be conceptual as well as visual, as in the frequent contrasts between the pagan imagery of Grotesque borders and the Christian imagery of the paintings they frame, or as in the title pages and ornaments that mark the beginnings and ends of books. In short, the Grotesque art that concerns us here is, literally, an art of transition (Fischel 1948, 1:166).[14]

But the alienated natural forms, and the spatial ambiguity, may only be special cases of what I would identify as the sixth principle of renascence grotesquerie, its universal dualism. This appears most clearly in such mixed figures as the ubiquitous herms and satyrs, more subtly in the ambiguity of the modeled form engaged in the plane surface. The mixture may be physical or contextual; actual instances of Grotesque decor almost always employ images from more than one ontological category, though it is not always clear whether the decorator's will or only some concatenation of accidents has brought them together.[15] But the dualism of the Grotesque runs well beyond the simple mixing of forms. As many of the writers who have thought about it contend, assemblages of Grotesque imagery constitute worlds that are representations neither of our normal world nor of others having their own inherent logic, but of ambiguous hybrids, at once alien and famil-

iar, disturbing and reassuring (Dacos 1969, 121; Fletcher 1964, 39–43; Kayser 1963, 20–21, 34–35).[16]

Thus the Grotesque style in renascence art is a style whose principles run exactly counter to the principles customarily assigned to the Renaissance style, and especially to that style's presiding principle of rational, hierarchical, ideal order. We can therefore consider the Grotesque as a style in which renascence artists could express some of the tensions that arose from the incompatibility between the ideals espoused and imposed by government, by church, by university, by all the agencies of institutional culture, and the actualities of individual experience.[17] The ideal claimed that if somebody like Gascoigne could learn to imitate the literary authorities of the past, he could earn a comfortable place at court. The actuality was persistent unemployment. The ideal claimed that a lover, by contemplating the image of the divine in the lineaments of his chaste mistress, could achieve communion with the ineffable. The actuality was gnawing sexual frustration. In the art we have been discussing, the ideal continues to be expressed in nodes of calm acquiescence or celebratory affirmation, such as the biblical *istorie* surrounded by the grotesques of the Vatican *logge,* or Gascoigne's surrender to the imperatives of Petrarchan Beauty: "Thus am I Beauties bounden thrall, / At hir commaunde when shee doth call" (1968, vol. 1, "The Arraignement of a Lover").

When he articulates the ideal of love, Petrarch tends to do so in poems that tie the natural world, the world of art, and the world of his own emotions into hierarchical relationships whose complexity mirrors the complexity of all the relationships in all the departments of actual human life:

> Apollo, s'ancor vive il bel desio
> Che t'infiammava a le tesaliche onde,
> E se non hai l'amate chiome bionde,
> Volgendo gli anni, già poste in oblio,
>
> Dal pigro gielo e dal tempo aspro e rio,
> Che dura quanto'l tuo viso s'asconde,
> Difendi or l'onorata e sacra fronde,
> Ove tu prima, e poi fu'invescato io;
>
> E per vertù de l'amorosa speme
> Che ti sostenne ne la vita acerba,
> Di queste impression l'aere disgombra:

Sì vedrem poi per meraviglia inseme
Seder la donne nostra sopra l'herba
E far de le sue braccia a se stessa ombre.

(1968, *rime* 34)

The poem draws the Thessalian past and the Provençal present, the sea and the earth, summer and winter, the natural world of leaf, grass, and shade and the human world of golden hair and solacing arms, into a complex, interanimating whole, leading toward a hyperbole astonishing in its typically Petrarchan simplicity, which nevertheless seems only natural as the culmination of this train of thought.

It is when the ideal seems unattainable that Petrarch's logic and imagery break down:

L'arbor gentil, che forte amai molto'anni,
Mentre i bei rami non m'ebber a sdegno
Fiorir faceva il mio debile ingegno
A la suo ombra, a crescer ne gli affanni.

Poi che, securo me di tali inganni,
Fece de dolce sè spietato legno,
I'rivolsi i pensier tutti ad un segno,
Che parlan sempre de'lor tristi danni.

Che porà dir chi per Amor sospira,
S'altra speranza le mie rime nove
Gli avessir data, e per sostei la perde?

Nè poeta ne colga mai, nè Giove
La privielegi; et al Sol venga in ira,
Tal che si secchi ogni sua foglia verde.

(1968, *rime* 60)

Here we find many of the same images as in *rime* 34: the laurel boughs' beauty and shade, a consonance between the poet and some pagan divinities, the passage of time. Here, however, they work toward destruction, not affirmation. Time is disjunctive, not conjunctive; the poet calls on the old gods not so that he can rise to their level but to bring them down to his. Variety becomes monotony—"sempre . . . tristi danni"—and even the rhythm becomes insecure, as the comfortable end stops and mid-line caesuras of *rime* 34 give way to the hesitant enjambments and unbalanced caesuras (lines 5 and 13) of *rime* 60.

Three things are especially noteworthy in the present context. One is the collapse of complex intellectual, emotional, and spatial hierarchy, the fact that instead of being securely placed at the base of the shading tree, in some fixed, known relationship to other places and roles, the poet (or at least his alter ego) is here lost. The second is the language: the linking of *dolce* and *spietato, secchi* and *verde,* that produces oxymoron, the figure whose dualism, disjunction, leveling, and alienating yet paradoxically uniting activity makes it the distinctive figure of renascence literary Grotesque. The third is the mental activity—typically expressed in terms of the passage of time, but also sometimes of the crossing of space—that places the artistic consciousness not actively at the center of the ideal world, participating in it and enjoying its riches, but as a relatively powerless observer condemned to wander in the margins, tracing some erratic, serpentine course. The Grotesque style thus becomes exploratory, critical, sometimes even subversive.

Beyond its power to express psychological states of alienation and despair, the Grotesque's intrinsic tendency to present us at the same time with images of this world and some other, this space and some other, this time and some other, nature and art, order and disorder, draws it readily into the service of allegory and thus gives it conceptual as well as expressive force.[18] Even in medieval liturgical art, not all grotesques had carried allegorical meanings. But as a practical matter, most did. (It is useful to remember that the Book of Revelation contains many Grotesque images, from the four living creatures and the lamb with seven horns and seven eyes through the locusts with human faces and lions' teeth to the seven-headed beast.) In the renascence, as we have seen, discussion of the visual arts as well as literature was carried on almost entirely in terms adapted from rhetoric. And when that discussion was extended to embrace the Grotesque during the sixteenth century, it was with reference to its allegorical utility that the mode was both attacked and defended. Late renascence (and especially Counter-Reformation) thinkers discussed the specifically Renaissance Grotesque style of Raphael and Michelangelo as one way by which the recovered riches of classical culture could profitably be invested in the Christian cause.

These writers stressed the venerable character of the style as a repository of secret wisdom by calling it not only *grottesca* but *antica.* (This synonymy passed into English and has considerable bearing on the application of these ideas to English literature.) It is important to concede that the debate was not one-sided. As some tropes, repeated in new

contexts, become moribund and even dead, so some Grotesque images, drawn without systematic thought from an available repertory, drop their iconographic potential to become mainly decorative.[19] The issue appears to be a matter of linkage. Grotesque figures by themselves may or may not be allegorical. In conjunction with "normal" images the likelihood increases. A satyr by himself is picturesque. A satyr grabbing a nymph is concupiscent. A satyr grabbing a nymph in the vicinity of a praying hermit is probably Concupiscence. Another way to think about this is with reference to emblems. An emblem may be thought of as a static allegory, an allegory as a moving emblem (in both senses). We do not usually think of emblematic images as Grotesque. But take away their frames, set them moving, put them in relationships with one another, and they appear both allegorical and Grotesque. (Imagine meeting on the street a winged lady, smiling, nude, with the rear part of her scalp shaved bald, a ship's wheel tucked under one arm and a cornucopia under the other, balancing on a globe, first blessing and then cursing anybody willing to converse with her.) A high degree of this sort of interconnection is the special characteristic of the grotesques of the Domus Aurea, a characteristic that reappears in the Vatican *logge,* the galleries at Fontainebleau, and the high great chamber at Hardwick (where the prominence of images of the Ulysses-Penelope story may indicate influence from Rosso's and Primaticcio's most famous work, the Galerie d'Ulysse at Fontainebleau, destroyed in the eighteenth century).

These considerations, in typically Grotesque fashion, bring us to English literature by way of Spenser's *Faerie Queene,* and thence to some particular Tudor uses of the Grotesque. The Faerie Queene herself may or may not be grotesque; she is without doubt, as regards the poem itself, the product of a dream.[20] Certainly the application of the term to Spenser goes back at least to Ruskin, though he had in mind the Gothic strain.[21] For the renascence tradition we may approach through a doorway in Lord Orrery's *Parthenissa* (1676), decorated with "Groteskery . . . to evidence that within inhabited Mysteries and Riddles," reminding us that grottoes always seem to be the entrances to mysterious realms, and opening up the possibility of a connection with Spenser's "darke conceit" (Clayborough 1965, 19). It is worthwhile here to consider etymology. There is no grotto, so called, in *The Faerie Queene,* but there are plenty of caves, virtually all inhabited by creatures whom the term *Grotesque* appears to fit in both the general and the specifically renascence sense.[22] Moreover, the poem (and the minor works, too) is full of

the kind of solitary image, or small cluster of images on a single object —that is, of emblems—typical of Elizabethan decoration, both visual and literary, as we have seen. Cambina's chariot, "decked . . . in antique guize" (4.3.38), features a lion, a lady, and a pair of twined serpents crowned with olive. The poem has no herms, but it does have one or two hermaphrodites, and a great many monsters, both the kind produced by the deformation of one natural form and the kind produced by the juxtaposition of foreign parts. And more general instances of this kind of Grotesque mixing of alien natures, of one thing turning into another, appear (ambiguously) in the poem's several protean figures, including Archimago, Guyle or Malengin, and Proteus himself. [23]

We can approach closer. It has been noted that in the late sixteenth century the popular Italian term for Grotesque work was *antica;* its punning character is clarified by the two English spellings for the same word, *antic(ke)* and *antique.* Spelled *anticke,* the word most often (as in all Shakespeare's uses) refers to bizarre human behavior. But it occurs several times in *The Faerie Queene* in contexts where the reference to a specific decorative manner is unmistakable. The first of these deserves to be quoted in full:

> His yron coate all overgrowne with rust,
> Was underneath enveloped with gold,
> Whose glistring glosse darkned with filthy dust,
> Well yet appeared, to have beene of old
> A worke of riche entayle, and curious mould,
> Woven with antickes and wild Imagery . . . (2.7.4)

This is the armor, inlaid and perhaps ("woven") covered with an embroidered surcoat, of Mammon. He is interesting not only because he is something of a grotesque himself ("An uncouth, salvage, and uncivile wight"), whose house is underground, like the Domus Aurea, only to be approached through an opening in the earth—that is, a cave —but also because he and his house and its furnishings and other inhabitants illustrate so many of the features of the Grotesque as analyzed so far. The first half of the episode seems to draw chiefly on the Gothic tradition, while in the second part a more classical spirit presides. The underground realm abounds in monsters; it is furnished with such Grotesque ornaments as trophies, spider webs, and golden chains and especially with a tree that bears golden apples and shades a silver seat, an epitome of the Grotesque mingling of nature and artifice. Like other Grotesque art, Mammon's warehouse of images is, in several senses,

superficial: with respect to Guyon, because it is furnished only with delusory appearances; with respect to the poem as a whole, because it is merely a static image, an extended emblem, from which no character (except Guyon, who explicitly refuses to belong to it) emerges to develop and participate in the further action. And Guyon participates in it only as an observer. In terms of the world of Faerie, the cave is borderline, at the edge of the primary narrative surface, and Guyon's visit to it is explicitly a divagation from his quest. Finally, it is, as Guyon experiences it on our behalf, profoundly ambiguous.

Similar observations apply to two iconophrastic passages in which Renaissance Grotesque decor itself is described. One is the gilded frieze in the inner room of the castle of the magician Busirane, "Wrought with wild Antickes, which their follies playd" (3.11.51), passed on to us through the consciousness of another marginal observer, Britomart.[24] These are related to the tapestries of the first room, depicting scenes from Ovid (also the source of the pictures in the Galérie François I at Fontainebleau, and of much other grotesquerie), and to the renascence commonplace according to which unreasonable lovers become prisoners in the Grotesque spaces of their own deformed and deforming imaginations.[25] In another place, Spenser describes a room

> dispainted all within,
> With sundry colours, in the which were writ
> Infinite shapes of things dispersed thin;
> Some such as in the world were never yit,
> Ne can devized be of mortall wit;
> Some daily seene, and knowen by their names,
> Such as in idle fantasies doe flit:
> Infernall Hags, *Centaurs,* feendes, *Hippodames,*
> Apes, Lions, Aegles, Owles, fooles, lovers,
> children, Dames.
>
> (2.9.50)

This is a room in the Castle of Alma, the emblematic house that rather grotesquely images the human body.[26] Specifically, it is the room devoted to the mental function on which the Grotesque particularly depends; it is the chamber of Phantastes.

Another use of the term *anticke* connects the Grotesque with a large class of complex conventional images, and thence with Elizabethan rhetoric in general. The description of Belphoebe, huntress and queen, fair and chaste, is one of the longest epideictic catalogs in the poem.

She has "antickes" on her buskins (2.3.27). She also has roses in her cheeks, lamps for eyes, a forehead of ivory engraved with the triumphs of love, pearls and rubies for teeth and lips, gold wire in place of hair, and marble pillars instead of legs (perhaps the poem contains a herm after all). The attributes are all conventional, to be sure. But if they were rendered visually, the result would be Grotesque.[27] The possibility is brought closer to realization in the construction of that gorgeous artifact, the artificial Florimell with which a concerned mother who happens to be a witch tries to assuage the son's helpless passion for the real heroine of that name (3.8.6). When we consider further that those images of visual art most directly related to literature, the emblems, are intrinsically Grotesque, the proposition asserts itself that Spenser's whole descriptive apparatus may be termed grotesquely iconophrastic.[28]

But the abstract and general characteristics of *The Faerie Queene* are as interesting in this connection as any particular details. Like other Grotesque art it is (in no derogatory sense) marginal: that is, it takes place around the edges of life. It is more fantasy than direct imitation. Although it explores the ethical, political, and religious concerns of a fully developed late Elizabethan society, its landscape is the landscape of the medieval frontier. Apart from a few shadowy servants and one community of shepherds, its characters are either errant knights and ladies or monsters and outlaws—no ordinary farmers, tradespeople, civil servants. No one in *The Faerie Queene* mends a broken harness or cooks a meal. Even in its own narrative terms, it happens not at the putative center of its world, Gloriana's court, but in the forest and waste places of Faerie Land; indeed, that center does not appear in the poem but only at its edge, in the Letter to Ralegh. The Grotesque concern with the uncertain boundaries between nature and art is a recurrent theme of the poem, very clearly visible in the contrast between the two Florimells but also raised by the well-known passage at the end of book 2 where the ivy in Acrasia's Bower turns out be to made of painted gold, by the image of her lover in Britomart's magic mirror, which has the power to drive her to distraction as fully if not as tragically as Tennyson's Lady of Shallott, and by the questions, especially insistent in books 5 and 6, about the respective contributions of nature and nurture to virtue, justice, gentility, and right living. The poem's disjunctive narrative procedures, not only the interlacement that keeps several stories going at once, and the inability of any of its characters to stay on the right track, but also its frequent apostrophes and other

authorial intrusions, seem analogous to the characteristic disjunctions of Grotesque decor.[29] And the deep and incessant dualism signaled in book 1 by a heroine and villainess named Una and Duessa is by now a commonplace of the criticism of Spenser's work.

Nowhere do these characteristics appear more clearly than in the figure of Artegall, the knight who particularly represents Justice. Though his name connects him with transalpine Europe rather than the Mediterranean, his appearance is sometimes Gothic ("For all his armour was like salvage weed, / With woody mosse bedight" [4.4.39]), sometimes classical ("And all his armour seem'd of antique mould" [3.2.25]). Moreover, he was raised in a cave. He is thus a classical Grotesque, both antique and antic. The pun, potential throughout the poem, becomes insistent in the proem to book 5, and generally in connection with Artegall; the word itself occurs in the second line, introducing the contrast between an orderly past and a present characterized by just the sort of "dissolution" (line 4), of things running into other things, that is a decisive structural principle of the Grotesque. Many of his adventures involve dismembering, monsters, role change (for instance, his own stint in woman's weeds *chez* Radigund). He comes (literally) from the natural world—and, as the proem and first canto of book 5 insist, from an alienated nature, kinder and purer than the degenerate, disorderly present. His home is in the woods, from which he sallies from time to time to bash somebody, then retire. Still, the name Artegall bespeaks art and balance; for all that his own acts are often impulsive and injudicious, his task is to impose a rational order on the protean chaos of a poetic world more closely related (in its frequent topical references) to Spenser's England than any other part of the poem. He thus stands, an errant colossus, astride the dichotomies: art and nature, nature and nurture, classical and Gothic, ancient and modern. In characteristic Grotesque fashion, he joins but does not succeed in harmonizing them. He is a kind of traveling oxymoron.

An insight into the critical problems posed by Artegall's dualities is offered by analogous figures, less fully developed than Artegall, who commonly appeared in the ephemeral spectacles laid on for royalty. Such spectacles typically involved several dozen characters, divided (like the characters in *The Faerie Queene*) into ideal and Grotesque. The tradition is clearest in the masques, where the two groups appeared separately, each conveying half of the world, as it were.[30] To the extent that the dichotomy thus enacted was also a conflict, however, it had to be resolved outside the work itself, in the mind of the spectator but also

in the figure of the royal personage, whose own dual nature, at once natural and ideal, unified the microcosm (Kantorowicz 1957, 436–50). What is implied is that the work is not itself a complete image (*imago*) of the idea—of Justice, for example—but rather a set of materials for constructing such an image—a number of propositions, a number of individual emblems, and a narrative framework that works to identify, attract, and stimulate the audience. A similar analysis can be made of the grotesqueries of Raphael or Primaticcio.

In other words, the process is very like the constructions of the programs we looked at in the previous chapter. In the proem to book 5 of *The Faerie Queene,* Spenser anatomizes Justice, sketching its nature and history in the world, mostly by contrasting the actual present with an ideal past. In the arts, however, the results are expressed in concrete symbols rather than abstract words. Thus the individual episodes of book 5 illustrate Justice's roughness, vulnerability, source in the very nature of the world, and so forth. The poet having carried out the dialectical analysis, drawn up the emblematic materials, and outlined the structure, the reader then takes over to complete the job, constructing a full image of Justice from the diffuse, paratactic array of hundreds of particulars and statements made about it in the Legend of Artegall. If this analysis is accurate, the affinities of the poem with large-scale works of Renaissance Grotesque decor become all the more striking, and especially with respect to that element of the poem that has from the beginning seemed to its critics most problematic, its structure. Consider again the Vatican *logge* or the gallery at Fontainebleau. A visual field, divided into units of equal size by its major structural members, was to be decorated. A humanistic scholar, perhaps in consultation with the artists, drew up a program, with its major places occupied by complex emblems from classical sources and from the Bible (the Vatican) or from Ovid (Fontainebleau).[31] The field was prepared by being covered with a uniform ground, on which the executing artists then laid down their emblematic images. These comprised, first, a great many objects, grotesques, transitional figures between experience and idea, nature and art, angel and beast, pagan and Christian. These were linked to one another by various means, so that they bound the field together. Framed themselves by the architectural features of the space, they also framed a series of pictures, based on another set of esthetic principles; specifically, the inset pictures were more fully composed according to the best High Renaissance practice, with an integration of spaces, proportions, figures, colors, and iconography much more complete and

unambiguous than in the Grotesques.[32] The finished decor has a subtle logic; the scenic paintings are thematically related, and the Grotesque figures sometimes indicate or emphasize elements in the scenes. And there is an entry point at which inspection of the space normally begins. But in fact, that inspection can begin and end at any point without much confusion. Moreover, the stopping point, the end of the space, is, with regard to the decor, quite arbitrary; there is no reason why the same kind of decoration could not be carried on for as many bays again.

Such a structural analysis seems to me very responsive to the facts about *The Faerie Queene*. The bays of the architecture correspond to the books of the poem; the uniform ground is the uniform style within a uniform stanza. This carries a great many detached images, and some extensive allegories, a few (like the corresponding *istorie* in the palaces) combining narrative, emblem, and grotesquerie into elaborate and richly significant compositions. These images are tied together by the unwinding, unended narrative, but they are most often related to their neighbors by contrast, disjunction, rather than by similarity or even an obvious causal or logical connection. There is a customary entry point, at the beginning of book 1, and as is always the case with literature by comparison with the visual arts, the poem has a much more compulsive sequence than the loggia or gallery. But the sequence is less critical than in many narratives, and readers of the poem know that its disjunctive procedures make it possible to begin reading at just about any point without much loss of understanding or pleasure. [33]

A single segment of this enterprise will illustrate these disjunctions. Book 2 begins with an authorial comment and then a bit of exposition relating the narrative to that of book 1. The first episode belongs to what I might call the social mode of romance (Archimago's attempt to set the Redcross Knight and Guyon at odds by means of a false accusation of rape). The author then modulates into romance's fantastic mode (the lurid spectacle of Amavia, bleeding to death from a self-inflicted wound beside the body of her lover, Mordant, himself the victim of a sorceress's plot). An interpolated bit of Ovidian mythologizing (the account of a spring so chaste that it refuses to cleanse a child's bloody hands) gives way to another piece of social romance, but this time quite formally allegorized (the Castle of Medina). Breaking away from Guyon and Redcross, Spenser then gives us a bit of romantic comedy (the youthful exploits of the mock hero, Braggadoccio), interrupted by an elaborate Renaissance emblem (the blason of Belphoebe, a romantic Diana, chastity personified, also an image of Elizabeth).

Returning to Guyon, we follow him into another allegory, a psycho-machia this time (Furor, Occasion, et alia), which sets up a novella (the tale of Phedon, Philemon, Claribell, and Pryene, probably based on Ariosto but with other analogues in Bandello, Whetstone, and Shake-speare's *Much Ado*). The psychomachia resumes, but shortly Spenser segues into a *descriptio loci* (a knight, Cymochles, and assorted females in various stages of undress, reminiscent of any number of Bellinis and Titians) and then, after a narrative link, another of the same (same knight, though only one lady this time, but still the only instance in the book of two episodes of similar tone and type back to back). This scene becomes the setting for another piece of social romance (the battle between Cymochles and Guyon for Phaedria's favors), which turns, however, back into the psychomachia. The next episode is the allegori-cal core of the book. Yet it takes place outside Faerie Land, and none of its characters appear elsewhere in the poem except Guyon, and he only as a nonparticipating spectator (Mammon's Grotto, discussed above, itself drawing motifs from many literary and visual traditions).

The next bit comes out of the Bible and saints' lives (Guyon pro-tected by angels in the wilderness); it gives way to a resumption of the psychomachia (the debate between the reasonable Palmer and the intemperate knights Pyrochles and Cymochles), and then an epic battle (Arthur to the rescue of Guyon versus the two angry knights). There follows another elaborate formal allegory (the House of Alma), itself framing a pair of chronicle histories (of Britain and Faerie Land) and culminating in another battle piece (Arthur versus the forces of Male-ger). This cuts to an allegorized voyage (Guyon's transit of the Gulfe of Greediness, more Ovidian than Homeric, along with Mammon's cave the fullest collection of grotesques in the book and recalling the Galérie d'Ulysse at Fontainebleau). Finally, the book closes with another ex-tensive *descriptio loci* (the Bower of Bliss, like the previous two in having a lover and his lady at its focal point, and even more obviously related than the first two to the Mars–Venus topos of Renaissance painting by its use of the story of the net of Vulcan), rounded off by a last bit of narrative and pointed by the Grotesque emblem of the hogman, Grill, complete with motto.

I have outlined the contents of book 2 of *The Faerie Queene* in such detail to emphasize the great variety in the types of images constructed by Spenser and the discontinuities that mark the movement from one kind to the next. Yet I wish also to bring out the serpentine connections among them: the uniformity of style and form, the continuing charac-

ters and stories, the constant concern with the theme of Temperance. All these testify to an overall concept (made explicit, indeed, in the Letter to Ralegh), which governs not just the book but the whole poem and which thus can be said to animate a program whose goal is "to fashion a gentleman or noble person in vertuous and gentle discipline." Just such concepts seem to have governed the programs at Fontainebleau and the Vatican, where in the same way a variety of images is drawn into a harmonious ensemble. By contrast the typical miscellany or even a collection like Tusser's *Five Hundredth Points,* though its images may be much less various than Spenser's or Raphael's—mostly portraits, mostly complaining sonnets—imposes no necessary relationship between them. There is always the sense that one could be taken out and another substituted in its place without affecting the others. With respect to the degree of control imposed, a middle ground between the ordinary gallery and the fully programmed room is occupied by the *studiolo,* a room full of paintings and other objets d'art either carefully chosen from among the works of many artists to go together in a pleasing and sometimes intellectually coherent manner or executed by a single artist, which nonetheless still does not quite amount to a single immense work.[34] The literary counterpart here might be something like Spenser's volume of *Complaints* (1591, but clearly including some work first drafted as much as fifteen years before), comprising pieces that share a common theme but differ widely in style and subject. (Its title page has a similar structure.) But gallery, studiolo, or programmed room all depend on the encadrement of complex images by simpler ones. All call heavily on their readers' or viewers' previous experience: they appeal to tradition, habit, fashion. All share in a curious way this property, that though not exactly predictable, they are never surprising, either. A reader coming fresh to *The Faerie Queene* from experience with its predecessors may not be able to know ahead of time (given its disjunctive character) what will show up next. But when the next item does appear, it will not astonish (except perhaps by the brilliance of the execution). In the Grotesque world, marvels are commonplace. And for all the linking power of the Grotesque style, these works remain fundamentally aggregative in comparison with the more fully composed works to come.

Such a conception of structure turns out to apply to many works of English literature, and of the other arts as well, from the second half of the sixteenth century: morality plays, collections of tales, sonnet sequences, even poetical miscellanies. Not all of them contain Grotesque

materials, antickes, as numerous and prominent as Spenser's. If, like the moralities, they do, the figures often have a lineage as much Gothic as classical. Spenser himself marks the possible range here in the contrast between the indigenous forms, including verse forms, of *Mother Hubberds Tale* and the High Renaissance traceries of *Muiopotmos*. A third strain can be discerned in Nashe's *Unfortunate Traveller* (1594), whose grotesqueries have a quality of coarseness and violence reminiscent of the northern European prints that were presumably the most prominent element in Nashe's visual arts experience.[35] Earlier prose narrative, and especially the string of romances inaugurated by Sidney's *Arcadia* and running through all the commercial authors of the 1580s and 1590s, displays both Grotesque decor and programmatic structure. Typically these books have tighter plots than *The Faerie Queene,* but as C. S. Lewis has claimed, the plots often (as also in debating-society fictions like *Euphues*) serve mainly as connecting tissue for inset compositions, not only narrative-descriptive, as in Spenser, but also rhetorical.[36] Like *The Faerie Queene,* they seem to lie across the borders between daily experience and pure fantasy, and their rhetoric is equally apt to appear Grotesque if taken literally, and equally reliant on various kinds of *amplificatio.* That observation allows us to bring in the sonneteers and epideictic writers of the miscellanies and the plaintive chroniclers of *The Mirror for Magistrates.* On the visual side, note that many title pages combine classical, Gothic, and Grotesque images; so do initials and other ornaments, and the ephemeral structures built for progresses and entrees. The memorial portrait of Sir John Luttrell shows him on a giant scale, wading in the sea. The foundering ship behind him is painted to another scale, the allegorical figures he addresses to a third; they occupy their own space.

One last point must be made. In an important pair of articles, Michael Camille has argued that the marginal grotesques in medieval manuscripts (and in other complex medieval works of art, such as churches), with regard to both structure and imagery, supplied the artists who made them with a way (not always exploited, of course) to challenge, undercut, qualify, or otherwise resist the authority of the more fully articulated work, whether verbal or visual, that they bordered (1985a, b; see also Harpham 1982, 34–38). In effect, they are mutterings from the back of the meeting hall, catcalls from the crowd lining the parade route. Specifically, he says, they allowed the largely nonliterate limners and masons of the age to sustain the oral culture that had formed them against a newly dominant literacy. Camille quotes

Walter J. Ong, S.J., on the "psycho-dynamics of orality," which are "additive rather than subordinative . . . aggregative rather than analytic . . . redundant or copious"—precisely the qualities we have seen as characterizing Traditional art and the Grotesque (1985b, 36). To the extent that literacy was both the sign and the agent of the political establishment, however, the Grotesque also provided a means by which politically helpless artists, even those who were literate themselves, could subvert the authority it served. Authority surely recognized the challenge for what it was. Its marginality, however, robbed it of real danger; it could thus be tolerated, even enjoyed, by holders of power who must themselves sometimes have felt similar frustrations.

Let us consider the semiotics of Grotesque architectural decor. A rich Elizabethan has engaged a sculptor in wood to ornament the screen in his new hall. Why should the artist propose or the patron approve a design whose most prominent feature is a quartet of giants, not facing out away from the hall as if to protect it, but rather scowling down at the guests? The artist has carved on either side of the patron's bed imps who leer down on the conjugal embrace with such faces as, asleep, one would meet only in a nightmare. The table from which his breakfast is served sits on the back of a pair of monsters, female heads and torsos with the legs and hindparts of lions—sphinxes, whose own food, we recall, was human flesh (fig. 41). Trapped in the plaster above the entrance to the room a tormented face emits an endless, soundless shriek, as though in witness to a chamber of horrors behind it.

No single or simple explanation will account for these peculiar features, whose counterparts can be found at Burghley, Hardwick, Audley End, and elsewhere, not least because the builders and patrons and theorists of the period did not discuss them. The most important factor was no doubt fashion; for whatever reasons, people all over Europe (those who could afford it) were employing such imagery as they built and furnished their homes toward the end of the sixteenth century. And fashion always has something irrational about it. A second explanation arises from the fact that architecture, always the most rational of the arts because of its necessary obedience to geometry, physics, and economics, had during the renascence been further rationalized by the application of Vitruvian method: those giants on the screen very likely occupied compartments defined by Doric or Composite pilasters, echoing an order of columns applied to the facade. But renascence estheticians were unanimous in calling for variety as well as order, and renascence psychology authorized the workings of the imagination, as

41. Grotesque table (English, c. 1590), after a design by Jacques Androuet Du Cerceau. Photo: David Evett.

well as the reason, as long as those workings were controlled, kept within bounds—as long as those giants and imps were imprisoned in a pilaster, contained in a cartouche, and relegated, by and large, to corners, edges, and other transitional positions.

A third factor relates to the function of a house as a refuge, a place of protection against hostile forces of nature and man. In medieval buildings, the thick stone walls and tiny windows, the massive crude beams and the minimal decoration, all offered implicit reminders of the dangers outside. But as wall gave way to window, as masonry disappeared behind plaster, paneling, or tapestry, as beams were carved and gilded, the protective functions of houses yielded—on the inside as well as the outside—to the ostensive. Since ostentation ran counter to moral orthodoxy, it became desirable to install discreet reminders of the enemies without. A related factor is the general ritual principle by which dangerous spirits are brought under human control by being in effect trapped by art in their effigies.

Finally, I would argue that Grotesque imagery serves the same purpose as those grotesquely dressed balloon-prickers (very often dwarves or otherwise physically or mentally deformed), the licensed fools, to offer constant subversive reminders to the man (or woman) of sufficient wealth and power to build and furnish a big house. Most generally, they serve as what Wallace Stevens has called "emanations" of the imagination as it struggles to help us endure "the pressures of reality" crowding in upon us. "It is a violence within that protects us against a violence without" (Stevens 1951, 36). We can come at this idea through an image whose very ubiquity may muffle our recognition of how Grotesque it is, the death's-head, everybody's visual reminder that all flesh is grass. Hence those scowling giants, like the one who silently follows Guyon through Mammon's realms, ready to "rend him in peeces" should he weaken (*FQ* 2.7.26–27), might well image for the lord of the manor the fragile nature of his power (the giant was a common image in the writings of the time for the masses of ordinary men, so much more numerous than the aristocrats who governed them) and his need for constant vigilance. Most of the herms in Tudor art are shown naked from the waist up; their bare breasts and wild beards, together with the ubiquitous phallic or vulvar forms that substitute for direct representation of the sexual members, signify the threat presented by an unbridled sexuality, both male and female, to a civilized society. In a similar way, a crouching sphinx may articulate the gynophobic anxiety

of the patriarchal male. All these remind members of the establishment
who they are or might become:

> man, proud man,
> Dress'd in a little brief authority,
> Most ignorant of what he's most assur'd
> (His glassy essence), like an angry ape
> Plays such fantastic tricks before high heaven
> As makes the angels weep; who, with our spleens,
> Would all themselves laugh mortal.
> (*Measure for Measure* 2.2.117–23)[37]

So Isabella, a helpless, unsexed, suppliant girl, calls attention to the
intrinsically Grotesque nature of the lord Angelo and others like him.
(It is even to the point that his soliloquy, a few lines further on, is
full of oxymorons and centers on the Grotesque image, like something
out of a medieval margin, of a saint being used to bait a hook.) So
Spenser could glance at Elizabeth's restraint of his supporters' military
ambitions in Ireland and the Low Countries by subordinating Artegall
to Britomart and Radigund, or articulate the married man's nightmare
of cuckoldry through the Grotesque transformation of Malbecco from
rich man to monster. More generally, from his own marginal position
at the geographical, political, and economic edge of Britain, he could
construct a uniquely full critique of British ideas and practices whose
disjunctions, refractions, alienations, nevertheless largely screened him
from censure. From expressions like this, the patron or audience takes
moral and psychic profit, and the artist the satisfaction (such as it may
be) of having spoken a subversive truth.

6

The Toad in the Garden:
Actual and Ideal Landscape

Grotesque art is an art of mixtures and hybrids; it sets a premium on craftsmanship. As this art is emblematic, noumenal, and neo-platonic, we may also call it *idealistic* and connect it with other kinds of art that have such a character. As it is imitative, phenomenal, and Aris-totelian, we may call it *realistic* or *mimetic* or *ikastic* and connect it with other art of similar character. This is a common kind of dichotomy, of course, although the terms used to express it vary; a familiar version is Amy Lowell's formula for effective poetry, "imaginary gardens with real toads in them." I want to propose that in general, as the century progressed, Tudor artists became increasingly attentive to the toads; their art tended to shift away from the idealistic toward the ikastic pole, at a pace that accelerated rapidly in the last two decades of the century, partly in response to developments outside the arts—in optics, travel and exploration, building practices—that stimulated interest in direct imitation of natural phenomena. I am arguing, furthermore, that the shift specifically rests on an increasing attention to spatial relationships —including, crucially, artists' awareness of their own positions vis à vis their subjects. Note that at any time it is only a matter of relative em-phasis: all representational art is fundamentally idealistic in its reliance on signs, symbols, and conventions, and a powerful party in contem-porary philosophy and criticism holds that even our most immediate physical sensations reach our consciousness only as mediated by lan-guage. Beyond this concession, however, I believe that most readers and viewers will distinguish significant differences among individual artists' readiness to recognize, value, and yield to the data of phenome-nal experience.

This fact opens up some of the trickiest problems in interarts criti-

cism because a wider gap appears between language and phenomenal reality than between that same reality and even the most abstracted visual representation of it. (Consider the difference between the sounds represented by *h-o-m-o* and the Japanese ideogram for *man*.) The question, then, of the actual process involved in verbal imitation, mimesis, is enormously difficult. The problems ease somewhat if we turn our attention from the issue of the representation of things per se to the issue of relationships among the elements of those representations. Highly idealistic art tends, I think, to push individual things into isolation. Disconnected from particular times and spaces, they also become disconnected from one another. When I consider Plato's ideal chair, I do not also think about his ideal cushion, table, rug, cat, fire, or cabinetmaker. I cannot imagine the lovers who stroll through the gardens around Spenser's Temple of Venus gathering in one of his "faire lawnds" to play volleyball. Reversing the equation, I have proposed that a highly idealistic view of the world that is yet trying to express itself through images rather than abstractions will tend to produce a planar art, in which objects appear in a unique space, dissociated from other objects, including especially the rest of the objects in the space occupied by the artist. It will produce a paratactic art, in which the components are discrete and univalent. And such art will tend to have these characteristics whether produced in neoplatonic Byzantium or in Christian humanist England, whether in visual or verbal media. A view of the world attempting to mediate between idea and actuality, such as that expressed in *The Faerie Queene,* will certainly include some hypotactic features. But the connections between them will tend to remain arbitrary, subject to ideas more than experience, and hence the structure will tend to remain paratactic. A view of the world that attends closely to phenomenal reality, however, will tend to see items in their physical and temporal relationships, in context. And the art that expresses such a view is likely to be correspondingly intricate and hypotactic. The development of spatial and temporal consciousness is thus a component of the esthetic shift from Traditional toward renascence forms.

A convenient ground on which to explore these propositions in detail is furnished by landscape—which has among others this property, that the thing itself remains relatively stable and constant, by contrast with human artifacts and institutions, although ideas about it and images of it may change. (A parallel process can be observed in treatments of the human body.) We can trace through the sixteenth century a process whereby English writers and artists become increasingly atten-

tive to the particularities of the physical landscape in which they live, and increasingly interested in representing those particularities in their art. The process holds (using Henry Peacham's terms) for both *topographic* (actual) and *topothetic* (imaginary) landscape, for both discovery and invention, and for both art and literature (*Garden of Eloquence* 1603, 141–43; see also Miriam Joseph 1947, 129–30, 321). Like the renascence more generally considered, this development can be seen occurring, with local variations of emphasis and timetable, all over Europe. In England, as on the Continent, we find that it involves not only a developing consciousness of the world, but also and in consequence a developing awareness of the difference and distance between artist and subject. This distance, even as it afflicts the artist with certain kinds of uncertainty, also enhances the degree to which the data of experience can be brought under control—not intrinsically (the word *data* means what it says), but as they are set in relationship to one another, in contexts. And as we shall see, this development has important implications for the overall relationships among artist, material, and audience.

We are alerted to some ways in which the dichotomy can help us to understand sixteenth-century art by some images that seem to be governed by both views. Ambrosius Holbein's woodcut for the 1518 Basel edition of More's *Utopia* dots the imagined topography of that virtuously pagan isle with churches, each with its cross atop its spire. The fine engraving by Marcus Gheeraerts the Elder of the Garter procession of 1576 has portrait figures of the Garter Knights passing through an elaborate Renaissance loggia. The loggia is quite unlike any surviving piece of sixteenth-century English architecture; if it were anywhere, it would have to be at Windsor, where the ceremony occurred. Beyond the loggia, however, is a landscape in which an architecturally accurate Windsor castle appears. Moreover, the landscape is full of the steep-sided rocky hills typical of sixteenth-century Flemish landscape painting but unlike anything in that part of Berkshire, and several members of the procession not only were absent on the historical occasion but never set foot in England in their lives (Strong 1977, 169–73). The engraving of "Stonadge" (Stonehenge) in Kip's Wiltshire map for Camden's *Britannia* (the 1607 edition) looks like a little mountain range; the title page of the edition of 1600 shows a better likeness, but sets it in hilly country near a village rather than isolated on the plain. Programs for Elizabethan allegorical paintings call for portraits of Queen Elizabeth, Sir Nicholas Bacon, and Sir Thomas Gresham to be set among allegorical figures (Brit. Lib. Sloane MSS 1041, 2v; 1096, 4r). The fine

Sheldon tapestries woven in Warwick around 1611 and now at Hatfield House illustrate the four seasons, as usual, by showing the customary farming and hunting activities of northern Europe. Among the fauna appear satyrs and lions, reminding us of the lions and serpents and olive trees of *As You Like It*. Perhaps all these works were devised at a holiday resort along the seacoast of Bohemia.

Rosemond Tuve puts the case with polemical force when she describes the typical Elizabethan work of art: "This artifact was designed to please on grounds of its formal excellence rather than by its likeness to the stuff of life—a relatively formless subject matter not to be identified with the poetic subject and evidently not even loosely identified with 'reality.' . . . Poets well understood the role of a credible vividness in accomplishing [their] intentions, especially in certain genres; but profound suggestiveness or logical subtlety is likely to displace sensuous accuracy in the images" (1961, 25). The position certainly reflects the neoplatonic origins of most renascence critical theory. As I have already indicated, the rigor with which the doctrine was applied varied.[1] Perhaps it would be most exact to say that late medieval and renascence artists followed nature closely when no more important consideration intruded. The best illuminators often recorded small details with great care, and the almost photographic exactitude with which International Style painters depicted flowers, birds, the designs of carpets, and the texture of cloth and stone is well known. Still, it remained for Renaissance artists and critics to establish, as Irwin Panofsky says, "what seems to be the most obvious, and actually is the most problematic dogma of aesthetic theory: the dogma that the work of art is the direct and faithful representation of a natural object" (1966, 1:243). Alberti, great mathematical idealist that he was, asserted that "The painter is concerned solely with representing [Lat. *imitare,* It. *fingiere*] what can be seen" (1966, 43). The doctrine, like most Renaissance esthetic concepts, transferred readily to the other arts. Mintorno held that "the poet who described the natural world convincingly was the greater deceiver and the more skillful because of it" (quoted in Scoular 1965, 89). Or as George Puttenham put it (with his customary good sense), "And neverthelesse, . . . a Poet may in some sort be said a follower or imitator, because he can express the true and lively of everything [which] is set before him, and which he taketh in hand to describe: and so in that respect is both a maker and a counterfaitor: and poesie an art not only of making, but also of imitation" (G. G. Smith 1964, 2:3).[2]

As any number of renascence esthetic assertions and of renascence

artistic practices based on them imply, the artist formed by these ideas was no warbler of woodnotes but a systematic investigator. Alberti spoke of the artist "as a man engaged in a scientific occupation" (quoted in Blunt 1968, 10). The original Renaissance tenet was that within the realm governed by *recta ratio* there is no incompatibility between ikastic and idealistic images. In an early and admittedly somewhat naive stage, Brunelleschi in his painting of the Piazza del Duomo in Florence filled the portion occupied by the sky with polished silver, which reflected the actual sky, including the moving clouds (J. White 1972, 114). Later, Raphael set portraits of living statesmen, churchmen, poets, and artists among the idealized images of great men of the past in his frescoes in the Stanze della Segnatura of the Vatican. The art theorists Carlo Dolce and G. P. Lomazzo called for absolute historical fidelity in the costume and architecture depicted in both classical and biblical paintings (Lee 1940, 237–38). Still, Brunelleschi's device had no important imitators. Raphael painted his contemporaries as beautiful men and women in beautiful postures. The classical robes and buildings in renascence paintings are not frayed or stained or obscured by the repairman's scaffolding unless their iconography calls for a contrast between Old and New Dispensations. Even in northern painting, the depiction of human beings is tied to the intellectual notions of hierarchy—shepherds and donors have warts or missing teeth, but saints and rulers exhibit features of ideal beauty.[3] The toads still have diamonds for eyes.

As the doctrine matured, however, it led in some curious directions. Hieronymus Bosch achieved some of his most striking results when he drew idealistic images—that is to say, emblems—into a naturalistic context, by translating metaphors literally into pictures ("the very stones did weep"); indeed, one source of the emotive power of his fantastic paintings, and those of his follower Bruegel, may be that they herd flocks of emblems, which, as we saw earlier, normally occur in the two-dimensional, paratactic realm of the Grotesque, into spaces ruled by that most powerful of all naturalistic devices, illusionistic perspective. Bruegel went a stage further by employing features of the phenomenal world with well-established symbolic meanings, such as effects of weather, season, terrain, and iconographically loaded poses and gestures and objects, in strongly naturalistic contexts. At this point the garden is beginning to become real.[4]

The iconic bias of Tudor art seems to have kept this tendency muffled up in England. Few of the thousands of mourning figures on sixteenth-century English funeral monuments approach the late Gothic natural-

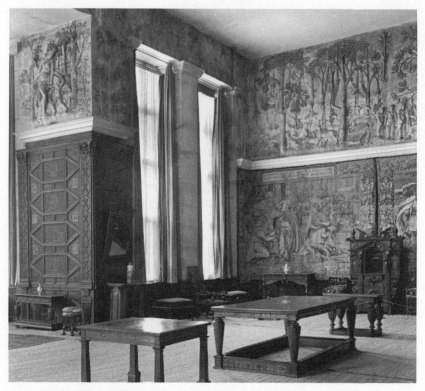

42. Robert Smythson, Hardwick Hall, Derby (c. 1597), the High Great Chamber. Photo: The National Trust.

ism of Claus Sluter's *pleurants* on the ducal tombs in Dijon (1404–5); such wall paintings as have survived two periods of religious iconoclasm and several changes in taste owe allegiance more to Byzantium than to Brussels. For brief moments, to be sure, the representational genius of Pietro Torrigiano and Hans Holbein seems to have astonished and captivated English eyes (at least around the court), and a few other Continental artists of the time of Henry, Edward, and Mary, such as Joos van Cleeve and Guillem Scrots, had illusionistic skills of nearly the same order. But the peculiar early Elizabethan rigor set in during the late 1550s, affecting, as we have seen, even that most ikastic of genres, the portrait.[5] Only in the 1580s did the thaw begin to produce effects like the use of real tree bark (at Theobalds) and real tree trunks (at Hardwick) in order to assure the representational accuracy of plaster friezes, in a mode of naive naturalism reminiscent of Brunelleschi's mirror of 140 years earlier (Girouard 1976, 65; Summerson 1956, 122–23) (fig. 42).

Similar processes occurred in poetry. By the end of the Middle Ages, a very stable and reliable set of symbolic landscape conventions had developed, derived like other iconographic materials from biblical, classical, and indigenous northern European sources.[6] Thus "a well-established Gothic tradition" saw in images of the forest this world as contrasted with the next (Robertson 1963, 225). The symbol remained constant for Dante, Chaucer's *Book of the Duchess,* Sannazaro's *Arcadia,* Sackville's induction to *A Mirror for Magistrates,* and Spenser's *Faerie Queene,* as well as *The Tempest* of Giorgione, any number of Temptations of St. Anthony, and probably Bruegel's *Landscape with the Fall of Icarus.* In the masques of Ben Jonson and Inigo Jones, wild nature, with the reek of mortality upon it, is contrasted with the predictable, quasi-heavenly court (Orgel and Strong 1973, 1:39). This is as much as to say that landscapes, like other things, became emblems. Within this framework, the richest commonplace was that of the *locus amoenus,* the sweet concurrence of shade tree, grass, and stream or pool that served as the ubiquitous image for recreation of all kinds from the *Odyssey* onward. Like other complex emblems, the *locus amoenus* could be exploited to a great variety of ends. In one context, it stands for Eden; in another, the lure of the flesh. It appears "naturally" as part of the scenic background of works by Theocritus, Vergil, Ovid, Petrarch, and nearly everybody else. It also occurs in a number of interesting iconophrases. The shepherds' temple in Sannazaro's *Arcadia* (*prosa* 3) is decorated with pastoral paintings. Sidney sets Basilius's symbolic lodge in an extensive *locus amoenus* (the whole of Arcadia, in effect) surrounded by a desert (Laconia, and the rest of the Mediterranean world).

Yet as this tradition developed through the renascence, it, too, became gradually infused with the disposition toward naturalism. The shift was slow and partial; writers continued to use the old landscape formulas until the nineteenth century, a fact suggesting that the development bespoke the emergence of new interests and concerns more than the disappearance of older ones. And they tended to invoke the formulas in paratactic terms, by generating lists of discrete items. Change did occur, however, accompanying the literal and figural widening of European geographic horizons that has long been recognized as one of the major features of the renascence. A pivotal development was the interest in optics on which, from Alberti through Leonardo, and Galileo through Newton, scientific progress swung.[7]

Although optical study touched pure science on the one hand, vanishing-point perspective on the other, much of the attention was quite practical, part of a search for improved instruments of survey-

ing and navigation and, as such, part of the great surge of work in geography and topography.[8] The fifteenth and sixteenth centuries were, of course, the great age of intercontinental exploration, of da Gama, Columbus, Magellan, Hudson, Frobisher. These men, and their associates and followers, traversed most of the globe, and accounts of their voyages were gathered in the great sixteenth-century collections of Ramusio and Hakluyt and summarized visually in the great atlases of Ortelius (1570), de Jode (1578), and others (Cowley 1940; Wright 1958, 508–48). This exploration had commercial motives. But men also traveled extensively on diplomatic missions of the kind that took Wyatt, Surrey, Elyot, Cheke, and others to the Continent, while Sidney and others traveled in the name of education, perhaps carrying the pocket atlases available as early as 1583.[9]

The impact was such that by the early sixteenth century More felt impelled to supply his *Utopia* with both a geography (a nice combination of exactitude and mystery) and a topography (a nice mixture of practical and symbolic features). In England, however, the major developments occurred under Elizabeth. Sir Thomas Smith apparently took over from one Reginald Wolfe some English remains of an uncompleted project for a "Universal Cosmography of the Whole World" and incorporated them in his *De republica anglorum* (1565, published 1582). Much augmented, these seem to have supplied the core for William Harrison's *Description of Britaine* (1577) and *Description of England* (1586–87) (Dewar 1964, 114).[10] Their topographic and social emphasis was supplemented in the historical dimension by William Camden's *Brittania* (1586). The first edition of Hakluyt's *Principal Navigations* appeared in 1589. These written materials were supplied with visual keys by the county maps of Christopher Saxton's *Atlas* (1579); John Norden's *Speculum Brittaniae* series, begun in 1593; and its successor, the *Theatre of the Empire of Great Britain* of John Speed (1611). But Englishmen had shown an interest in maps for some time. A 1577 inventory of the possessions of Sir Thomas Smith lists "cards with tables of wainscot" including "a description of England, Scotland, and Ireland . . . and another description of various countries" (Dewar 1964, 194).[11] John Buxton has proposed that Elizabethans "hung maps . . . upon their walls, not landscapes" (1965, 114).

What Buxton is implying is that maps are one thing, pictures another. Maps are practical, to be sure; they derive from the actual world. But even in our own day they depend on a highly symbolic and conventional imagery. Topographical landscape drawings and paintings,

especially when they represent landscapes rather than buildings, are much more purely esthetic and much more individualistic. Yet maps and topographical pictures proliferated simultaneously. Accurate depiction of buildings began to appear in late medieval portraits, Italian but especially Flemish (Lavedan 1954, 21). Landscapes, though they increased in complexity and importance in both Italian and northern paintings throughout the fifteenth century, remained idealized, topothetic, until the earliest authenticated topographies, of Dürer, in the 1480s.[12] The early decades of the sixteenth century saw a substantial surge of interest in topographical landscape, culminating in the drawings, prints, and paintings of Bruegel. For some reason the surge subsided, perhaps in response to Reformation and Counter-Reformation spirituality, and did not pick up again until the next century.[13]

Some of this interest may be related to developments in architecture and town planning that gave people increased visual access to the world about them. All medieval (and most Tudor and Stuart) English houses were dark and inward looking; they had relatively few windows; the windows they had were small and shuttered and opened mainly onto courts and yards. In the country houses were built whenever possible in dips and hollows of ground, so as to be out of the wind; in the city they squeezed tightly together on narrow streets. Sixteenth-century London had no large open spaces within the city walls, nor even any "public" places of resort in the modern sense; people gathered in churches, guildhalls, and theaters, and the largest patches of open ground were the Thames-side gardens, themselves subdivided by walls and hedges, of large private houses, episcopal palaces, and the Inns of Court. The first square was not opened until 1631 (Carrier and Dick 1957, 77).[14] But England shared these restrictions with the rest of Europe. Medieval people had little documented interest in wide-open spaces. Their idea of heaven on earth was a snug *hortus conclusus* or *locus amoenus,* and even Petrarch, who is said to have identified himself as the first modern man by climbing Mont Ventoux for the view, treated his wide prospect as an object lesson in humility and turned from it to the pages of St. Augustine almost at once.[15]

During the renascence, however, buildings as well as their dwellers opened their eyes, and even more so in England than on the Continent. Houses grew higher and, if important, forsook the sheltered dell for exposed but imposing hilltops. Nonsuch, to judge from the surviving pictures, dominated its surroundings as completely as François I's Chambord; Leicester's buildings at Kenilworth tower over the work

of Henry V. Windows grew larger and larger, since glass was one of the luxury items available to new wealth. In older buildings, like Hampton Court, The Vyne, Kenilworth, even Burghley, the hall windows went higher to admit more light. But the sills remained high, too; later in the century sills dropped, so that the windows were good for looking out of as well. These features are particularly noticeable in the rooms specifically developed by the English during the Tudor period for relatively casual social commerce, the parlors and galleries, which are almost always on an upper floor, facing out across the gardens to the fields beyond.[16] The whole process is carried to its imposing (or ridiculous) conclusion at "Hardwick Hall, more glass than wall," proud on its Derbyshire ridgetop; at Aston Hall above Birmingham (c. 1618); and especially at Wollaton, which dominates all of Nottinghamshire not only by its site atop a solitary hill but also by its enormous glass-walled lantern tower (fig. 23).

If changes in building practice helped sensitize English artists to topography, the process was slow. Signs of topographic sensitivity in the visual arts of Tudor England are scattered; most of the scenes are accessories to portraits or narratives.[17] A miniature of about 1500 shows Charles d'Orleans in the Tower with London Bridge beyond; the buildings appear to have been sketched on the spot, though the proportions are distorted and the human figures magnified severalfold in the medieval manner. Only one major topographical oil has come down to us, Joris Hoefnagel's *Wedding at Horsleydown* (c. 1570), now at Hatfield; it is also important as one of the earliest English genre paintings and hence one of the first to take into a medium customarily reserved to "significant" personages the kind of ordinary scenes from ordinary life otherwise confined to prints (fig. 43). At about the same time Hoefnagel's painting of Nonsuch was engraved for inclusion in the great atlas, *Civitatis orbis terrarum,* published by Braun and Hogenberg in Cologne. The 1590 edition of Thomas Hariot's *Virginia,* published in Frankfurt, was richly illustrated with DeBry's engravings after the watercolors of John White, showing not only carefully observed native American dress and customs but also glimpses of the American landscape. The London edition of 1588 was, however, not illustrated. Hilliard's Accession Day miniature of George Clifford (c. 1590) has a view of London (perhaps from an unidentified print) as background— though the scale is radically distorted by compression in the horizontal and expansion in the vertical dimension (fig. 44).

In this as in other visual fashions, the English grew more active after

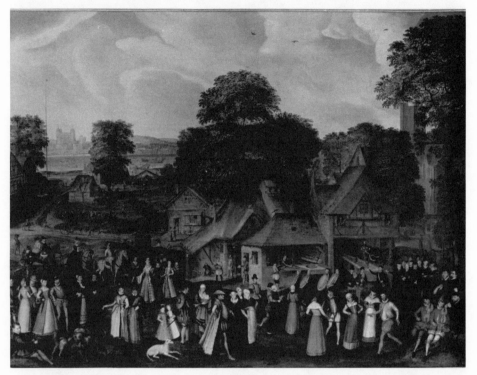

43. Joris Hoefnagel, *Wedding at Horsleydown* (1570?), Hatfield House, Herts.
Photo: Courtauld Institute of Art.

the turn of the seventeenth century, just about the time Angel Day's effusion on the subject of landscape in painting gave them a sense of the possibilities: "The curious painter in drawing a perfect peece of *Landskip,* presenteth many things unto the eie, the conceit whereof is marvellous: for the great admiration we do there seeme to behold, the most pleasant and goodlie vallies: woods hie and decked with statelie trees (some tops whereof the wind seemeth to wreathe and turne at one side) then goodly rivers, hie waies and walkes, large situate & high climing hils and mountains, far prospects of Cities, steeples, and Towrs, ships sayling on seas, and waves blown up aloft, the element clere, fair and temperate . . ." (1599, 23). The archway built by the merchants of London to welcome James I (1604) was surmounted by a forty-five-foot-wide representation of the city as viewed from Southwark, topographically accurate (fig. 35). In his *Art of Drawing* (1606) Peacham included a chapter on landscape in which he seems to ex-

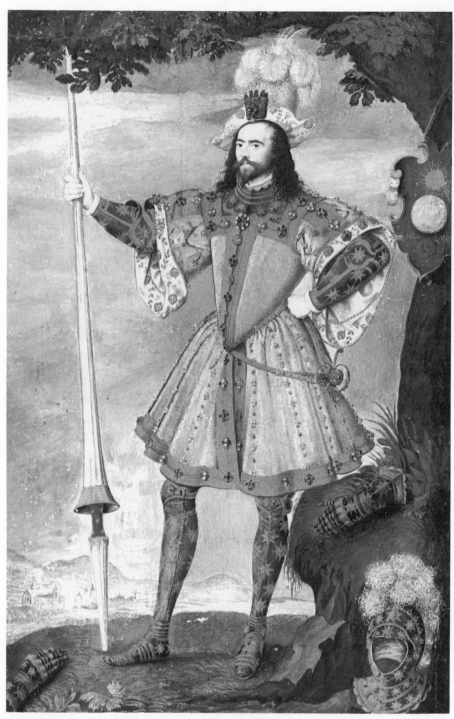

44. Nicholas Hilliard, *George Clifford* (c. 1590). The National
Maritime Museum, London.

pect the artist to work from life. The Florentine Constantino de' Servi apparently designed for Thomas Campion's *Masque of Squires* (1613) a background showing London and the Thames in full Renaissance perspective (Strong 1986, 105). A fine portrait of about 1615 attributed to William Larkin and thought to represent the Lady of St. John of Bletso (now at Montacute) shows the full-length figure standing before a grave with a death's-head on top of the piled earth; in the background stretches a well-painted landscape with a definitely topographical feeling to it. Much less skillfully painted but displaying the same mixture of symbolic and realistic elements is a pair of pictures by John Gipkym or Gipkyn known as *Henry Farley's Dream* and depicting Old St. Paul's as it actually appeared about 1616, with a crowd of people gathered to hear some notable preacher from the Pulpit Cross in the northeast corner of the churchyard, and as Farley hoped to see it refurbished with a steeple, gilt angels, and so forth (now in the possession of the Society of Antiquaries). Sir Joseph Kederminster had several landscapes painted on the paneling of the library he built for the church of Langley Manor, Buckinghamshire (c. 1620); the work is both various and sophisticated. Finally, Inigo Jones, who sketched landscapes on his trip to Italy early in the seventeenth century, followed the example of de' Servi and painted London buildings into the scenery for masques in 1622 and later, and incorporated recognizably topographical landscapes into some of his later work (Orgel and Strong 1973, 1:40–41, 359, pl. 122). Most of these artifacts date from after 1600;[18] together, they testify, along with some others we will consider later, to an increasing interest in natural scenery both as a significant emblem and as a thing worth attention in its own right.

Scattered and infrequent as are these instances from the visual arts, mimetic topography developed even more slowly in literature. The language available to Tudor topographers was not very exact in its visual referents—but then, neither is ours. We, however, are disposed to try. In the earlier sixteenth century, in this as in other activities, the principle was to codify experience in terms of an established set of ideal categories, and in this, as in other kinds of writing, the result was a list, a string of features, a paratactic blazon (it is no accident that a well-developed *topos* treats landscape in terms of female anatomy).[19] Camden's account of Ounsberry or Roseberry Hill in the North Riding of Yorkshire will illustrate; it gives "a most goodly and pleasant prospect downe unto the vallies below lying a great way about, to the hils full of grasse, greene meddowes, delightsome pastures, fruitful corne

fields, riverets stored with fish, the River *Tees* mouth full of rodes and harbours, the ground plaine and open . . . (1610, 721). John Derricke tried a more poetic vein, with modest success:

> The hills directly ronnying forthe,
>> and turnying in agenne:
> Much like a sort of croked mates,
>> and overthwartyng menne.
>
> (1581, B4r)

The poet's failure is especially marked here because the landscape components of the book's illustration are among the most sophisticated produced in England in the period. A striking example appears in the venerable Thomas Churchyard's New Year's gift to Elizabeth in 1594, "A Pleasant Conceit" of a painter, who to avoid Pygmalion's fate paints instead of "the kindly red and white" of female flesh first grapes, grain, and flowers, then a whole gazetteer of British towns and castles—Northampton, Warwick, Bedford, Lincoln, Kildare, Hartford, Huntington, Worcester, Southampton, Pembroke, Shrewsbury, Oxford. Once Worcester, he says, "like Huntington did looke." But how that was, we might well guess, for Churchyard's sequel is totally deficient in visual particulars:

> Woster that once, like Huntington did looke,
>> Stoode still farre off, as it would not be knowne:
> Yet soft and fayre, in ranke her place she tooke,
>> She worthy was, of right to have her owne.
> In fame and praise, and worldly honour both,
> In noble name, in vertue, grade, and troth.
> If Painter had, not toucht this Towne no way,
> God knowes thereof, what might good people say.
>
> (Nichols 1966, 3:327)[20]

In this period topographical poetry chiefly means Drayton's *Poly-Olbion* (1612), of course. But while it is true, as we will see later, that Drayton had developed a sense for landscape perceived in relatively pure visual terms, that sense does not get much play in his topographical epic. Instead, we find the kind of catalog of features that Camden produced:

> Appearing to the Flood, most bravely like a Queene,
> Clad (all) from head to foot, in gaudy Summers
>> green;

Her mantle richly wrought, with sundry flowers and
 weeds;
Her moystfull temples bound, with wreaths of
 quivering reeds;
Which loosely flowing downe, upon her lusty
 thighes,
Most strongly seeme to tempt the Rivers amorous
 eyes.
And on her loynes a frock, with many a swelling
 pleate,
Embost with well-spread Horse, large Sheepe, and
 full-fed Neate.
Some wallowing in the grasse, there lie a while to
 batten;
Some sent away to kill, some thither brought to
 fatten;
With Villages amongst, oft powthred heere and
 there;
And (that the same more like to Landskip should
 appear)
With Lakes and lesser Foardes, to mitigate the heate
(In Summer when the Fly doth prick the gadding
 Neate,
Forc't from the Brakes, where late they brouz'd the
 velvet buds)
In which, they lick their Hides, and chew their
 savoury cuds.

(18.25–40)[21]

This is historically a significant passage: the first recorded English use of the word *landscape* in connection with an actual scene. Although it appears in Angel Day's *English Secretarie* (1586), and although Richard Haydocke had used it in his translation of Lomazzo's *Della Pittura* (1598), Sylvester in his Du Bartas (1605), and Drayton in his own *Barrons Wars* (1603), it was still uncommon enough so that Drayton felt called on to gloss it, as "The naturall expressing of the surface of a Country in Painting." In our context the words *naturall, surface,* and *painting* are obviously important. Yet we must not permit their naturalistic implications to deceive us. The passage owes much more to reading than to observation. In likening a stretch of countryside to a woman it calls upon a

topos that derives from the equally paratactic description of Natura in Alanus de Insulis's *De planctu Naturae* (other important instances occur in Chaucer's *Parlement of Foules* and Spenser's Mutability Cantos). More generally, it is grounded in the *locus amoenus* tradition running back through Statius, Ovid, and Vergil to Theocritus and finally Homer, whose essential quality is the idealism that caused Petrarch to prefer Augustine over the Alps. As Curtius puts it, "The finest fruit ripens on espaliers" (1953, 197). And that includes the output of most of the Tudor and Stuart writers who cultivated topographical ground.

Toward the middle of the sixteenth century, nevertheless, a different, more visually exact style began to appear in the writings of one kind of traveler. Here is a sample, written in 1554:

> The 17 day in the morning we had sight of the Ile of Madera, which does rise to him that commeth in the Northnortheast part upright land in the west part of it, and very high: and to the Southsoutheast a low long land, and a long point, with a saddle thorow the middest of it, standing in two and thirtie degrees: and in the West part, many springs of water running downe from the mountaine, and many white fieldes like unto corne fields, & some white houses to the Southeast part of it: and the toppe of the mountaine sheweth very ragged, if you may see it. . . . Also in the said part, there is a rocke a little distance from the shoare, and over the said bight you shall see a great gap in the mountaine. (Hakluyt 1903, 6:155–56)

Almost for the first time in English, we have a landscape description from which it would be possible to make a tolerably accurate painting. The precision bespeaks less a painterly eye than a provident mind, however, for of course the description here is of a landfall, and intended to serve the very workaday purpose of assisting the sailor in his navigation and the merchant in his trade. Hence William Burroughs, the great explorer of the Arctic, gave explicit instructions to his subordinates sailing in other ships: "When you come to have sight of any coast or land whatsoever, doe you presently set the same with your sailing Compasse . . . drawing also the form of it in your book. . . . And . . . doe you drawe the maner of biting in of every Bay, and entrance of every harborow or rivers mouth . . ." (Hakluyt 1903, 3:260).

But something of the same spirit began slowly to creep into writing of a more distinctly literary character. *Coryat's Crudities* (1611) is the account, by an observant man with a penchant for getting into

trouble, of a standard gentleman's tour, from London to Venice and back. Thomas Coryat was not particularly sensitive to landscape; he shared his contemporaries' distaste for wild nature, such as the Alps, and their interest in human nature, such as the Venetian courtesans. He was distinctly different from most of his predecessors, however, in one respect: he measured things. He measured the Louvre in paces, he measured the arcade of the Piazza San Marco in feet, he devoted an entire page to a description of the Rialto Bridge so crammed with numerical specificities that a blueprint could almost be made from it.

Sir Walter Ralegh was likewise interested in the magnitude and number of things. But as the title of his *Discoverie of the Large Rich and Bewtiful Empire of Guiana* (1596) suggests, he saw the natural world in esthetic as well as practical terms. The work is essentially a prospectus issued to raise money for a second voyage; it was in Ralegh's interest to expend his very considerable rhetorical gifts so as to stimulate the imaginations of prospective investors. The prose that resulted is a remarkable combination of traditional *locus amoenus* motifs and careful observation, of both topothetic and topographic elements:

> When we ronne to the tops of the first hils of the plaines adjoyning to the river, we behelde that wonderful breach of waters, which ran down *Caroli:* and might from that mountaine see the river how it ran in three parts, above twentie miles of, and there appeared some ten or twelve overfals in sight, every one as high over the other as a Church tower, which fell with that fury, that the rebound of waters made it seeme, as if it had beene all covered over with a great shower of rayne: and in some places we took it at the first for a smoke that had risen over some great towne. . . . I never saw a more beawtifull countrey, nor more lively prospectes, hils so raised heere and there over the vallies, the river winding into divers braunches, the plaines adjoyning without bush or stubble, all faire greene grasse, the ground of hard sand easy to march on, eyther for horse or foote, the deare crossing in every path, the birds towards the evening singing on every tree with a thousand several tunes, cranes and herons of white, crimson, and carnation pearching on the rivers side, the ayre fresh with a gentle easterlie wind, and every stone that we stooped to take up, promised eyther gold or silver by his complexion. (1928, 54–55)[22]

Coryat got better value from his Venetian courtesans, for these promises were the glints of fool's gold, as Ralegh discovered to his ultimate

sorrow. But his mixture of ocular proof, literary borrowings, and appeal to the spirit of free enterprise is a uniquely full epitome of the elements in the topographical writing of the sixteenth century.

Still, it is a piece of rhetoric, with clearly affective intentions, and despite some sense of the connection between features in the opening sentences, mainly paratactic in structure. For development of a language of landscape description almost wholly free of the binding habits of the landscape *topoi,* we must wait on another literary man, the translator of Ovid, George Sandys. Like Chaucer's knight, he made the voyage to Jerusalem by way of Venice, Constantinople, and Cairo, and he wrote it up in his *Relation of a Journey begun An. Dom. 1610* (1615). What is remarkable about Sandys is his attitude. He is not impious, or cynical, or mercenary; neither is he gullible or impassioned or idealistic. He is detached, in a scholarly way. He records things. He does not often judge them, though from time to time, as in his view of Constantinople or from the top of the pyramids, he will express his delight. His usual manner can be illustrated by this description of the approach to Jerusalem from the west: "Our passage for five houres together lay through a narrow streight of the mountaines; much of the way no other then such as seemed to have bin worne by the winters torrent. . . . Ascending by litle and litle, at length we attained to the top, which overtopt and surveyed all the mountaines that we had left behind us. From hence to *Jerusalem* the way is indifferent even. On each side little round hils, with ruines on their tops, and vallies, such as are figured in the most beautifull land-skips" (154).

There are many significant things here. Like the commercial voyagers before him and the Automobile Association since, he has a practical slant on things, so that he gives travel times and evaluates the quality of the road: the toad is looking out for flies and storks. He differentiates between agreeable and disagreeable landscapes, like Sidney, but with no apparent moral purpose; the desert, here, is a geographical datum, not a sign of spiritual desolation. Nowhere does he seize the occasion to imitate the classical *topoi.* The language throughout is indicative, not evaluative. Above all, he lives up to his title, for the passage, like the book as a whole, is full of relations. Sandys relates things chronologically. He relates things causally: "no other then such as seemed to have bin worne by the winters torrent." He uses a word still quite new in English, *land-skip,* in a sentence that suggests that after a century and a half, the painters had begun to teach the writers to see the elements of the world not only in their concrete, particularized substantiality but

as they are related in context, as though for the first time. The book is also more richly furnished with illustrations—sixty-odd plans, maps, views, gathered up from a great many previously published sources—than any other English travel book of the period. Among them, the pictures and the descriptions constitute a symbolized visual experience without precedent.

In doing so, they point to a large change in English—in European—perception, and subsequent expression, of the visual world as a system of spatial relationships rather than as an assemblage of symbolic images: "*Over this* on a little flat, stands the ruines of a Monastery, *on the South side* naturally walled with the steepe of the mountaine: *from whence* there gusheth a living Spring, which entreth the rocke, and againe bursteth forth *beneath* the mouth of the Cave. . . . This *overlooketh* a profound valley, *on the far side* hemd with aspiring mountains" (183, my italics). The perception of spatial relationship requires, first, the perception of the perceiver, as it were, the perception by the artist that you cannot be observer and participant at the same time.[23] We will consider the matter of self-consciousness more fully below. For now, let us focus on a particular line of distinction, on the distance between perceiver and perceived, as the baseline distance of which all the other expressed distances are functions. Awareness of that line requires detachment like Sandys's. Such detachment had been supplied for the quattrocento painter by the concept of the picture as a window.[24] When you make an opening in an epistemological as well as perceptual barrier, you allow the mind to pass but not the body. (The inhabitants of the platonic cave recognize their inhibited state only when they become aware of the larger world beyond.) The idea is even more clearly conveyed by Alberti's recommendation to painters to check their work by looking at the subject in a mirror (which would frame it, test the perspective, and subtly modify such optical characteristics as color), and by Dürer's perspective grid.

Similar detachment came to writers more slowly. The deep connections between language and quotidian life, the deeply authoritarian character of sixteenth-century rhetorical education and poetic theory, and the deep conservatism of European social, intellectual, even religious practice promoted habits of literary imitation. Iconoclasm, cultural xenophobia, and whatever other factors inhibited a full-blown English renascence in the visual arts insulated English writers from the visual education available to their Italian, French, Flemish, and Dutch counterparts. Yet it is a fact that Continental writers, although they exhibited signs of visual awareness at a considerably earlier stage than

English writers, went only so far with it, then as it were backed off. The humanistic bellelettrists of the High Renaissance—Bembo, Flaminio, Navagero, Fracastoro, Poliziano—anticipated Ralegh and Drayton (and followed Vergil) by using the landscape *topoi* to describe real features of the landscapes around the homes of their patrons and themselves; so did Ronsard in France. But nothing in these writers—or in any Continental writers before 1600—exhibits more spatial sensitivity than *Poly-Olbion*. The exception is Sannazaro. His *Piscatory Eclogues* (1526, written earlier) are full of references to the Baian coastline, and his *Arcadia* (1501) contains half a dozen extended landscapes, as full of spatial referents as anything in classical or Renaissance literature, and gathers them into something closer to a full literary topography than anything else in the period. The landscape descriptions in *Arcadia* refer to the surroundings of Naples in terms borrowed closely from Vergil and Ovid. But the various dells and fields and hillsides are spatially connected to one another chiefly through the fact that the narrator registers his consciousness of movement, change, and hence context as he passes from one to the next (Leach 1978).

It is obviously important that Sannazaro was writing pastoral. Pastoral, first off, offers opportunities for description. But so do other genres, including epic. The *topos* of the *locus amoenus* is quite literally central to *Orlando Furioso, Gerusalemme liberata,* the *New Arcadia, The Faerie Queene,* and *Paradise Lost,* as A. Bartlett Giamatti has decisively shown, and the idea central to the centrality of the landscape *topoi* in those works is the ultimate alienation of the epic hero from the pleasures of the natural world (1966). But in the epic, that alienation, I would argue, is moral, not epistemological: it is because of the natural *kinship* between man and anthropomorphized landscape that the Bower must be blasted, Eden left behind. In pastoral, however, the detachment is a function of perceptual as well as moral distance. The pastoral poet, though he may work through rustic personas, is himself a sophisticate, able to appreciate the simple delights of a world he is pleased to visit, but unable to enter fully into a place he could not and would not make his home. It is as though he looks at the world through the window opened by the painters and is always aware not only of the distance but also of the sophisticated craftsmanship of the frame, which in turn reminds him of the rest of the palace, and the city where it stands.[25] In this context (which includes the landscape as an element), his own social standing is not important. But his citizenship (in the sixteenth-

century sense) is. If renascence pastoral poetry and landscape painting developed at about the same time and at about the same rate, it must have been in part because both are bourgeois arts, in the literal sense of that word. Both depend on a sense of the natural world as something "out there" (beyond the walls) to be sought out, observed, measured, organized, framed, and brought back in neat packages to town (not, as in epic, slain and left to rot except for the trophy brought back in triumph).[26]

As the separation of artist from subject promoted the perception of spatial relationships, the need for means to express them arose. For visual artists that need was met by successively more sophisticated systems of perspective.[27] As we can see from looking again at the passage from Sandys, verbal artists needed to develop a hypotactic syntax that broke away from the grammatical parallelism so ubiquitous in Tudor writing (which tended toward parataxis because it produced strings of monovalent units) and that, by combining several kinds of adverbial construction in the same sentence, implied multiple relationships. The procedures for producing both visual and verbal hypotaxis were to some degree available to artists and writers working in England from the early years of the sixteenth century onward. But like other English renascence phenomena, topothetic landscape bloomed late and almost all at once. As we have seen, the word itself did not enter the language until near the end of the sixteenth century. The thing (that is, evocations of natural scenery with some indication of spatial relationships) appeared in scattered spots prior to 1580. The east window of St. Margaret's, Westminster (1501), shows the crucifixion in a landscape, with Henry VII and his queen as kneeling donors. It was probably made by Dutch artists. At about the same time, Gavin Douglas was translating Vergil and expanding the landscape bits. But Alexander Barclay's *Eclogues* (c. 1515), closely based on Mantuan, contain no more than casual references; the pastoral per se is not enough. The painting of the Field of the Cloth of Gold (c. 1520) places the two kings and their retinues in a fancifully ideal landscape, complete with alpine peaks and dragons (fig. 10). A portrait of Leicester of about 1565 shows the earl at the door of a palace, with a rudimentary planar landscape beyond; at about the same time Sackville was opening the induction to *A Mirror for Magistrates* with a somberly forceful winter landscape of what we might call the evocative type, in which a string of terms each with its set of standard associations establishes a mood without providing a picture:

The wrathful winter, proaching on apace,
With blust'ring blasts had all ybared the treen,
And old Saturnus, with his frosty face,
With chilling cold had pierc'd the tender green;
The mantles rent wherein enwrapped been
The gladsome groves that now lay overthrown,
The tapets torn, and every bloom down blown . . .

.

And sorrowing I to see the summer flowers,
The lively green, the lusty leas forlorn,
The sturdy trees so shattered with the showers,
The fields so fade that florish'd so beforn. . . .

(R & B 273, lines 1–53)

This recalls clearly the passage from Lodge's *Rosalynde* used to illustrate English poetical parataxis in chapter 1—no particular point of view, no spatial interrelationships. Sidney opens his *New Arcadia* with a topothetic description similar in terms and structure to Ralegh's topographic report on Guiana:

There were hilles which garnished their proud heights with stately trees: humble valleis, whose base estate semed comforted with refreshing of silver rivers: medows, enameld with al sorts of ey-pleasing floures: thickets, which being lined with most pleasant shade, were witnessed so to by the chereful disposition of many wel-tuned birds: each pasture stored with sheep feeding with sober security, while the prety lambs with bleting oratory craved the dams comfort: here a shepheards boy piping, as though he should never be old: there a yong shepherdesse knitting, and with all singing, & it seemed that her voice comforted her hands to work, & her hands kept time to her voices musick. As for the houses of the countrey (for many houses came under their eye) they were all scattered, no two being one by th'other, & yet not so far off as that it barred mutual succour: a shew, as it were, of an accompanable solitarines, & of a civil wildnes. (1917–26, 1:13–14). [28]

Like the Italy of the *Aeneid* Sidney's Arcadia has not only a geography but also a topography.[29] Or at least, the area around Basilius's lodge can be pretty clearly visualized, especially the nearby river, with its meadows and copses, and Amphialus's castle, ten miles away (the precision is noteworthy), with its rock, river, and meadows.

The pastoral romances of Greene, Lodge, Edwards, and others that appeared in a steady stream through the 1580s almost all have an obligatory *locus amoenus* or two, mostly without spatial sophistication:

> The ground where they sat was diapred with *Flora's* riches, as if she meant to wrap *Tellus* in the glorie of her vestments: round about in the forme of an Amphitheater were most curiouslie planted Pine trees, interseamed with Limons and Citrons, which with the thickeness of their boughes so shadowed the place, that *Phoebus* could not prie into the secret of that Arbour; so united were the tops with so thicke a closure, that *Venus* might there in her jollitie have dallied unseene with her deerest paramour. Fast by (to make the place more gorgeous) was there a Fount so Cristalline and clere, that it seemed *Diana* with her *Dryades* and *Hamadryades* had that spring, as the secrete of all their bathings. (Lodge 1967, 2:183)

For the landscape lover, slim pickings.

In Spenser's work, the pickings are in many respects fatter. He deserves detailed attention if only because the word *landscape* is used so often—and so thoughtlessly—in Spenser criticism. His early poems exhibit no particularly well-developed sensitivity to landscape. Indeed, *The Shepheardes Calender,* for all its country setting, contains no verbal landscape even as elaborate as Sackville's, though its woodcuts (especially June, August, and November) all show the shepherds and their activities out of doors. *Colin Clouts Come Home Again* (1595), Spenser's other pastoral, is equally barren; so are most of the poems in the volume of *Complaints* (1591).[30] Only in *The Faerie Queene* do we find many relatively well-developed landscape passages. These possess a good deal of interest and importance, especially because of their pervasive moral ambivalence, which makes them one of Spenser's chief means for expressing his sense of the corruption and uncertainty of all material things. For our immediate purposes, however, they are striking in the degree to which they represent the same paratactic agglutination we saw in Sackville. Faerie Land as a whole is constructed on purely paratactic lines; a moment's thought about *The Lord of the Rings* or the Narnia series will indicate how utterly Spenser has declined to imagine a geography into which the various woods and fields and castles of his wonderful poem might be organized, and we have already noted how the procedures of the poem lead the reader from image to image in ways which suggest that Spenser has a goal but not (in the geographical sense, at least)

a plan.[31] But these procedures also operate within individual descriptions. Consider the most extensive of them, the account of the Bower of Bliss, which runs through thirty or so stanzas of book 2 (12.38–71):

> There the most dainty Paradise on ground,
> It selfe doth offer to his sober eye,
> In which all pleasures plenteously abound,
> And none does other happinesse enuye:
> The painted flowres, the trees upshooting hye,
> The dales for shade, the hilles for breathing space,
> The trembling groves, the Christall running by;
> The art, which all that wrought, appeared in no
> place.
>
> (St. 58)

Similar procedures mark Spenser's other extended *loci amoeni*, the Garden of Adonis (3.6) and the Garden of Venus (4.9). All these are ideal *loci* in the rhetorical as well as the topothetic use of the word, elements in elaborate emblems of concupiscence, procreative love, social love. As such they correspond precisely with the equally emblematic landscapes set into the corners of a group of Elizabethan portraits (of Lord Francis Russell, Lord Edward Russell, and Sir Edward Hoby), dating from the 1570s and 1580s, which tell allegorical stories (though more private in character than Spenser's) in which the men have played clearly defined roles. In either the verbal or the visual emblems, more specific spatial and temporal organization, by tying them to particular time and space, would undermine their intended effect. [32]

Spenser's most complex landscapes come at the very end of his career, in that part of *The Faerie Queene* written after his trip from Ireland to London in 1590, during which he could have been exposed to some of the fresh influences on English culture. These passages exhibit the kind of mythmaking, the mixture of ideal and actual elements, that appears in the painting of Elizabeth and the goddesses, one of the few surviving Elizabethan paintings to contain a substantial landscape; this painting balances the very real Elizabeth and her two ladies-in-waiting, enclosed by the walls of their apparently imaginary palace, against the imagined forms of the three goddesses, with Windsor Castle hill rising behind them (fig. 24). The topographic elements entrain a degree of spatial complexity unusual for the period. They devolve mainly, however, from some kind of confrontation between ideal and actual, in

which the actual is victorious.[33] The painting hence remains a transitional work. So do Spenser's treatments of Acidale and Arlo Hill.

In the first, the truant knight Calidore, on pastoral vacation from his assigned quest, comes upon the pastoral poet Colin Clout (see Kamholtz 1980, 63–64):

> It was an hill plaste in an open plaine,
>> That round about was bordered with a wood
>> Of matchlesse hight, that seem'd th'earth to
>>> disdaine,
>> In which all trees of honour stately stood,
>> And did all winter as in sommer bud,
>> Spredding pavilions for the birds to bowre,
>> Which in their lower braunches sung aloud;
>> And in their tops the soring hauke did towre,
> Sitting like King of fowles in majesty and powre.
>
> And at the foot thereof, a gentle flud
>> His silver waues did softly tumble downe,
>> Vnmard with ragged mosse or filthy mud,
>> Ne mote wylde beastes, ne mote the ruder clowne
>> Thereto approch, ne filth mote therein drowne:
>> But Nymphes and Faeries by the bancks did sit,
>> In the woods shade, which did the waters crowne,
>> Keeping all noysome things away from it,
> And to the waters fall tuning their accents fit.
>
> And on the top thereof a spacious plaine
>> Did spred it selfe, to serve to all delight,
>> Either to daunce, when they to daunce would
>>> faine,
>> Or else to course about their bases light;
>> Ne ought there wanted, which for pleasure might
>> Desired be, or thence to banish bale:
>> So pleasauntly the hill with equall hight,
>> Did seeme to overlooke the lowly vale;
> Therefore it rightly cleeped was mount *Acidale*.
>
> (6.10.6–8)

This scene is not fully visualized.[34] Except for the height of the trees there is no indication of scale; the relationships among wood, hill,

stream, and dale are not clearly explained; we cannot tell whence the stream comes, nor where it flows. No more than any other of the land-scapes in *The Faerie Queene* is this one firmly placed in relationship with the other places treated in this portion of the narrative.[35] It has the spa-tial indeterminacy of the woodcuts of *The Shepheardes Calender,* in which full-grown trees are no taller than a man (Januarie), sheep about the size of Pekingese (November), and dogs taller than steeples (May). The negative references to "filthy mud," "wylde beastes," "ruder clowne," and "filth" invoke, if only indirectly, English rural actualities. Yet by comparison with the earlier idealized landscapes Acidale is spatially co-herent, to the point where it might plausibly derive from some spot Spenser actually knew and loved. The proposition draws credence from the fact that the genius of this *locus amoenus* is Colin Clout, the per-sona of Spenser himself. Calidore, whom Spenser explicitly locates "in the covert of the wood," outside the charmed space, sees the shepherd-poet amidst 104 naked maidens, who dance as he pipes. These include "that iolly Shepheards lasse," Colin's own love, who chiefly inspires his music. But she is no more "real" than the others, the Graces and their handmaidens: all of them vanish the instant Calidore emerges from his hiding place to accost them, leaving poor Colin,

> who for fell despight,
> Of that displeasure, broke his bag-pipe quight,
> And made great mone for that unhappy turne.
>
> (St. 18)

The fascinating thing about this episode, as far as we are concerned here, is the way it bridges actual and ideal experience, *in terms of point of view.* Colin, the idea of the poet, occupies the center of an ideal land-scape into which he can call by the magic of his singing Ideal Beauty itself—that is, beauty (such as a shepherdess might possess) infused with Grace (much as the ideal landscape infuses actual natural beauty with the grace of permanence and perfection). Calidore, the idea of the audience (the object of the poem is "to fashion a gentleman or noble person in vertuous and gentle discipline"), looks on from the conceal-ment of the wood through which in his full knightly identity he moves on his unceasing heroic quest. Spenser, the actual poet, and we, the actual audience, look on from our places outside the poem. Initially he, and we with him, are ikastically conscious of time and space, of the im-plied threat to the birds (Colins) singing in the lower boughs from the hawks (Calidores) in the treetops, of the "noysome things" kept outside

the charmed circle by the nymphs and fairies. Soon, however, all of us are caught up in the image of beauty animated by Colin's music; the geography of Acidale gives way to the geometry of the dance, and the time kept (in a passage distinguished even by Spenserian standards for the extent and complexity of its repetitive elements) is the ideal time of the song. But when Calidore moves, we are brought back to awareness of the distance between ideal and actual; the spell is broken, along with the instrument that made it. The stanzas that follow (19–20) are full of time-place reminders: *ioyous dayes, Here, here, fled away, thence, in place, hence displace, things passed*. For a while, Acidale itself abides, and retains its appeal to Calidore:

> the place, whose pleasures rare
> With such regard his sences ravished,
> That thence, he had no will away to fare.
> (St. 30)

As the poem develops, however, even Acidale vanishes. Calidore returns to the shepherds' village and his own pastoral mistress, Pastorella. Within a few stanzas, noisome things begin to break in upon the pastoral contentment of the place. Calidore is able to defend against the attack of a lion. But while he is away hunting other wild beasts a band of brigands attacks, leaving desolation behind:

> He sought the woods; but no man could see there:
> He sought the plaines; but could no tydings heare.
> The woods did nought but ecchoes vaine
> rebound;
> The playnes all waste and emptie did appeare.
> (6.11.26)

In the unfinished book 7, presumably the last thing Spenser wrote, between the publication of books 4–6 in 1596 and his death in 1599, one of Spenser's most powerful myths, Mutabilitie, the ambitious *nouvelle arrivée* goddess who gives the book its name, is tried before Dame Nature for her attempted coup d'état against the planetary oligarchy. The setting is not some emblematic amphitheater stitched together out of the landscape *topoi* but an actual spot, the most clearly topographical *locus* in all of Spenser. Of Arlo Hill, the general locale, Spenser says only that it is high and wooded. From its slopes, however, arises the river Molanna, shallow yet lovely:

For, first, she springs out of two marble Rocks,
 On which, a grove of Oakes high mounted
 growes,
 That as a girlond seemes to deck the locks
 Of som faire Bride, brought forth with pompous
 showes
 Out of her bowre, that many flowers strowes:
 So, through the flowry Dales she tumbling
 downe,
 Through many woods, and shady coverts flowes
 (That on each side her siluer channell crowne)
Till to the Plaine she come, whose Valleyes shee
 doth drowne.

(7.6.41)

It is easy to imagine Spenser in his study actually visualizing this stanza in a way he had not visualized the Bower or Garden or Temple, retracing with his mind's eye a route his own feet had followed more than once before. And he puts these recollections to a very particular purpose. The episode as a whole treats the inroads made by mutability upon the original cosmic order:

within this wide great Universe
Nothing doth firme and permanent appeare,
But all things tost and turned by transverse. . . .

(7.7.56)

Exhibit A is the Arlo region, for although it was once "the best and fairest Hill" in all of Ireland, it has been made "the most unpleasant, and most ill." The agent of this sad change is Diana, as Spenser explains in a charming neo-Ovidian myth; enraged by collusion between the infatuated wood god Faunus and her nymph Molanna, by which the satyr is afforded a glimpse of the goddess bathing in the nymph's stream, she has filled the river with stones and caused Faunus, Actaeon-like, to be clothed in a deerskin and chased by hounds. But she has also abandoned the area altogether:

All those faire forrests about *Arlo* hid,
And all that Mountaine, which doth over-looke
The richest champian that may else be rid,
And the faire *Shure,* in which are thousand Salmons
 bred.

(7.6.54)

Her protection withdrawn, the area has become the haunt of wolves and thieves. In other words, the spatial and temporal particularities of the place as expressed in the poem derive from the fact that it is very explicitly not ideal, by contrast with the other idealized landscapes. Like Acidale a couple of cantos earlier, hypotactic Arlo marks the distance between poet and subject, actual and ideal; thus implicated in a relatively well-developed set of spatial and temporal relationships, both become correspondingly vulnerable to the mutability of the sublunary, postlapsarian world.

If English poets began to imagine landscape in spatially sophisticated ways only toward the end of the century, so did English visual artists. Printmakers rather than painters led the way. An especially interesting set of examples is furnished by the woodcut illustrations for Holinshed's *Chronicles* (1577). The pictures are used in the old independent paratactic way, one image doing representational duty for half a dozen different episodes scattered over as many centuries of history. But in themselves they are both visually and conceptually sophisticated, hypotactic. A picture of a king giving orders to a master builder for the construction of a church occurs initially in the context of the coming of Christianity to England, and quite appropriately shows the monarch in "Romanesque" costume suitable to the Romanesque architecture of the church (fig. 45). (In subsequent uses to illustrate royal support for the church the style is less visually appropriate to the historical situations.) The print has other significant features, as well; the management of space indicates an exceptionally full understanding of both the linear perspective suitable for townscapes and the planar perspective suitable for landscapes. And the demotic realism of the figures of the workmen at their tasks and of the brick kiln in the left background means that the emblematic representation of the nascent church has a much more complex context than had normally been the case in the past.[36] But it took the painters and other artists a while to catch up. An embroidered Judgment of Solomon of about 1585 opens to a clumsily executed landscape background; so does Hilliard's *George Clifford,* while his emblematic picture of the earl of Northumberland lying in a *hortus conclusus* not only devotes 90 percent of the picture plane to nature but also suggests some connection with literature through a quill hanging from one of the trees (figs. 32, 44). Yet Hilliard's handling of landscape is no more spatially competent than Giotto's.[37]

It is about this time that English portraits begin, fairly routinely, to show glimpses of landscape through open doors or windows; the Welbeck portrait of Elizabeth shows her inside, but in a room that

45. Raphael Holinshed, *Chronicles of England, Scotland, and Ireland* (1577), wood engravings. Reproduced by permission of the Folger Shakespeare Library.

somehow opens onto a garden with fields and woods beyond (fig. 16). Something like a real breakthrough seems to have occurred about 1595. In that year Robert Peake, a student of Hilliard who decided that his future lay with full-sized oils rather than miniatures, painted a portrait of a boy, with dog and bow; behind them a field runs downhill to a stream, with trees lining the far side. And early in the seventeenth century we find him, in two portraits of Henry, Prince of Wales, with a friend (1603, 1605), experimenting with spatial representation, so that behind the boys is a dog, behind the dog a horse, behind the horse a groom holding a spear, all set off at the crest of a hill against a naturalistic, perhaps topographic, landscape beyond (fig. 17). (The pose is interesting, too, since unlike most other figures in Tudor and early Stuart portraits, the prince is caught in action, sheathing the sword with which he has apparently just slain the deer lying at his feet.) Uccello, of course, had begun working with superimposed planes and figures obviously in movement in the 1440s, and both devices appear in such of the Holinshed woodcuts (1577) as the image, several times repeated, of a king with an arrow in his chest dying under a tree (fig. 45). Isaac Oliver went further, devising a highly effective landscape background for his romantic miniature of Lord Herbert of Cherbury (c. 1610), in which the portrait and the landscape are perfectly integrated (fig. 46).[38] These are portraits. The Fenchurch and Royal Exchange arches for the royal entry of James I (1604) included pure landscapes (almost certainly by Dutch painters) of considerable size—perhaps five feet square—the first pure landscapes painted for English patrons.

These paintings prepare us to look past Christopher Hussey's old assertion that English literature has no visual realism prior to Waller and Denham (1967, 23), to find Shakespeare producing descriptions of minute observation and complex spatial reference, in Gertrude's account of Ophelia's death (4.7.166–83) and in Edgar's trick on Gloucester:

> Come on sir, here's the place; stand still. How
> fearful
> And dizzy 'tis, to cast one's eyes so low.
> The crows and choughs that wing the midway air
> Show scarce so gross as beetles. Half way down
> Hangs one that gathers samphire, dreadful trade.
> Methinks he seems no bigger than his head.
> The fishermen that walk upon the beach

46. Isaac Oliver, *Edward Herbert of Cherbury* (c. 1610). Powis Castle, Powys.
Reproduced with the permission of the Trustees of the Powis Castle Estate.
Photo: The Victoria and Albert Museum.

> Appear like mice; and yond tall anchoring bark,
> Diminish'd to her cock; her cock, a buoy
> Almost too small for sight. The murmuring surge,
> That on th'unnumb'red idle pebble chafes,
> Cannot be heard so high. I'll look no more . . .
>
> (4.6.13–22)

It is not necessary to argue that this passage shows Shakespeare's ex-
perience of Mannerist foreshortening and vanishing-point perspective;
nothing in it required him to do more than actually look out the win-
dow of an attic room in a house on London Bridge.[39] But the willing-
ness to look is crucial. The establishment of a point of view is crucial.
And the production of a literary landscape organized vertically, rather
than horizontally, is remarkable: there is absolutely no precedent. There
is a kind of successor, which testifies quite sharply not only to the fact

of a change in the visual consciousness of spatial relationships taking place in England around the turn of the seventeenth century, but also to some connection between that change and the tutelage of the visual arts. Michael Drayton describes, in *Mortimeriados* (1596), the love nest of Mortimer and Isabella, an elaborate room in Nottingham Castle decorated with the kind of genteel erotica (Titian and the like, art almost always involving landscape) for which evidence suggests there was a contemporary English taste. Drayton's description of the pictures constitutes one of the period's most important iconophrases; it includes these stanzas, part of a version of the Rape of Europa:

> Heere clyffy Cynthus, with a thousand byrds,
> Whose checkerd plumes adorne his tufted crowne,
> Under whose shadow graze the stragling heards,
> Out of whose top, the fresh springs trembling
> downe,
> Duly keepe time with theyr harmonious sowne.
> The Rocke so lively done in every part,
> As arte had so taught nature, nature arte.
>
> The naked Nymphes, some up, some down
> discending,
> Small scattering flowers one at another flung,
> With pretty turns their lymber bodies bending,
> Cropping the blooming branches lately sprong,
> Which on the Rockes grewe heere and there among.
> Some combe theyr hayre, some making garlands by,
> As living, they had done it actually.
> (1961, 2.346–59)[40]

The passage is full of phrases that attach to it to the long *locus amoenus* tradition—"stragling heards," "fresh springs," "harmonious sowne"— and the last couplet of the first stanza nicely summarizes the deadlock to which the *paragone* of the sister arts had come by the end of the sixteenth century, while the last line of the second stanza is perfectly formulaic for late Elizabethan iconophrases. By the time Drayton had finished revising the poem, however, as *The Barrons Wars* (1616), he had replaced some of the conventional epithets with images more effectively visual, had set more emphasis on the verticality of his imaginary composition and on the spatial and other relationships among the particular images, and had revised his esthetic comments from an ideal to

a practical mode. The stinger is the word *Landskip* (first added in the version of 1603):

> By them, in Landskip, Rockie *Cynthus* rear'd,
> With the Clouds leaning on his loftie Crowne,
> On his sides shewing many a straggling Heard,
> And from his Top, the cleare Springs creeping
> downe,
> By the old Rocks, each with a hoarie Beard,
> With Mosse and climbing Ivie over-growne;
> So done, that the Beholders, with the Skill,
> Never ynough their longing Eyes could fill.
>
> The half-nak'd Nymphs, some climbing, some
> descending,
> The sundry Flowers at one another flung,
> In Postures strange, their limber Bodies bending;
> Some cropping Branches, that seem'd lately sprung,
> Upon the Brakes, their coloured Mantles rending,
> Which on the Mount grew here and there among;
> Combing their Hayre some, some made Garlands
> by;
> So strove the Painter to content the eye.
>
> (6.289–304)

The function of this passage is idealistic: the image suits the ethical context by juxtaposing emblems of kingship with emblems of pure concupiscence. But the procedures of the passage are ikastic; it has both the ontological variety and the spatial complexity of actual visual experience, and the needs and desires it offers to satisfy in its own explicit terms are esthetic, not moral. It is, moreover, distinctly, even strikingly, hypotactic, each stanza only one long complex sentence, rolling several different kinds of things related in various visual and conceptual ways into one ball. "Thus landscape grows into a school where relativity is taught, since here the terms decide the issue less by their own shape and idiosyncrasy than by their relation to one another and to the whole" (Friedländer 1949, 19). Moreover, Drayton indicates a sharp, fresh awareness of the artist laboring "to content the eye," on the one hand, and the eager audience longing to have its eyes contented, on the other. When the toad has decided the garden is home, and begun to ex-

plore the premises, it places things in contexts. Less fancifully, I would state that as artists became more conscious of the physical relationships among the things of the world, and developed a repertory of devices for representing those relationships, they likewise achieved new control over their own emotional and intellectual reactions. That control, in turn, gave them increased control over their viewers and readers.

7

Ut Architectura:
Tudor Hypotaxis

B ecause of the way it insists that the viewer see things in the same
way the artist has seen them, from the same point of view, in the
same relationships with the same context, linear perspective is perhaps
the most powerful of all the engines of ikastic representation.[1] As such,
it implies a radical increase in the degree to which the artist can be seen
consciously managing the sensory and hence the mental responses of
the viewer. In asserting such control, the work asserts an even more
comprehensive and compelling intrinsic authority than did the para-
tactic works of the Gothic and Traditional styles, since the procedure
allows the artist to regulate attention far beyond the discrete images
of the work to highly complex and sophisticated relationships among
them. Because such relationships are likely to express tension rather
than the predictability and hence security of paratactic art, such works
are dynamic where their predecessors were static, novel where they
were familiar. Yet by the same token they run greater risks of pro-
voking uncertainty, misunderstanding, rejection. Similarly, the artists'
increased responsibility means that the increased authority belongs at
least as much to them as to the ideas they articulate or the patrons for
whom they work, even as that same dynamic novelty tends to forfeit
the unobtrusive authority of the familiar, the orthodox, the established.
The development of visual and verbal hypotaxis in Tudor art therefore
has political and intellectual as well as esthetic interest.

The change was long and slow. As we have been learning, modern
notions about the two-dimensional representation of three-dimensional
space struggled into English culture slowly and hesitantly. The word
perspective, meaning something like "the science of sight," entered the
language in the fourteenth century, and as early as *Richard II* Shake-

speare used it in a technical, artist's sense, referring to a fashionable kind of painting or boxed construction devised so as to give a confused or distorted image from all points of view but one, or to give two very different images from two different (but still fixed) points of view.[2] The best-known example is Holbein's richly symbolic painting *Two Merchants* (sometimes called *The Ambassadors*), in which what appears from straight on as an indecipherable blob resolves itself when viewed from the left and below into a death's-head. Few other important artists practiced this kind of visual paronomasia, and as with verbal puns, the works were always as close to toys as to serious art.[3] But the fashion is important from a historical perspective because it depends on the very direct and conscious manipulations of spectator by artist, with the very direct and conscious intent to arouse delight by surprise. Predictability and regularity had been the chief elements in most Tudor art and literature. The esthetic use of surprise, however, is one conspicuous element in a larger pattern of conscious management of viewer or reader response by the artist, which, just as it had become important in Continental art, became increasingly important in English art of the late sixteenth century.

One way to approach this idea is to note that the surprise so obvious in these pictorial curiosities can in some ways be ascribed to *perspective* in the more familiar sense, denoting pictures that as it were seize upon the viewer by the startling coherence of their rigorous visual logic— which nonetheless is valid only from a single point of view. In that sense, the word's first published occurrence in English seems to have been in 1598, in Haydocke's translation of Lomazzo, *A Tracte Containing the Artes of Curious Paintinge*. (The word occurs in Brit. Lib. Sloane MS 1169, which seems to date from 1585.) The thing was almost as new as the word. An especially interesting instance is the portrait of Lord and Lady Cobham with their six children (1567, now at Longleat; fig. 47). It bespeaks strong Renaissance influence in the architectural details: a Vitruvian architrave and cornice (with engaged herm) at the upper left, the base of a Corinthian column at the upper right. The parallels in each converge. But each has a different vanishing point; so does the table in the foreground, whose sides converge toward a point high above not only the eyeline of Lord Cobham, the apparent horizon line for the figures, but also the top of the picture. The figures are flat and iconic, a falcon in the foreground appears to float rather than to stand, and the whole painting has that feeling of everything pulled forward into the picture plane characteristic of Tudor work.

47. Master of the Countess of Warwick, *Lord Cobham and Family* (1567).
Reproduced by permission of the Marquess of Bath, Longleat House,
Warminster, Wiltshire, Great Britain.

As late as 1590, painters otherwise as skillful as Nicholas Hilliard
and even Isaac Oliver were handling perspective clumsily; thirty years
later, when perspective devices had become more common in English
art, the scene painters responsible for transferring Inigo Jones's accom-
plished drawings to full-sized sets were not yet good at the work (Orgel
and Strong 1973, 1:37).[4] Consider Oliver's *Portrait of a Young Man, Said
to Be Sir Philip Sidney* (fig. 48). Roy Strong asserts that "the handling of
the perspective view of the house and garden is correct and exact, with
a vanishing point to which all lines converge" (1984b, 155). But the
visible underside of the house's roof, and especially the visible far side
of the garden arcade, imply a point of view far lower than that taken
for the figure in the foreground. My guess is that the background was
taken directly from a Flemish or Dutch print (the building, along with
its line of Lombardy poplars, looks French or Flemish, not English),

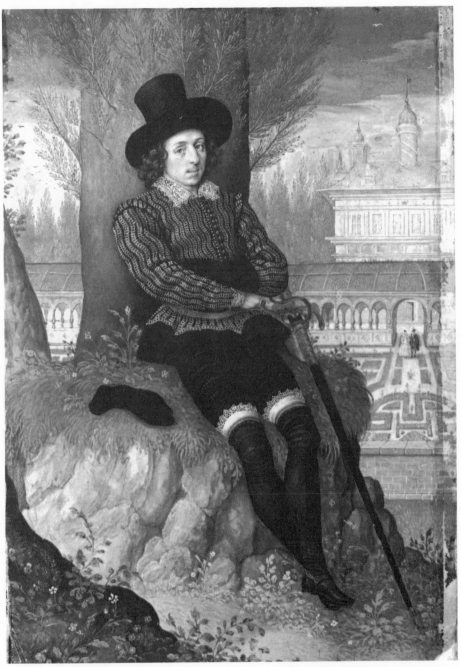

48. Isaac Oliver, *Young Man, Said to be Sir Philip Sidney* (c. 1590). The Royal Collections, Windsor Castle. Copyright reserved to Her Majesty Queen Elizabeth II.

perhaps by some other member of the workshop. Oliver's drawings, and his portraits of Essex, the Brown brothers, Richard Sackville, and others, all show a firm understanding of the device.

Some of the artisans (probably Flemish, for the most part) responsible for the better-quality woodcuts and engravings used in English books during the second half of the sixteenth century knew and used one-point perspective, and Harington expressed his pride that the illustrations for his translation of *Orlando Furioso* (1591, from the Italian edition of 1588) employed the newfangled optical gadget. And Sir Henry Wotton, who as ambassador to Venice had more opportunity to see first-class renascence painting than most Englishmen, wrote (probably during the 1590s) that painting was a notable art because it could with lifelike fidelity reproduce three dimensions in two (1651, 272). The career of Robert Peake, Hilliard's pupil, encapsulates the process. His early work, dating from the eighties, is typical Elizabethan stuff, half-length iconic figures on plain grounds. In the early nineties he expanded the image to full length; between 1596 and 1610 he grew increasingly bold in his treatment of space, adding recessional objects like tables and rugs, treating two or three figures in the same painting. His portrait of William Pope, Earl Downe (c. 1605), sets the figure in an archway with the courtyard of a house (it may be a topographical view of Wroxton Abbey) beyond (fig. 18). The picture's narrow format forces a very rapid recession to the vanishing point. But that exploitation of pictorial depth is obviously part of the program.[5] Renaissance art has really begun to arrive in England.

As I noted earlier, Peake was also experimenting with landscape, and especially with scenes in which the ground falls away behind the figures toward some distant, lower feature, at the very time when many English writers were beginning to commend wide prospects and private houses to provide them. These developments seem to belong to what Otto Benesch has characterized as the increasingly "dynamic" sense of space in northern Europe in the second half of the sixteenth century (1965, 147–52). Post-Reformation Tudor art—iconic, serial, flat —is an art of containment, of fixed hierarchies and closed horizons, characterized by the repetition of orthodox formulas, in end-stopped, regular forms. From the late 1570s onward, however, *openings* begin to appear, both literal and metaphorical. The perceptual and cultural effect of ample fenestration is doubtless impossible to gauge with any precision. In fact, it would be impossible to say whether the popularity of big windows was or was not itself the result of expectations

and needs fostered by other developments. Most likely, optics, explo-
ration, techniques of picture making that treated the picture frame as a
hole in a surface (often including a painted or molded architectural sur-
round), and an enthusiasm for glass all simmered together. We can be
sure that Shakespeare cared about windows, for he refers to them about
eighty times (Fairchild 1972, 11). Several surviving Tudor wall paint-
ings use the convention of painted architectural members to suggest
that they open into a contiguous space, although (even conceding the
ravages of time and bad restoration) all seem to the modern viewer too
crudely painted to *trompe* even the unsophisticated *oeil* (fig. 1).[6] There
is some remarkable paneling at Losely Park, Surrey, however, said to
have come from Nonsuch, using techniques perfected by Ghiberti to
suggest rapidly receding arcades by means of cuts actually less than
one-half inch deep. And an embroidered hanging at Hardwick, one of
a series on the liberal arts, uses standard perspective devices to show a
lady in a classical arch peering through a tube.

More significant (because more numerous and easier to date) are the
openings into pictorial space that began to reappear in English portraits
about 1585.[7] The process is neatly summarized in one set of works.
Around 1526, Holbein painted the family of Sir Thomas More, for-
mally but not stiffly grouped in their own sitting room. The painting
has vanished, but one of Holbein's sketches survives and shows behind
the family the back wall of the room, filled by a sideboard, a hang-
ing, and a closed door under a little canopy (fig. 19). In 1593 Rowland
Lockey adapted Holbein's original for More's grandson, eliminating a
few secondary personages and adding Thomas More II, his wife, and
his two sons. The back wall remains closed, covered for its entire length
by hangings. But a miniature version of the same picture, presum-
ably painted several years later (the younger son has added an incipient
beard) opens at the right through a Mannerist arch into a walled gar-
den, with London dimly visible beyond; moreover, the curtain at the
center rear is being parted by a servant, so that another room can be
glimpsed behind (fig. 49).

Wylie Sypher has called attention to the "perforated" space of late
Renaissance art (1955, 29).[8] It is certainly the case that late Elizabethan
masons and woodcutters began putting holes in things. Castle Ashby,
Charlton, Hardwick, Hatfield, Hinchingbrook, and Wollaton, among
others (all started between 1580 and 1607), have fancy balustrades along
the roofline; Hardwick's incorporates Elizabeth of Shrewsbury's ini-
tials, and those at Castle Ashby and Audley End include English and

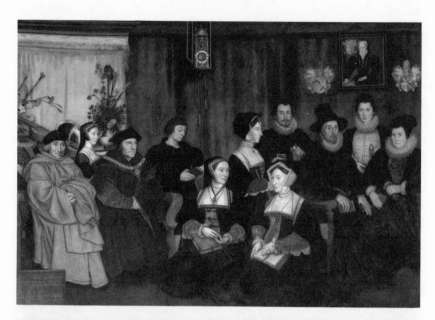

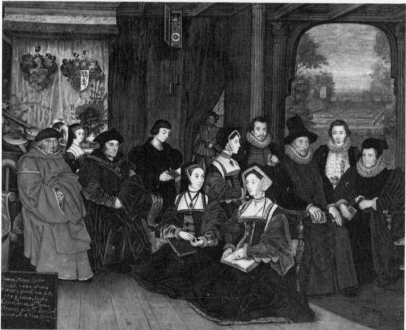

49. *Top:* Rowland Lockey, *Sir Thomas More, His Family, and Descendants* (c. 1593). National Portrait Gallery, London. *Bottom:* Rowland Lockey, *Sir Thomas More, His Family, and Descendants* (c. 1598). Reproduced by courtesy of the Board of Trustees of the Victoria and Albert Museum, London.

Latin mottoes, respectively. Indoors, staircases were at the beginning of the century mostly of stone, spiraled into a tower or laid flat up against a wall, and in the mid-century built in flights and landings around a solid masonry core. But they began in the latter part of the period to be built of wood, cantilevered from the wall (as at Mapledurham, Oxford) or hung on a central column (as at Parham, Sussex). Supplied, as they often were, with carved and pierced or elaborately turned balustrades, they give an effect of space divided but not enclosed (Girouard 1978, 93; Godfrey 1911; Sekler 1951) (figs. 50, 51). In funeral sculpture of the fourth quarter of the century, the figures begin to come clear of their bases and backs. An example is the monument to John Leweston at Sherborne Abbey, Dorset (d. 1584), where the sarcophagus with its dormant couple is surmounted by a canopy on six Corinthian columns, of which only the two right against the wall are partially engaged; atop the canopy is a line of hoops and circles (formed by writhing beasts) and square pillars; on these in turn stand naked human figures leaning on shields and clubs (fig. 52). The huge tomb in Westminster Abbey of Lord Hunsdon (d. 1596) assembles dozens of pyramids, canopies, balustrades, statues; not only do they enclose space within and between themselves, but their surfaces are heavily carved, and the use of radically contrasted colors of stone adds to the effect. [9]

What demands special emphasis in these works is the continuity of the space occupied by both artifact and viewer. James Ackerman talks about the shift in terms of a proposition first clearly laid down in Cartesian optics, that mass and extension are the primary properties of matter, while such superficial attributes as color and texture are secondary, accidental (1961, 88).[10] At issue are not only different ways of representing the visual world but also different ways of coding all kinds of information. One mode is essentially paratactic, additive, monovalent, the mode of most Tudor art, as we have seen. The other is hypotactic, integrative, polyvalent. We can observe them together in some transitional works.

A striking allegorical painting made for an unknown English patron sometime after 1570 shows a mature man in classical tunic and boots, eyes cast beseechingly aloft, being borne up by an angel toward a semi-nude Christ clasping his cross in a heaven of clouds and cherubs (see Mercer 1962, 148–49) (fig. 53). Around the Everyman figure (which might, however, be a portrait) are gathered his enemies: a soldier shooting a crossbow whose bolt is labeled "Coveitise"; a woman with a longbow and arrows of "Glotony," "Slowth," and "Lechery"; a devil with a short bow and arrows of "Pride," "Wrath," and "Envye"; and a

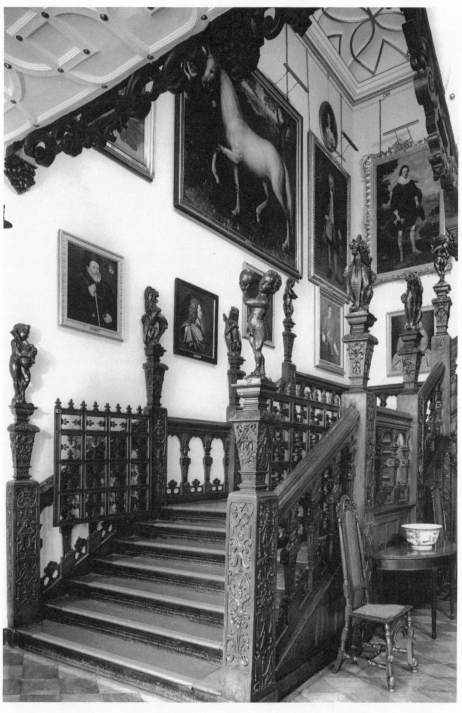

50. Artist unknown, Hatfield House, Herts., staircase (c. 1612). Reproduced by permission of the Marquess of Salisbury.

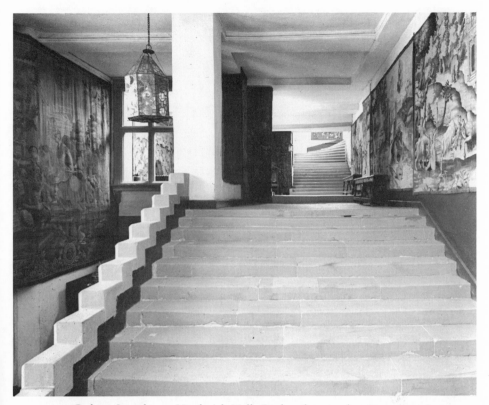

51. Robert Smythson, Hardwick Hall, Derby, the grand staircase (1597).
Photo: The National Trust.

skeleton who shakes a dreadful dart. The imperiled soul is defended by a large shield (behind him, however) and scrolls with legends reading "Prudens," "Good Busines," "Chastity," and so on, and a long *contemptus mundi* exhortation at the bottom. The figures are painted with some vigor; the double-decker composition, light above, dark below, though not found in other English pictures of the period, had been standard in Continental Ascensions and Assumptions for decades. The picture is "composed," in the Albertian sense, around the axial trio of man below, angel in the middle, Christ above, with the four assailants balancing each other around the man, and the ten putti in a variety of energetic postures enlivening the celestial region. Yet the iconic tradition remains in force. Each figure has its own appropriate emblematic background: a landscape for Lady Flesh, a paneled wall for Sir World, roiled smoke for Milord Devil; there is no communication among them except in their

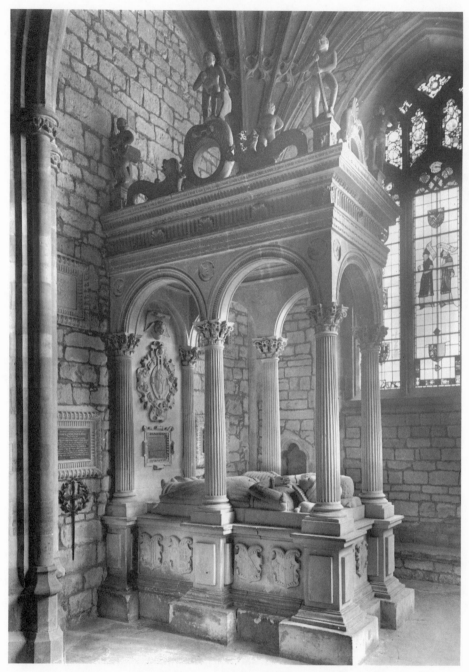

52. Artist unknown, Tomb of John Leweston (d. 1584), Sherborne Abbey, Dorset.
Photo: Royal Commission on the Historical Monuments of England.

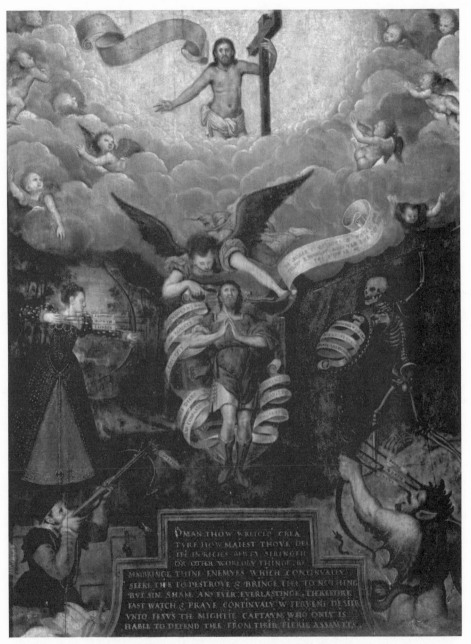

53. Monogrammist HE (attrib.), *Allegory* (c. 1580?). Private collection. Reproduced by kind permission of Sotheby's.

common purpose, nor between Christ and his allies above. Each figure is in action, in a way that is true of very few Tudor paintings. But the energy is, so to speak, purely potential; the pleasure that the painting gives arises from expectations gratified, as a familiar spiritual topology is set forth yet again clearly, economically, and forcefully. And the painting seems to share with the best Plain-style poetry the sense that problems have been set and solved in iconographic rather than esthetic terms, following a program very much like those discussed earlier. [11]

Some further characteristics of such programs can be stipulated. In looking at grotesquerie, we saw that the intellectual and esthetic energies of such works typically gather in a series of nodes or focuses, set off from each other by some sort of framing device, like the several backgrounds of the Everyman painting, or the architectural frames around the *istorie* in the gallery at Fontainebleau, or the transitional phrases ("Next saw we," "And next," "By him," "And fast by him," "And by and by") and stanza breaks that change the subject but not the context in Sackville's induction to *A Mirror for Magistrates*.[12] Within each node, depending on the overall design of the piece, conceptual and compositional unity may prevail. But between nodes, though some spatial or logical or narrative link will connect them, conceptual and compositional differences may well appear. This principle is especially well illustrated by such ephemeral spectacles as that organized for the entry of James I into London in 1604. The nodes of that procession were the seven archways, built by seven different organizations, in styles so varied as to constitute a full spectrum of available options, and though there were thematic recurrences, each arch had its own iconography. The accompanying verbal materials displayed the same variety. There was a spatial and temporal dimension, but the artists did not *use* it as part of the structure. One arch did not recall its predecessors or anticipate its successors, nor were the intervals between them considered as part of the design.

Over against the paratactic mode of the older kind of program, additive, nodal, synchronous, ceremonious, came a newer hypotactic mode, whose organizing principle in the visual arts was linear perspective. Medieval artists, says Max Friedländer, struggled always "to make the part representative of the whole" and produced single figures on neutral grounds (1949, 19). As Heinrich Wölfflin long since observed, however, Renaissance artists coordinated single figures into orderly wholes against meaningful grounds. And Baroque artists subordinated some figures to others, against a ground itself treated as a figure, the whole gathered into a complex, mutually interdependent

structure (1950, 169). At this point, the period labels do not interest me. The structural shift described does. It owes something to the new, practical interest in representation of the visual world discussed in the previous chapter. Beyond that, we can consider that perspective, according to John White, had three principal functions: to recreate reality convincingly, to give unity to the design, and to achieve harmony (or creative disharmony) between imitation and actuality, between the artifact and its context (1972, 148; see also Bender 1972, 110–11).[13] The transition can be observed in those courtly entertainments so prominent in the foregoing discussion, from a style of "dispersed decoration"—processing pageants in which each episode is independent—to a "newer," Italianate style based on perspective—the masque (Yates 1973, 239). The masque imitates reality by having its participants speak and act in spatially realistic three-dimensional settings. It strives for unity of design by setting up functional relationships among the various parts of the work, so that, for instance, the masque proper would be diminished qualitatively as well as quantitatively by the loss of its complementary antimasque (whereas Tamburlaine's heroic dimensions are not diminished by the absence of some clownish antitype). It develops harmony between modes by employing the court itself as the place, the courtiers as the performers, the court's concerns as the occasions and themes of the work.

The degree to which such a change occurred—and certainly the degree to which it can be observed in the arts of late Elizabethan England —is perhaps debatable. Madeleine Doran seems to indicate the continuing primacy of the paratactic mode in the drama when she notes a "focus on an immediate striking effect rather than on a total impression," and Roland Mushat Frye insists on the continuity of English *Weltansicht* from the Middle Ages through the reign of Elizabeth (Doran 1954, 234; Frye 1980, 32–35).[14] As I have been trying to show, however, the issue is not between structure and no structure but between paratactic structure, with what that implies about the author's subordinated relationship to his materials and his audience, and hypotactic structure, which implies artistic control of a greater number of elements and, in particular, a willingness to defer full expression, revelation, satisfaction, in the present moment in order to achieve some more striking effect subsequently. I have already conceded that the older mode operates in many works in all the arts well down into the seventeenth century. The point is that side by side with these works, others (perhaps by the same artists) display other qualities.

Things could hardly be otherwise given that the hypotactic mode

receives one of its most fundamental expressions in a structure repeatedly encountered, and honored by both precept and imitation, at every level beyond the most elementary of renascence education, that is, the periodic sentence (see Gordon 1966, 77–83; Sutherland 1957, 31–48).[15] To be sure, Englishmen had to struggle throughout the period, trying to wrench their recalcitrant native syntax into consonance with the Ciceronian patterns (a struggle that has attractive similarities to the contemporaneous push-and-pull between native and imported architectural devices); arguably, even Hooker achieved a truly Roman cadence only now and then. But in discussing meter, I argued that what mattered was the *idea* of meter, of an abstract principle governing the concrete expression, rather than any particular form. In the same way, I think, what came to matter for English culture was the idea of period, of complex structures of words (and the concepts behind them) organized by principles of subordination but also of suspense, structures in which the several components, though not all equally important, are all equally interdependent, and whose full import, rather than being implicit in each component and therefore predictable, must wait on the presentation of all the components before it becomes fully apparent. Such an idea, routinely presented and applied during instruction in grammar and rhetoric, would also tend to affect instruction in the third trivial subject, logic, and the development of Ramist logic, with its emphasis on structure rather than substance, seems a natural consequence of the periodic ideal of renascence education.[16]

Implicit in the idea of period (though in other ideas as well, and not necessarily a consequence of particular educational tenets) is the necessity for careful planning before the fact—the end of a successful periodic sentence must be in mind before the first word can be set on the page—and for revision, when possible, after it. Increased reliance on careful preparation can be seen in architecture, an area where, as we have already seen, humanistic ideas and customary practices meet: the very etymology of the word *plan* marries the two spheres. It would be silly to suggest that medieval builders or writers worked from stone to stone, bay to bay, line to line, or fit to fit, with no more than a general idea, carried forward from the experience of similar undertakings, of the final form of the structure—surviving plans, to say nothing of works as carefully and richly articulated as *The Divine Comedy* or any Gothic cathedral, scout such a notion. Still, Frank Jenkins has documented through the sixteenth century an ever-increasing reliance on detailed drawings and, later, on three-dimensional models; as we

shall see, buildings like Longleat, Theobalds, and Hatfield House were designed, not just accumulated (1961, 18).[17] The most prominent Elizabethan educator, Richard Mulcaster, urged that all students be taught to draw, as a thing useful in "architecture, picture, embroidery, engraving, statuary, all modeling, all platforming, and many the like, besides the learned use thereof for astronomy, geometry, chorography, topography, and some other such" (R & B 843). (The passage attests as well to a general inculcation of visual sensitivity.) John Thorpe and Ralph Smythson, by gathering up large collections of plans, elevations, and detail drawings, show themselves planning to plan: their portfolios are the architect's equivalent of the writer's commonplace book (Girouard 1962; Summerson 1966). The development affected decoration, both interior and exterior, as well as construction; Eric Mercer has discerned a shift from the programs of the Tudor era, which are quite purely customary and local and ad hoc when left primarily to craftsmen and quite purely ethical and emblematic when assigned to humanists, to a Jacobean mode in which rooms and facades are treated "as an artistic whole" (1953, 157). [18]

Nikolaus Pevsner and A. L. Rowse both claim to find in the development of the arts in England, from the middle of the sixteenth century to its end, a general "process of ordering," which they discern in things like symmetrical facades and axial plans, but also in things like "the tidying up of English verse" (Pevsner 1960, 24; Rowse 1972, 142). That process would presumably work from relatively small things toward larger ones. Thus English poets managed the iambic line first, then the English sonnet; then, as Carol Thomas Neely demonstrates, they began to apply to groups of sonnets the kind of control earlier imposed on the individual poem (1978). In the same way, very large houses continued to exhibit an old-fashioned looseness of conception for some time beyond the point when relatively modest structures were built to highly unified designs (Mercer 1962, 49).[19] As such transitions occurred, they necessarily included awkward intermediate periods. Painters experimenting with linear perspective did not master fully coherent illusory space all at once; especially in treating the nongeometric forms of landscape they progressed from planar to volumnar representation through a stage in which the picture was divided into several receding planes— a stage native English painters did not attain until around 1600. Artists eager to regard the picture as an extension of the space in which it hung, but uncertain of viewer response, put into their pictures mediating figures, *Sprechern,* who make direct eye contact with viewers

and hence establish a psychological bridge across the spatial boundary; the practice also suggests the emerging awareness of the distance between see-er and seen earlier identified as a crucial element in post-medieval epistemology (Sypher 1955, 143–44).[20] Within a panel or page of grotesquerie, the continuous line connects one figure to the next; in this characteristic may lie the roots of the use of grotesques as transitional elements in complex structures like the galleries at Fontainebleau or *The Faerie Queene*. In architecture, such classical elements as were introduced into Tudor buildings typically marked points of spatial transition—gateways, doors, windows (Mercer 1962, 40). In books, they appeared as title pages—the very notion of a special page, something more elaborate than *Incipit liber whatsisis* to mark the boundary between life and book, is a relatively late development.

Successful hypotaxis depends on a body of structurally effective transitional devices, devices that not only help reader or viewer move from one element to the next but also indicate relationships more various than mere sequence in the process. Chaucer evidently had an emerging sense of the possibilities here, but died before he could finish ordering his sequence of diverse tales into a periodic whole. Murray Roston calls him a Renaissance artist, one emphasizing "local realism," however, rather than structure (1987, 13–61). Assorted features of assorted arts testify to a rising sixteenth-century awareness of transitions—and to attainment of the means to satisfy it. The ceremonial ride or *allée,* for example, that striking instance of conspicuous consumption ruled straight across the countryside rather than following the terrain, and serving only as access to a great house, not as common road, was invented in Italy in the quattrocento, brought to its apotheosis for the châteaux of François I and his successors, and imported to England by Henry VIII. In addition to title pages, books began to accumulate other introductory materials: dedications; commendatory verses both by and to the author; epistles to the reader from the publisher, the author, some interested friend (like Spenser's E.K.), or all three. Houses grew porches and balconies, staircases and galleries and loggias and rooftop pergolas; miniatures were given beautifully decorated hinged covers; and plays prologues. Where scenes in part 1 of *Tamburlaine* open abruptly, leaving the audience to deduce the identity of new characters and the new locale, part 2 offers transitional information:

> Now have we martcht from faire *Natolia*
> Two hundred leagues, and on *Danubius* banks,

Our warlike hoste in compleat armour rest.
 (1973, 1.1.6–8)

Now, bright *Zenocrate*, the worlds faire eie,

.

Now rest thee here on fair *Larissa* Plaine,
Where *Egypt* and the Turkish Empire parts . . .
 (1.3.1–6)

These developments arise from the rhetorical basis of renascence education and thought. All of them exhibit awareness of the viewer, visitor, or reader as an initially neutral or inert receptor needing to be poked, prodded, teased, enticed, coaxed, led, or otherwise moved to cross some kind of psychological no-man's-land. "But this doubtless is a point of great art," says Sir John Harington, "to draw a man with continual thirst to read out the whole work, and toward the end of the book to close up the divers matters briefly and clearly," and he goes on to repeat the idea in an image of a man walking in a garden where trees at intervals supply both shade and fruit (G. G. Smith 1964 2:217). A similar image (as well as many of Harington's ideas) occurs in Sidney's *Apologie for Poesie:* the poet is monarch of all sciences because "he dooth not only show the way, but giveth so sweete a prospect into the way, as will intice any man to enter into it. Nay, he dooth, as if your journey should lie through a fayre Vineyard, at the very first give you a cluster of Grapes, that, full of that taste, you may long to passe further" (G. G. Smith 1964, 1:172).[21]

Sidney presents the image without the explicit concept in the revised *Arcadia* (1584–85, published 1590) when he describes Kalander's garden as presented to Musidorus:

which he thought to shewe him before his going, as the place him selfe more then in any other delighted: the backeside of the house was neyther field, garden, nor orchard; or rather it was both fielde, garden, and orcharde: for as soone as the descending of the stayres had delivered them downe, they came into a place cunninglie set with trees of the moste taste pleasing fruites: but scarcelie they had taken that into their consideration, but that they were suddainely stept into a delicate greene, of each side of the greene a thicket bend, behinde the thickets againe newe beds of flowers, which being under the trees, the trees were to them a Pavilion, and they to the trees a mosaical floor: so that it seemed

that arte therein would needes be delightfull by counterfaiting his enemie error, and making order in confusion.

In the middest of all the place, was a faire ponde, whose shaking christal was a perfect mirrour to all the other beauties, so that it bare shewe of two gardens; one in deede, the other in shaddowes: and in one of the thickets was a fine fountaine [of Venus with the infant Aeneas]. . . . Hard by was a house of pleasure builte for a Sommer retiring place, whether *Kalander* leading him, he found a square room full of delightfulle pictures, made by the most excellent workeman of Greece. (1917–26, 1:17–18) [22]

This passage, like the garden it describes, is full of interesting things. The space is a complex space, three-dimensional ("the descending of the stayres"), which reveals itself to the eye only little by little. The poet (for so Sidney would have called himself) gives us the scene in a syntax equally complex, in long sentences, equally full of subordinations and surprising turns. The first of these, in particular, is essentially periodic in character, for its closing phrase, "making order in confusion," though it does not contain the main verb or subject, yet gathers up and focuses the import of the elements that precede it. The concept itself represents that deeply Sidneyan, deeply renascence ideal of *sprezzatura,* art "counterfeiting his enemie error," and so concealed in nature as to seem no art.

The periodic structure, moreover, leads the reader as it leads the stroller until they come to the conceptual center of the piece, concealed among thickets as the capstone phrase of the sentence is concealed among clauses. In this instance, that center is itself complex, a series of three iconophrastic images that, as they move from relatively general and abstract to relatively concrete and particular implications, constitute a kind of period of their own. The first is the "faire ponde," whose "mirrour" expresses through an absolutely conventional metaphor the mimetic character of the entire work. At the same time, it ushers in the dichotomies ("one in deede, the other in shaddowes") that will energize the tale. Some of these appear more particularized in the second emblem, the statue of Venus with the infant Aeneas at her breast, an image of youth and age, classical and modern, past and present, but especially of the domination but also the nourishment of martial virtues by the virtues of love, which is the major theme of Sidney's epical romance. This emblem, in turn, gives way to a third extended iconophrasis, more particular yet. The decorated summerhouse is retired from the house

just as Basilius's lodge, where the action of the plot will center, is re-
tired from the court; the subjects of the several paintings all directly
anticipate important episodes to come.[23] At the center of the center, so
to speak, is Philoclea's painting of herself and her parents. Kalander's
account of the picture not only completes the exposition entailed by a
beginning *in medias res* (itself a strategy of deferral at the macro level)
but also lays out the ground on which Musidorus's love for Pamela and
involvement in the affairs of her family and country will be built. The
reader has thus been led artfully but insensibly into the heart of the tale.

The principles underlying Sidney's romance (to which we will re-
turn) can be discerned in other sixteenth-century art, but not until late.
Early Tudor houses and gardens on the scale of Kalander's developed
in several stages, more or less ad hoc, as the needs of the household re-
quired and its resources allowed. At Penshurst, where Sidney grew up,
the fourteenth-century hall and solar had been augmented about 1430
with a new, larger set of private apartments sharing one corner with
the older buildings but partially offset (fig. 20). During Sidney's young
manhood, a long gallery was built out perpendicular to the far end of
the private apartments; a little later Sir Henry Sidney put up an exten-
sive new set of buildings, in the form of a T with its foot attached to the
other corner of the dais end of the hall, incorporating that most up-to-
date fashion, a loggia, and creating, together with the existing medieval
curtain wall, three courts (Binney and Emery 1975). The house had
a kind of practical logic, no doubt, determined by the habits of the
household. But it had no clear conceptual principle—hardly surprising
in a structure not so much built as accumulated over a period of several
centuries, in response to several sets of social demands. [24]

From Nonsuch onward, however, substantial English houses were
much more likely to be planned and built all at one go. The structures
that survive lack the romantic appeal of a Haddon, a Penshurst, a Speke,
or a Knole. But they have a much greater coherence of plan and unity of
design. Most of the very great houses of this type—Burghley's Theo-
balds, Sir Christopher Hatton's Holdenby, Robert Cecil's Wimbledon
—are gone, though plans for many of them survive to tell us about
their design. Others—Thynne's Longleat, Burghley House, Howard's
Audley End—have been so extensively remodeled on the inside that a
sense of their original character is irretrievable. Of those that remain,
the most splendid is Robert Cecil's Hatfield House, thirty miles north
of London, on the slope above Old Hatfield where Elizabeth lived dur-
ing her half-sister's reign (a house of the older courtyard type most of

which was demolished to supply timber and bricks for the new structure).[25] Although it was built late in our period (completed 1612), it can properly be treated as the culmination of Tudor practice (even to the extent that some of its details supply early instances of Stuart neoclassicism). Hatfield was not, like Haddon and Penshurst, a fortified manor gradually turned into a lordly mansion, or even, like Longleat and scores of less splendid piles, the principal residence of a great landowner, visually dominating the country from which his wealth derived. It was, instead, a palatial retreat, where Cecil's royal master, James I, would come with his court for recreation. Huge, elaborate, costly as it was, it was planned to lie largely empty most of the year. But for periods of a few days or weeks, the fructifying effects of a visit from the king would cause it to bloom into activity like a desert cactus.

Hatfield House is a work of art (fig. 54). Its ends were practical enough: it was meant to keep Cecil high in royal favor and thus to sustain the kind of wealth that made its construction possible in the first place. But those ends were attained by an esthetic agency: every surviving Jacobean feature of the house seems meant to delight. It was richly adorned, by the best available craftsmen (mostly foreigners). It was supported by bevies of summerhouses, lodges, and lesser outbuildings (mostly gone now), and by acres of garden and miles of park. What especially interests me, however, is the layout. Hatfield has the same assortment of spaces as Haddon or Knole, and the E-plan design is typical of the period. But the disposition of spaces seems to assert a level of authority, a degree of conscious ordering, of artistry concealed behind the naturalness of custom, very consonant with the spirit of Sidney's merely imaginary house of Kalander. This spirit expresses itself in things like the provision of numerous staircases and galleries, which make communication within the house relatively easy and discreet by standards of the period (and help keep the inferior members of the household out of the way of the gentlefolk), or like the fact that the kitchen was dug several feet into the ground in order to maintain its necessary height of ceiling and still fit it into the overall scheme. Many similar features appeared in Thomas Howard's Audley End (1605–16; fig. 21), if we can judge confidently from P. J. Drury's reconstruction (1980, pl. 4), but the effects are more striking at Hatfield because the "public" rooms are folded into a single wing rather than strung out around a court. Conscious artistry seems especially clear, however, in the layout of the major rooms.

Hatfield today is approached from the north, along a rather short

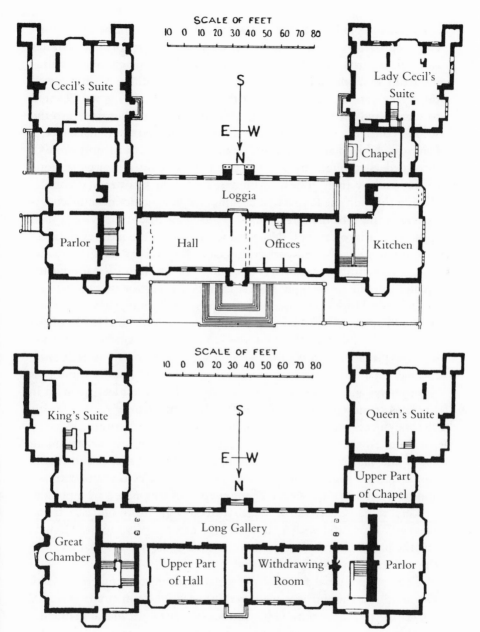

SCALE OF FEET
10 0 10 20 30 40 50 60 70 80

S
E+W
N

Cecil's Suite

Lady Cecil's
Suite

Chapel

Loggia

Parlor

Hall

Offices

Kitchen

SCALE OF FEET
10 0 10 20 30 40 50 60 70 80

S
E+W
N

King's Suite

Queen's Suite

Upper Part
of Chapel

Long Gallery

Great
Chamber

Upper Part
of Hall

Withdrawing
Room

Parlor

54. Robert Lyminge (attrib.), Hatfield House, Herts. (c. 1612), ground floor
plan (*top*); first floor plan (*bottom*).

drive off the public highway. In 1612, when it was finished, its "official" approach was from the south, along a ride cut for several miles through the park and cresting a gentle hill to give a view of the building from some distance. Arrived at the house itself, the visitor passed through a gate in a curtain wall into a first court (now gone) devoted to stables and secondary lodgings, then through another gate into the second court. At the far side the visitor encountered the Renaissance: a handsomely decorated limestone facade, arcaded, with a frontispiece of three orders (thought by some to be the first architectural work done in England by Inigo Jones) surmounted by a clock tower and cupola. Passing through the loggia that occupies the ground floor on the courtyard side and into the screens passage, itself an arcade, the visitor then turned right into the hall, decorated with some of the most elaborately carved and gilded woodwork in England. Beyond lay the grand staircase, wonderfully carved (fig. 50), whose several flights led the visitor up and around to the king's great chamber, lying across the east end of the main block and centered on a splendid chimneypiece, designed by the Flemish artist Maximilian Colt, bearing a life-size statue of the king. At the other end of this room an attractive anteroom opened into the private quarters of the king, a suite of three rooms each more intimate than the last. Or, turning to the right, the visitor would pass through yet another arcade into the long gallery, the most splendid in England, running for 180 feet across the south front, with two fine chimneypieces and a colonnaded frieze above the beautiful marquetry paneling. At the far end, another right turn led into the private dining room and parlor (subsequently combined into one room) and thence to the queen's great chamber (to be used by the Cecils at other times, and now the library), with its chimneypiece surmounted by a portrait of Cecil in mosaic, made in Venice in 1608, a gift from Donne's friend Henry Wotton, and with a view over the privy gardens to old Hatfield and the parish church. Between this room and the queen's chamber was the gallery of the large, rich chapel. [26]

The "processional route" from kitchen to great chamber, as Mark Girouard has shown, was well established by the time of Edward IV (1978, 46–52). It grew more sumptuous decade by decade; at Hatfield it constitutes a kind of royal progress in little. It has a strong logic, moving from outdoors in, from lower to higher, from public to private, from secular to sacred. Yet is is not simply linear. It turns, rises, folds back upon itself.[27] Nor is it closed. It is full of the kinds of openings that we have seen becoming characteristic of the English arts around

the turn of the seventeenth century. On the facade the arcade, the disengaged columns of the frontispiece, the two levels of pierced cresting, the open cupola, all permit space to play in and around form. The hall woodwork is literally full of holes, especially the musicians' gallery. The wooden staircase encloses space as it returns upon itself, and the complex forms of its newels are surmounted by free-standing figures. The king's great chamber, like all the upper rooms, has huge, low-silled windows affording wide prospects over garden and park; the dropped bosses of its fine plaster ceiling each gather four pendant acanthus-leaf scrolls to enclose a pearl of space. The sequence is also full of changes and surprises. Most rooms are entered around a corner. Each has its own distinctive character and offers its own distinctive prospect. In particular, the turn into the long gallery is astonishing. But the gallery has its own surprise, a little room off its middle (ideally suited, no doubt, for conversations tête-à-tête) that in turn has two windows that look down upon the hall below. It is hard to imagine a place more clearly planned for "gaiety and pleasant company," as John Buxton puts it (1965, 81).

A similar sense of conscious design, and similar uses of opening, turn, and surprise, can be found at other houses, such as Wollaton, Aston Hall outside Birmingham, Burton Agnes in Yorkshire, Blickling in Norfolk. If anything, the approach to Hardwick, and the passage through a fine hall, up a wonderful masonry staircase, and into the splendors of a great chamber that many think the finest room in England, is even more dramatic than the sequence at Hatfield (figs. 51, 42). A comparable sense of architecture as oeuvre seems to have animated Gresham's Royal Exchange, inspired by any number of northern European markets and city halls in which all the appropriate symbols could be gathered into a "*Gesamtkunstwerk* of architecture, painting, and sculpture" (Edgerton 1972, 76).

And a comparable sense in literature animates the oeuvre of Philip Sidney. Sidney's interest in the visual as well as the literary arts is well documented. We have already seen some signs of it in his own work; they are seconded by facts about his life.[28] His travels took him to many of the artistic centers of Europe—Brussels, Paris, Fontainebleau, Venice, Prague—where he had a better chance than most English writers to see a lot of first-rate Continental work (also to develop an intimate familiarity with the work of Ramus). He had his portrait painted by Veronese and was an early patron of Hilliard; indeed, his friend Greville asserts that "there was not a cunning painter . . . or any

other artificer of extraordinary fame that made not himself known to this famous spirit and found him his true friend without hire" (quoted in Wallace 1967, 221).[29] He was too poor to build for himself, but both his uncle, Leicester, and his father, Sir Henry Sidney, undertook major building projects during his life, and John Aubrey says that the grounds at his sister's house, Wilton, were modeled on the description of Basilius's lodge in *Arcadia* (Hunt 1971, 36). Besides inventing the architecture of Kalander's house, Basilius's lodge, and Cecropia's castle in *Arcadia,* Sidney made an entire sonnet on an architectural conceit (*Astrophil and Stella* 9). And in the *Apologie for Poesie* (c. 1581), he ascribes to the right poet a special grasp of "the highest end of the mistres Knowledge, by the Greekes called *arkitecktonike*" (G. G. Smith 1964, 1:161).

This is tricky ground. Sidney, following Aristotle, is using the term in a primarily moral sense; the poet inculcates a kind of self-knowledge and self-control that leads to "well-doing and not . . . well-knowing only." But Aristotle had also used the word literally, as well as figuratively, in reference to building practices; French instances in that sense occur by the fifteenth century, and English as early as 1608. Hence it seems plausible to discern behind the particular philosophical application a more general concept, derived from etymology, and as applicable to the arts as to any orderly human business, of particular actions or motifs or figures or images made rationally subservient to a larger purpose or work. This attitude contrasts sharply with that discerned earlier, of the artist reacting in terms dictated by external authority to the discrete phenomenal expressions of a noumenal reality beyond his comprehension. Instead, here we find the supervising intelligence exercising its own authority, imposing its own order on the materials of the work, whether they be the rooms of a house or the phrases of a sentence. Already, in the later pages of the *Apologie,* there appear signs of such a transfer, as where Sidney reprehends the English poets for their lack of design: "it will be found that one verse did but beget another, without ordering at the first what should be at the last; which becomes a confused masse of words" (G. G. Smith 1964, 1:196). In fact, Sidney has some remarks that seem to relate this lack of periodic control to the old Plain style, as where he charges the Petrarchan sonneteers with frigidity of invention, and to the Decorated, as where he looks with scorn on contemporaries whose only skill is to "cast Sugar and Spice upon every dish that is served to the table" (1:202). (Note how the image

makes the writer the passive recipient rather than the active initiator of subjects.)

More interesting than Sidney's theory, however, is his own practice. In *Astrophil and Stella* (1581–82?), periodic design is an obvious characteristic in many individual sonnets, especially those, such as 21 ("Your words, my friend") and 71 ("Who will in fairest book of nature know"), whose last line or so stands the entire poem on its head, overturning the grave arguments of philosophy with a sudden concession to the devastating power of Stella's beauty and Astrophil's desire. In the sequence as a whole the implied narrative, however rudimentary and confused, gives the book more coherence than any English predecessors. The *Apologie* gets its skeleton from the traditional seven-part design of the classical oration, as taught by didactic rhetoric; Sidney's special gift here is in the extraordinary control of tone, both within sentences and in larger units, and especially his free movement across a wider lexical and syntactic range than can be seen in any earlier English prose. [30]

Sidney's architectonic genius appears most clearly in the *Arcadia*. The first form of that work is pretty firmly constructed by comparison with most of the other English prose romances and with the episodic development of earlier narratives, both prose and verse, such as the typical *Mirror for Magistrates* tragedy, a novella like Gascoigne's *Master F.J.* (1573), or a hybrid like *Euphues*. Except for the pastoral interludes, however, its structure is straightforward, chronological narrative with a few expository inserts serving as the vehicle for the rhetorical bravura pieces—speeches, descriptions, poems—that provide much of the book's real interest. In other words, it is still a gallery. The revision is altogether another thing: I would call it the most truly revolutionary act of the English renascence. The very germ of the undertaking marks a new departure. Previous second versions of successful English works, as we have seen, had been revised by the addition of new material, although Gascoigne, in this as so many other things anticipating Sidney's more complete achievement, had not only added some new materials to his *Flowers* of 1573 but made enough minor changes in the substance and order of the various pieces that the work deserved to get a new title, *Posies,* in 1575. It is even to the purpose to note that the later title implies a greater degree of organization than the earlier one. But like the second Hatfield, the *New Arcadia* was rebuilt from the ground up using the bricks of the first. Although he carried over much of the text of the *Old Arcadia,* Sidney gave it a rich new beginning, made ex-

tensive changes in the order in which events are narrated, added new characters and new events, to a point, of course, where the plot is taking a line so divergent from the original tale that the critics have had to wonder whether Sidney left the work unfinished because he was drawn away from it by the political and military concerns to which the end of his period of rustication exposed him, or because he had overrun the boundaries of his plan. Whatever the motive for giving it up, however, a process of revision so extensive expresses forcibly something new in English art, the sense of the writer's material not as something in effect given to him by tradition and authority and custom, which he is only passing along, but as his own creation, still plastic, still subject to his shaping intellect and will, "freely ranging within the zodiac of his own wit." [31]

As significant as the fact of the revision is the shape it takes. The work becomes more complicated. Not only does Sidney add new characters and episodes, but he breaks up the linear narrative line of the *Old Arcadia* by the extensive use of inset retrospective narration, interruption, and interlacement. One important effect of these changes is to enhance greatly the element of surprise. This was in any case a striking feature of the Greek romances that were among Sidney's important sources. But in the *New Arcadia* he substantially increases the frequency with which disguises are assumed and cast off, identities revealed, startling messages received, well-laid plans sent awry, and desperate situations rescued by seeming chance or luck; and these reversals are conveyed by narrative forms that amplify the apparent improbability of the events by their intrinsic discontinuity. [32]

Sidney's works, then, share fundamental esthetic features with Hatfield House and with other important works of later Elizabethan and early Jacobean art. They are complex, various, richly ornamented. They employ means and materials devised and developed by Continental workmen to peculiarly English ends. They are full of openings, prospects, turns, surprises. They comment upon themselves: the pastoral interludes in *Arcadia* supply direct and ironic reflections of the chivalric narrative; the staircase carvings at Hatfield depict the activities—hunting, fishing, eating, sleeping, making music, making love—that go on in and around the house. Especially they express an architectonic, periodic sense of the artist's relationship to both his means and his audience. He dominates his materials, subordinating each individual detail to the overall conception, first of the local unit—the sentence, the single surface—then of larger units—the poem or speech or episode,

the room—finally of the entire work or house. He dominates his audience by delight, not in the long run as an end in itself but rather as the most effective means for achieving whatever ethical or social purpose first moved him to undertake the work, yet locally encouraged even with no other end in view. [33]

Hatfield House is relatively late, of course, and the work of a team of builders and artisans, though under the magisterial direction of Robert Cecil. Sidney's one-man show is earlier, and perhaps for that reason more interesting. Nothing quite like it will come along for some time —of Lodge's *Rosalynde* (1590), Marlowe's *Edward II* (1593?) and *Hero and Leander* (1593? published 1598), Spenser's *Amoretti* (1595), none has the magnitude in either plan or execution of the *New Arcadia*. (I have already argued my conviction that *The Faerie Queene* [1590–1596], rich and splendid as it is, retains the paratactic structure of Traditional rather than the hypotactic structure of renascence art.) Lodge's *Rosalynde* yokes a rhetoric influenced by both Lyly and Sidney with a narrative modeled on Sidney's. But as Lodge's language never extends to the plainness Sidney is capable of at one extreme or to the grandness he can achieve at the other, so his romance lacks both the comic and the heroic elements of the *New Arcadia*. The sonnets of Spenser's *Amoretti,* though beautifully unified by their melodious fluency of language and mastery of form, by recurrent images, and by Spenser's coherent philosophy of love, lack the variety and wit of *Astrophil and Stella*.

The most interesting analogue is perhaps Marlowe. *Dr. Faustus* combines the symmetry of *de casibus* tragedy and of a richly varied and ornamented but still balanced, regular, end-stopped iambic line, the episodic processional structure of morality plays and didactic pageantry, and the Grotesque mingling of elevated and debased materials, with a new conception of dramatic character, neither a passive Everyman of a sinner nor a monomaniacal Tamburlaine of a hero, but a changeable, surprising mixture of intellect and sensuality, atheist and believer, overreacher and flop. These elements remain incompletely integrated, however; granting all the uncertainties surrounding the text, in the end the play seems to me added up, in the traditional Tudor paratactic way, rather than architectonically contrived, and it has the wayward charm, the improvisational vitality, of Penshurst rather than the magisterial authority of Hatfield.

Edward II is much more carefully built. Like any architecture, it is held up by its tensions. Edward and Mortimer summarize the age-old struggle between king and nobles. Gaveston, Edward's French favor-

ite, stands for Continental sophistication—and corruption—against the plain speaking and traditional ethics of the English. He also represents the appeal of truancy from duty, custom, obligation—all the burdens of kingship, husbandship, fatherhood, focused on the queen and the young prince. Through and around the crown pass the lines between old guard and *nouveaux arrivés,* scholars and soldiers, Rome and Canterbury. Marlowe fashions these energies into a work much more various and rich in its plotting than any of his earlier pieces, and one that displays throughout a clear sense of its responsibilities to its viewers.

For all that, the work retains the rhetorical character of earlier Tudor literature. It is not just that the level of discourse remains largely the same throughout the play, high-middle to elevated as suits speeches virtually all either declamatory or deliberative—that is, made up largely from traditional moral and political formulas. It is not just that with a couple of trifling exceptions (dictated by events from the chronicles) the characters are all aristocrats. It is that all of them are contained within and absorbed by their roles in a way that precludes the development of conceptual distance, detachment, ironic self-consciousness.[34] Contrasts with Shakespeare are both inescapable and forcefully instructive. Edward, like Henry VI, is defeated by his wife in league with an ambitious nobleman. To the end he complains that external forces, agents of fortune, have brought him down. At no point does he express any awareness that his own faults have had a bearing on his fall. Having sought safety in a monastery after a military defeat, he commends the beauties of the contemplative life:

> Stately and proud, in riches and in traine,
> Whilom I was, powerfull and full of pomp,
> But what is he, whome rule and emperie
> Have not in life or death made miserable?
> Come *Spencer,* come, *Baldocke,* come, sit downe by
> me,
> Make triall now of that philosophie
> That in our famous nurseries of arte
> Thou sucked from *Plato,* and from *Aristotle.*
> Father, this life contemplative is heaven,
> O that I might this life in quiet lead,
> But we alas are chaste, and you my friends,
> Your lives and my dishonor they pursue.
> (1973, 4.7.12–23)

But he produces no such speech of contemplative reevaluation as that of Henry VI on his molehill (*Henry VI, Part 3*, 2.5). Like Shakespeare's Richard II, Edward has alienated the old nobility of the realm by self-indulgently amusing himself with new and less noble favorites and by adopting a personal style (including a rhetoric) more flamboyant and opulent than decorum will allow. Unlike Richard's, Edward's self-dramatization never grows critically self-conscious. The speeches he makes during his captivity (and a dreadful one it is) are all in the vein of traditional complaint:

> Within a dungeon *Englands* king is kept,
> Where I am sterv'd for want of sustenance,
> My daily diet, is heart breaking sobs,
> That almost rents the closet of my heart.
> Thus lives old *Edward* not reliev'd by any,
> And so must die, though pitied by many.
> (5.3.19–24)

Many of the same motifs appear in Richard's last splendid soliloquy. But his sense of himself as a character, in relation to a wonderful, terrible world, allows him to declare that world in some important senses to be made by him, done and undone, as much as he by it:

> Sometimes am I king;
> Then treasons make me wish myself a beggar,
> And so I am. Then crushing penury
> Persuades me I was better when a king;
> Then am I king'd again, and by and by
> Think that I am unking'd by Bullingbrook,
> And straight am nothing. But what e'er I be,
> Nor I, nor any man that but man is,
> With nothing shall be pleas'd, till he be eas'd
> With being nothing. (5.5.32–41)

Perhaps the most revealing case is Mortimer's. The pitiless scheming by which he supplants Edward in both council chamber and bedchamber marks him as one of the first Machiavels. On close analysis, however, the baleful energy that invests him in the second half of the play turns out to flow as much or more from others' remarks about him, especially the king's, as from anything he himself says and does. At the moment when old king, young king, queen, and all seem to be under his control, he displays none of the ironic, practical coolness of Machia-

velli himself, Iago, Edmund, even Richard III, but rather the arrogance
of a man consumed by his own image:

> The prince I rule, the queene do I commaund,
> And with a lowly conge to the ground,
> The proudest lords salute me as I passe,
> I seale, I cancell, I do what I will,
> Fear'd am I more then lov'd, let me be feard,
> And when I frowne, make all the court looke pale,
>
> . .
>
> Mine enemies will I plague, my friends advance,
> And what I list commaund who dare controwle?
> *Major sum quam cui possit fortuna nocere.*
>
> (5.4.48–69)

Of course, the fortune to which he proclaims himself superior strikes
him down forthwith, and the speech with which he accepts his fate
employs the *topoi* of the *de casibus* tradition so completely that the play
becomes a triumphant capstone to that edifice:

> Base Fortune, now I see that, in thy wheele
> There is a point, to which when men aspire,
> They tumble hedlong downe: that point I touchte,
> And seeing there was no place to mount up higher,
> Why should I greeve at my declining fall?
>
> (5.6.59–63)

The architect of that edifice, however, is not Mortimer but circum-
stances; all along, he has only seized opportunity, not manufactured it,
and Marlowe himself can be seen rather giving a richer, clearer voice to
the old chronicles than new-fashioning their materials into a structure
obedient to new imperatives of thought and art. Those imperatives do
speak in *Edward II* with the French accents of Gaveston, something of
a grotesque in his sexual and social ambiguity, but self-made, an artist,
who works "the pliant king" with poetry, music, masks, comedies, and
the kinds of mythological shows so ubiquitous in the accounts of the
entertainments accorded Elizabeth (see especially 1.1.50–71), and who
can turn his low birth but refined manner into an ironic advantage over
the high-born, coarsely trained English lords:

> Base, leaden earls, that glory in your birth,
> Go sit at home and eat your tenants' beef,

And come not here to scoff at Gaveston,
Whose mounting thoughts did never creep so low
As to bestow a look on such as you.

$$(2.2.74-78)$$

Gaveston's time has not yet come; he dies an ignominious death. But within a decade of this play Gaveston's style will dominate the Jacobean court. Still, he is only one forward-looking accent in the generally retrospective fabric of the play, like the great Renaissance screen in the middle of that late Gothic masterpiece, King's College Chapel.

Perhaps responding to the hypotactic qualities of his classical sources, Marlowe embraced the architectonic mode much more warmly in *Hero and Leander*. This brilliant poem as often caps a narrative or descriptive passage with a didactic generalization as *Edward II,* and its characters are equally confined within their roles. The fact that Marlowe can talk about and around them as well as through them, however, sets up possibilities for ironic juxtapositions and displacements not yet manageable within the conventions of English drama. The control is not complete. For all that its plot comes from Musaeus, the poem seems to me to owe even more to Ovid: bravura descriptions and mythological narrative as in the *Metamorphoses,* love lore as in the *Amores,* love plaints as in the *Heroides,* love play as in the *Elegies,* even some traces of the cultural history of the *Fasti.*[35] Each of these books has its own distinctive tone, and when Marlowe mixes imitations of all of them into a single poem, incompatibilities arise. Thus the sharp amatory sophistries with which Leander woos Hero (1.129–328) consort oddly with his clumsy gropings as he wins her (2.26–83, 235–334). There is, however, a sense of overall design in the poem, or at least in the two books of it that Marlowe finished (he left George Chapman to complete the work). Leander's pleadings in the court of love and the mythological digression in which Marlowe explains why the Fates hate lovers represent types of work that might well appear in a late medieval encyclopedic poem like *Le Roman de la rose* or *The Pastyme of Pleasure.* The difference is that we can assign to these instances of Marlowe's *amplificatio* strategic ends beyond the intrinsic interest or charm or moral utility of the segment. Leander's speech is conventional for lovers, and full of brilliant strokes; yet this rhetorical machine topples into a ditch when Marlowe reveals that the castle it was designed to conquer had surrendered at first glance to the physical, not intellectual, attractions of its builder. Both it and the mythological digression participate in a strategy of defer-

ral that, Gordon Braden has argued, constitutes one of the significant modifications Marlowe makes in Musaeus's original (1978, 141–44).

In this strategy, Braden says, though there are few real impediments to the lovers' mutual desire, a string of temporary blocks arising in some cases from within the story, in others from the intrusions of the author, mean that the consummation is repeatedly postponed. Thus tensions are built up by the reciprocating dominance of now one, now the other member of a pair of contestants whose apparent opposition is actually only cooperation. (In *Edward II,* by contrast, where dominance oscillates between Edward and Mortimer, the opposition is real, and the outcome mutually destructive.) The tensions are then released in a climax all the more satisfying for having been deferred. The procedure is peculiarly appropriate for a poem about sexual love. More generally, Braden says, it is a typical pattern of Baroque art. And note that the process applies, on a large scale, the hypotactic qualities of a periodic sentence whose last unit turns out to contain the independent verb.

We can see the periodic impulse working in the poem on a smaller scale by looking at Marlowe's management of the decasyllabic couplet. By skillfully adjusting syntax, internal pause, and enjambment, Marlowe substitutes the sentence for the couplet as the structural unit of the poem, allowing his matter sometimes to be confined and pointed by the rhyming pair, sometimes to pile up through several potential stopping points toward a final release:

> So having paus'd a while, at last shee said:
> Who taught thee Rhetoricke to deceive a maid?
> Aye me, such words as these should I abhor,
> And yet I like them for the Orator.
> With that, *Leander* stoopt, to have embrac'd her,
> But from his spreading armes away she cast her,
> And thus bespake him: Gentle youth forebeare
> To touch the sacred garments which I weare:
> Upon a rock, and underneath a hill,
> Far from the towne (where all is whist and still,
> Save that the sea playing on yellow sand,
> Sends foorth a rattling murmure to the land,
> Whose sound allures the golden *Morpheus,*
> In silence of the night to visite us,)
> My turret stands, and there God knowes I play
> With *Venus* swannes and sparrowes all the day.
>
> (1973, 1.337–52)

The first two sentences occupy a couplet apiece and carry on the intellectual rhythm of the preceding speech, Leander's barrage of amatory commonplaces, which quite naturally have tended to fall into epigrammatic boxes. The third exceeds its couplet by half a line; the couplet so encroached upon contains an enjambment but remains itself end-stopped. But the next sentence, built up from a series of phrasal and clausal modifiers, carries through three couplets, with an impetus amplified by a closing series of three lines without internal pause, two of them enjambed, into a fourth; and even then an additional independent clause remains to complete the period. (The effect is very like the building, crash, and subsidence of a wave.) The procedure is no more natural than would be a series of closed couplets; it is apparently no part of Marlowe's plan to imitate the cadences of normal speech.

In fact, *Hero and Leander* flaunts its artifice with that same mixture of boldness and naiveté that characterizes its hero and heroine. They themselves are as fully confined within their roles, as free from the ambiguities of self-knowledge, as Edward or Mortimer; they are only the most complicated of the golden toys Marlowe has set singing in his tree. But much more than in *Edward II*—more even than in the *New Arcadia* (if not more than in *Astrophil and Stella* and the *Defense*)—we see the artificer himself outside his work. And if in many ways Marlowe's part of *Hero and Leander* is less of an achievement than Sidney's heroic romance, it is in one important respect, which it shares with Hatfield House, more venturesome: in its willingness to posit what seems to us moderns, at least, a rationale for its art that accepts stimulation and gratification of the various appetites, rather than the desire for moral reassurance, as an appropriate, adequate, acceptable end.

The *New Arcadia* and Marlowe's part of *Hero and Leander,* unfinished as they are, summarize what we might call the preparatory phase of the English Renaissance. They display complete mastery of the paratactic modes of earlier Tudor art, but subordinated to the periodic interests of hypotaxis as the mode through which an àrtist will tend to express the vision that grows from and with self-consciousness. At the same time, in their differing motives—and audiences—they also mark an important development in the economic conditions under which art was being made toward the end of the sixteenth century, developments that impinged strongly on the artists' relationships to their patrons and hence on the form and substance of their art. It is to these developments that we now turn our attention.

8

Bottom's Dream: The Autonomous
Artist and the Audience

The great efflorescence in the English arts at the end of the sixteenth
century was fostered by socioeconomic as well as by intellectual
and political change. In particular, the shift from traditional patronage
to open-market sale, by shifting the initiative from patron to artist,
encouraged artistic autonomy. Earlier, we saw how the young blades
of the Inns of Court struggled for intellectual independence within
the old system. But a second group of even freer spirits broke more
fully (though never wholly) from establishment patronage; I refer to
the clutch of professional writers and artists in something like the
twentieth-century meaning of the term whose hatching out in the 1580s
and 1590s was such a remarkable phenomenon. These men were not
altogether without antecedents. John Heywood, "the last minstrel," as
Hyder Rollins called him, was never a courtier in the way Wyatt or
Ralegh or even Spenser was; he seems to have been content to be an
entertainer, by and large, and his work rarely displays the humanist's
intellectual or social ambition. But he wore court livery all his long
life. Gascoigne, as we have seen, rejected the servility of patronage with
one hand (*Tam Marti*) while courting the security with the other (*quam
Mercurio*): his last work, *The Steel Glas* (1576), unabashedly begs for
support in both dedication and text. Hilliard very obviously exploited
traditional modes of patronage when he worked directly for the queen
or members of the court, then turned toward new markets when he
painted London merchants or sold multiple copies of his portraits of
Elizabeth.

The new men were different. They came out of the background and
training that had produced Skelton, Googe, Grimald, Turbervile, and
Spenser; from bourgeois artisan or mercantile families they went to

local schools, then if they could to one of the universities.[1] But something happened. It involved the frustration of humanistic expectations exemplified in the careers of Spenser and Lyly. It involved the rise of a substantial bourgeoisie educated enough to have developed a taste for the arts and wealthy enough to gratify it. It involved the continuing erosion of old ways—including old ways of patronage. "Like the concept of order and the moralistic hostility toward usury, patronage was in conflict with a world moving from an agricultural economy and a closed society to a capitalistic system and an open society" (E. Miller 1959, 94).[2] The changes in patronage meant that the professionals exchanged the products of their study and labor not for a secretaryship or a sinecure but for cash, and the freedom—to fail as well as succeed—that went with it. The break with the older tradition was not sharp, of course; earlier Tudor artists and writers certainly understood the economic value of their work, while the later professionals continued to set fulsome dedications to men and women of wealth and authority at the head of at least some of their works, and a few achieved documented indebtedness to a single patron for periods of several years. Moreover, those with university backgrounds claimed intellectual kinship with the amateurs of the courtly tradition and publicly scorned the likes of Shakespeare and Dekker. But in what they did, not said, even the University Wits by and large applied an entrepreneurial formula like that of successful visual artists on the Continent, working now for one patron, now for another, going where the market seemed most favorable, carrying their humanistic pride (not part of the baggage of the typical Elizabethan visual artist) into the new fields. And the names of the leading figures in the group—Kyd, Greene, Lodge, Chapman, Drayton, Marlowe, Shakespeare, Nashe, Jonson, Deloney among the writers, Smythson and Oliver among the visual artists—express its importance.

The quality of their work can certainly be related to the strength of the models raised up for them out of the tradition of genteel patronage from Skelton onward. Equally interesting, however, and more obviously a function of the economic conditions in which they wrote, is the coruscating variety of the late Elizabethan efflorescence. Many of the important late century literary types made somewhat tongue-tied entrances in the seventies or early eighties—the sonnet sequence, the prose romance, the novella, the Ovidian narrative—and were then brought to fluency by Sidney and Spenser (to whom the professional writers all owed, and acknowledged, large debts). To these existing

forms the professional writers (and the Inns of Court group with which they had many interconnections) brought a wonderful variety of tones; the changes rung on the sonnet sequence are only the most obvious instance. And they introduced as many new forms on their own: Ovidian epistolary complaint, epyllion, satire, epigram, picaresque narrative.[3] Of these the most important, both intrinsically and in influence on the subsequent course of English literary history, were the forms that announced most clearly the development of a new audience whose loose change fed, clothed, and housed these authors: namely, the bourgeois fiction of Deloney and Dekker, which much more fully than the congeners of *Arcadia* and *Euphues* anticipated the novel, and the popular drama, which was a major source of income for most of these craftsmen from the University Wits onward.

Besides new forms, later Elizabethan writers and visual artists explored new tones. There was a fresh freedom with language and imagery; at about the time when the colloquial ingredients of song lyric, jest book, and interlude, first transferred into more elevated genres by Sidney, were burgeoning into the demotic gusto of Nashe and Shakespeare, Joris Hoefnagel was painting a country wedding (fig. 43). There was a new familiarity, as the princes of *de casibus* tragedy and the knights and ladies of chivalric romance were followed from council chamber to closet and from high table to low dive. Hilliard and Oliver began to paint ladies and gentlemen of the court *en déshabillé*. There was a new literary interest in the quotidian furniture of life, in clothing, jewelry, hairstyles, in household goods, in the routine mechanisms of social and economic commerce, not as symbols or emblems but as interesting in their own right. Secularization of the arts was accelerated by Puritan iconoclasm; the providential turns in saints' lives and exemplary tales took on new vitality in the accidents of romance and Ovidian narrative, while the characters and structures of miracle plays underwent secular metamorphosis in the early works of Marlowe and Shakespeare.

In short, what was happening was something like the explosive enlargement of the range of subject matter, style, and form that went on in the arts of quattrocento Italy. Many of the same factors appeared, such as political ferment not quite amounting to chaos involving a scramble for political visibility of the kind that the arts could help provide. Where fifteenth-century Italians had been stimulated by increased commerce with the French and Germans to the north, the Turks and Levantines to the east, sixteenth-century Englishmen were aroused by increased traffic with Venice and the Baltic, and the excitement gen-

erated by southern European explorations in the Indies and tropical America had its counterpart in English explorations from Guiana to Labrador. There was a corresponding extension of the artist's market to include the middle class, a corresponding relaxation of the bonds of patronage, a corresponding freedom of artistic choice of subject and style, a corresponding fashion for esthetic novelty.[4] The social and economic position of the English professionals (including the nonaristocratic courtiers) corresponded to that of the more successful Italian artists. As groups of artists stimulated one another by competition and the exchange of ideas, so did groups of writers.[5]

The parallel is reinforced by the appearance at the end of the century of a few English visual artists whose relationships with patrons were similar to those of the great Continental artists of the renascence— and whose training, practice, and style exhibited strong influence from Continental traditions. These included the painters Hilliard, Oliver, and Peake and the architect Robert Smythson. In their work, as in that of their literary contemporaries, we can observe the emergence of two closely related attitudes. First, both the literary object and the art object began to be seen as not an offering to God, nor an act of service to a patron, nor an expression of general intellectual capacities or genteel accomplishments, but a commodity—more specifically, a commodity to be vended on a directly competitive basis in an open market. Nothing signals this development more clearly than Philip Henslowe's diary, where the pittances paid for plays are set down side by side with bills for lumber and drugget and memoranda of loans made and repaid to authors and apprentices alike. Some authors continued to be commissioned to write civic pageants or speeches for royal entrees. And such work still arose from institutional patronage. Henslowe and his fellows, however, were entrepreneurial middlemen, moved by immediate profit, not long-range public relations. Second, writers, apparently feeling on social and economic grounds the individual control over their work that, in the previous chapter, we saw developing on intellectual grounds, increasingly asserted themselves as self-conscious Artists.

With these developments in mind we can see that *A Midsummer Night's Dream* (1595?) supplies us with a wonderfully effective comic image of the practice of the arts in England under the Tudors. In the main plot, Duke Theseus as royal patron commissions through his master of revels an ephemeral spectacle to celebrate his marriage, and discourses critically on the place of the arts in life; the work that results, however clumsy, is based on Ovid and articulates the orthodox atti-

tudes of the Tudor aristocracy toward love, marriage, and the drama. The fairy charmer Oberon, working through his artisan Puck, wreaks on the Athenians wandering in his woods the kinds of transformations Marlowe's Piers Gaveston had only mimicked: his is an art whose subject matter is life itself. Puck himself embodies the protean character of the Grotesque; he creates that potent monster the man with the ass's head, and comes out of the forest to set his protective spells on the thresholds and cradles of the palace.

In the subplot, however, some fresh types appear. First of all, we observe a group of horny-handed craftsmen, somewhat awkward in a mystery not their own, who bring to the building of a play not a set of intellectual theories but the craftsmen's attitudes they would have brought to the building of a house or a pair of shoes, striving conscientiously and soberly and ultimately rather unselfconsciously to make something pleasing and useful out of customary materials (Ovidian plot, Senecan rhetoric, rhymed verse), and above all working together, Peter Quince as foreman worrying about schedules and assigning the individual jobs, but everybody contributing to the work such knowledge and talent and ideas as he can. At the center of this group is the vivid figure of Bottom, confident, self-assertive, a weaver of dreams and texts ready to make love to a fairy queen or correct a noble lord, overflowing with energy and invention, eager to shine—a winsome caricature of the authoritative artist. For his ambition, Bottom pays a steep if transitory price: alienation from his natural fellows and the knowledge of something precious had and then lost. In their ignorance, moreover, he and his mates produce a lamentable comedy, ludicrous, ungainly, deformed. But its exquisitely calculated blunders draw our attention toward something even more radically strange: the master artist himself, Shakespeare, autonomous, entrepreneurial, articulating "Pyramus and Thisbe" with the speeches of the Athenian aristocracy to make a whole whose balance of social, ethical, and esthetic elements constitutes perhaps the most satisfying final scene in any comedy of the time.

The works of these various artists and patrons and critics arise from various motives and draw on various resources. Oberon and Puck work with the creative energies of nature itself and are equally rich, potent, wayward, and unpredictable. At the other extreme, the young men represent the narrow classicism of the standard sixteenth-century courtly education, from which they take the ideas they use to organize their own lives and the values they apply to others. Hippolyta and Theseus

express more order than the fairies, more freedom than the young men, more uncertainty than either. Among them they mix confusion and control, predictability and surprise, delight and instruction, success and failure, in a rich blend. Along with its tragic coeval, *Romeo and Juliet,* which brings an equally diverse and daring assortment of forms and themes under an equally firm control, *Midsummer Night's Dream* seems to me the first complete realization in English of the concept, modeled by the great masters of the renascence and adumbrated for England in both theory and practice by Sidney, of the creative Artist, "lifted up by the vigor of his own invention" to set forth a new and golden world that is yet demonstrably and feelingly the one we already inhabit. [6]

Two features of the play represent the salient emphases of the last phase of Tudor art. The first is a self-conscious interest in the artist as character: "I Pyramus am not Pyramus, but Bottom the weaver" (3.1.20–21). The second is an overt concern with audiences and on-lookers, not only the publicly constituted audience of playhouse pa-trons watching a play about aristocrats gathered to see a play but also a hidden audience of voyeuristic stage managers peering through a screen of darkness and vegetation to see the results of their charms: "I'll be an auditor, / An actor too perhaps, if I see cause" (3.1.79–80). Managing audiences calls for a constant, thoughtful use of the properties of space and time as materials subject to the artist's will, not just data of the world in which the artist must live and work: "we see / The seasons alter" (2.1.106–7). And it means a pervasive use of equivocation and irony: "Still thou mistak'st" (3.2.345).

We shall look at the emphases on artist and audience in terms of the debate over the meaning and application of the term *Mannerism* in the next chapter. For the moment, however, let us consider them in themselves. Rensellaer Lee has argued that the "life blood" of what he calls "critical classicism" and others might call renascence art is its "ex-pressive movement," defined, however, not as the movement of feeling from the artist to the audience but as the movement of feeling in the audience by the artist (1940, 218). [7] As the work of Michael Baxandall suggests, the development inevitably followed the imposition of the habits of rhetorical training on a newly pluralistic world. [8] That train-ing confirmed to students, from the very beginning of their studies onward, that the materials of the arts were discrete, passive elements, which artists could dispose in whatever configuration they saw fit ac-cording to the requirements of the rhetorical situation. As long as the materials themselves were felt to be literally *data,* however, given to the

artist by prior authority, and as long as the possible configurations were only to be selected from standard patterns, artists produced works with the paratactic predictability of early Tudor art. As we have seen, the renascence in effect liberated artists to find their own materials by calling on experience as well as authority, and to devise patterns *de novo*. In the visual arts the prime sign of such a process was linear perspective; in literature it was hypotaxis at the level of the whole work as well as the individual sentence.

An especially striking development is the increased incidence of the kind of shock or surprise that arises from sudden subversions of expectation, as in Sidney's transformation of Love from the jolly youth traditionally feigned by painters and poets into "an old false knave," horned, with a thousand eyes, "halfe a Man" and "halfe a Beast" (1962, OA8), or in Nashe's transformation of the Seven Deadly Sins from emblematic monsters into the folks next door *(Piers Pennilesse, 1592, in R & B 875)*. On a larger scale, there is the sudden popularity of the sudden shifts and revelations of romance in the Greek manner, both in translations and in such English adaptations as *Arcadia*.[9]

A second index to the conscious artistic management of reader's or spectator's feelings appears in the growing readiness of late Tudor artists to traffic in deception and suspense.[10] A simple instance occurs in Burghley House, Hardwick, and other buildings where dummy windows maintain external visual symmetry while permitting the internal installation of assymetrical functional elements like staircases. Visually more complex examples include the "curious perspectives" (discussed earlier) to which Shakespeare apparently alludes in *Richard II* (2.2.18), and Chapman in *Ovid's Banquet of Sense* describing a statue of Niobe that makes a fountain by its tears:

> So cunningly to optick reason wrought,
> That a farre of, it shewd a womans face,
> Heavie, and weeping; but more neerely viewed,
> Nor weeping, heavy, nor a woman shewed.
>
> (1962, St. 3)

A third (and closely related) development is the urge toward novelty (often satirized): my lord must have a new suit, the latest French or Spanish fashion, a new *impresa* for the tournament, even a new lady on his arm.[11] A fourth is the exposure of subjects previously concealed behind a name and a prohibition: uncensored eroticism in Marlowe's *Hero and Leander* or Oliver's *Nymph and Satyrs* (1610?); adultery and domes-

tic murder in *Arden of Feversham* (1592). In literature, romantic surprise becomes more common, as when a remarkable series of coincidences allows an obscure prophecy to come true (in the *Old Arcadia*), or a shepherd girl turns out to be a nobleman's daughter (in book 6 of *The Faerie Queene*).

A fifth mode of audience management, which seems to combine elements of the first four and is the most interesting of the lot, first clearly appears (as usual) in Sidney, then spreads: *charm,* both the word and the attribute.[12] The insinuating grace and beguiling wit of both *Astrophil and Stella* and the *Apologie,* the throwaway jokes and ingratiating turns of tone and thought, surely deserve the modern sense of the term; we perceive similar qualities in things as disparate as Spenser's *Muiopotmos* (1591) and Nashe's *Lenten Stuffe* (1599), Mercutio's dream of Queen Mab and the Nurse's affectionate garrulity, the rueful self-mockery of Herbert's "The Collar" and Drayton's "Since there's no help." Charm, of both mien and execution, characterizes the miniature portraits of Hilliard and Oliver (which could indeed be worn as talismans, too), the jewels and trinkets that were the age's favorite expressions of friendship, and the embroideries, often "high fantastical," that were the major element in domestic decoration, along with the grotesqueries discussed earlier. William Cecil at Theobalds and Robert Cecil at Hatfield spent thousands of pounds on clockworks and other mechanical conceits and filled their gardens (as had their Continental predecessors at the Villa d'Este, Bomarzo, Fontainebleau) with elaborate and very expensive "toyes"—including waterworks very similar to those imagined by Sidney for Basilius's gardens in the *New Arcadia* (1.14) (Stone 1973, 88–90; see also Shearman 1967, 125–35).

But *charm* had another, more potent meaning for its Tudor users. The word derives from *carmina,* "song," and at three important points in the *Apologie,* Sidney uses it (and its verbal derivatives) in a sense closer than ours to the earliest English uses, referring specifically to chants sung in the performance of magic (G. G. Smith 1964, 1:151, 154).[13] The figures that flash to mind are Faustus and especially Prospero. His charms, like Sidney's, are means to move earthbound spirits toward heaven; that is the stated purpose of all the arts. In this connection, then, it is stimulating to find the Italian critic Vincenzo Danti setting *charm* between *use* and *beauty,* as though the concept could mediate between earthly need and celestial gift, nature and grace (Barocchi 1960–62, 1:236).[14] Seen in those terms, such mediation involves a contrast not so much between ideal and actual as between an idealism abstracted and generalized and

another, parallel idealism referenced to the individual. Holbein worked in this vein during the first, More-ish phase of his career in England, when his ability to capture personalities in relaxed poses and intimate settings astonished his new admirers. Subsequently, the hieratic urgencies of the court entailed a portraiture concentrating on the sitters' public roles. But toward the end of the century, a quality of fantastic individualism crops up in pictures of the earl of Cumberland, the earl of Essex, and others, in fancy-dress costumes and exotic settings. The most striking is perhaps Gheeraerts's portrait of Sir Thomas Lee (1594), which commemorates his years of service in the Irish wars by showing him in a loose tunic without shirt, hose, or even shoes, in a wild landscape—an English soldier Hiberniated (fig. 28). These paintings have much more freedom and charm than most portraits of the period. And they bespeak an important element in the development of the arts in Elizabethan England, the rapid growth of that esthetic consciousness touched on earlier. What charm can do, here, is to go between some familiar polarities, as Bottom's charm helps us to accept both the world of the fairies and the world of the aristocrats, as the charm of all the mechanicals links the workaday world with the world of the imagination. In a similar way, Juliet and her Nurse can be taken as naturalistically developed characters, as elaborated types, or as idealized exempla of impatience and inconstancy. [15]

These procedures—shock, novelty, deception, charm, equivocation —imply a vigorous development of a sense of artistic control during the last decades of the reign of Elizabeth. People turn to art when other modes of expression fail them. Humanism had taught that learning applied to life, history to current events, *ethice* to *practice,* could disturb mountains if not move them. Hence one of the principal features of the renascence was its radical interest in history and its concomitant sense of the possibility that human affairs might not only change but also advance. Like most enthusiasms, however, this one lost some of its steam in its confrontation with actuality. Harry Berger has traced through *The Faerie Queene* an overall decline in epic objectivity, in the ability of the poem to present its heroic images as universally valid: "Bound up in this development is a growing loss of faith in history and historical process, a growing failure to see any pattern in God's creation. The poet cannot find the traditional and expected pattern of order in the chaotic world that surrounds him. . . . Loss of faith in historical process leads Spenser to a new dependence on poetic and imaginative process" (1961, 97).[16] We saw some other indications of this develop-

ment in the previous chapter, with respect to the changes in the role of the artist brought on by changes in the economic and political context. Louis Montrose has argued that in the postmedieval mind aspiration was always conditioned by an anticipation if not an expectation of failure (1979, 37, 48, 61; see also Helgerson 1978, 903–4). The excitement generated in the Sidney circle in the early 1580s (like that in the Somerset circle thirty years earlier) seems to have alleviated this tendency. But the ending of *The Shepheardes Calender* implies a general sense of the inadequacy of poetry to achieve results in the sphere of public affairs, at least: "My boughes with bloosmes that crowned were at first . . . / Are left both bare and barrein now at erst" *(Dec.* 103–5).[17] Hence the poet moves into spiritualized or estheticized modes. Even Sidney's *Apologie* tends that way; although he trumpets the utility of literature as a means of teaching virtue throughout the work, the peroration emphasizes between the lines of its bathetic ingenuities the metaphysical rather than the ethical value of poetry. Moreover, as Phillips Salman has shown, the customary didacticism of sixteenth-century literature has a profoundly esthetic character: in critical theory just as in experience, delight turns out to be a product of as well as a means to effective teaching (1979, 329–32).

That kind of stylistic freedom implies a distinction between the realm of the esthetic consciousness (whether author's or audience's) and that of the work or its subject. Its appearance marks a great change. As we saw in chapter 3, medieval and early Tudor artists perceived themselves by and large as speaking *for* a collective human consciousness of which they were only representative instances. Their task was to clothe familiar propositions in fresh "garments" nevertheless cut over customary patterns. They occupied the same field as their subjects and their audiences. Later artists, by contrast, came to perceive themselves by and large as speaking *to* a collective consciousness from which they were individual derivatives. They began to make garments for familiar propositions in new patterns and materials, and even to make some new propositions. They stood at the edge of the field occupied by their subjects and audiences—from where, as we have seen, they sometimes spoke for themselves in the subversive language of the Grotesque.

Signs of this shift appeared in widely diverse places.[18] We may detect a form of it in the rise of the virtuoso collector, interested in something like art for art's sake; though the phenomenon did not fully appear before the reign of James I, it began to emerge at the court of Henry VIII.[19] The practical outgrowth of such education was the Sey-

mour group in the time of Edward VI, anxiously learning what the latest and best styles were and then commissioning works along those lines. Henry VIII, Leicester, and other early- and mid-sixteenth-century Englishmen gathered large collections of works of art. But as far as can be determined from the scanty records, their motive seems to have been the sort of eclectic ostentation that marked their houses, court ceremonies, and manners. Not until the first decade of the seventeenth century did there surely appear in England men and women of substantial means either knowledgeable and discriminating themselves, or supported by knowledgeable and discriminating agents, or both, who went after art objects in a systematic way. The flagship collections were those assembled around the sons of James I, first Henry and then Charles, apparently stimulated by, and stimulating in turn, the earls of Somerset and Bristol and the duke of Buckingham. A seamark is established by Daniel Mytens's portraits (1620, now at Arundel Castle) of the earl of Arundel and his wife among their classical statuary.[20] We may see the shift in the courtly estheticism that led young men like Sidney and Oxford to compete in the invention of *imprese,* in the frantic pursuit of sartorial novelty, even in the development of idiosyncratic styles of handwriting.[21] We may find it yet more clearly expressed in the appearance in England of writings about art, literary but especially visual. For criticism as distinct from instruction, attention to work already done rather than to work proposed, implies the emergence of a concept of art as a thing in itself, as having an essential character distinct from the particular end of the particular work, the individual building or entertainment or portrait.[22]

All these activities imply an interest in the individual artist, as distinct from the work. The most striking renascence expression of this interest was Vasari's *Vite* (1550, 1568), but it had begun to appear much earlier. Initially, it was expressed as respect for the artist's technical skill in controlling the medium.[23] Increasingly, however, it came to be the artist's vision that provoked admiration, the ability to compose what is in its effect on the viewer or reader a second nature.[24] In language, this godlike mastery of the materials of experience spoke through periodic hypotaxis, complex metrical and stanzaic structures, variety of rhetorical devices, variety of genres—ultimately, through the kind of incessant modulation of tone we find in Ariosto, Rabelais, Montaigne, Sidney, and Shakespeare. Douglas Peterson argues that members of the generation prior to Shakespeare's, having worked out the poetic possibilities in the vernacular, bequeathed to their followers an instru-

ment for "subjective reflection" (1967, 223). The statement is equally true, however, of the system of vanishing-point perspective, whose geometries locate the single eye of the painter and viewer in space; the visual experience becomes unique, individual, in a way very different from the iconographic generalization typical of medieval art. Peterson's proposition can also be related to the concept of the architect, personally controlling the whole form of a building. In painting and printmaking the special demonstration of *virtu* came through effects of three-dimensional space: modeling of both draped and nude figures and chiaroscuro as well as perspective. In architecture and the decorative arts, artistic power accommodated the practical demands of living patterns and crafts practices to the ideal forms distilled from study of classical models and treatises.

These processes depend upon education in the largest sense of the term and in the renascence were at least initially based on codifiable principles, on method, as we have seen. But because they produce a reality "far clearer and more structured than any perceptual reality," they are able to produce an illusion of "a total order," a noumenal reality that the human mind can turn back on the phenomenal reality from which it was derived (Maiorino 1976, 480, 485; Sypher 1955, 60–61). Such devices, much more fully than the corresponding features of medieval works of art, impose the artist's view on the reader or viewer. Where the parataxis of Traditional art in effect trusts viewers to place their own emphases, renascence hypotaxis tries to control them in advance. Vanishing-point perspective forces the viewer into a fixed position vis-à-vis the images in the picture. In extreme instances, such as Raphael's late Vatican frescoes, the large paintings of Pontormo, Fiorentino Rosso, and Tintoretto, the huge murals of Veronese, the management of perspective devices may produce dizzyingly complex or even ambiguous images. But the uncertainty is imposed by the authority of the artist, not haphazardly produced by the intrinsic incoherence of our experience. In literature, the advanced renascence writer, by choosing now to satisfy, now to violate, the expectations set up by his use of familiar forms and materials, by withholding closure in periodic sentences and larger forms, or by using surprise, prevents the reader from anticipating the next move.[25] The result is to lock the audience into a state of dependency. The relationship may, as we have seen, be essentially dialectic, requiring the experience of the reader or viewer to complete the statement. But the artist always has the first, proactive move.

A common reaction blends admiration with fear—that is, regards artists as magicians of a kind, and their art as magical (recalling the comments about "charm" made above). It seems to the point that the basic materials of the magician—"lines, circles, letters, and characters," as Marlowe's Faustus lists them—are also the basic materials of the artist and the writer. The impulse testifies, however, to an awareness that when they exercise this kind of authority, artists may well have begun independent movement outside the boundaries of social and cultural orthodoxy. Traditional patrons always commanded authority of their own, of course, which in the nature of the case they were usually reluctant to lose or even share. A "liberal" patron like Pope Julius II or the earl of Essex might for a time allow a particularly favored artist a good deal of local autonomy. At any point, however, the patron could (and often did) cut the freedom short, perhaps even by cutting the patronage off (as Leicester may have withdrawn his direct patronage from Spenser and as the queen certainly withdrew hers from Hilliard).[26] And the new patronage of the marketplace had its own insistent orthodoxies. Artists were therefore obliged to move carefully. We have already seen how they could use the Grotesque to suggest heterodox positions through the imagination; Nicole Dacos observes that Grotesque art allowed painters to escape "l'oeil vigilant des patrons et humanistes pour devenir seuls maîtres de leur art" (1969, 21). In reaction to their success, the ecclesiastical authorities of the Counter-Reformation rejected not only Grotesque art but the whole notion of the autonomous artist working outside the constraints of institutional Christianity; indeed, the question of possible relationships between the individualizing tendencies of Reformation theology and the emergence of the idea of the Artist with a capital *A* is very intriguing though doubtless in the end unanswerable.

A similar struggle for autonomy went on in the English literary scene toward the end of the reign of Elizabeth as young writers from both the Inns of Court group and the professional group found ways to resist, to circumvent, or to co-opt the dominance of the court, sometimes marginally, using the Grotesque, but sometimes, as we will see, centrally, from within the establishment, by using some resources of Mannerist and Demotic art. Both the court and the religious establishment sought to retain control, limiting the number and especially the form of portraits of the queen, closing the theaters of London, suppressing satires, punishing politically sensitive writers like Sir John Heyward and others. This is also to suggest that as the artist moved intellectually from a position comfortably within the practices and orthodoxies of

the culture to a position critically outside those customs—from Polonius's position to Hamlet's, shall we say—so the artist moved socially from a well-defined place among the artisans of the culture to a provisional place among the travelers and strangers and hangers-on. Such a shift is enacted over and over again in Shakespeare's plays, to the point where we might identify it as the primary structural device in his work: Valentine and Orlando among the bandits of *Two Gentlemen* and *As You Like It,* Hal in Eastcheap or wandering disguised through the camp at Agincourt, Lear and Prospero among fools and castoffs. As Bottom learns, such "translation" brings freedom but also danger; it brings excitement but also anxiety. And the power that comes with marginality strains and sometimes ruptures the social nexus.

We are dealing here with the specifically artistic aspects of a more general phenomenon, what Stephen Greenblatt has called "self-fashioning." Consider the contrast between the arms borne by a medieval knight and the fantastic ad hoc devices invented for an Elizabethan ceremonial tilt. The former express iconically a manorial and familial history and character of which the particular bearer is only the temporary custodian; they make him as much as or more than he makes them. They are fixed and public. Romantic *imprese,* such as those described by Sidney in the *New Arcadia* (1.16, 2.21) and actually worn at the annual Accession Day tilts, are by contrast highly individual, devised for a particular person and a particular occasion; they are ephemeral and often secret, masks as much as announcements (Strong 1977, 129–62). Malcolm Airs has perceived behind all renascence architecture the idea of a great building as a means of achieving personal fame (1975, 8). The impulse sounds most clearly in stone boasts like Wollaton or Hardwick, lofty piles dominating the surrounding countryside from the tops of hills, but it is also discernible in the hunting lodges, "high and alone," that became fashionable around the turn of the seventeenth century and that Basilius's retreat in *Arcadia* seems to have anticipated (Girouard 1963a, 736–39).[27] By 1570 or so the regal insolence of Holbein's Henry VIII, standing astride his Turkish carpet like a colossus, or even the rather swaggering *sprezzatura* of Scrot's Surrey, had for the ordinary Elizabethan knight or burgess, commissioning his or her iconic portrait, given way to a much more reserved, sober, inward-focused pose. But full-length pictures of the queen opened the way for aspiring men like Leicester, Cumberland, and Essex, who all had themselves painted standing with legs akimbo in full armor or full court dress, haughtily staring at the world and looking tall enough (Manner-

ist disproportion between head and body tending to exaggerate their apparent height) to please even Mercutio (fig. 43).

Only a few gentlemen (Gower, Hilliard, Nathaniel Bacon) were skilled enough with the brush to produce literal self-portraits. But A. C. Hamilton's treatment of Sidney's life as the preparation and presentation to the courtly world in England and abroad of a series of personas—"from his birth he began to live the legend confirmed by his death" (1977, 12)—teaches us to perceive how a whole generation of young, well-born Elizabethans, educated in the praise-and-blame mentality of epideictic rhetoric and living in a court where messages of all kinds, whether they dealt with love or war, were conveyed through images and emblems, in effect invented characters for themselves. Yet individual self-dramatization was, after all, only the personal version of a national undertaking, which expressed itself through the linguistic chauvinism of Ascham and Mulcaster; the poetic programs of Sidney, Harvey, Dyer, and Spenser; the new historiography of Smith and Camden; the topographies of Norden and Speed; the history plays of Shakespeare and others; Drayton's *Poly-Olbion;* the borough and county coats of arms in Burleigh's hall; and Elizabeth's incredible wardrobe.

The more artists are aware of the self, explore the self, assert the self, the more they must question their relationships with the world outside the self. With respect to sixteenth-century English lyric poetry in general, this process has been analyzed by Jerome Mazzaro. He suggests that the European intellectual trend toward individuality and subjectivity was encouraged by despotism, which drove the bruised personality inward; among the results were a push toward novelty and a tendency for the poet to speak through an individuated persona rather than the normative voice of earlier work (1970, 16–17, 107, 135, 165; see also Greenblatt 1980, 177). The process is associated with interest in the idea of man the microcosm. Life being what it is, however, the microcosm is likely to become a mote, a reed, a thought in a shade. As an idea, Vitruvian man fills his circle from top to bottom and from side to side. In perspective, in terms of experience, from the intellectual distance of the esthetically conscious and spatially sophisticated observer, he is a poor, bare, forked animal stretched out upon the tough rack of the world. Eventually, such inquiries lead into the deepest ontological, epistemological, and metaphysical uncertainties; we will look at some artistic manifestations of the process in the next two chapters. But the earliest and best defined re-visions come in the artists' relationships with institutions, and expecially with those institutions to which they are most obviously responsive.

Eric Mercer notes that until about 1570 the style of easel portraits and miniature portraits was similar; after that date, the styles diverged. The divergence reflects a dualism that only wealthy courtiers could afford to express (miniatures, as jewels, were more costly than easel portraits), between their public servility and their private individualism (1962, 195–98; see also Strong 1983, 9–12). But Mercer's proposal links with other features of later sixteenth-century English life to indicate the emergence of a general distinction between public and private selves that appears to have been a relatively new thing. Neither the conditions of manorial or monastic life, organized around hall and dormitory, nor a practical morality and theology expressed in fixed roles and hierarchies invited the distinction. It does not appear to be expressed by Chaucer, by the Gawaine poet, by Castiglione or Elyot (although it is by Machiavelli). Lancelot's struggle in Malory's *Morte Darthur* is moral and theological, not social; he does not shed his knighthood when he sheds his clothes; naked, filthy, and insane, he still displays the lineaments of gentility, unlike Edgar in *King Lear*. The conditions of life changed, however. Manor houses developed private dining rooms, bedrooms, chapels, closets. The monasteries were dissolved. The spreading waves from these changes resonated with the emphases of renascence educational theory and practice and of post-Reformation theology on the primacy of the individual mind and soul. Gascoigne repeatedly insists on the compatibility between his Martial and Mercurial selves in a way that Wyatt or Surrey do not, implying that he feels some stress between them. George Gower vaunts his education, and Nicholas Hilliard his medium, as genteel accomplishments that lift them above the mechanic rout; evidently their professions and their allegiances are at odds. Sidney in one place distances himself from "base men with servile wits" who sell their writings for money, and in another complains wittily about the tension between his public obligations and private desires. Shakespeare dramatizes various forms of the conflict in *Love's Labor's Lost, Henry VI, Measure for Measure, Antony and Cleopatra, Midsummer Night's Dream,* and explores the ambivalences of self-consciousness through Richard III, Hal, Viola, Hamlet, Edmund, and Prospero.

In all these cases the institution against which the various authors can be seen to be reacting, whether in their own persons or through some mask, is the court. The frequency, the intensity, the varieties of resistance increase decade by decade, until by the 1590s the culture is producing an art that either ignores the court almost entirely (the bourgeois fiction and drama of Dekker and Middleton, the bourgeois por-

traiture of Hilliard and Oliver) or, what is in many ways more interest-ing, seems to treat the court on the artist's terms as well as the court's. I am now working on ideological as well as on practical grounds: it is a matter not just of the new forms of patronage already treated but of new attitudes toward the old patrons. For ideological as it has already for practical matters, *Midsummer Night's Dream* supplies a para-digm (with some help from *Love's Labor's Lost*). And the point of focus is the lamentable comedy of Pyramus and Thisbe. The mechanicals have apparently competed for this commission against other entrepre-neurs, for the master of the revels asks Theseus to choose among several possible entertainments (all evidently unsuitable on some ground or other). Though Philostrate predicts crude work, the Duke announces himself at the outset ready to take the will for the deed: "For never any thing can be amiss, / When simpleness and duty tender it" (5.1.82–83). Nevertheless, neither he nor any of the court spares the lash when they comment on the performance and the performers.[28] The implied ironies ("but yet in courtesy, in all reason, we must stay the time" [5.1.254–55]) appear more sharply in *Love's Labor's Lost,* where a character very simi-lar to Bottom, Costard the clown, responds to similar sarcasm with corrections and appeals for leniency—"a marvellous good neighbour . . . but for Alisaunder—alas, you see how 'tis—a little o'erparted"— and a character similar to Peter Quince, the schoolmaster Holofernes, correctly assesses the taunts of the young aristocrats—"This is not gen-erous, not gentle, not humble" (5.2.583, 629).[29] In both works, the play-within scene leads to an oddly dark ending, which involves in *Love's Labor's Lost* stinging rebukes by the women of their own class for the lordlings' self-centered foppery. And it is worth noting that although productions of these works typically mime the remuneration, in cash, of these members of the lower orders for their conscientious disasters, in neither of them does the text in fact specify any reward; it is thus quite possible that the poor are sent empty-handed away.[30]

I do not mean here to propose some fully revisionist reading of these plays but only to call attention to some problematic features. The issue is especially urgent because these episodes occur near the ends of the plays, at points where according to the most widely ac-cepted understanding of Shakespearean comedy the initially rigid and impotent world of the play ought to have been corrected and reani-mated. In fact, none of the social lessons that might have been taught the young gents by their experiences in the woods, about their own limitations, about the necessary balance between freedom and respon-

sibility in sexual as well as social relationships, seems very fully to have been learned. In the last pages of *Midsummer Night's Dream* the women scarcely speak, nor do the men address them; it is all reduced to the same old courtly display behavior.[31] In the widest context, what this means is that the lessons of the play are really for the audience, not the characters. Those lessons include a hefty dose of skepticism about the appropriateness of the courtly formulas as guidelines for behavior. And they include a significant suggestion that true virtue lies in action, not condition. In a wider context yet, such a notion calls into question all sorts of a priori propositions—philosophical as well as political. I say "calls into question" advisedly; Shakespeare reaches no firm conclusions here, and his work is often explicitly ambivalent, as in those many instances where his characters express the traditional view of women as weak and vacillating even as the women they are talking about (sometimes they themselves) are displaying conspicuous fidelity and endurance. The point is that things once firmly settled, such as matters of social value and personal identity, have lost their solidity, have taken on the provisional quality of a play, of a dream—"Methought I was—there is no man can tell what. Methought I was, and methought I had—but man is but a patch't fool, if he will offer to say what methought I had"—which so baffles the ordinary senses and expressions that it can only be turned into art: "The eye of man hath not heard, the ear of man hath not seen, man's hand is not able to taste, his tongue to conceive, nor his heart to report, what my dream was. I will get Peter Quince to write a ballet of this dream. It shall be called 'Bottom's Dream,' because it hath no bottom; and I will sing it in the latter end of a play" (*Midsummer Night's Dream* 4.1.207–19).

9

All This Knav'ry: Mannerism and
the Demotic in the Arts of Tudor England

The figures of Bottom and the other mechanicals face to face with the men of the court, of homeliness contrasted with high fashion, lead our attention toward a consideration of the Mannerist style, which has dominated most recent discussions of the Tudor arts, but also of what I call the Demotic mode, that involvement with ordinary quotidian actualities that serves as a kind of antidote to idealism in the rational sphere as the Grotesque does in the imaginative.[1] We have followed some developments in the arts and culture of Tudor England that gave artists an ever wider range of subject matters and forms with which to work, an ever larger and more various clientele, new forms of patronage, new ideas about themselves. We have seen how the initiative in all kinds of transactions, from choice of subject to the smallest details of execution, increasingly moved from patron to artist, who correspondingly gained in freedom, both to assay and to fail. At the same time, the old forms and ideas and patterns of behavior retained a great deal of vitality. No artist trying to live and work in a capital like Elizabethan London could afford too obviously to ignore, much less to confront, the establishment, not only religious and moral and political but economic: the fates of Gascoigne and Drayton and Hilliard ceaselessly struggling for patronage, of Spenser stuck in Ireland and Sidney rusticated to Wilton, of Marlowe and Greene dying in low surroundings, of Davies and Marston watching their books burn or Donne listening to his children cry, tell us much. Successful courtiers and bishops, great landowners and rich merchants, all enjoyed great power and, because they had almost all come through the same system of training and testing, tended to share assumptions and expectations. In a period whose

esthetic and educational practices rested on the idea of imitation, the established forms and procedures retained great authority regardless of the specific situation; Raphael or Holbein or Vitruvius for the painter or architect, Vergil or Petrarch for the poet, demanded attention. In other words, even more strongly than at some other periods, the late Tudor artist of merit worked within the tension between new freedoms and old constraints.

This tension—yet another version of the gap between ideal and actual—has been extensively treated in the animated discussion carried on in recent decades by historians of all the arts concerning the term *Mannerism* and its connections with the terms *Renaissance* and *Baroque*.[2] Few topics in cultural history have stirred up more disagreement or generated more confusion, and it is with some reluctance that I put another contribution on the pile. But much of the previous interarts criticism of the period has involved this term. And although the controversy brings the methodological and historical problems of interarts criticism right to the fore, by the same token the questions raised are far too important to be circumvented in a study of the artistic and literary styles of Tudor England. As I noted in considering the parallel term *Renaissance,* a survey of such a nomenclatural controversy has the effect of calling up a good many related issues and hence serving as a kind of summary. It appears, moreover, as though the argument were moving toward the kind of uneasy consensus earlier reached by scholars around the terms *Renaissance* and *Baroque*. Livio Dobrez expresses it sensibly:

> Now terms available at present in this field are certainly inadequate. Renaissance covers too much and fails to make distinctions which are occasionally required; Metaphysical is misleading and limiting, drawing unwarranted lines between the poetry and the drama of the period and failing to distinguish between the very different talents of, say, Donne and Crashaw; as for Tudor, Elizabethan, Jacobean, and Caroline, these labels provide little more than a chronology of royal families and individuals. We need a term with wider connotations than Metaphysical, narrower connotations than Renaissance and, on present evidence, Mannerism is, for good or ill, the term we will use. (1980, 85)

My treatment of the Mannerism question will therefore bring this book toward a close, as my treatment of the Renaissance question opened it. Still, there will remain some crucial characteristics of the best late

Tudor art and literature that analyses dominated by the word *Mannerism* cannot more comfortably account for than can those constrained by *Renaissance*.

Most of the authorities agree that although the term has been widely used in historical and/or ideological senses only during the last century or so, it descends from *maniera*, "style," a word used by Vasari in the mid-sixteenth century with neutral or positive connotations but applied by the seventeenth-century critic Giovanni Pietro Bellori to tag a set of sixteenth-century painters whom he charged with the degradation of the great achievement of the Renaissance. (Note that the term has an intrinsic descriptive element, much more significant than the etymologically mysterious *barocco*.) Most authorities agree on certain Mannerist characteristics and devices: eroticism; obscure or novel subjects; discordant colors and figures; irrational or ambiguous management of space; calculated violations of classical principles of design or composition; rich decorations; multiple views, scenes, or points of view; and distortion of human and other forms.[3] And there is general agreement on a list of visual artists whose work in effect defined the style, in which the late Raphael, the late Michelangelo, and Tintoretto are the greatest names, and Fiorentino Rosso, Parmigianino, Pontormo, Primaticcio, Giulio Romano, Bronzino, Francesco Salviati, and Vasari himself are among the more noteworthy and consistent practitioners.

Beyond this point, disagreement rules. But it can be organized around two large issues. One concerns the range of the term *Mannerism*. To critics at one extreme, Mannerism comprises only "certain works of a certain kind produced by certain artists between about 1520 and 1590, and only in certain parts of Italy," works based on the exaggeration of High Renaissance principles acquired through intensive direct study of Raphael and Michelangelo, and not necessarily characteristic of the whole oeuvre of a given artist (L. Murray 1967, 30–32).[4] (Such a view is of no interest to us, of course, since it shuts out English art of any kind.) At the other extreme, Mannerism becomes the dominant style in all the sixteenth-century arts of all Europe—including Elizabethan England—and indeed, characterizes much nineteenth- and twentieth-century work as well. But consideration of this issue must finally depend on consideration of another, that is, the *contents* of the term: the origins and motives and forms of the style.[5] And the protean character of the phenomenon appears in the great number and variety of the treatments of that second issue.

For our purposes, the various views are usefully summarized in three

works. In *Mannerism: The Crisis of the Renaissance and the Origin of Modern Art,* Arnold Hauser analyzes Mannerism as what I would call a mode, as the artistic manifestation of a general cultural state (1965). (As such, it appears in many periods and places; hence his discussion moves on from the sixteenth and seventeenth to the nineteenth and twentieth centuries.) The term expresses a crisis, as the subtitle indicates. The Renaissance had been holistic, affirmative, coherent. But under the pressures of a variety of social and intellectual forces it broke down— "all in pieces, all coherence gone"—and its primary philosophical, spiritual, and esthetic legacies were paradox and tension. The Renaissance values survived, but they had to keep company with their antinomial complements, Order with Disorder, Balance with Imbalance, centripetal Affirmation with centrifugal Despair—the very tensions we might expect to find racking an artist alive to new ideas and forms and markets, yet still reined in by a culture largely governed by older ones. To Hauser, the mode's significant stylistic traits are those that signal anxiety or ambivalence or dissimulation: strong chiaroscuro, distortion of figure, diagonal or double-decker composition, and so on. Since the surge and collapse of the Renaissance was a pan-European affair, it affected every European artist not insulated from it by circumstance or temperament, whether painter or poet; hence Hauser's list of Mannerist artists includes virtually all the great names in sixteenth-century and early seventeenth-century literature and the visual arts, including Michelangelo, Montaigne, Bruegel, Tasso, and El Greco. Hauser has little to say about English visual arts. But he awards the usual honors to Tudor and early Stuart literature and gives Shakespeare and Donne important places in his Mannerist pantheon.

A second approach considers Mannerist artists in their professional rather than personal relations to their culture—as a style, in other words, rather than a mode. To the art historian John Shearman, like Hauser extending his field to include literature (and music as well, in addition to the decorative arts, which Hauser mostly ignores), the decisive development in sixteenth-century art was not the collapse of the Renaissance. Instead, it was the continued, sophisticated, knowledgeable application of Renaissance devices by artists who had come to regard themselves as virtuoso entrepreneurs (*Mannerism,* 1967). The painter or plasterer or playwright so conceived sought artistic solutions to artistic problems, not psychosocial solutions to psychosocial problems. Such an artist was competing for commissions from and sales to the most sophisticated patrons. That being the case, he was profoundly

conscious of style—that is, of *maniera*. In order to attract particular attention to his work, he needed to make it contrast distinctly not only with that of his contemporaries but with that of his great predecessors as well. It was the effort to be stylish that produced the deviations generally regarded as Mannerist characteristics. Though Shearman acknowledges the recurrence of certain typically Mannerist elements—distortion, imbalance, crowding, organization around curved axes—his emphasis frees his definition from reliance on any particular feature of style. Whenever you find a sixteenth-century artist exploiting the stylistic resources of his art, whatever they are, as significant in their own right—esthetically, that is, rather than didactically—you have found a Mannerist, he says. Hence his list differs considerably from Hauser's. To him, the definitive literary Mannerists are Guarini in Italy and Lyly and Pettie in England; he calls El Greco a painter who used Mannerist means to non-Mannerist ends, explicitly excludes Tintoretto and Shakespeare, never mentions Bruegel, and names Montaigne only as the victim of a Mannerist practical joke, drenched with water from nozzles in the walls of a garden grotto that were actuated by the weight of an unsuspecting stroller as he sat down to rest.

James V. Mirollo, in *Mannerism and Renaissance Poetry: Concept, Mode, Inner Design* (1984), tries to reconcile the modal and stylish approaches of Hauser and Shearman by defining three different kinds of Mannerism. He centers his argument in the proposition that Mannerism is "art that comments on art, that reveals rather than conceals art"—art, that is, based on close and self-conscious imitation of previous work, on the obligation to "contend with, to quote but not to ape a predecessor whose achievement in a particular genre or form has been declared supreme or unsurpassable, or simply *the* norm" (68). The three strains of Mannerism he finds to be the "mannered," in which artists only *exploit* a few salient devices in the model; the "stylish," in which they *refine* devices in the interest of a hermetic estheticism; and the truly "mannerist," in which they *refresh* the devices by recurring from imitation of art to imitation of nature. These categories allow the term to cover the work of a Michelangelo or a Donne and still to find a place for the anonymous English builder applying to a chimneypiece a design taken from a Continental pattern book, itself based on the designs of a hermetic esthete like Giulio Romano, in turn responding to images in the work of Michelangelo and Raphael.[6]

Mirollo's most useful point (one that also strives to ease the tension among the various authorities) is that from the latter part of the six-

teenth century onward, any of the late renascence styles—Renaissance, Mannerist, Baroque—became available to knowledgeable artists as an option, which could be exploited to some particular purpose, great or small, general or local, and which therefore would not necessarily characterize whole oeuvres or even whole works (68–69).

I will concede at the outset that the whole argument must be academic at least to the extent that no Tudor artist would have called himself a Mannerist or even accepted a call to align himself with one party of artists against another; we are a long way from the hunger for ideology that has governed both the arts of our time and its criticism. For academic purposes, however, we need these terms. Yet some substantial difficulties remain. These involve some of the more intractable problems of interarts criticism using any labels, but two in particular: the problem of the transferability of stylistic features from art to art and the problem of the transmission of stylistic features from place to place. The problems have, I think, undermined many of the earlier attempts to use such terms as *Mannerist* effectively, as a couple of examples will show.

According to Hauser, Mannerist painters expressed their sense of the fundamental discontinuity between ideal and actual worlds (heaven and earth, for instance) by means of double-decker compositions, such as those of Raphael's *Transfiguration* and El Greco's *Burial of the Count Orgaz*. (We might add the Everyman picture discussed in ch. 7 [fig. 53].) Cyrus Hoy, following Hauser closely, transfers the notion of double-decker construction from the visual arts to Jacobean tragedy, especially Shakespeare's *King Lear* and *Antony and Cleopatra*. For the most part, the transfer involves a shift from physical to conceptual elements; thus the characters in *Lear* often invoke or deplore the involvement or indifference of the gods. Much less commonly, the conceptual transfer also receives a visual statement. Thus the climactic scene of *Antony and Cleopatra* calls for its protagonists to ascend into their own funeral monument from the main-stage level that has been the scene of all the previous action (1973, 55, 63).[7] It is not clear to me, however, why such spatial contrasts are peculiarly Mannerist (many medieval miracle plays invoke similar metaphysical concerns and use similar devices in their staging). More to the point: whereas the double-decker composition of the paintings is a fundamental element in them, a primary datum of their subjects and conceptions to which other elements of the works are subordinate and without which the works would be radically different, the corresponding features in the literary works are relatively

local in their effects. In the Raphael painting, the viewer focusing on the kneeling apostles in the lower half of the work must still be aware of the radiant Christ above. But in *King Lear* all happens on one level (including Gloucester's supposed leap from the cliffs of Dover); the appeals to heavenly authority are made only now and then, locally, but in any case the language and the action of the play offer us only a partial and local warrant for supposing that human beings can anticipate either divine retribution from above for their abominable behavior here below or relief from the suffering it produces. Unlike the viewer of El Greco's painting, we no more than the mourners can see the face of God; we must find such assurance as we can in the pitifully transitory joy of the reconciled Lear and Cordelia. As for *Antony and Cleopatra*, cutting half a line, where Cleopatra says to the dying Antony, "We must draw thee up" (4.19.20), fits the play for performance on a stage not equipped with an upper level, a fact suggesting that the double-decker concept is not deeply part of the play's nature.

A second illustration is furnished by the way Wylie Sypher (along with some other critics following him) transfers the *linea serpentinata* from its visual, physical embodiment in Michelangelo's paintings and sculptures to the conceptual realm by identifying it as a characteristic feature of Donne's logic (1955, 155–61). The work he selects as an example is "The Anniversarie":

> All Kings, and all their favorites,
> All glory'of honors, beauties, wits,
> The Sun it selfe, which makes times, as they passe,
> Is elder by a yeare, now, then it was
> When thou and I first one another saw:
> All other things, to their destruction draw,
> Only our love hath no decay;
> This, no to morrow hath, nor yesterday,
> Running it never runs from us away,
> But truly keepes his first, last, everlasting day.
>
> Two graves must hide thine and my coarse,
> If one might, death were no divorce.
> Alas, as well as other Princes, wee,
> (Who Prince enough in one another bee,)
> Must leave at last in death, these eyes, and eares,
> Oft fed with true oathes, and with sweet salt teares;
> But soules where nothing dwells but love

(All other thoughts being inmates) then shall prove
This, or a love increased there above,
When bodies to their graves, soules from their
 graves remove.

 And then wee shall be throughly blest,
 But wee no more, then all the rest.
Here upon earth, we'are Kings, and none but wee
Can be such Kings, nor of such subjects bee;
Who is so safe as wee? where none can doe
Treason to us, except one of us two.
 True and false feares let us refraine,
Let us love nobly, 'and live, and adde againe
Yeares and yeares unto yeares, till we attaine
To write threescore, this is the second of our raigne.

 (1967, 108–9)

Sypher calls the logical development of this piece "tentative, circulat-
ing, shuttling." It is true that it works back and forth between (shuttles?
—the pull toward this kind of metaphor in critical writing is certainly
strong) or, more precisely, calls on now one, now another, of two anti-
nomial sets, namely, that of earthly love, carnal, temporal, corruptible,
and that of heavenly love, spiritual, eternal, incorruptible.[8] The poem
could perhaps be said to have a double-decker structure—except that it
seems rather to blur than to urge the distinction. In stanza 1 the lovers
are in the world, but their love is said to have the qualities of heav-
enly love ("our love hath no decay"), more or less as the mourners of
the count Orgaz stand around his corpse while saints and angels plead
for his soul to Christ aloft. In stanza 2, however, earthly and heavenly
love are separated. In stanza 3 the sets are blended but less confidently
than in the beginning.[9] So stated, the development evidently follows
a standard dialectic pattern. Quite apart from the question whether
Sypher's language accurately represents the logical activity of the poem,
his analysis raises an important methodological question about visual
metaphors like "*linea serpentinata*," "revolving-view," "going about and
about," "circulating."[10] In such visual arts as painting or sculpture or
architecture, a line, once laid down, stays put; its various parts retain
their relationships to each other and to the whole. Some of Sypher's
metaphors imply that Donne's subject—for instance, love—has such
a stable structure, of which Donne's analysis only brings out differ-
ent elements from different points of view. As an *experience,* however,

rather than a set of ideas, and especially as an experience happening in time, the thing itself—the love, the poem—changes as it is discussed or read.

Moreover, like the true double-decker, the true *linea serpentinata* (at least on the scale of a painting or statue) reveals its whole structure to the eye in a single and seemingly instantaneous glance, whereas the reader takes in the "points" of the poem one at a time, each new one displacing and to some extent obliterating the one before it, so that by the time one reaches the beginning of stanza 2 the details of stanza 1 have quite dispersed. In short, Lessing's old distinction between temporal and spatial art forms seems to apply. [11]

My point here is not that we cannot learn something about renascence English poetry by studying Italian or Spanish Mannerist paintings, or even that there are not some things in the plays of Shakespeare and the poems of Donne that arose from ideas and feelings that also animated Raphael, Michelangelo, or El Greco. The trick is to locate the features that seem to affect viewers and readers in comparable ways, to be functionally and structurally comparable, to affect the work on something like the same scale. That inquiry needs to be careful of easy analogies. (The danger is great enough that I have certainly fallen into the trap myself more than once in these pages.)

In discussing these works of Shakespeare and Donne we might usefully notice that they have the kind of intricacy and interdependence of parts we have already noticed in drawing the distinction between paratactic and hypotactic structures. In the mysteries and moralities, the status of God and the status of man are data of the plays, which the plays do not change but only confirm (among other things, by unequivocally rectifying the false understanding of human and divine status of the Herods and Maks and Everymen). They are deeply and constantly double-decker in conception as well as execution, and the same figures always stand on the same deck, so to speak. In *King Lear* and *Antony and Cleopatra,* the status of whatever gods there be and that of humans in relation to them, the status of Roman order and that of Egyptian energy in relation to it, change throughout the works, each being repeatedly revalued by and in terms of the other. We might then consider a distinction between the double-deckeredness of Raphael's *Transfiguration,* in which the Christ above has the visual solidity of the Apostles below, although made radiant by the clouds around him and the brightness apparently within him, and that of Tintoretto's *Nativity,* in which the

angels occupying the attic region of the stable are painted as though evanescent, insubstantial, by comparison with the Holy Family.

All these works might be called *periodic,* in that the relationship of their parts, their syntax, as it were, is not completely determined until the last term has been uttered.[12] In the visual arts, where the movement of the eye, wandering over surfaces, denies strict closure, a conceptual analogue, something that works to the same end, can occur. It may be the image of the infant Christ so quiet and peaceful in his mother's lap, in the geometrical and structural center of the work, or perhaps the descending dove of the Holy Spirit, or perhaps just the tetragrammaton presiding over an allegorical tableau. But not all periods are harmonious. In "The Anniversarie," the last line, by calling bathetically into question the macrocosmic scale of reference of most of the poem's images, urges a substantial revaluation of the earlier elements, a second reading, so to speak, in which we are more alert to ironies. In issuing that call, furthermore, it issues simultaneous challenges to two distinct orthodoxies—the Pauline, in which carnal love is only an expression of our corrupt state ("Two graves must hide . . .") and the Petrarchan or neoplatonic ("our love hath no decay").

The shift to an aural metaphor is calculated. In contrast to *King Lear* and *Antony and Cleopatra,* and above and beyond the differences between tragedy and lyric, dramatic distance and first-person intimacy, the style of "The Anniversarie" draws attention not just to the materials of the poem but to the author speaking them, to the style itself, as an object of interest in itself. The basic tension in the poem, many of its metaphors, even its dialectic construction, go back to Petrarch and beyond. Donne refreshes them by using rhythms closer to those of ordinary speech than those customary in English love lyrics of the time, by inventing a stanza form, by counterpointing his logic against the stanza form at several points (notably the logical breaks at lines 13 and 23). The effect is to invigorate a moribund tradition and thus allow Donne to compete for attention in a market or anteroom crowded with other poets still confined within the outmoded conventions. At the same time, the conceptual twist of the ending, bringing the issue "down" from great moral, metaphysical, and metaphoric "heights" to the quotidian facts of a commonplace love affair, reminds readers forcefully just how they have been beguiled by the artistry of the piece.

I call such admonitions *gnomons,* pointers. The Greek term referred initially to the index of a sundial, then to a figure in Euclidean geome-

try. I have generalized it here to mean, visually, any figure based on the intersection of two straight lines at any angle but a right angle, and metaphorically, procedures that distract readers or viewers from some previously established direction or center (Evett 1986, 120–25).[13] Gnomons remind not only readers and viewers but also writers and artists where they are, what time it is; they have the effect of bringing attention away from the work of art to the experienced world around it. They are ubiquitous in Donne and Shakespeare and quite common in the work of some other writers of the period and in Mannerist visual art, in which angled forms tend to lead the eye out of the painting or building rather than back toward the center, in contrast to the circles and triangles typical of Renaissance art, to the true *linea serpentinata* typical of Grotesque art, and to the wave forms, spirals, and other complex curves of the Baroque. Striking English examples are Gheeraerts's Welbeck portrait of Elizabeth, where the strong directives of the olive branch in the queen's hand and the sword at her feet, but especially the angle formed by the three subordinate personages behind her and the path beyond them, lead the eye out of the picture toward the surrounding actuality, and Hilliard's Henry Percy (figs. 16, 32).[14] And I would insist that while *gnomon* is just as much a metaphor as *serpentine,* it carries a set of associations that are much more appropriate to the actual functions of the elements involved in the works of art. For all that, the primary value of the term is heuristic, not descriptive; though "The Anniversarie" does not in fact twist or point, the term *gnomon* works better than *serpentinata* to remind us of our experience of the things the poem caused our minds to do as we read it, or even to suggest the character of other works we have not read.

There remains the problem of accounting for the characteristics of these works by reference to works by other artists in other media in other times and places, the problem of transmission. Most recent critics who haved worked with both visual and verbal arts have drawn their terms, concepts, emphases, and illustrations from art history, and especially from art historians' analysis of early sixteenth-century Italian painters, sculptors, and architects. Then they have applied the borrowed materials to late sixteenth-century and early seventeenth-century English writers. Few of those writers, however, had much if any opportunity for direct visual experience of Italian art. They could not travel to Italy; they could have seen few if any Italian paintings, fewer sculptures, and no architecture at all. How then can we responsibly attribute important structural and stylistic features of Elizabe-

than and Jacobean plays to structural and stylistic features of Italian paintings? Sypher, Hauser, Hoy, Cousins, Roston, and others derive from Max Friedländer the notion that the devices they call Mannerist express a pan-European *Geistesgeschichte* carried by all the elements of culture. Indeed, I will readily concede that in the decorative arts and portraiture, Mannerist influences on English work were extensive. Artists widely considered Mannerists, beginning with Holbein, did visit England. Many imported books contained Mannerist illustrations and ornaments; in architecture and orthography, pattern books like de Vries's *Architectura* (1577) consisted of little else. There was a market in England for prints (how extensive is still not known), and the print medium was hospitable to Mannerism. Italian and Spanish Mannerist influences were transmitted through Dutch, Flemish, and French intermediaries even before the religious wars drove so many Continental artists across the Channel. Many motifs traveled through the agency of tapestries, majolica ware, and other decorated household objects, which much more extensively than paintings and sculpture seem to have been imported from France and Italy. The immediate sources, however, were predominantly northern, not Italian, though these critics nonetheless all begin with Italian renascence artists, and with the so-called major arts of painting, sculpture, and architecture.

In addition to these practical matters, the issue of transmission opens up a psychological problem. It begins with the question of motive. In answering that question, three factors emerge. The first two both relate to John Shearman's suggestion that we focus on the particular artist facing a particular artistic problem, which might be solved in a variety of ways, rather than on many artists' compulsive commitment to some single vision of the world. The first factor is the force of iconographic programs. Tudor portraits retained the rectilinear axes and centralized composition of Renaissance work long after they had adopted the impassivity, surface polish, and anatomical distortion (especially in the proportion of head to body) widely ascribed to Mannerism.[15] And they tended to retain the same characteristics whether the artist was some reasonably inventive, experienced, even innovative practitioner —Scrots, van der Meulen, Gheeraerts, Nicholas Bacon—or the veriest anonymous hack, and whether the sitter was some restless adventurer like Ralegh or Essex or so stable and resolutely orthodox a personage as Burghley (fig. 27). The style of these portraits has its expressive and iconographic functions. The rigidity of composition and posture invoke order, while facial impassivity and somberness of palette imply

prudence, self-control, a sense of the fragility of earthly things. The high polish and elaborate dress express wealth; the anatomical distortion increases the apparent height and thus attributes power.

Secondly, Shearman's analysis tells us that the style was ubiquitous because it was the style, because that's what an artist competing for commissions in a ready-money market could sell. From the 1570s onward English architecture began to incorporate such Mannerist features as the tapering pilasters, scrolled consoles, obelisks, and strapwork inspired by Michelangelo's Laurentian Library, Giulio Romano's Palazzo del Tè, and the châteaus and hôtels of Philibert de l'Orme and Jacques Androuet du Cerceau, mainly as these were passed through by the pattern books of Wendel Dietterlin and Jan Vredemann de Vries. (Burghley House is the prime instance, but see also the striking courtyard facade of Longford Castle, Wiltshire, illustrated in Lees-Milne 1951.) For the most part, however, these features were only applied superficially to structures whose essential conception remains traditionally English. Even the giant orders of Kirby Hall (c. 1570, and less disproportionate, all the same, than Giulio's) ornament the facade only of a standard English courtyard house. As Nikolaus Pevsner instructs us (1960), not perhaps until the second decade of the seventeenth century did people begin to put up houses in which articulate principles of style seem to have affected the design from the ground up and the inside out—Blickling, north of Norwich (1616–25), remains the finest distinctively English example, though the concept was even more fully expressed in the Palladian severities of the Queen's House, Greenwich (1616; fig. 55). And even these relatively novel houses still remain in the mainstream, if at the head of it, taking their major features from earlier authorities in a relatively unmodified form.

Finally, beyond iconography and fashion, there is indeed, as Hauser and others claim, the possibility that the gnomonic procedures of Mannerism could offer the artist some relief from the tensions invoked at the beginning of this chapter. An artist working within the intellectual, social, and esthetic parameters of the late Tudor establishment could use a gesture that highlighted inconsistencies in the orthodox position or that directed attention to the actual world even though the work ostensibly presented an ideal in order to suggest, without having to assert it directly, an element of dissatisfaction or anxiety or even dissent. In other words, the Mannerist gnomon supplied a resource within the rational aspects of the work analogous to the resource supplied within the imaginative aspects by the Grotesque.

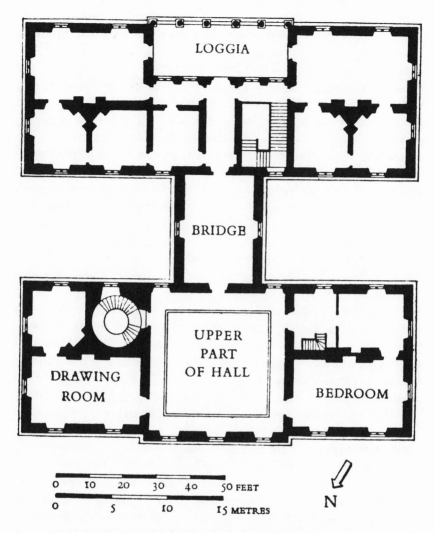

LOGGIA

BRIDGE

UPPER
PART
OF HALL

DRAWING
ROOM

BEDROOM

| 0 | 10 | 20 | 30 | 40 | 50 FEET |
| 0 | | 5 | | 10 | 15 METRES |

N

55. Inigo Jones, The Queen's House, Greenwich (1616), first floor plan. From
Sir John Summerson, *Architecture in Britain, 1500 to 1800*.
Photo: Cleveland State University.

The application of the gnomon helps discriminate among Mirollo's three strains, helps distinguish the Mannerist from the mannered, the explorer from the exploiter. Symmetry, parataxis, the application of ornament, had been general characteristics of earlier Tudor literary style. We feel Lyly exploiting them until they almost become the raison d'être of the work; he rather has his characters speak in order to supply occasions for rhetoric than uses rhetoric to make their speech more memorable or affecting or clear—the renascence sense of method operating on a prerenascence set of forms. The proliferation of ornamental devices on many late sixteenth-century English funeral sculptures has the same effect, though in most instances the crudity of the work suggests a lack of sophistication. A stylistic feature almost unanimously ascribed to Mannerism, and one easily transmitted by prints, is chiaroscuro. It is a ubiquitous feature of Tudor portraiture, of the heavy carving of Tudor and Jacobean furniture, of the strapwork and other surface ornament of late Tudor buildings, and indeed (as a by-product) of the extensive fenestration of later Tudor architecture. When the actors moved from the natural light of the public theaters to the flickering candles of the indoor theaters, the chiaroscuro quality that some critics have ascribed by analogy to the effects of Stuart drama when read was actually present when the works were originally played.[16] Contrasts of dark and light in the imagery of both dramatic and nondramatic poetry had also long been commonplace. We should, however, distinguish between moral and psychological applications. An iconographic use of the imagery of dark and light to express moral contrast has ancient roots. When chiaroscuro is used gnomonically to isolate and hence to emphasize features, as well as or rather than to class them as good or evil, then we can call the device Mannerist. The feature is especially striking in the work of Ralegh, Marlowe, Chapman (all said to be members of that shadowy brotherhood the School of Night), and Greville (see Bradbrook 1965). When Marlowe allows us to follow Leander into Hero's darkened chamber, the visual effect referred to is distinctly erotic—and not obviously judgmental:

> Unto her was he led, or rather drawne,
> By those white limmes which sparckled through the
> lawne.

> (1973, 2.241–42)

The Mannerist label fits most comfortably on clothing, always an index to status and role. Then as now, style mattered in dress, and even Kate the Shrew is pleased when Petruchio tells her they will

> revel it as bravely as the best,
> With silken coates and caps, and golden rings,
> With ruffs and cuffs, and farthingales, and things,
> With scarfs and fans, and double change of brav'ry,
> With amber bracelets, beads, and all this knav'ry.
>
> (4.3.54–58)

The gnomon here is the final phrase, however, which by suddenly shift-
ing the ethical register of the speech from probative to critical, points
the auditors (including Kate) toward a new and larger context within
which customary behavior is to be considered. A radical use of costume
in pictures, such as the bare legs in Gheeraerts's portrait of Sir Thomas
Lee, has a similar effect.

That is as much as to say that style also matters in undress. George
Gascoigne's *Master F.J.* (1573) stands with others of that remarkable
transitional figure's innovations, the earliest original English effort in
the genre of the erotic novella for which William Painter's translations
from assorted sources in several tongues, *The Palace of Pleasure* (1566),
had established a vogue.[17] In following it, Gascoigne may only have
been attempting to find new English customers for his work. Mas-
ter F.J. himself, however, clearly articulates many of the anxieties of
both the author and the age. The story is set in one of those country
houses so prominent in the history of the visual arts of the period, and
thus inaugurates a tradition without which English fiction would be
radically impoverished. It is a tale of sexual intrigue, full of eavesdrop-
ping and innuendo, deceit, hypocrisy, double-dealing of various kinds
—and of the development of self-awareness in an attractive but foolish
young man. These characteristics seem fresh, even provocative, because
as revealed in the arts, mid-Elizabethan culture was closely buttoned
up. Country-house dialogue, even discussion of love, had appeared in
Thomas Hoby's translation of Castiglione's *Courtier* (1561), but with
none of the erotic elements so prominent in Gascoigne; adulterous rela-
tionships among the lords and ladies of older courtly romance were
clearly censured. On the visual side, nudity is rare in Tudor pictures—
strikingly so by contrast with even other northern European countries;
when it does occur (and almost always in prints rather than paint-
ings) the figures are either clearly emblematic, like the allegorical ladies
who frame Elizabethan title pages, or Grotesque, like their counterparts
around fireplaces and headboards (fig. 38).

When the context of nudity becomes naturalistic—that is, when we
move from Olympus or Arcadia to the next-door-neighbors' bedroom

—a quality of voyeurism is inescapably introduced. Such a sense is ubiquitous in Continental Mannerism, from Fiorentino Rosso and Pontormo through Bartholomeus Spranger and Hendrick Goltzius. The closest one comes to it in Elizabethan visual art is perhaps those miniatures by Hilliard, Oliver, and others that show their sitters en déshabillé, in shirt only, or smock, with loose collar and perhaps a hint of a smile (fig. 31). In literature, however, from Painter and Gascoigne onward, nudity, sexuality, and voyeurism all become more common. Ariosto is routinely assumed to be reflecting the painting of his Venetian associates in his titillating views of Alcina, Angelica, Olympia, et aliae; in canto 28 of *Orlando Furioso* Iocundo spies the queen in the embrace of her dwarf through a little hole in the wall. Something of his eroticism, though chastened, carries over into Spenser's descriptions of Acrasia and her staff in the Bower of Bliss and of Serena, who is ashamed to be seen naked even by her longtime lover (FQ 2.12.63–78, 6.8.37–51). More noteworthy is Malbecco, on his way to becoming Jealousy, forced to watch his wife sporting with the satyrs:

> At night, when all they went to sleep, he vewd,
> Whereas his lovely wife emongst them lay,
> Embraced of a *Satyre* rough and rude,
> Who all the night did minde his joyous play.
>
> (3.10.48)

And more noteworthy yet is Calidore, gazing from under the trees at "an hundred naked maidens lilly white" dancing to the music of the shepherd-poet Colin Clout. The knight is curious rather than prurient, but his appearance at the edge of the wood shatters the vision in a way that images very forcefully the fragile state of the artist's attempt to draw the ideal and the actual into the same realm, for instance by bringing classical nudity into an Elizabethan countryside (6.10.4–30). More purely psychological tensions surround dozens of direct and indirect versions of the Actaeon myth: Sidney's Pyrocles, disguised as a woman, looking upon his beloved Philoclea at her bath in an agony of frustrated desire (*New Arcadia* 2.11); Spenser's Faunus (FQ 7.6.42–53); Chapman's Ovid, peering at his Corinna from behind a bush as his *Banquet of Sense* is readied (1595, sts. 42–46).[18] In all of these instances, by adopting a rhetorical strategy that brings the reader or viewer into a state of complicity, the works gnomonically open themselves out into their actual context.

Shakespeare's voyeurs in a limited, sexual sense—Tarquin in *Rape*

of Lucrece, Iachimo in *Cymbeline*—are unequivocally villainous. More complicated are those lookers-on who use what they see to affect others' behavior, like Iago; indeed, all the Machiavels (including such presumptively virtuous characters as Vincentio in *Measure for Measure*) might profitably be considered in these terms. They are social artists, in effect. They manipulate other people the way a painter manipulates forms and colors; they plot and plan like architects; like playwrights they make scenarios in which they also act, though in Elizabethan plays, including Shakespeare's, usually in minor roles, like that of Don John in *Much Ado about Nothing.* The dangers of entrepreneurial improvisation are always present; even Prospero is ultimately rebuked by Ariel. Yet the appeal is very hard to resist. In Stuart drama, the Machiavels increasingly star in their own melodramas; disguise, imposture, dissimulation, figure more largely. As the audience spends more and more of its time listening to shameful pacts made and honored, hypocrisies confessed, guilty secrets revealed, it is drawn ever further into the eavesdropper's role— that is, made aware of its status as onlooker rather than active participant. It becomes complicit in the artist's *methods,* as we saw the readers of Donne's "Anniversarie" becoming complicit as they become aware of their own vulnerability to artifice (see Greenblatt 1980, 216).

These ideas seem to me productive when applied to work of the most important English visual artists of the late sixteenth century of whom we have much knowledge, Nicholas Hilliard, Isaac Oliver, and Ralph Smythson.

Hilliard commends himself to us in this connection as much in his career as in his oeuvre (figs. 30, 32, 44, 56). As we have seen, most of his miniatures remain within an essentially iconic tradition, planar and formulaic; they are "speaking pictures" in that they were intended to carry very particular messages of devotion or longing to very specific recipients (see Edmond 1983, 38). When he did venture into more elaborate, more open compositions, his work suffered. Still, much more clearly than any other English visual artist of the time, Hilliard constructed a career for himself. The son of a goldsmith (and miniatures were treated more as jewels than as paintings), he seems to have learned to limn in the traditional crafts-practice way, by working in the shop of an established artist, perhaps Lavina Teerlinc or John Bettes (Edmond 1983, 29–30; Strong 1984b, 66–69). As an index to his "self-fashioning," however, observe that in his *Treatise Concerning the Arte of Limning* (written rather late in his career, around 1600, when he had already lost much ground to his great competitor Oliver), he claims rather to have

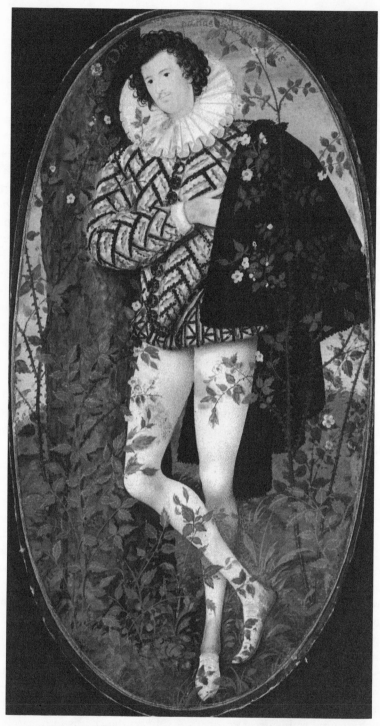

56. Nicholas Hilliard, *Young Man Among Roses [the Earl of Essex?]*
(c. 1587). Reproduced by courtesy of the Board of Trustees of the
Victoria and Albert Museum, London.

founded his work in study of the greatest model for English artists, Holbein, whose miniatures were just as admired as his full-size pictures (but whose work did not deeply influence Hilliard's style). He also sought additional sophistication at the court of France, where he seems to have enjoyed a measure of success and to have picked up additional tricks of the limner's trade.[19] On his return to England, he developed a clientele particularly among the lively young gentlemen of fashion, whom he painted in a style that emphasized physical beauty as much as the character brought out by Holbein or the role and station expressed in the typical Tudor easel portrait.[20] Soon he was in demand by the grandees of the court, and even the queen herself. In the *Arte of Limning* he first insists strongly on the genteel character of his art by contrast with the mechanic labors of ordinary painters, then lays out a few principles very clearly and forcibly. He attracted young painters, including Rowland Lockey and Robert Peake, to his atelier, and dominated the trade in England until Isaac Oliver brought in from the Continent a more expressive style, seemingly more appealing to the Stuart court, and displaced him. He defined himself as an artist, found a clientele, and imposed his vision upon it. He has not been universally numbered among the Mannerists. But his emphasis on not only style but also stylishness, and his awareness of a tradition descending from the great masters of Florence and Rome (especially Raphael), seem to fit him for membership in that company.[21]

All this sounds like a history of unbroken success, at least until the end of the century. Yet Hilliard never achieved real security. Formal court appointment as serjeant-painter went to other, lesser talents, and although he worked for the queen from 1572 on, he received no pension until 1599. Such a life, at once inside and outside the establishment, produced art exhibiting tensions of various kinds. Although most of his images belong comfortably enough to the mainstream tradition of Tudor portraiture, some of the more venturesome include distinctly gnomonic features. The portrait of Henry Percy, the wizard earl of Northumberland, for instance, however crude its management of space, is full of gnomons, both visual (the angular forms of masonry, tree branch, crooked arm, book, the way the feet and gloves overlap the framing wall of the garden) and conceptual (the abandoned pose, cast-off gloves, and dishabille of the man, or the globe-and-feather balance over his head) (fig. 32). (See Strong 1984b, 108–9.) It is even to the purpose to notice that the figure lies in the outer ward, not the inner sanctum, of this *hortus conclusus* of the intellect.

Isaac Oliver's personality and career are less well documented than Hilliard's.[22] But even more than his great rival's, his actual work expresses the new esthetic developments (figs. 31, 46, 48). He was the child of Huguenot immigrants; as the fortunes of the religious wars permitted, he apparently returned to France and the Low Countries for his basic training as an artist. He had thus mastered renascence techniques and subjects (including linear perspective and the nude) before he went to Hilliard to learn about miniatures. Within that genre he used a much greater variety of poses and techniques than Hilliard had, and on a group of subjects that ran from prosperous grocers to King James I. His pencil sought feeling and character beyond the surface features, which might be beautiful or plain. He painted his sitters in bright light or dim, hard-edged or soft, dressed or undressed, with or without symbolic attributes, as the situation seemed to demand, and it is in his miniatures, not Hilliard's, that we can find competent treatment of three-dimensional space, including the first effective uses of landscape. In addition to portrait miniatures, he painted at least one mythological piece, a *Diana,* and one large religious limning, *The Madonna and Child in Glory,* which derives its composition from the Italian Mannerist Federigo Barocci and its iconography from a Roman Catholic tradition curiously at odds with Oliver's Protestant biography. (It can be said that Catholic Europe offered much more interesting and various commissions for narrative painters than the iconoclastic north.) He may also have copied Veronese's *Mystic Marriage of St. Catherine* while visiting Venice in 1596. He seems to have painted some *istorie,* though none have survived to be firmly identified as his; what we do have are drawings of subjects untouched by other English painters, including biblical episodes and a study called *Nymphs and Satyrs* that exhibits the frolicking eroticism of Marlowe's *Hero and Leander.* Here I would especially note Oliver's versatility and flexibility. He adapts his style to the particular expressive requirements of the particular work, rather than imposing the same style on all subjects. And the pictures are often distinguished by gestural effects. Thus a portrait of one man leads us out of the frame by the direction of the subject's gaze and the tilt of his head, whereas another subject, though more centripetally constructed, yet points in a strikingly ambiguous way perhaps to the jewel he holds, perhaps to his heart or liver (the traditional seats of love), perhaps to someone outside the picture (a husband? a wife? a spy?) (fig. 31). We know little of Oliver's life. What we can be sure of is that even more than Hilliard he spent most of it as a foreigner, and that he sought

and found continuous employment by constantly updating his style in keeping with the fashions of the day.

Whether Robert Smythson was a mere builder or an architect properly so called is a matter for dispute. What cannot be disputed is that he was associated with several of the most important building projects of the period (see Girouard 1983). He had some of his early training at Longleat, where he was exposed to the richest piece of Renaissance neoclassicism in England under the authority of an uncommonly well-informed patron, Sir John Thynne, one of the original Somerset group along with John Shute and Sir Thomas Smith. Here he would have encountered a concept of style as the expressive component of the whole program for life that was renascence humanism.

When he went to Nottingham to supervise the construction of Wollaton (1580–88) for Sir Francis Willoughby, another spirit dominated (fig. 23). Three styles go together to make Wollaton. The plan and silhouette, perhaps inspired by Burghley House, represent a kind of Elizabethan Gothic, in which four corner towers and a central lantern tower say "castle" in glass as well as stone. Both the relentless symmetry of the house and its interior layout are carried forward from the main Tudor tradition. The ornament, more profusely applied than in any other surviving structure of the period, is Flemish Mannerist and includes many features directly traceable to the pattern books. The house gives the overall impression of a clamorous struggle for effect, a *dernier cri* quality quite consonant with Mirollo's notion of the mannered.

Smythson's next stop meant another kind of work. The countess of Shrewsbury had been interested in building for a long time, and although of modest origins, she was by marriages and experience a great lady, wife (albeit estranged) of one of the country's richest and most powerful magnates, keeper and companion of Mary, Queen of Scots, and grandmother of a girl with a slender but real claim on the English crown. After a kind of trial run at Worksop Manor in Nottinghamshire (no longer standing), Bess and Smythson collaborated in the design of Hardwick (1590–98). The elements are the same as at Wollaton. But at Hardwick the towers only *imply* "castle," the symmetry is relieved by variety in scale and proportion, the Mannerist ornaments enrich the facade but do not dominate it. The ensemble manages to be impressive, graceful, even powerful—as the lady who built it must have been. And the effect is carried into interior spaces notable for both the variety and the appropriateness of their styles: restrained neoclassicism in the hall, humane gothicism in the stair, rich Flemish Mannerism in

the long gallery, and some extraordinary pastiche of these and others in the great chamber (figs. 42, 51). It is not here a matter simply of striving for effect, but rather of letting effect arise from situation: an attention to nature first, then art, if you will. On the outside, both the building's height and generally vertical emphases and the reflective effect of its windows seem to me gnomonic. Inside, the most striking element is the way stairs, doorways, and windows not only indicate but strongly call attention to changes of level and direction that also mean changes in style or function or realm. For that reason, of these buildings Wollaton seems to me simply mannered, Hardwick more fully Mannerist.

All three of these artists, then, can be seen mastering the available stylistic options of the time and applying them variously (though always within some personal, idiomatic range) at the instance of their various patrons. It is easy to imagine them (especially Hilliard) at the court of Duke Theseus, painting the young people under the trees of the orchard during the day, despising the mechanicals with them at night, making "fancy's images," plying their increasingly genteel trade. I emphasize "genteel" because even when executing commissions from bourgeois patrons, Hilliard and Oliver worked either in a refined, elevated, aristocratic mode or in a Manneristically parodic departure from that mode.

At Hardwick, however, we find traces of another attitude. Great as it is, the house differs from Hatfield, and presumably from other prodigies like Theobalds, Holdenby, the original Audley End, in that the private quarters, though spacious, are distinctly not grand—have, indeed, a modesty of scale, material, and ornament, a kind of homely directness, which reminds us that Smythson built the house for Elizabeth Hardwick, daughter of a country gentleman, not for Elizabeth Tudor. In fact, it is my sense that grand as Hardwick is, something of the same homeliness infuses even the hall and staircase and great chamber, all the public rooms except the gallery—and indeed, not only at Hardwick but at most Tudor country houses. For this homeliness, the continuity within English building practices may account. Whatever the cause, the quality directs our attention to a more widespread characteristic of sixteenth-century English art.

There is an important group of European artists of the period whose work has always seemed to escape the defining parameters of the stylistic sequence from Renaissance to Mannerist to Baroque. It seems to me appropriate to recognize in the most characteristic work of some of the period's greatest artists a profound readiness to grapple with the

most intractable facts of the human situation and the most intractable problems of the relationships between humans and the macrocosm. It is precisely this seriousness that makes the literal meanings of the term *Mannerism* fall so awkwardly on the oeuvres (if not always the individual works) of Rabelais and Montaigne, Bruegel, Cervantes and El Greco, Shakespeare, Donne, Herbert. At the same time, these figures all share a notable openness to and love of the earth, of ordinary daily common human life, which also appears in Caravaggio, Rubens, de la Tour, Rembrandt, Vermeer, and Velasquez, but not in Van Dyck, Bernini, Poussin, Crashaw, Milton, Corneille—a kind of working crafter's sense of the importance of raw materials, of tools, of sweat, of the other workers in the house or shop or street, a kind of responsibleness, to which the label *Baroque,* with its implications of monumentality, opulence, princeliness, seems to me equally inapt. The artist who can create Bottom is an artist who has touched bottom himself, digested inadequacy and humiliation as well as the exhilaration of artistic power, slept to dream and risen to labor at his task. What critics of the Hauser school refer to as "disjunctions" and "reverses" and "dislocations" in the work of Shakespeare, Donne, Herbert, are often attributable to those artists' refusal to be governed by the propositions of *any* closed, totally coherent esthetic, moral, or even theological system. The Wife of Bath tells us that Experience can always, on grounds of common sense if not right reason, challenge Authority, as Holofernes challenges Boyet. In order to plan, lead, govern, institutions may pretend otherwise. But ordinary folks know better.

It seems to me very important to reiterate that Mannerist artists worked within the conventions of Renaissance orthodoxy, earning such independence as they could achieve not by abandoning but by exaggerating what they found in their predecessors. They were also able to express some conflicts between ideal and actual by indicating the existence of alternative realities through gnomonic gestures. Work that I will label by the term *Demotic,* however, not only indicates but actually imitates items from the realm of common experience. When Shakespeare wants to comment on the behavior of self-indulgent aristocrats, he can use an official moralist like Friar Lawrence, discussing Romeo from within the institution of the church and in the officially sanctioned terms. Or he can bring on the stage the likes of Costard, Bottom, or the Nurse, either to speak the plain truth in plain and common terms or to highlight by a kind of parody the foolishness of their "betters." More subtly, from within an idealistic context—say, the traditional lit-

erary view of love—he will suddenly bring in the context of quotidian experience by means of a patch of quotidian language: "I will live in thy heart, die in thy lap, and be buried in thy eyes; and moreover, I will go with thee to thy uncle's," the final clause not only breaking out of conventional imagery into the language of common sense but in the process confirming the potentially coarse interpretation of "die in thy lap" (*Much Ado about Nothing*, 5.2.102–4). Such procedures are hardly original with the later Elizabethans; one of Chaucer's great strengths is a corresponding readiness to salt even the most elevated of his poems with common terms, often at moments of great moral or emotional significance: "Who yaf me drynke?" Criseyde says at the instant when Troilus's manly beauty stirs her to love, and the simple line becomes the hinge on which the whole poem swings (all the stronger, of course, because of the allusion to Tristan and Isolde). But my point is precisely that unlike Mannerism (or, indeed, Renaissance art before it and the Baroque after it, and the International Style and neoclassicism before and after them), the Demotic does not depend on the esthetic and cultural conventions of a given period, except in the most general ways. Hence, like the Grotesque, whose sources in the imagination carry over from age to age, Demotic procedures are available to artists of any time; they constitute what I call a mode rather than a style.

At any rate, we can see such procedures working throughout the Tudor period if perhaps more freely and abundantly toward its end. Wyatt, often confined within establishment lines, nevertheless offers some interesting cases in point. Thomas M. Greene argues that Wyatt, much more than Surrey, achieved a truly creative reworking of the Petrarchan materials. One reason was that, faced with the "impoverishment" of English poetic means—forms, rhetoric, prosody—he intensified his poems by intensifying the "reality of the woman" addressed, particularly by putting her in real time and by insisting on her physical rather than spiritual being, making her, as well as himself, vulnerable to the vicissitudes of time and chance, rather than placing her essential self above the accidents of the sublunary world as Petrarch and most of his followers did. This "opening up to the non-self" allows the poet to break out of the hermetic narcissism endemic to the idealistic Petrarchan mode (1982, 247–48). Sidney produces similar effects not so much in his radical turns—" 'But ah,' Desire still cries, 'give me some food' " (1962, *Astrophil and Stella* 71)—whose overt exploitation of the tradition is Mannerist in nature, as in his use, even in those parts of the poems that seem to accept the idealistic vision, of a language close in diction,

syntax, rhythm, and imagery to the language of everyday, sometimes in a whimsical, even trifling way: "Deare, why make you more of a dog then me?" (*Astrophil and Stella* 59); sometimes to set up the very idealism that he elsewhere mocks, so that it becomes earned, not merely assumed:

> Come let me write, "And to what end?" To ease
> A burthned hart. "How can words ease, which are
> The glasses of thy dayly vexing care?"
> Oft cruell fights well pictured forth do please.
> "Art not asham'd to publish thy disease?"
> Nay, that may breed my fame, it is so rare:
> "But will not wise men thinke thy words fond
> ware?"
> Then be they close, and so none shall displease.
> "What idler thing then speake and not be hard?"
> What harder thing than smart and not to speake?
> Peace, foolish wit, with wit my wit is mard.
> Thus write I while I doubt to write, and wreake
> My harmes on Ink's poore losse, perhaps some
> find
> *Stella's* great powrs, that so confuse my mind.
> (*Astrophil and Stella* 34)

Another feature of the Tudor Demotic voice is a sense of the necessity, even value, of work—an idea, after all, that posits a world in which things are not tied into static and inescapable patterns, but rather one where something can be accomplished, that is, brought toward an end. Thus Wyatt:

> I must goo worke, I se, by craft and art,
> For trueth and faith in her is laide apart.
> (1950, 20)

If the attainable end is at best the rupture of a painful relationship, that is the way the world wags. It is here that we can draw the visual arts into view. One of the striking features of Elizabethan portraiture, from Holbein onward, especially by comparison with Italian, Spanish, and French work, is the lack of apparent interest in the ideals of human beauty developed in Renaissance and Mannerist artists by their study of classical models. The figures in Tudor portraits have strongly intellectualized aspects, as we have seen; their individuality tends to be

subordinated to an iconography that emphasizes role and tradition. But by and large the figures, both faces and bodies, are not drawn to look more shapely than nature had originally made them.[23] (The message that Fortune's gifts are arbitrarily distributed was so often stated in the sixteenth century that most people seem actually to have accepted its truth; hence the power of a character like Edmund, in *King Lear,* who evidently does not.) "Here I am," these pictures say, "with all my warts" —as well as my staff of office or coat of arms or emblematic device. In an area of art where idealism might have operated, observation of the actual held primacy instead. Thousands of Tudor families ordered funeral monuments for their parents and spouses; all but a few seem to have been content with the sturdy craftsmanship of the local mason. This does not mean that the monuments are not sometimes elaborate, even opulent; it does mean that they hardly ever seem to be trying to be competitively modish. In short, a practical, commonsensical, no-nonsense strain runs through all the arts in Tudor England, providing a constant counterpressure to whatever idealism was in current fashion.

Hence, while "mere" Mannerists seem content to remain within the stylistic conventions of the reigning authorities of the age, although they strain at them by exaggerating one feature or another, artists such as the Shakespeares and Caravaggios of the world keep stepping outside such conventions altogether, not necessarily in some rebellious, self-centered way, but in obedience to their sense of the common experience of the people around them. Attention to the Demotic features so marked in their art will help us as we look further at an artistic stance that pays concentrated attention to the individual mind confronting its world.

IO

Something of Great Constancy

The kind of self-consciousness that moved the major artists in late Elizabethan England entails a disturbing awareness of a gap between self and other, between the observing or creating writers or painters and the world they have looked upon, the audiences they are trying to reach. The mirror held up to nature, even as it intensifies the colors and clarifies the relationships of the objects it presents, holds its viewers at a distance from what they view; except for themselves, they can see only those things on which they have turned their backs. Such alienation heightens awareness of space and promotes dualistic or dialectic thinking; it may also arouse shame, melancholy, and anxiety. And it fosters certain devices in the arts, including pastoral, parody, the extensive use of irony and paradox—the devices formerly identified with Metaphysical poetry and often considered in connection with T. S. Eliot's notion of "the dissociation of sensibility." Yet there remain also the satisfactions of invention and craftsmanship, of mastery and mystery in their several senses. The achievements of late Tudor art emerge from the interaction of these states.

The self-conscious observer, whether moonwatcher or voyeur, must be intensely aware of space and place. I mean here not just the generalized sensitivity to space discussed in chapter 5, which led toward an awareness of structure as subject to the artist's will, but also a very immediate, practical consciousness of the effect of changes in point of view, distance, frame. Such a consciousness appeared in the late Elizabethan public theater, apparently through the confluence of earlier traditions, scenically very different yet fundamentally similar in important ways. In discussing space in the theater we need to consider two types. The first is the theatrical space itself—that is, the stage with its width, depth, and perhaps height, in its spatial relationships with the place

provided for spectators. The second is the dramatic space—that is, the space imagined in the play. Medieval and early Tudor drama uses space in the planar, cellular manner of the other arts. The sequence of pageant wagons of the York or Coventry cycles is strikingly paratactic; within individual plays, spatial complexity normally extends no further than such rudimentary iconographies as inside/outside (Garden, Ark, Stable) and higher/lower (Heaven-Middle Earth-Hell). The mansions or booths of *The Castle of Perseverance* and the Cornish mystery are organized in purely planar and iconographic terms (and largely regardless of the visual and auditory needs of an audience spread around the periphery of a good-sized field). Within and between these plays and sequences, the fact of travel is sometimes significant (Exodus, Adoration of the Magi, country simplicity to city corruption), but not often richly particularized. No advance in spatial sensitivity can be seen in the later moralities and interludes and the early professional plays. The concept of unity of space meant that neoclassical imitations of classical plays treated space according to method, not the peculiar needs of an individual play or scene, although the single fixed scene was normally a piazza, a space with no particular function or population.

One salient feature of the late Elizabethan efflorescence, however, is a quantum jump in the richness of both theatrical and dramatic space. Permanent rather than ad hoc theaters meant clear spatial definition; balconies, traps, and machines meant greater spatial complexity. Even more striking is the development of the playwrights' spatial imaginations. We follow Marlowe's *Tamburlaine* (c. 1587–88) all over central Eurasia, but changes of scene do not entail changes of tone; the geographical freedom works as an emblem of Tamburlaine's heroic aspiration, no more (although it surely counts on the general Elizabethan interest in geography aroused and fed by mapmakers and travel writers). We follow Lyly's *Endimion* (1587) from garden to desert and back; again the movement is emblematic, for regardless of changes in scene the rhetoric and subject matter of the play remain the same. In *Friar Bacon and Friar Bungay* (1589), however, when Robert Greene shifts the scene from the villages and towns of Suffolk to the palace of Hampton Court to the scholars' lodgings of Oxford, he makes some attempt to shift the ruling values, attitudes, even language, from bourgeois to aristocratic to clerical, from estate to estate, though the changes are modest and likely to yield to other theatrical considerations (the language of the country beauty, Margaret, is no less polished than that of her noble suitors, for example). Still, in these plays, as in Marlowe's

Tamburlaine, the scenic liberties are felt as being to some extent ends in themselves, like the three-dimensional effects of early stereophonic recordings. Marlowe, younger and more inventive than either Lyly or Greene, his sense of theatrical and dramatic possibilities developing fast, gives us in *Dr. Faustus* (1589?) movements from cloister to court, private to public scene, that affect the presentation in a psychological way; the alternation of interiorized soul-searching and exteriorized showing off is an effective device for stimulating and moving the audience of the play. The devices are subtler and more effective yet in Kyd's *Spanish Tragedy,* and may help explain that play's power. (Note that in these works, for the first time, the audience is being made voyeuristically privy to dark secrets.)

But the resources for scenic flexibility of the late Elizabethan public theater were first fully exploited, I think, in the plays Shakespeare wrote around 1595: *Merchant of Venice, Midsummer Night's Dream, Richard II,* and *Romeo and Juliet.* In *Merchant of Venice,* Shakespeare not only contrasts mercantile Venice with aristocratic Belmont, but within Venice gives us the Rialto, Shylock's dark and sober house, and the Duke's court, each with its distinctive atmosphere—originally conveyed by language but visually stimulating to modern designers. Richard II's *pèlerinage humaine* is launched by speeches from Mowbray and Bullingbrook that give passionate voice to a longing for the security of home; Richard's unsteadiness, both personal and political, finds a powerful extended image in his incessant movement, as Bullingbrook's movement (reminiscent of Tamburlaine's, but not so monotonously expressed) signifies his restless ambition; every one of the scenes in which they appear has a different setting. No passage in the Elizabethan drama uses the vertical dimension of the stage more movingly than the scene of Richard's surrender—"Down, down I come, like glist'ring Phaeton"— initiating a fall that finds surcease only in the strikingly contrasted confinement and fixity of Pomfret Castle dungeon. Shakespeare remains unparalleled among the playwrights of the world (unless perhaps by Brecht) in his dynamic use of dramatic and theatrical space. Yet he was only carrying out more fully than anybody else a general Elizabethan awakening to the third dimension. You will remember that at the same period Hilliard, Peake, and Lockey were investigating spatial illusion in painting, and Robert Smythson and his patrons at Wollaton and especially Hardwick were building houses in which one can feel space, within rooms, between rooms, between rooms and the out-of-doors through the medium of large windows, between houses and gardens,

within gardens, being exploited to specific psychological, even rhetorical, purposes.

This kind of conscious movement through space can arouse wonder and delight, as travelers and architects and the designers of pleasure gardens understand. But as Mowbray and Bullingbrook know, there is a dark side. Directed movement, according to some students of perceptual psychology, has this property: that it conduces to melancholy. "Melancholics, then, are gifted for geometry . . . because they think in terms of concrete mental images and not of abstract philosophical concepts; conversely, people gifted for geometry are bound to be melancholy because the consciousness of a sphere beyond their reach makes them suffer from a feeling of spiritual confinement and insufficiency" (Panofsky 1948, 1:168). Piero della Francesca comes to mind, also Piranesi and Escher. The intense melancholy of the typical Bruegel owes much to those small figures, faceless or impassive, posed as though moving along a gnomonic diagonal away from the viewer into the recesses of a vast space. Parmigianino at the beginning and Tintoretto toward the end of the Mannerist phase of renascence art use rapid spatial recession to a point within the picture space but well off its center as a highly disturbing element in their pictorial rhetoric; the same device occurs in the Sieve and Welbeck portraits of Elizabeth and the large miniatures, mostly depicting melancholy lovers and students, of Hilliard and Oliver. In architecture, this is the age of long galleries and of complex staircases with surprising turns and openings that may provoke either delight or anxiety; important examples are in Michelangelo's Laurentian Library, Vignola's Villa Farnese di Caprarola, the Château de Chambord, Cecil's Wimbledon, and Smythson's Hardwick. Indeed, according to Pevsner, "This tendency to enforce movement through space within rigid boundaries is the chief spatial quality of Mannerism" (1964, 223).[1]

Note, however, that the issue is not merely the articulation of spatial distinctions but also the imposition of directed movement, which is to say, of time.

> Spatial 'here' and 'there' stand to one another in a simple relation of distance; two points in space are merely differentiated, there is in general no preferred direction in the passage from one to the other. As spatial factors, the two points are 'potentially co-existent' and in a sense equivalent; a simple movement can transform 'there' into 'here,' and 'here,' after ceasing to be such, can

be restored to its previous form by the reverse movement. Time however reveals, in addition to the distinction and distance between its elements, a unique and irreversible 'sense' in which it proceeds. (Cassirer 1953, 1:217)

The crucial word is *irreversible:* you can't go home again. Theocritus knew that as he looked back along the road that had led him from the hillsides of his native Sicily to the urban bustle of Alexandria, and a similar sense of irretrievable innocence infuses *The Shepheardes Calender,* the pastoral elements of *Arcadia,* the endings of *As You Like It* and *The Winter's Tale.* An almost pathological consciousness of the passing of time (the primary gnomon is the sundial) is, needless to say, one of the most prominent features of Elizabethan and Jacobean literature. It presumably derives in part from renascence attention to history. It expresses itself in part in a fascination with ruins, to which, as A. H. R. Fairchild has noted, Shakespeare and other Elizabethan writers paid much more attention than to buildings under construction (1972, 30–33).[2]

These gnomonic modes are venerable, and ubiquitous. The melancholy of movement from some "here" to some "there" invests the traveler like a mantle (Odysseus, Beowulf, Gawaine); it was majestically enunciated by Vergil and Dante, whence it passed to chivalric romance and courtly dream vision and was caught up in that most frequently reiterated Petrarchan *topos,* the image of the laboring ship:

> Yet hope I well, that when this storme is past
> my *Helice* the lodestar of my lyfe
> will shine again, and looke on me at last,
> with lovely light to cleare my cloudy grief.
> Till then I wander carefull comfortlesse,
> In secret sorow and sad pensivenesse.
>
> (Spenser, *Amoretti* 34)

What seems different about the traveler's melancholy of the later sixteenth century is a note of fear not just personal but cosmological. Mutability and the inevitability of death are as obvious to medieval and Traditional artists as to Mannerists. But such artists mostly show deep confidence in the underlying stability of things, of fixed hierarchies and immutable Nature, and in the undergirding and overarching benignity of God's Providence. J. R. Huizinga and many other historians have investigated the breakdown in that confidence through the fifteenth and

early sixteenth centuries, especially in northern Europe; I will not press the issue further here.

What I will point out is that the negative complement of the delight produced by surprise is anxiety. Even trusted servants and courtiers must have felt some uncertainty as they passed through the rooms and around the corners of Hatfield or even Hardwick toward the ruler or magnate waiting in the privy chamber. There is something curiously tense, even a little fearful, about the shadowy personage who appears behind the family group in Lockey's More portrait; the courtly figures who enter the garden in Gheeraerts's Welbeck portrait of Elizabeth manifest some of the same caution (figs. 16, 49). In literature the line was initiated early and explicitly by John Skelton, just at the turn of the sixteenth century. The protagonist of his dream vision *The Bowge of Court* (1498) gropes through a thickening miasma of courtly dissimulation, perhaps inspired by the discovery that the agency in which the humanistic courtier has been trained to place his chief reliance, language, is liable to be turned against him: the character's name is Drede. Gascoigne's Master F.J. and Lyly's Euphues enter similar labyrinths. More complex versions, seemingly drawn from a revised understanding of the human condition rather than from particularly disturbing experiences with the particular institution of the court, appear in Chapman's *Bussy D'Ambois* and Shakespeare's *Hamlet, Macbeth,* and *Othello.* Nashe's Unfortunate Traveller blunders from one nightmare to another as he follows his master, Surrey, from court to camp, jeweler's shop to jail, through a black-comedy world in which the laugh is almost always on him. The most spectacular expressions of uncertainty in an unpredictable world full of unpleasant surprises occur in Jacobean plays like *The Revenger's Tragedy* (1606), *The Duchess of Malfi* (1614), *The Changeling* (1628).[3] The most moving expression is perhaps Spenser's. The wandering heroes and heroines of *The Faerie Queene*'s first five books are not particularly melancholy, perhaps because they have no settled homes to begin with. The end of book 6 and all of book 7, however, present images of an ideal pastoral world, a kindly home, ravaged by remorseless foes (if not Spenser's own Kilcolman destroyed by the Irish rebels, someplace like it); the last words of the poem envisage rest and quietness only beyond the grave.[4]

A very interesting variation appears in the revised *Arcadia.* Spatially, this is one of the most complex and sensitive works of the period, on both the geographical and the domestic scale. Its early stages, still closely based on the original version, retain a Renaissance clarity

and temper; the social and ethical values seem clear enough, and the characters, though no mere stick figures, can normally be assigned to virtue or villainy even when unruly passions have led them into folly. Book 2, however, presents an increasingly ambiguous picture of an ever-widening world through a series of interlocked tales of lust, rapine, murder, intrigue, betrayal, frustration, and imprisonment, set in assorted places ever more distant from the Arcadian country house of the main plot.[5] These themes, initially distanced by the device of retrospective narration, come closer in book 3, as the abduction of Pamela and Philoclea draws virtuous and villainous alike into a situation of Byzantine complexity. As the scene shifts from pastoral retreat to besieged castle, the center of attention moves from a group of characters who have heroic qualities but whose concerns and relationships are those of Roman comedy (Basilius the *senex*, his lustful wife, their beautiful daughters and the eager young men who are in love with them, their oafish servant, and so on) toward an essentially tragic pair, the Machiavellian intriguer Cecropia and her pathetic, noble son, Amphialus, trapped by her policy but also by the demands of his own chivalric code. Indeed, at the point where Sidney breaks off everybody seems trapped, by lust, greed, fear, and folly, but also by love, duty, and honor, as though to be so trapped were, indeed, our lot in this world.

A similarly complex situation, similarly animated by the ambiguous results of unambiguously motivated acts, by the consequences of folly but also by conflicts between apparently incompatible goods, is the subject of a later romance, Shakespeare's *Winter's Tale* (1611). This play is especially interesting in the present context because it moves us from Sicilia to Bohemia and back, court to country, and because it contains Shakespeare's sole reference (5.2.94–102) to a historical artist, one who has a prominent position in all authorities' list of Mannerists, Giulio Romano.[6] *The Winter's Tale*, unlike the *New Arcadia*, is resolved along satisfying lines: the good the characters have done lives on, their villainies and follies are decently interred. It is crucial, however, that the resolution, though prepared by repentance, patience, fidelity, requires an artifice almost amounting to a miracle. That is because the energies of the play flow from otherwise unbreakable tension among the great, irreconcilable antinomies whose clash resounds, according to Hauser, Sypher, Hoy, and others, at the core of Mannerist art: love and friendship, love and duty, innocence and knowledge, simplicity and complexity, country and court, nature and art, and so on.

In stating this, one need not necessarily accept without qualification

the view that Mannerist dualism reflects some individual or corporate angst deeper, keener, more widespread, among sixteenth-century Europeans than among the thoughtful people of any age.[7] Dialectic set the patterns for renascence education, and the formal dialogue was a favorite didactic contrivance from Castiglione and Bembo through More to Daniel's *Musophilus* (1599). No figure is more common in Petrarchan literature than the oxymoron (which I have earlier identified as a Grotesque rather than Mannerist device); most Petrarchan sonnets have an adversative construction. The elemental early Tudor esthetic device, symmetry, is based on duplication. Yet the partisan contentiousness stirred up by religious controversy and political uncertainty, the literary leadership assumed by those professional disputers the lawyers, perhaps the effects of the vogue for investigation of the various Eastern mysteries with their deeply dualistic character, seem to have helped produce a special fashion for dualistic thinking, writing, and crafting in the latter part of the sixteenth century that affected the work of individual artists.[8] The division in the church had produced two where there had mostly been but one. More fundamentally yet, as Stephen Greenblatt has forcefully argued, the schism opened to some eyes a new perspective in which it became possible to see all institutions and doctrines as essentially fictions, provisional works of the shaping imagination seeking control of the ambiguous data of experience (1980, 113). And such a notion comfortably contains the exploratory attitudes toward authority I have discerned in *Midsummer Night's Dream,* Donne's "Anniversarie," and other works.

Whether or not people in the later sixteenth century were actually feeling less whole than their grandparents had felt, they had easier access to ambiguous modes of expression. It is certainly the case that various kinds of irony and equivocation appear much more extensively in late Elizabethan and Jacobean literature than in earlier Tudor work. No period presided over by the author of the *Praise of Folly* (translated by Sir Thomas Chaloner in 1547, several times reprinted) could be totally without irony; Skelton is often ironic, and More and Wyatt also (perhaps that is one reason they appeal to us more than their contemporaries do). But the dominant early Tudor modes are straightforward. Plain-style verse mostly speaks plain in either its epideictic or its sententious form, while the controversial writings of first-phase Reformation tend to go in for heavy slugging rather than the privy nip. Douglas Peterson traces the later interest in equivocal figures of various kinds to their prominence in Thomas Wilson's *Arte of Rhetoric* (1967, 227).

Rosalie Colie suggests the deep-reaching influence of the classical para-
dox, transmitted through humanistic education and reinforced by the
paradoxes of Christian theology (1966, esp. 33–40). She notes how the
racking antinomies of Petrarch's love sonnets generated raw material
for a hundred imitators. His crucial invention, however, passed only
to the more sensitive and sophisticated of his offspring: his vision of
and from a doubled self, the actual poet, so to speak, windlassed by
love, terrified by death, subject to the whips and scorns of time (and
of his chaste fair), set over against the ideal poet, disengaging himself
by exercise of intellect from the coils of mortality, gazing down upon
his follies from some hard-earned Mont Ventoux of penitential detach-
ment (Colie 1966, 74–89). That dual vision was granted to Chaucer's
Troilus in the palinode of the poem that bears his name. It appears in
some of Wyatt's songs but not, oddly, in most of his Petrarchan son-
nets, nor in those of the other Tottelians.[9] Gascoigne's Master F.J. and
the personas of his *Posies* sometimes express a kind of desperate con-
sciousness of their besotted state but seem powerless to escape it or
even to maintain their awareness for more than a line or two before
returning to a univalent mode of praising or complaining discourse.

In Sidney, however, the double self is at the very center of the
enterprise; *Astrophil and Stella* works through a pervasive device of self-
contradiction summed up in a phrase from the last line of sonnet 45,
"I am not I." The mechanism, simple enough in conception though
complex in application, is the rejection of rhetoric, learning, artifice
of all sorts, in favor of unadorned nature and simple common truth,
in poems that are brilliantly learned, rhetorical, artificial. Yet there is
an important difference between Sidney and Petrarch. In Petrarch the
two selves occupy slots in a clearly differentiated hierarchy of values;
the vision *sub specie aeternitatis* must have the first, last, best word. The
positions in the Sidney sequence are much more truly equivocal; if any-
thing, the rhetorical superiority goes to the man of earth in order to
counterbalance the bias toward Petrarchan orthodoxy presumed to lie
in the reader. (Outside the sequence, which we must ultimately per-
ceive as an elaborate *jeu d'esprit,* Sidney pledges unswerving allegiance
to orthodox morality and theology.) Hence the wit and artifice seem
much more fully ends in themselves, *dulce* brought into balance with
utile because the imposition of esthetic control is so satisfying to both
artist and audience.

It seems to me that only in some such terms as these can one account
for salient features of certain late Elizabethan and early Stuart works.

Marlowe in *Hero and Leander,* even Donne and Davies in their satires and songs, are relatively easy to deal with because their positions outside the framework of orthodox society as bohemians or students imply a license to have their cakes and eat them by alternating licentiousness and moralizing with no sign of hypocrisy. Graver spirits, especially Greville and Chapman, pose graver problems. Greville's poems repeatedly equivocate:

> *Sathan,* no Woman, yet a wandring spirit,
> When he saw ships saile two wayes with one wind,
> Of Saylers trade he hell did disinherit:
> *The Divell himselfe loves not a halfe-faste mind.*
>
> The *Satyre* when he saw the Shepheard blow
> To warme his hands, and make his pottage coole,
> Manhood forsweares, and halfe a beast did know,
> *Nature with double breath is put to schoole.*
>
> *Cupid* doth hide his shafts in Womens faces,
> Where smiles and teares dwell ever neere together,
> Where all the Arts of Change give Passion graces;
> While these clouds threaten, who feares not the
> weather?
>
> *Sayler* and *Satyres, Cupids* Knights, and I
> Feare Women that Sweare, *Nay;* and know they lye.
> (1939, *Caelica* 21)

Poems of this kind, which express a deep mistrust of equivocation in masterfully equivocal rhetoric, occur over and over again in Greville's work; over and over again the pain of perception is balanced by the pleasure of expression, to the point where the doubleness is not an incidental product of the mind at play but an ontological position. Similar things appear in those more serious works of Davies and Donne, of Herbert, Burton, and others, that supply most of the examples for Colie's study. The apotheosis of the mode seems to me to occur, however, in Shakespeare's *Antony and Cleopatra* (1606–7?), a triumph of rhetorical and dramatic artifice so dazzling as to make it seem as though the artist has abandoned even the wire and is standing on his head, with nothing but thin air between him and the center ring forty feet below, juggling three knives and singing "Come Hider Love to Me."

Paradox, irony, dissimulation, all arise from an awareness of the self as radically disengaged from the world around it. The mode thus pro-

foundly engages the artistic self-consciousness with which this chapter has been concerned throughout. Here a major esthetic problem appears. There is a class of pictures—self-portraits—in which self-referencing obviously occurs, often, no doubt, involving some kind of irony.[10] But most visual art objects have no obvious means for indicating the presence of the ironist in the work in the way that the first-person pronoun routinely performs that job in literature. What are the means, then, for self-referencing in architecture, garden design, furniture making, the planning of title pages or ceremonial entrees? One means is through sheer virtuosity of execution.[11] Such mastery becomes obtrusive by comparison with received norms. In the sixteenth century, the norms were often those of Renaissance art. Because they are restful (being balanced in composition and color, customary in subject and iconography), Renaissance works impose themselves without imposing stress. But Mannerist distortion and imbalance break the norm and hence do impose stress.[12] The artists' mastery of technique draws attention—refers us—to their selves. [13]

There are problems: some element of conscious command is always present in the arts, so that distinguishing between the quiet pleasure that all crafters will take in doing the work as well as they can and the self-asserting flourishes of the virtuoso must depend on knowledge and taste, and must inevitably be an uncertain business. Still, some objects seem to thrust themselves forward. Hilliard's *Young Man among Roses* is much larger than the average miniature, but still oval like standard miniatures, not rectangular like other large miniatures that have the format of easel portraits (fig. 56). Its color scheme is unusually pale (although the black cloak supplies striking chiaroscuro effects). The pose is elegant and, because it seems to catch the sitter in a relaxed, private moment, strikingly novel by contrast with most full-length portraits of the time. Above all, the complex imagery—rich doublet, plain but textured cloak and hose, tree/bark, rose/leaves/thorns/blossoms, grass, clouds—supplies opportunities for the kind of virtuoso texture work present in European easel portraits from the early fifteenth century onward but now for just about the first time (c. 1587) attempted on this tiny scale. Both the sitter and the artist seem to be demanding special attention.[14] And while we need not suppose that the artist shares the sitter's melancholy, we can, I think, suppose that even a highly confident professional would embark on so demanding and daring a piece with some trepidation, and experience correspondingly strong feelings at its completion. [15]

Attention to the problem of private self-satisfaction versus public

self-assertion brings on attention to a second problem, the very inter-
esting question whether there is a precise visual analogue to verbal
irony. Can a work of visual art "say" one thing and "mean" another?[16]
More specifically, can we discern in the visual arts in England of the
late sixteenth century anything analogous to the fashion for equivo-
cation, irony, double-dealing, so strongly affecting contemporaneous
literature? Again, there are partial answers. We have earlier considered
the fashion for Grotesque decor and noted that the style depends upon
the juxtaposition of incongruous images, on the simultaneous presen-
tation of different orders (for instance, Christian and pagan, natural
and artificial). In Grotesque art, the juxtaposed objects, and the systems
to which they refer, remain discrete. It can be questioned whether the
two halves of a standard herm really coalesce. But suppose we consider
Mannerism as a kind of art in which the discrete materials of the Gro-
tesque are subjected to the unifying techniques of the renascence—in
particular, are brought into that coherent renascence three-dimensional
space. Such a coalescence does perhaps occur in such relatively sophis-
ticated images as the Hibernian portrait of Sir Thomas Lee, in which,
like Spenser's Artegall, he is both courteous knight and salvage wight
at once (fig. 28), or in cases where the sophistication of the decor as a
whole draws a single form—such as Bottom—into complex relation-
ships with the others around it.[17] Consideration of such works reminds
us that to detect verbal irony the auditor or reader usually has to know
things not being said; it functions vis-à-vis external frames of reference.
There do, in fact, seem to be some visual counterparts. For instance,
initially, at least, the herms defending a fireplace drew some of their
esthetic force from their partial resemblance to the engaged columns,
Gothic or classical, that traditionally appeared at that place.[18]

On a more sophisticated level yet, it seems possible that artists work-
ing against solid, established expectations might use not only icono-
graphic and narrative elements (which in any case usually have clear
verbal counterparts) but also aniconic forms and techniques—color,
scale, perspective in painting, texture or material or structural member
in architecture—to convey mixed attitudes or feelings if not specific
ironic ideas. Michelangelo's Laurentian Library lobby (1524) is full of
consoles too massive for the pilasters they do not in fact support, pilas-
ters tapering toward the bottom rather than the top, niches housing no
statues, staircases leading to no doors, all emphasized by strong con-
trasts in color and texture and by exquisite workmanship; by turning a
plain stone wall into a studiolo of architectural commonplaces Michel-

angelo implies that the work is not primarily a building but a piece of art, designed and constructed not to keep the rain out but to stimulate wonder, to charm.

Similar effects (though less severe and grand) may be perceived in the exteriors of Burghley and Wollaton, the interiors of Hardwick and Knole. In the case of an acknowledged master like Michelangelo, whom we know from letters, poems, and memoirs to have been deeply self-aware, well informed, occupied with theoretical as well as practical questions, we seem authorized at least to suspect the presence of concentric spheres or envelopes of meaning, in a sequence something like this: This is a shelter. But the artist has glorified it and made it grand. But to spend substance and energy making something useful into something grand is wasteful and arrogant; by calling attention to his artifice the artist is calling attention to the waste and arrogance, discreetly sending up his patron. But by agreeing to ornament the plain he has tacitly assented to the patron's values; he is therefore sending up himself. But reason not the need; humans (or at least artists) are great precisely because they can transcend necessity, apply their creative minds toward making a second nature. But this enterprise must be sent up by the transitory puniness of human creations by comparison with the divine. But it is in the consciousness of that disparity that the virtue resides; no credit goes to things achieved without strain or loss. But in the end all aspiration is mocked by the hope of salvation. And so on. Thus Michelangelo, Rabelais, Cervantes. In the case of collaborative projects involving patrons of whose self-critical powers and habits we have no record and artists like Robert Smythson about whose articulacy and theoretical insight we know nothing, we can only guess.

We are on somewhat safer ground with puns and anagrams, a fascination with all the devices of rhetoric, a love of strange new words, extravagant tropes and conceits, new genres; with a willingness to mix styles, to shift from prose to verse and back again, from low comedy to high despair; with costumes and disguises, masks and masques; with a hair-trigger alertness to hypocrisy, deceit, self-delusion; with a demonstrable belief that the materials of art are not monumental idols which the artist serves but protean, subject to the artist's will and hand and to a corresponding suspicion if not conviction that life imitates art in the sense that the activity of a well-nourished mind allows us more or less to make it up as we go along. These prominent features of late sixteenth-century English literature are produced by self-conscious artists in full control of their works, and they seem to express the outlook

of European *manierismo*, stylishness. It seems to me undeniable that they also express much genuine emotional anxiety and intellectual uncertainty, that they are used not only to state the traditional propositions about the uncertainty of all sublunary things, the fickleness of fortune, the inescapability of death, but additionally to investigate those propositions as though for the first time; as Colie concludes, at the far side of an epidemic of paradoxy lay a radically new epistemology, and the long-range product of the new thought was extension of the notion of artistic freedom to the whole fabric of life: recombinant DNA.

It will not do to overstate the case. All Tudor artists some of the time, and most of them all of the time, continued to convey traditional messages in traditional forms. In some of the arts, especially funerary sculpture, the only change seems to have been in the direction of increased size and opulence; the working vocabulary remained much the same. Domestic architectural decoration in stone, plaster, and wood exploited, often crudely, often strongly, a limited vocabulary of Grotesque and decorative motifs through the last three decades of the sixteenth century, although at Speke, Burton Agnes, and Blickling there is early seventeenth-century work that rivals in mastery and refinement good Continental craftsmanship of fifty years earlier.[19] Painters went from half-lengths to full-lengths, filled in the backgrounds, and diligently recorded the almost annual change in the styles of clothing, but except for some works of Oliver, the English portrait wore an iconic mien well down into the seventeenth century; and there were still no native—and not many immigrant—artists doing narrative or genre pieces at any point during the reign of James I. Not until around 1600 did the majority of the books published in England use roman type for the body of the work, and most printers continued to use borders and ornaments twenty or thirty years old that when they were new had followed French or Flemish models already well worn. The devotional and controversial work that constituted the largest fraction of the printers' output changed its emphases somewhat but not, by and large, its methods; the most frequently printed group of sixteenth-century English poems was the psalter of Sternhold and Hopkins, first issued in 1547 and reprinted two or three times a year for well over a century. Sidney and Spenser had applied their new rhetoric, new sense of artistic freedom, to medieval forms; Davies advocated self-reference in quatrains more elegant than Grimald might have written but no less plain; and Shakespeare at his most problematic worked comfortably within the ethical terms of Christian orthodoxy and the esthetic terms of the popular dramaturgy of the day.

In fact, I would like to argue that the special character of late Tudor and early Stuart art, by contrast with its Continental counterparts, depends on its sturdy, even blockheaded, refusal to let go of its crafts origins. Bottom, with his insistence on the rude mechanisms of play making, finally attributes more power to the artist and the imagination than either Theseus or Oberon. The Duke, in his worldly authority, will when pressed adapt Law to recalcitrant Life. But he sees at the heart of the dream only "airy nothing." To Oberon life is a tissue of images and accidents, and the world a dark wood now and then illuminated briefly by some passing moon. Only Bottom knows both the stubborn substance and the transforming form. At the very end of his career, Shakespeare gives us an even richer version of the same myth, when the gross blunderings of Stephano, Trinculo, and Caliban recall Prospero (who comprises the authority of both Theseus and Oberon in a single figure) from his stately dream of eternal fecundity and felicity to a material world in which every third thought must be of his grave. In terms of my recurrent distinction, I might propose that in this work paratactic intensity of focus on the image at hand continues to function within, but also against, the hypotactic hierarchy, and to urge on the audience values ascribed outside the context in competition with those arising from the context. Thus Dogberry insists that he is both an ass and "a wise fellow" (*Much Ado,* 4.2.74–87), and remembering that by recognizing villainy when he falls over it he has solved a mystery beyond the powers of his social and intellectual superiors, we deny either proposition at our peril.

It is easier to assess the achievement of literature than that of the other arts in late sixteenth-century England, and in literature, to name Sidney the most influential figure, Spenser the most representative, Shakespeare the most accomplished. Sidney made a great impact as a patron, not so much directly (too poor and dead too young) as in a kind of hagiographic sense, a fathering figure beneath whose presiding protection other writers might gather. His own work supplied a whole series of pathfinding models—in the sonnet sequence, the courtly and heroic versions of the romance, the pastoral, the masque—which subsequent poets (including Shakespeare) could imitate, modify, emulate. He also presented, in the *Apologie,* not only precepts of varying utility but also a list of the established genres and forms that English poets had not yet mastered: elegy, satire, regular tragedy, ode, and especially epic; within twenty years all the lacks had been filled. Above all, the new freedom, in form, character development, and tone, which Sidney exploited meant that he inaugurated if he did not actually inspire

this strikingly rich and varied period in English literature. Spenser's oeuvre includes examples of every important genre except the dramatic; he brilliantly married the classical and medieval past with the renascence present in not only his work but his life. Shakespeare, for his part, was patronized throughout his career in the traditional manner by Southampton and the Essex group, the lord chamberlain, successive sovereigns. But he also exemplified in a gratifyingly neat way the character of the entrepreneurial artist, learning, traveling, by his judicious variations on familiar modes establishing and exploiting new markets, earning the respect of his fellow craftsmen, the regard of the great, and the second biggest house in town. He, too, stimulated other craftsmen by example more than precept (although we may suppose that he shared at least as much knowledge in conversation over a tankard at the Mermaid as Sidney had spread with his books).

Among them, Sidney, Spenser, and Shakespeare (with support from Gascoigne, Marlowe, Peele, and Nashe; Daniel, Drayton, Davies, and Donne; Cheke, Aschham, Mulcaster, Wilson, and Puttenham; Tyndale, Coverdale, Jewell, and Hooker) completed a process. The process was the validation of the English vernacular as a verbal medium adequate to any expressive task and the adaptation to it (or of it to them) of classical rhetorical, metrical, and generic forms. It also involved the validation of the principal native forms, in the same categories, as competent in their own ways to meet the real needs of English audiences.

In the visual arts, though no names so conspicuously great offer themselves as epitomes (Isaac Oliver the bourgeois court miniaturist and Robert Smythson the artisan country builder come closest), similar processes had been going on. For reasons having perhaps some roots in political, social, and economic instability, in Reformation iconoclasm, in English visual insularity, the achievement here was less. The visual arts remained low on the social scale; visual artists remained dependent on local patrons and inhibited (if also sustained) by the inertia of traditional crafts practice. Visual idioms being less restricted to a single culture than those of the language arts, much of the work was done by foreigners, especially in painting, printmaking, plasterwork, ceramics, and glass, where the tricks of the trade had to be learned in the ateliers of Brussels, Paris, or Venice. Yet these makers, too, were obliged to come to terms with indigenous traditions (or face the apprentices' sticks and rocks). Among them all, they brought together the planar parataxis of early Tudor art and the volumnar hypotaxis of the nineties, the rational historicism of Ciceronian humanism and the fantastic im-

mediacy of the Grotesque. They absorbed whatever they could of the news brought back by explorers of geography, cosmography, anatomy, the cabala. They lived through religious and political upheaval, and adjusted to some at least of the economic and social implications of enclosure, international commerce, the New World.

In short, the English went through the stages and the typical events that Italians had gone through before 1490, Frenchmen by 1530, Flemings by sometime around 1545 or 1550. After nearly a century of getting ready, they were equipped to have the Renaissance. Another process had also been going on, the customary dialectic that has always taken generations of Western artists from rationalism to fantasy and back, from adherence to orthodox ways to rebellious exploration of novelty and back, complicated in this instance by rapid linguistic changes, political uncertainty, and the artistic vacuum created by the artistic abdication of the sovereign. At any rate, by the early seventeenth century the English were confident enough of their native traditions to begin playing at full-gauge neoclassicism.

Jonson's *Sejanus* (1603) kicked off. Within a year or two English collectors were buying in European markets, and Oliver and Inigo Jones had gone to Italy, like John Shute half a century before, to study painting and architecture. Not far down the road were Jones's Queen's House (1616) and the Banqueting Hall at Whitehall (1625), the sojourns as court painters of Van Dyke and Rubens, the Democritean empiricism of Hobbes and Locke and the neoplatonism of Henry More, and those twin climaxes to the last, Baroque phase of the renascence, *Paradise Lost* and the new St. Paul's. Better late than never. But given the work of Sidney, Spenser, Shakespeare, and the high great chamber of Hardwick Hall, better late, perhaps. The hybrid forms of Tudor England have their own energy, vitality, life. They also have their own beauty. And it seems to me to be a beauty that grows very often from the ingenuousness, even sometimes the crudeness, of the work: honest craftsmanship, adapting traditional forms to new demands without either abandoning one or fully achieving the other, often falling between stools, but nonetheless conveying an irresistible sense of common humanity. To judge from the surviving examples (the possible exceptions, such as Nonsuch, Somerset House, and Wimbledon, are the places that have in fact failed to endure), Tudor domestic architecture is on the whole livable— built to a human scale, built to last; there are not many surviving Tudor rooms in which one feels that it would be wrong to sing or laugh out loud or call in the children to meet a guest. Tudor furniture is nothing

if not solid. Tudor portraits present men and women buckling down to serious life, not gods on holiday or nymphs attending a perpetual fancy-dress ball. Tudor literature at its most rarefied almost never loses sight of quotidian actualities and at its greatest manages, by exploiting the whole range of the language, the whole range of the society, the whole range of human concerns, to be the most universal literature known. Renaissance neoclassicism represents, by contrast, the triumph of ideas. When we compare *Sejanus* to *King Lear,* we need not regret that a deeply classical English tragedy was so long in coming.

It is not my purpose, however, to make invidious comparisons. Rather, I have sought to discern among a great many works of Tudor art their underlying similarities in concept, subject, form, and function—in other words, to sketch out a Tudor esthetic. That esthetic has turned out to be, in Karl Kroeber's phrase, "a coherence of alternatives"; at any point, a given feature of a given work will share characteristics with only some of the other contemporary pieces, and indeed may not "cohere" with all the other features of the same work.

Nevertheless, some overall patterns emerge. One of these is the tendency, now assertive, now retiring, of English patrons and artists to draw on the ideas and images built up by the Continental renascence. Though that tendency varied from artist to artist and even from art to art, in a general way it rose and then fell at the very beginning of the period, again in the early years of the reign of Henry VIII, again with the accession of Edward VI, and finally, most strongly, at the end of the century. I have contended that the crucial element in the renascence was education and that two alternative modes of organization governed the arts in sixteenth-century England. The earlier, and more widespread, was paratactic; it arose from the rhetorical concepts of *amplificatio* and *copia* and involved the application to a surface or base of discrete, monovalent items, some decorative, some emblematically expressive. The later, less common but more potent to our modern tastes, was hypotactic; it devolved from the rhetorical concepts of *compositio* and period and involved the articulation of assorted polyvalent items into complex structures, often characterized by surprise or irony. A transition from the paratactic to the hypotactic mode appeared in the ubiquitous Grotesque decor of English houses and furnishings, which turned out to have a literary counterpart in the work of Spenser and other writers.

In addition to education in the narrow sense, an important factor in the development of the hypotactic mode was the education in a wider sense offered by the published results of renascence exploration of both

macro- and microcosm. In particular, the compass and the lens seem to have fostered in late sixteenth-century England a new awareness of space, and to have provoked developments in syntax, both verbal and visual, with which to express it. Willingness to experiment accompanied changes in the social order that led in turn to changes in the system of patronage. In particular, the distinction between aristocratic amateur and common crafters, put under strain from the beginning of the period by humanistic education, gave way at the end of the period to a much more complex hierarchy in which writers, previously restricted to the court, entered the marketplace still wearing the dignity if not the livery of their former calling, and thereby prepared the way for visual artists to flourish at court—although this development, anticipated in the early years of Henry VIII, did not come about fully until the time of Charles I. Finally, and most important, these various lines of change took artists from a position within a fixed and stable hierarchy on whose behalf they expressed a relatively stable set of ideals in a relatively fixed set of ways, to a position on the edge of a rapidly changing world on whose behalf they explored a growing range of phenomena and ideas expressed in forms whose gnomonic shifts of perspective and register drew audience as well as artist into a new understanding.

One valuable result of studying Tudor culture in terms of visual as well as verbal art, of art history as well as literary history, is that it makes more clearly apparent the full set of conceptual, structural, and stylistic options available to the sixteenth-century artist, in any art, and of roles, too, whether social or economic, because it makes more clearly visible than emphasis on either visual or verbal matters alone would permit the full compass of the artist's experience. To be sure, there remain large gaps and areas of blurred vision. Important subjects must be scanted because the raw material does not exist. Urban architecture, for instance—the actual houses in which the most important Tudor artists actually lived and worked burned in the Great Fire or survive only in conjectural restorations. The buildings that had the greatest contemporary influence likewise perished, such as Nonsuch, Somerset House, Leicester House, the Royal Exchange, Wimbledon. So did most ordinary domestic furnishings and implements and clothing; school books, household Bibles and psalters, toys, tools, working plans and drawings, because they were in regular daily use, were worn out and thrown away. About other things important scholarly work remains undone. We still have little reliable information on the sources of English book ornaments, the circulation of Continental prints in

Elizabethan England, the methods by which English painters and engravers were trained, or the extent of artistic commerce with Germany and France, as well as the Low Countries. There is no comprehensive study of Tudor interior decoration, of household utensils, of emblematic painting. Authorities still differ passionately (or grope in confusion) in such areas as stage design and decoration, acting style, the incidence of topical allegory or numerologically based design, the degree of overt and covert recusant resistance to Protestant iconoclasm.

Still, what we can see is impressive enough across the range of the arts in England, and especially in literature: the program whose possibilities had first been suggested by Skelton, More, Wyatt, and Surrey, by Somerset and Shute, Thynne and Smith, Holbein and Hereford, which had been written out by Sidney in the *Apologie for Poesie,* was around the turn of the seventeenth century being widely acted out. And the artist, sometimes reveling, sometimes fearful, in the freedom that comes from self-awareness and self-definition, ranging across an unprecedented variety of subjects, audiences, styles, glancing from earth to heaven and heaven to earth, was transfiguring the materials of experience into something of great constancy, however strange, and admirable.

Appendix: The Special Case
of Sir Thomas More

It is not hard to make the case that the Renaissance in England oc-
curred early, and quite fully, in the work and life of Sir Thomas
More. He encouraged the spread of Renaissance visual culture by his
patronage of Holbein, whose work for More was much freer and more
technically adventurous than his work for Henry VIII. He encouraged
the spread of Renaissance philosophical and literary culture both as the
English contact person for Erasmus and other Continental thinkers and
writers and through his own voluminous and highly various writings.
He was among the first Englishmen to write epigrams. His letters show
strong influence from Cicero. His life of Richard III, written not long
after Machiavelli's history of Florence, initiated modern historiography
in English. *Utopia* is perhaps the most deeply classical book written by
an Englishman prior to Sidney's *Arcadia*. Its debts to Plato, Herodotus,
Plutarch, Lucian, and a swarm of other Greek and Latin predecessors
reveal More's deep and eclectic classicism. Its symmetrical structure
could as well be Traditional as renascence, but the subtle organization
of the parts, and the intricate relationships between the naturalistic and
utopian halves, exhibit a hypotactic rather than paratactic conception
of the form of the book. Even his controversial writings have a richness
of reference and style that anticipates the richness of Hooker.

For all that, I have chosen not to engage More in the argument of the
present book because the circumstances of history conspired to make
him a kind of sport. During his heyday, he participated fully in the
humanistic activities of the England of Henry VIII, of course. But when
the doctrinal and political ruckus over the king's divorce cut him off
from royal favor it also cut him off from influence, and when the Refor-
mation took England into the Protestant camp his allegiance to Rome
meant that his works were in effect exiled, like other recusants, and so
remained largely unknown and unread in England. He thus remains
outside the main line, like a giant boulder whose movement precipitates
an avalanche but does not accompany it down the mountainside.

Notes

INTRODUCTION

1. Sypher's 1985 bibliography lists twenty-one books on art, many entirely confined to continental Europe, none with more than a few pages on England. By contrast, he cites only two books on England, both studies of all the arts (including literature), John Buxton's *Elizabethan Taste* (1965) and James Lees-Milne's *Tudor Renaissance* (1951). He makes absolutely no reference to the many books and articles by Sir Roy Strong, a one-man task force in Tudor and Stuart painting and ceremonial art, or to such other major authorities in that area as Erna Auerbach, Mary Edmond, James Morell, and David Piper. Nor does Sypher cite the architectural historians, including Mark Girouard, Eric Mercer, Nikolaus Pevsner, and Sir John Summerson, who have done so much to expand our knowledge of Tudor and Stuart buildings, to say nothing of the scholars—John B. Bender, Alan T. Bradford, Norman K. Farmer, Jr., Lucy Gent, Ernest B. Gilman, Elizabeth Hageman, Clark Hulse, John Dixon Hunt, Ruth Samson Luborsky, James V. Mirollo, Richard Peterson, and many others— who have followed Sypher into that dangerous but fascinating area between the visual and verbal arts since he published the account of his first visit in 1955. Sypher's thesis, moreover, that Shakespeare is the prime English representative of that international movement called Mannerism, is offered with absolutely no indication that the assumptions it rests on and the critical procedures it follows have attracted much skeptical comment by critics and historians as eminent as René Wellek. As for Roston, see my review in *Comparative Literature Studies* (1988).

2. Various authorities have noted the tendency among literary historians to use the term *style* largely in reference to those features that distinguish one artist from another, and among art historians to use the term in reference to those features that link artists into groups. Most of the uses in the present work belong to the second type; *style* will almost always refer to a set of features (more or less clearly defined) that are shared by the work of many artists working within a given historical period. Sets that seem to cut across historical boundaries, such as those labeled here *Grotesque* and *Demotic,* I call *modes.* (*Demotic* is my term for what other students have labeled *Realism* or *Naturalism.*)

3. Svetlana Alpers's more recent publications have been increasingly skeptical about the validity of stylistic labels even in art history; see esp. "Style Is What You Make It" (Lang 1987, 137–62). Michael Baxandall (1979) argues for a much greater variety of activities and emphases among art historians than the Alperses chose to notice in their article.

4. On his way to a similar if more abstractly phrased conclusion, Jean Laude observes that until very recently paintings and other works of visual art were never subjected to the same kinds of analysis as texts (1972, 478).

5. The fact helps us recognize how deeply people's assessment of the arts of any time or place is determined by their prior experience of art: for instance, we bring to an evaluation of the mimetic adequacy of a painting extensive exposure not only to other paintings but also to still photographs, movies, and television, whereas Elizabethans largely had to judge pictures that used Renaissance techniques according to standards derived from life in a visual environment dominated by Traditional works.

CHAPTER 1. *Plane Style*

1. Commercial and professional interests did some significant building in London, especially Sir Thomas Gresham's Royal Exchange (1567). But only Middle Temple Hall (1570), which has some nice Renaissance touches in the screen, survives. Though many Oxford and Cambridge colleges have sixteenth-century elements incorporating Renaissance details, none extend far: the principles of design and construction remain medieval.

2. Eric Mercer asserts that beginning in the southeast in the mid-fourteenth century, a change in building practice came to affect "vernacular" architecture throughout the country; a similar shift began in the mid-sixteenth century (1975, 5–6).

3. Spenser, in *Colin Clouts Come Home Againe* (1595), condemns the "painted bliss" of a corrupt court whose members sell "all their wealth for painting on a wall" (685, 724, quoted from the Variorum *Works*).

4. Noteworthy recent discoveries include the rather crude moralizing frieze at Little Moreton and the much more sophisticated biblical scenes (based on Continental prints) at Canons Ashby. On the latter, see Cornforth 1984.

5. Erna Auerbach discusses fully the process by which the portrait initials of the Rolls became increasingly Renaissance in style under Henry VIII and Edward VI and then returned to a medieval manner after 1557 (1954). There are anomalies throughout—the woodcuts illustrating Bateman's *Travayled Pilgrim* (1569) include a view of *The House Called Reason* apparently based on Raphael's School of Athens and probably derived from an intermediary print. No comprehensive account of sixteenth-century English book design has yet appeared, although Ruth Luborsky's forthcom-

ing catalog of Elizabethan book illustrations will help fill the gap and at least make it easier for other scholars to assemble the necessary materials. The useful chapter on British books in Jeudwine 1979 is available only in a few major libraries. In sampling approximately four hundred ornamented sixteenth-century books, I found that Renaissance borders, initials, and other ornaments became the norm by 1550, but roman type did not really take over from Gothic black letter until the end of the century. F. W. Reader states that in Tudor wall painting the shift from medieval to Renaissance styles was very complete and very swift, and describes work from the later years of Henry VIII that shows strong Renaissance influences as mediated through the French (1935–36, 254–60, 271–75). But the surviving examples are too scanty to support generalization.

6. Alan T. Bradford has sketched a view of an "aggregative" Tudor style compatible with mine (1981).

7. What I call *paratactic structure* has many affinities with what Kenneth Burke, in his "Lexicon Rhetoricae," called "repetitive form" (cited in Doran 1954, 21). My awareness of this element in Tudor art was awakened by Nikolaus Pevsner's comment on the Perpendicular "refusal to mould space, to knead it together" (1956, 97). For an application of his idea to fifteenth-century English literature, especially Lydgate, see Steinberg 1981.

8. The modest farmhouses moved from various points in the southern counties to the Weald and Downland Open Air Museum in Sussex have designs painted on crown posts, beams and rafters, bargeboards and fascia boards; the brick fill between the beams of the walls is laid in herringbones, and the interior and exterior plaster is combed into straight, zigzag, and wavy lines. George P. Bankart has a whole chapter on pargeting, comb work, and other kinds of exterior surface decoration (1908).

9. An ordinance of 1582 gave to the Painter-Stainers Company of London control over a variety of mass-production techniques for the application of patterns to walls and woodwork, apparently to defend a lucrative trade against the competition of Flemish immigrants (Englefield 1923, 69).

10. B. Sprague Allen asserts that to artists both visual and verbal "the classic world was merely a new, vast emporium where they could secure material that had the powerful attraction of novelty" (1937, 1: 17).

11. Svetlana Alpers cites Francesco da Hollenda's contention that northern art "aims at rendering minutely many things at the same time, of which a single one might have sufficed to call forth a man's whole application" (Lang 1987, 151).

12. A survey of the possibilities can be taken from the inventory of Elizabeth's clothes made in 1600 (and comprising almost one thousand garments accumulated during her long reign). Many of the loose gowns, round gowns, safeguards, lap mantles, and so forth were embroidered only in more or less elaborate nonfigurative patterns. But many had images on

them that (omitting some repetitions) constitute a kind of visual euphuism: fish; flowers; "wormes"; a dead tree; artichokes; suns and clouds; fountains, snakes, and swords; "antickes"; flies, worms, and snails; wheat and branches; rainbows, clouds, and lightning; leaves, pomegranates, and men; a face; snails, worms, flies, and spiders; birds of Arabia; hoops, flowers, and clouds; flames, peasecods, and pillars; pomegranates and artichokes; signs of the zodiac; butterflies; castles. John Nichols reproduces the inventory (1966, 3:500–512). An equally rich catalog of images could be made from the annual lists of New Year's gifts both to and from the queen; an astonishing variety of subjects appears on jewels, platters, fans, boxes, and even (most charming of all) the marzipan decorations on the cake presented to the queen each year by the royal pastrycook. A chronological analysis of these subjects might well supply an effective index to changes in aristocratic tastes. Plasterers, painters, and carvers worked from the same sources. The splendid paneling in the long gallery at The Vyne, Hampshire, finished before 1528, includes animals, goblets, weapons, farm implements, and other tools. At the end of the period, the equally splendid newels on the great staircase at Hatfield House carry fruits and vegetables, together with the gardening implements used to grow them and a portrait of the gardener who supervised their growth, musical instruments, hunting equipment, and the tools of the artists, surveyors, and builders who planned and constructed the great house that these carvings adorn (fig. 50).

13. The other two are the forensic and the deliberative. O. B. Hardison, Jr., reminds us that according to Aristotle the special devices of the epideictic orator are comparison and amplification (1962, 31).

14. Epideictic rhetoric, even more than the deliberative and forensic branches, employs a battery of *topoi* whose content as well as form is determined by tradition, such as the *blazon* and the *descriptio loci,* and tends to attract to it others, such as the ship-in-a-storm formula for expressing the troubled mind, originally developed for more general use.

15. A very curious and interesting insight is supplied by the tale of Hemetes the Hermit as written up by George Gascoigne for presentation to Elizabeth on progress at Woodstock in 1575 (Brit. Lib. Royal MS 18 A xlviii). In the surviving manuscript the tale, itself a Gothic survival (or revival) hinging on the healing powers of virginity, is presented in English, Latin, Italian, and French versions, punctuated with emblems that combine drawings and mottoes or verses. The first illustrates Gascoigne's own motto, *Tam Marti quam Mercutio,* and shows a kneeling knight offering a book to the queen; the other three, in Latin, Italian, and French, all complain about the harsh treatment afforded truly faithful servants and by implication praise in advance the generosity of the sovereign. So this little book seeks to say the same thing eight different ways, with absolutely no sense that the medium has any influence on the message. The drawings are

reproduced in Gascoigne's *Works* (1968, 2:472–510). The tale was printed (annexed to *A Paradoxe of Baldnesse,* and without illustrations) in 1577 and 1585.

16. It is tempting to think of Richard as an early Tudor and Bulling-brook as a late Tudor esthetician.

17. The assertion is truer of country houses than of city houses; at the end of the century Fynes Moryson was finding London unimpressive by comparison with Continental cities because its great houses were scattered and court-centered (1617, 3:73). Mercer 1962, Strong 1969a, and Gent 1981 all emphasize the perpetuation in England through the sixteenth century of the medieval emphasis on line and color. The development is in no way peculiarly English; indeed, throughout the period we find English patrons emulating Continental predecessors.

18. Spenser is quoted throughout from the Variorum *Works* (1932–49).

19. According to Raymond Southall, "The operation of a constraining norm, 'the golden fetter,' [made] itself further and more subtly felt in an equation between style and ornamentation, the norm of material wealth having its correspondence in a style which is richly decorative." He goes on to pay special attention to Spenser and Hilliard (1973, 36).

20. See esp. Erna Auerbach 1954. She uses the portrait initials of the Plea Rolls as a stable form within which to study stylistic change or stasis and shows convincingly how a brief period of experimentation with spatially more complex images during the reigns of Edward and Mary gave way to an unremittingly iconic, hieratic style throughout the reign of Elizabeth. The process is neatly summarized by the medal portraits of the monarchs from Henry VII through James I in Speed's *Theatre* (1611). Strong followed Auerbach, as his title, *The English Icon,* suggests (1969b).

21. Arthur Gardner discerns a cyclical movement from the flat, decorative forms of Saxon and Romanesque art, through the "architectural" and "volumnar" qualities of Gothic, to flat, decorative Tudor (1973, 95, 261). Mercer notes that the people who exercised the greatest influence on English building in the latter part of the period, de Vries and Wetterlin, were not, properly speaking, architects, but rather printmakers with a "decorator's" approach (1962, 76–78). And Sypher avers that in mid-sixteenth-century literature through euphuism and beyond, "all the many details are held in the same plane of interest" (1955, 91).

22. Ernest Gilman states that within the Lutheran strain of sixteenth-century Protestantism, visual images in books (including Luther's own) were "redeemed from the taint of idolatry by [their] verbal context" (1986, 36).

23. W. G. Thomson's book includes the probate inventory of the nearly two thousand tapestries owned by Henry VIII. Most tapestries came from France and the Low Countries. Henry VII brought Flemish weavers to

England (Kipling 1977, 41); though most returned to the Continent, a few stayed. Indigenous industries developed at Barcheston, beginning around 1560, and at Mortlake around 1620, but neither accounted for more than a modest fraction of the total market. The Barcheston output is interesting as an index to taste; the identified subjects include a number of county maps, a smaller number of biblical scenes, and emblematic representations of the virtues and vices. Similar subjects, as well as the floral patterns that often appear in the borders and backgrounds of tapestries, occur in the "Turkey-work" carpets and embroidered hangings that, much more commonly than tapestries, were made in England.

24. George P. Kernodle calls attention over and over to the use of printed cloths as backgrounds in triumphal arches, booths, and other quasi-theatrical structures (1944).

25. Although Spenser includes narrative paintings in the decor of the House of Alma (*FQ* 2.9.53), only a few fragmentary narrative murals survive, most notably the biblical scene, probably from a Flemish engraving, at Canons Ashby. We have no purely narrative English easel paintings of the Elizabethan period; the closest we come are those pictures of Elizabeth that have a strong narrative component—*Elizabeth and the Three Goddesses* and *Elizabeth in Procession*—and the funeral portraits of Sir John Luttrell and Sir Henry Unton (figs. 11, 24, 26). In sixteenth-century England much more purely than in the seventeenth-century Dutch work discussed by Svetlana Alpers (1983) does what she calls the "descriptive" (as opposed to the "narrative") mode preside. For examples of narrative in Elizabethan embroidery, tapestry's domestic cousin, see Digby 1963, esp. pls. 45, 47, 48, 59, 60, 61, 62.

26. The point is made with great force by the sixteenth-century printed chronicles, which (like the manuscript chronicles before them) illustrate the successive rulers of the land with a small number of woodcut "portraits" each used several times; there is no pretense at individual resemblance, since the idea of *king* or *queen* is what matters (as a moment's thought about the contents of any religious icon will show). Purely imaginary images appear in other areas—Gabriel Harvey says that he kept a set of pictures of the great philosophers (probably Low Country prints) for contemplation and encouragement (1884, 81). Svetlana Alpers argues that northern painters put the point of view in the picture plane rather than at the optimum viewer's distance from it as was normal in southern work; one consequence is that the term *perspective,* "rather than referring to the representation of an object in respect to its spatial relationship to the viewer, is taken to refer to the way in which appearances are replicated on the pictorial surface" (1983, 51–52).

27. Hayden White glosses the term *paratactic* as "conceptually under-determined" and the term *hypotactic* as "conceptually overdetermined," and

then goes on to talk about a middle ground in which discourse is "properly syntactic" (1978, 4); the analysis seems complementary to mine.

28. A notable feature of sixteenth-century English printing is the indiscriminate mingling within a single book of borders, initials, and ornaments that vary wildly in style and quality. Strong notes that sixteenth-century English gardens were "series of enclosed squares and rectangles, separate visual experiences" (1979, 60).

29. Vergil: Grief, Care, Disease, Age, Fear, Hunger, Poverty, Death, Hardships, Sleep, Evil Pleasures of the Mind, War, Furies, Discord; Sackville: Remorse, Dread, Revenge, Misery, Care, Sleep, Age, Malady, Famine, Death, War, Discord.

30. "[The characters] are all also, in a sense, opera singers. They have specific little solos which have to be fully taken. The play is an intricate mosaic of extreme emotions and there is no bridge from one emotion to another; no Stanislavski comfort. It is the break from one mood to another which gives the play its vitality" (Hall 1983, 240).

31. The text as we have it probably exaggerates this structure. A note from the printer, Richard Jones, states that he cut from the staged form of the play "some fond and frivolous gestures," presumably the kind of comic underplot we find in *Dr. Faustus,* and thus denied *Tamburlaine* a similar place in the tradition of the Grotesque.

32. The painting of Henry VIII and François I with their retinues at the Field of the Cloth of Gold (now at Hampton Court; attributed to Hans Roest, c. 1520) not only shows an enormous panorama of the (imagined) landscape, with the tents, lists, and banqueting house constructed for the occasion, but also depicts as occurring simultaneously events that were actually spread over several weeks (fig. 10). The mural of the Prodigal Son at Knightsland Farm, Hertfordshire, illustrates the young man's departure, his riotous living, his fall upon evil times (represented by two women driving him forth with brooms), and his sojourn among swine, all in the same crude landscape (fig. 1). Several of the woodcuts for *The Shepheardes Calender* (1579) combine images synchronically. That for May, for instance, arranges in a landscape three different episodes of the tale of the fox and the kid around a central depiction of the shepherds' Mayday procession, while the speakers of the poem stand talking to one another in the background (since they are drawn the same size as the foreground figures, they each look twelve feet tall). The funeral painting of Sir Henry Unton (c. 1596) depicts the major events of his life in a dozen vignettes scattered over the surface of the painting around the central image, taking him from England to France and back, from birth to burial (fig. 26).

33. S. Clark Hulse has some provocative if not wholly clear comments on a contrast between the "purely esthetic resolution" of dramatic structures like *As You Like It* and *Measure for Measure* and the artistically clumsy

but morally unambiguous forms of earlier work (1978b, 103). In the visual realm, a painting that combines Albertian *compositio,* naturalistic content, and illusionistic technique will tend to become an experience in and of itself rather than either an emblem or an icon. The process is most clearly marked in Mannerism, which one major authority has defined as that group of late Renaissance works of art in which the execution, the means, became more important than the program, the message (Shearman 1967, 44–48). The two traditions can be said to compete in Hieronimo's iconophrasis, between his conception of the proposed painting as an emblematic memento and his use of the occasion to relive the experiences (and to convey them, through techniques long inculcated in the study of judicial rhetoric, to an audience). Mercer discusses briefly a sixteenth-century custom of revenge portraits that was especially practiced in Scotland but that may include the Scrots portrait of Surrey (1962, 163–64) (fig. 12).

34. These passages all belong to an iconophrastic tradition descending from the description of Achilles' shield in *Iliad* 18 and studied in detail by Jean H. Hagstrum (1958).

35. From Burgkmaier's and Dürer's *Triumph of Maximilian I* (1515–18) onward, such processions, and other ceremonial activities, became important subjects for printmakers; English instances are the Gheeraerts Garter procession (1576), the memorial of Sidney's funeral prepared by Thomas Lant and engraved by Theodore de Bry (1587), and the souvenir book by Stephen Harrison of James's formal entrance into London (1604) (Strong 1984a).

CHAPTER 2. *The First and Chief Grounds*

1. Svetlana Alpers discusses the distortions in the study of northern European art induced by this Italian bias (1983, xx). Real trouble tends to arise when the labels take on intrinsic value; the quarrel about Mannerism (see below, ch. 9) would surely have been both less protracted and less fierce had it not begun with the proposition that *Mannerism* is a term of blame, *Renaissance* one of praise.

2. In literature, a rough gauge is provided by the incidence of English works with Greek titles (excluding straight translations): before 1540, none; between 1540 and 1560, three; between 1560 and 1580, six; between 1580 and 1590, eighteen. I use the chronological tables in Lewis 1954, 559; the count is not exact, of course, but the general outline is undeniably correct.

3. On iconoclasm generally see Phillips 1973. Ernest B. Gilman's study of the effects of iconoclasm on literature is full of interest (1986).

4. Mercer suggests a connection between such relatively unadulterated Renaissance influences and a sympathy with if not an allegiance to the old religion (1962, 70). Sir Thomas Smith's Hill Hall and Sir Christopher

Hatton's Kirby, among the most thoroughly Renaissance houses of the time, challenge the proposition; both men were committed Protestants. I would suggest instead that the mode often marks an effort to claim new authority from within the establishment, so that the peaks in the graph of Renaissance activity correspond with the transitions from Henry VII to Henry VIII, from Henry VIII to Edward VI, and from Edward VI to Elizabeth; with the period of religious, political, and military intrigue surrounding the Alençon negotiations (1575–80); and with the weakening queen's last decade and the transition to James (1593–1603).

5. On a smaller scale there are the Renaissance frames and cast shadows that Hilliard began to add to his miniatures in 1614 (Strong 1984b, 130).

6. The richest source of information on Tudor education is still Baldwin 1944. For a somewhat less cumbersome introduction see Charlton 1965. And as an epitome, see the elegant outline in Lanham 1976, 2–3.

7. Thomas M. Greene distinguishes among four imitative strategies: (1) *reproductive* or *sacramental* imitation, "reverent rewriting of a hallowed text," as in the hundreds of translations of Greek and Roman classics, but also of some modern works, themselves imitative, which like Petrarch's *canzone* achieved classic status; (2) *eclectic* or *exploitative* imitation (Lat. *contaminatio*), "the eclectic mingling of heterogeneous allusions"; (3) *heuristic* imitation, exploiting the historical discontinuity between source and imitation to produce what Ben Jonson called "Discoveries"; (4) *dialectical* imitation, involving implied or explicit expression of the artist's awareness of the historically determined inadequacies of the source to address the contemporary situation. Greene proposes that any one of the four can govern an entire work or appear in only a single phrase, and that all four might appear together in a single work (1982, 38–47). All these types of imitation are founded in an explicit allegiance to authority. The general sense of Greene's argument, however, is that both within individual authors and within societies, there tends to be movement from the first toward the fourth type, a progressive freedom in the treatment of literary authority— a change that, I would argue, implies a corresponding freedom in the treatment of other kinds of authority. Greene discerns four stages in the growth of English historical consciousness with respect to literature. The first is exemplified by Caxton, an essentially medieval thinker with a dim awareness of the past. The second is exemplified by Gavin Douglas, aware of the historical distance and of his own inadequacies by comparison with his model, Vergil, but still largely naive. In the third stage, a writer like More understood the challenge posed to any would-be imitator not only by the intrinsic excellence of the model but also by the problems created by historical disjunction. More himself, however, did not take up the challenge. (I disagree with Greene on this point; see the Appendix.) The fourth stage occurred when Surrey but especially Wyatt (imitating Petrarch, Juvenal,

and Seneca) demonstrated an "attention to context" that issued in "something new," only weakly heuristic in Surrey, but amounting to dialectical independence in Wyatt (Greene 1982, 242–43). Greene's privileging of what an older esthetic might have called "originality" leads him to undervalue the importance of Surrey in matters of form.

8. Phoebe Sheavyn observes the effect on imaginative literature of the totally theological orientation of university education, noting in particular the paucity of English editions of classical authors; it is not surprising that "with the exception of Thomas Heywood . . . no writer of any repute kept up his connexion with either University" (1967, 109–12). In the course of study prescribed for the young Edward VI, there are no poets among the classical authors on the list (although a few do appear among the vernacular authors, Italian, French, and Spanish, with whom the young prince was expected to be conversant; see Baldwin 1944, 1:245).

9. Vitruvius was included in Vives' list of recommended classical authors and hence became a fixture in the standard curriculum; see Baldwin 1944 1:190. Lucy Gent has found Vitruvius listed in thirty-seven sixteenth-century inventories and other book lists (1981, 74). Ascham, in *The Scholemaster* (1570), included drawing among the subjects proposed for his school, as did Mulcaster's *Elementarie* (1582), but few other educators followed them. Frances A. Yates argues that John Dee, in his preface to Billingsley's Euclid (1570), was teaching architectural principles to the middle class (1969, 21). James Lees-Milne notes that gentlemen traveling in Italy during the century often wrote about architecture but ignored painting (1951, 72).

10. The various authorities disagree over the degree to which Somerset House actually applied Renaissance ideas to English building practices. Contemporary comments unite in calling it novel and splendid; the surviving pictorial records are ambiguous. Lees-Milne thinks it likely to have been Italianate inside and out (1951, 56). Pevsner supposes that it involved only some Renaissance ornament (1954).

11. Lees-Milne finds in Sharington's Lacock (1540–53) the earliest surviving Elizabethan building in which Renaissance features are "constructional" rather than merely "decorative" (1951, 51).

12. A good many writers discussed the visual arts in works mainly dealing with other subjects; see the survey in Gent 1981, ch. 1. But after Shute no one devoted an entire book to the intellectual aspects of art until Haydocke's translation of Lomazzo in 1598. The anonymous *Limning: A Very Proper Treatise* (1573) is limited to what we might call the mechanical elements of the art: how to prepare the card and lay on the ground, how to grind and mix colors; it says nothing whatsoever about subject, composition, lighting, proportions, etc.

13. The term is applied to Shute himself on the title page of his book; as Marcus Whiffen observes, however, he is not known to have designed

a building (1952, 21). The fact reinforces the distinction I am making here between theory and practice. In his translation of Adrianus Junius's *Nomenclator,* John Higgins rendered *architecta* as "the maister workman" (1585, 503). This book is full of illuminating correspondences, many of which indicate how imperfectly the English (or at least Higgins) understood classical and Continental antecedents. Gent documents the general lack of a visual arts vocabulary (1981, 15–17).

14. There is also extensive, skillful application of the orders at Lacock, and rather less skillful at Kirby Hall (c. 1570), now only a shell, and at Hill Hall (not yet complete when Sir Thomas Smith died in 1577). Alan T. Bradford notes many places where even Longleat has strikingly non-, even anti-, Renaissance components, especially the fanciful cupolas, gables, and ornaments of the roof (1981, 14).

15. The fashion for Renaissance funerary decor may have been influenced by the Renaissance style of Solomon's Temple and other structures depicted in sixteenth-century illustrated Bibles, especially the Geneva, which would tend to assure the suitability of the style for use in churches.

16. According to Greene, imitation is imitation, whether the source is classical, like Vergil, or modern, like Petrarch (1982). He concentrates throughout on learned authors, however, never descending to the demotic level, where the force of authority is much less conscious but no less strong: "We've always done it this way" rather than "Vitruvius teaches us to do it this way."

17. As early as 1562, a year before Shute's book, Peter Kemp was writing to Burghley using terms from classical architecture (F. Jenkins 1961, 26).

18. As Martin Kemp summarizes it, according to renascence theory the arts "were governed by rational processes of discovery and making . . . rather than by capricious creativity of an anarchically modern kind" (1977, 397). Whiffen begins his little study of Elizabethan architecture by observing that it is "nothing if not artificial" (1952, 13). For a fuller account of an academic approach to art by a Tudor patron, see Richard Simpson's study of Sir Thomas Smith (1977). According to Gent, the "desperate shortage" of technical terms for the planar arts clearly indicates lack of contact with Continental work (1981, 16).

19. Although the Golden Section connected the orders with Pythagorean numerology, the seven-to-one ratio of head to body made the sculptural rules harmonize with other numerological traditions, and the triangular basis of perspective made it compatible with trinitarian theology and other symbolic structures, such symbolic use of numbers had been widely applied to architecture throughout the Middle Ages. Lavin 1968 is a brilliant demonstration of the quattrocento elaboration of the symbolic possibilities implicit in the mathematical bases of perspective.

20. For illuminating remarks on relationships among education, the mathematical elements of the visual arts, and certain important needs of a mercantile society like that of quattrocento Florence, see Baxandall 1972, esp. 36–40, 80–108.

21. Plans for a number of houses constructed on this principle appear in the most important single architectural record of the period, the collection of plans and drawings made by John Thorpe and his son during the decades on either side of 1600 (Summerson 1966). The front range sometimes accommodated the long gallery, as well, after that especially English room became fashionable.

22. As late as Thomas Howard's Audley End (1605–16), builders were putting a dummy entrance at the dais end of the hall in order to achieve external visual symmetry. John Buxton identifies the horizontal disposition as classical/Renaissance, the vertical as Gothic (1965, 57–59). John Harvey insists that Gothic and Renaissance forms are basically incompatible (1951, 38). A parallel from the book arts, by the way, is the habit of setting the lines of long sixteenth-century book titles in successively smaller type, so that the most important words sometimes get the smallest print.

23. According to Mercer, the hall in farmhouses and cottages also began to shrink, a change which implies that the social shift occurred at all class levels (1975, 5).

24. Thorpe's plans, both his own and those he took from other builders, illustrate half a dozen solutions; the most successful, as at Parham and Hatfield, was to dig the kitchen into the ground eight or ten feet and then wrap the house around a two-story-high hall, with staircases at either end. Robert Smythson, whose set of plans is the other major source of documentary information, was even more ingenious (Girouard 1962). It seems plausible to suppose that the rather rapid English transition to the Palladian mode in the 1620s and 1630s reflected not only a change in taste but the accumulated intellectual pressure imposed by the ever-increasing availability of books on architecture, which began to be published on the Continent in large numbers only after 1550.

25. I am conscious of treading on mined ground here. The study of English meter in general, and of renascence English meter in particular, is complicated by linguistic disagreements over the way metrical differentiae are expressed in English and over the actual phonology of sixteenth-century English. The issues are clouded by bibliographical and orthographic uncertainties (for instance, the differences between the manuscript versions of Wyatt and those in Tottel) and by insoluble questions about the talent of particular poets. In any case, the major works on renascence English versification—Saintsbury's old *History of English Prosody,* Thompson 1966, and the remarks scattered all through C. S. Lewis 1954—are all more or less unsatisfactory, though a more promising line of inquiry has been opened by Suzanne Woods (1985). See also Ing 1968 and Peterson 1967.

26. Ing generalizes the quotation into a contention that Elizabethan metrical innovators "looked to the visual arts, where there was much precept and practice concerning structure," but without citing any particular possible sources (1968, 63). Drayton, in the preface to *The Barrons Wars* (1603), relates ottava rima to the Tuscan order, since both are founded on a ratio of 6:2.

27. Note the title of R. L. Montgomery's book-length study of Sidney's verse, *Symmetry and Sense* (1961); Montgomery does not treat the concept in terms of a general sixteenth-century esthetic, however.

28. The technical part of Puttenham's *Arte of English Poesie* (1586) is called "Of Proportion Poeticall"; the term is carried through many of the subsequent chapter headings.

CHAPTER 3. *Emblems and Programs*

1. Michael Leslie follows Peter Daly by calling for a distinction between *emblems* and *imprese* as respectively public and private symbolisms (1985, 22–24); the distinction seems valid and will affect interpretation of particular images. But since it has no bearing on my more general argument I have not been at pains to mark it in what follows.

2. Given that emblems exhibit the aggregative and planar structure typical of Traditional art, it is worth observing that although the vogue for them (in the narrower, relatively technical sense) began, like many other renascence enthusiasms, in Italy, with Alciati, it flourished more strongly and longer in northern Europe, where it readily married the indigenous procedures.

3. The proposition seems to harmonize with the account of Spenser's method in Paul Alpers 1967, chs. 1, 2. See also Frye 1980. Fletcher's assertion demands qualification. Much southern European allegorical painting, and much done in the north as well, was inspired by classical or biblical narrative; such painting (and the prints that followed it) placed allegorical figures in a space realized according to the principles of perspective, most often a landscape, somewhat less commonly an interior. A convenient set of illustrations is supplied by the many representations of the Tabula Cebetis executed all over Europe from the early sixteenth century to the mid-eighteenth century (Schleier 1973, with more than a hundred illustrations). More narrowly emblematic work, drawing on a more eclectic repertory of images, is more likely to behave as Fletcher says. A powerful confirmation is supplied by the most elaborate instances of Elizabethan visual allegory that survive, the manuscript programs (Brit. Lib. Sloane MSS 1041 etc.) discussed later on in this chapter. These programs, if executed, would have produced works with as many as sixty figures, each fitted with up to half a dozen attributes, each alone or as part of a small group occupying its own discrete space.

4. According to Richard Simpson, "the link between pictorial and other studies arose from a preoccupation with objects and images as sources of information. This concept enabled images to be understood, and their importance to be judged, by the essentially literary analytical method of critical comparison adopted by renaissance scholars" (1977, 5–6).

5. As usual, the English follow the Italians at a distance, for the earliest Continental editions of Cartari were also without pictures.

6. The notion helps account for the way the characters in *FQ*, nominally together in space and time, tend to separate, so that the "group" of Red Crosse, Una, and the Dwarfe in 1.1 is initially described as three independent figures, of whom one disappears and the other two almost at once go their separate ways, like figures from the panels of a triptych (Fletcher 1964, 103).

7. Clark Hulse describes the process in fuller terms: "Mythography . . . mediates . . . between discursive and non-discursive thinking: the material of the visual world is made into narrative, narrative into argument, and argument into vision" (1978b, 96). A. H. R. Fairchild summarizes the whole discussion when he calls Elizabethan art theory neoplatonic (1972, 115–17); the label is misleading, because the tradition has other sources, including the Old Testament insistence that physical objects matter only as they express spiritual realities, but it does emphasize the idealism of this mode of thought.

8. He is particularly interesting to me because of his close connection with John Lyly, who seems in this speech by Apelles in *Campaspe* (1584) to be describing a typical Hilliard portrait miniature: "For now, if the haire of her eie-browes be black, yet must the haire of her head be yellowe; the attire of her head must be different from the habit of her body—els must the picture seeme like the blason of auncient armorie, not like the sweet delight of new-found amiablenes. For, as in garden knottes diversitie of odours make a more sweet savor, or as in musicke divers strings cause a more delicate consent, so in painting, the more colours the better counterfeit, observing black for a ground, and the rest for grace" (1924, 3.4.137–51).

9. Strong asserts that Hilliard's style shows no real sign of influence by Holbein, being based instead on the techniques of wood engraving, and that Hilliard's sojourn in France influenced the composition of his paintings but not other aspects of his technique (1983, 67; 1984b, 68–69).

10. Note Hilliard's Elizabethan copies of earlier portrait miniatures of Henry VII, Henry VIII, Jane Seymour, and Edward VI, made for the politically significant Bosworth Jewel (c. 1600–1603) (Strong 1983, 85–86).

11. Lyveden New Bield was never finished, but Longford Castle in Wiltshire, a triangular building incorporating assorted trinitarian symbols, built by Sir Thomas Gorges, is still the family home. A few other symbolic

Tudor and Stuart buildings survive, and one of the most interesting plans in John Thorpe's collection is a design for a house in the shape of his own initials, *IT* (the collection includes plans of both the Tresham and Gorges houses).

12. See the engravings of the seven arches in Harrison 1603 (reproduced in Bergeron 1971, pls. 2–8).

13. Margery Corbett and Ronald Lightbown note that early editions of Cartari and other mythographers were without illustrations: "There could be no clearer evidence of the primacy of literary over visual authority" (1979, 29).

14. Edward B. Gilman notes that Sidney relates the "foreconceit" of a literary work to "the imaginative groundplot of profitable invention." The term *groundplot,* Gilman says, comes from architecture, and "suggests an 'imaginative' conception of the text as a floor plan on which the writer constructs—and from which the reader reconstructs—the full 'spatial' volume of the work" (1986, 23).

CHAPTER 4. *The Eye of Expectation*

1. Essays on patronage in the various arts are gathered in Lytle and Orgel 1981. For the patronage of painters see esp. Erna Auerbach 1954, which pays special attention to the court and the office of serjeant-painter; Edmond 1980, which concentrates on Continental immigrants; and the various works of Sir Roy Strong, esp. 1977, 1986, and 1987. On architectural patronage, the important studies include Airs 1975, based on close study of hundreds of financial records; the many books and articles of Mark Girouard, esp. 1959, 1962, and 1983; F. Jenkins 1961; Mercer 1962 and 1975; and Summerson 1953, 1956, and 1966. Only a few of the many significant treatments of Tudor literary patronage can be listed here; older surveys include Miller 1959 and Sheavyn 1967; among more recent ones are Greenblatt 1980 and Helgerson 1979.

2. A useful conspectus is supplied by Chambers 1971, which reprints several dozen contracts, letters, and other documents recording various kinds of patron–artist relationships. It must be conceded that if many similar documents for sixteenth-century English art survive they have not been brought to view. Brit. Lib. Sloane MSS 1041 etc. ("Instructions to Painters") and Harley MS 6857 provide detailed insights into intellectual and esthetic relationships between patron and artist, but no information on their economic arrangements.

3. As John A. Walker phrases it, "an indispensable prerequisite of artistic independence is financial independence" (1979, 27).

4. The Painter–Stainers Company repeatedly sought from the authorities, and sometimes received, ordinances and orders protecting its markets

against incursions by foreign artisans and by other mysteries (notably the heralds and the plasterers): see Englefield 1923, 56–68.

5. Consider also the implied social status of the painter and poet in Shakespeare's *Timon,* 1.1.

6. According to Malcolm Airs, most members of the building trades were paid by the piece and lived at or slightly above the level of agricultural laborers (1975, 176).

7. J. A. van Dorsten finds "a marked difference between literary patronage and the patronage of painting in the sixteenth century," but also an important similarity in the lack of court support (Lytle and Orgel 1981, 193).

8. John Summerson calls attention to plans and drawings for Theobalds altered and annotated in William Cecil's own hand; he seems to have made all the significant decisions (1956, 108, 112). Richard Simpson's account of Sir Thomas Smith's supervision of the program for the wall paintings at Hill Hall, Essex (1977), lacks direct documentary support but is nonetheless persuasive.

9. These correspond generally to the "laureate" and "amateur" groups distinguished by Richard Helgerson (1978, 893). Miklos Szenczi traces various types of Baroque art to "courtly," "churchly," and "bourgeois" traditions (1978, 319–20).

10. A representative figure is Nicholas Grimald (1521?–62), whose output, including much now lost, seems to have included Latin and English tragedy, comedy, tragicomedy, familiar letters, *carmina* and epigrams, and satires, but also orations, commentaries on Cicero, Terence, and Horace, explications of the Psalms, an English rhetoric, and translations of Xenophon, Hesiod, Erasmus, Mathieu de Vendôme, Joseph of Exeter, Cicero, Plato, Vergil. Yet his place was never sure.

11. A. L. Rowse reminds us that Elizabethan literature was largely the work of young men (1972, 49).

12. The situation was complicated by the fact that so many artists were immigrants, Protestant refugees from France and the Low Countries but also itinerant craftsmen from a region overstocked with artists just looking for a market. As Mary Edmond has shown, they tended (like any immigrants) to form fairly tight communities, where they rented one another's houses, intermarried, and otherwise kept much to themselves (1980).

13. Across the Channel, from the early sixteenth century on, many visual artists received solid humanistic educations and operated on terms of intellectual equality with all but the most accomplished scholars; see Gibson 1981 and van Dorsten 1970. Few if any of the painters trained in England boast of their learning—Hilliard, whose *Arte of Limning* is the fullest autobiographical statement, does not (he cites no books but Lomazzo's *Treatise,* which he presumably knew in the translation of Richard Hay-

docke, who had in effect commissioned the *Arte of Limning;* he makes no classical references; and he uses *knowledge* and its synonyms almost exclusively in reference to the techniques of miniature painting), nor does the work of men like Robert Peake and Rowland Lockey testify to advanced scholarly attainment.

14. Maurice Harold Grant records a colored drawing of Windsor Castle and another of a Garter Knight; only the second is signed (1957–60, 1:31).

15. Mary Dewar traces the complex history of the building of the house, demonstrates that it was not finished until a quarter-century after Smith's death, and concludes that the murals probably date from the early seventeenth century (1964, 191–208). But Richard Simpson finds the presence of Smith's head and very possibly his hand on both architectural and intellectual grounds, and concludes that the murals were undertaken before his death (1977).

16. Margery Corbett and Ronald Lightbown discuss "the social prejudice against the practice of art as base and mechanical" (1979, 19). Lucy Gent offers a distinction between flat drawing, used for plans, alphabets, etc., and suitable for gentlemen, and what, following John Dee, she calls "zography"—that is, drawing from life, the "trick" of the "mechanick" painter (1981, 10–11).

17. We may note one more name, Sir William Burlase (d. 1629), sheriff of Buckingham; Ben Jonson, "The Painter to the Poet," *Underwood* (1640), no. 51, implies that Burlase was enough of an artist to have painted Jonson's picture.

18. The translation of Adrianus Junius's *Nomenclator* (1585) lists sculptors and illuminators as "artisans" but painters as belonging to "trades that tend to the making of folkes neat and trim," along with barbers and masseuses.

19. George Gascoigne in the preface to the *Posies* (1575) insists that he has not received "one grote or pennie" from the booksellers (1968, 1:4); he goes on to associate himself with Surrey and Lord Vaux.

20. See the intriguing distinction between "serious" and "rhetorical" views of literature set up by Richard A. Lanham (1976, 215–16).

21. Consider the minatory effects of the confiscation and burning of unauthorized portraits of Elizabeth in 1596 (Strong 1983, 125–26).

22. Gordon Ross Smith documents a widespread pattern of resistance to "authority" in all its forms (1980). He nowhere admits the practical force of events like the punishments meted out to Samuel Harsnett and Sir John Heywood. On the visual side, Foxe reports that a painter who greeted Philip and Mary as they processed through London with a painting of Henry VIII (as one of the Nine Worthies) giving the *Verbum dei* to a kneeling Edward VI was rebuked by loss of a finger (1563, 1472); the image was based on the title page of the Coverdale and many subsequent Bibles.

23. He notes Wyatt's retreat into irony and pastoral and Skelton's dive into the murkiest allegory. See also Strong on the private, even secretive, character of that distinctively courtly genre, the miniature (1983, 9).

24. The painting bears the monogram *HE* and was long attributed to Hans Eworth. But most historians now follow Strong (1969b, 144) in rejecting this attribution; David Piper suggests Lucas de Heere, one of the Flemish artists chased into England by Spanish persecution (1975, 87). Strong argues, on stylistic evidence, for Joris Hoefnagel (1987, 68), as does van Dorsten (1970, 54). Edgar Wind sets the painting in a tradition in which the goddesses represent the contemplative, active, and sensuous lives [house, castle, landscape?]; the queen dominates them because she unites all their virtues in her single self (1968, 82–83). Wind cites Lyly, Peele, and Francis Sabie. Louis Montrose argues that the painting was part of the campaign urging Elizabeth to marry and, by accepting Juno's role as matron and mediator, to integrate the austerities of virginal insularity with the fertility of wedlock (1980, 445–47).

25. Similar views on the composition of the picture are expressed by Michael Leslie, who argues that Elizabeth's "static, flat, iconic" pose expresses "stability" (1985, 18–21). Though Hilliard tells us that Elizabeth preferred to be painted in the diffused outdoor light of a garden (1981, 87), no surviving portrait of her shows her in a predominantly natural setting.

26. See Helgerson on Gascoigne's revisions of this book, which in other ways than the change of the title from *A Hundredth Sundrie Flowres* and the dedication to the clergy sought to increase its moral gravity (1976, 45–50).

27. Edwin Miller argues that the "amateurism" of mid-Tudor poetry reduced literature to a pastime and had the effect of debasing the enterprise in the eyes of people of the period (1959, 24).

28. Lawrence Stone reports a sharp drop in the number of noblemen's sons at the universities in the 1580s and a corresponding rise in those at the Inns (1965, 688).

CHAPTER 5. *A Violence Within*

1. For students of English literature and art, the study properly begins with Ruskin's "Grotesque Renaissance" (1906, 3.3). The most influential modern treatment is Kayser 1963. A brisk, opiniated introduction to the major issues is Harpham 1976; Harpham's elaborated treatment, *On the Grotesque* (1982), though stimulating, pays specific critical attention almost exclusively to nineteenth- and twentieth-century works. Sensible but also brief is Thomson 1972. Briefer yet, but with useful illustrations, is Ward-Jackson 1967. Piel 1962 offers a detailed account of the fifteenth- and sixteenth-century Italian work. I have offered a previous summary, with illustrations (1982). Not surprisingly, the subject has provoked much idiosyncratic criticism: remarks more stimulating than definitive will be found

in Baltrušaitis 1957 and Harbison 1977. Among works that concentrate on literature may be noted Clayborough 1965, which gives a very suggestive history of the development of the word along with a rather muddled theory based on Jungian psychology, and Rabkin 1976. Fletcher 1964 is littered, like the gardens at Bomarzo, with astonishing aperçus. Neil Rhodes, in his *Elizabethan Grotesque* (1980), begins, as I do, by recognizing "heterogeneous composition" as the essential element (9). He confines himself within a notion of "decorum" that limits his attention to "low style" and "low characters," however, and hence discusses only satire in pamphlets and drama. Indeed, much of what he calls "grotesque" I treat as Demotic—that is, work whose concerns and idioms articulate the quotidian experience of ordinary folks (see below, ch. 9). He makes very little use of the visual Grotesque, either. I suppose our work is loosely complementary. But the approaches are so different that the overlap is small—he mentions Spenser only once, in a footnote, Petrarch and Gascoigne not at all. Our major points of agreement are an admiration for the work of Thomas Nashe and our conviction that Farnham 1971 treats the term *Grotesque* too loosely to be very helpful.

2. For this information, and much of what follows, the prime sources are Dacos 1969 and 1977, both very fully documented and illustrated. Dacos's account stops about 1520, and there is no comprehensive study of subsequent developments, but much relevant material is scattered through histories of Renaissance and Mannerist art and through studies of the relevant individual artists. Very useful material on the place of the Grotesque in the critical discussions of the period is gathered in Summers 1972.

3. For the etymology of the term, see Clayborough 1965, ch. 1. Thomas M. Greene observes that "Renaissance archaeology was not free from primitive feelings about the earth, atavistic terrors and superstitions." Rabelais's Gargantua, he reminds us, was fictively disinterred (1982, 235–37).

4. Holbein had done extraordinary Grotesque exterior designs c. 1517–20 for the Hertensteinhaus, Lucerne, and the Haus zum Danz, Basel. The frieze and ceiling of Wolsey's Closet at Hampton Court (c. 1520) are in the best Renaissance tradition; the craftsmen were probably Italians. There was a grotto in the garden at Nonsuch centering on a polychromed statuary group of Diana and Actaeon; see Strong 1979, 63–69.

5. Writing in 1658, Sir William Sanderson termed this work "Citizen painting, being too common; and usually . . . very ill-wrought" (Croft-Murray 1962, 1:27).

6. There is no comprehensive treatment of Tudor interior decoration; Mercer summarizes earlier work, mostly scattered through dozens of books and articles (1962, 77–79, 99–144). For illustrations of the style in English middle-class houses see Reader 1935–36, 220–62.

7. For the sixteenth-century semiotics of this ubiquitous image see esp. Hershey 1988, 119–47.

8. There seems to have been a general Elizabethan taste for the marvelous; see Sheavyn 1967, 189–95, referring to works like Fenton's translation of Boistuau, *Certeine Secrete Wonders of Nature* (1569).

9. Eric Rabkin has suggested that the Grotesque is not so much a style as what he calls a "grapholect," a lexicon of images adaptable to many styles and hence very compatible with the parallel lexicon of emblems (1976, 20–25). I disagree with him because of my emphasis on the structural as well as the lexical elements of Grotesque art.

10. Note Harpham: "The grotesque must begin with, or contain within it, certain aesthetic conventions which the reader feels are representative of reality as he knows it" (1976, 462).

11. The idea is from Kayser 1963, 182. Arthur Clayborough treats the Grotesque as "an endeavour to transcend the limitations of the natural order" (1965, 61). Stephano Ray writes of "la tensione dinamica" in Raphael's architectural works between classical ideal stability and natural fecund dynamism (1974, 163).

12. See D. W. Robertson, Jr., on the "flatness" of late medieval grotesquerie (1962, 251–57), and Harpham 1976, 465. As Dacos observes, one important element of Grotesque is "the indefinite space in which it is painted" (1969, 63). Thus too Oskar Fischel: "The essential figure of the style was the intermingling of coloured plastic elements that are continued in colour on the flat surface" (1948, 1:155).

13. Carel van Mander, writing about art in the late sixteenth century, advised Netherlandish painters working in Italy to paint landscapes in fresco "next to your grotesques" (quoted in Stechow 1966, 58). Donald Howard has some stimulating pages on the "marginal grotesquerie" of medieval art (1976, 338–57).

14. That this is a renascence understanding of the Grotesque is made clear by Montaigne, who begins his essay "Of Friendship" (1.28) by observing that the painter whose work he admires puts in the center of the wall a picture "labored over with all his skill," then surrounds it with fanciful grotesques (1957, 135).

15. Alessandro Marabottini discusses the Grotesque artist as a master spirit presiding over "a miracle of equilibrium between the antique and the modern, between the sacred and the profane, between ornamentation and representation" (Salmi 1969, 257); Ray adds another half dozen dichotomies (1974, 185). See also Piel 1962, emphasizing symmetry (26) and dialectic (51). Michelangelo himself (or so one who knew him reports) described the Grotesque as the juxtaposition of alien forms according to fairly strict rules (Summers 1972, 150–51).

16. Edgar Wind observes that to Renaissance Platonists monstrousness was a sign of sacred mystery, along with other images belonging to "an intermediate state," ambiguous, suspenseful. He applies the principle to *FQ*

4.2.41–43 (Priamond, Diamond, Triamond) and 10.31–36 (the hermaphroditic Venus) (1968, 202–17).

17. "The grotesque often arises in the clash between the 'virtuous' limitations of form and a rebellious content that refuses to be constrained" (Harpham 1982, 7).

18. The notion is recurrent in Fletcher 1964; see also Tuve 1966, 39–75, and Honig 1959, 57–81. The idea gains support from Harpham's recognition that the mode is "pre-eminently interpretable" (1982, 19). Ray observes that an artist like Cellini will use the Grotesque in a "senso misterico," while another will turn to it merely to supply "classica concretazza" to a city scene (1974, 42).

19. Early British references neatly point up the issue. A royal inventory of 1561 itemizes "two pantit broddis the ane of the muses the uther of crotescque or conceptis"; both the context and the phrasing imply a sense of intellectual control. Florio translates Montaigne, however, as calling his essays "grotesques . . . pieced together of divers members, without definite shape, having no order, sequence, nor proportion except by accident." Both references are from the *OED,* s.v. *grotesque;* see Clayborough 1965, 3–7. Montaigne's remark comes from "Of Friendship" 1.28. He may have in mind the kind of farrago of images figured in books like Perret's *Exercitatio alphabetica* (1569; fig. 40). The two notions seem to come together in chapter 13, "Of Antique," in Peacham's *Art of Drawing* (1606); the style is "an unnatural or unorderly composition for delight sake, of men, beasts, birds, fishes, flowers, and without (as we say) Rime or reason," but the painter must "observe a method or continuation of one and the same thing throughout [the] whole work without change or altering."

20. The concept of the Grotesque as the *sogni dei pittori* goes back as far as Dürer; see Kayser 1963, 22. For a fuller application of these ideas to Spenser than what follows here, see Evett 1982.

21. Ruskin 1906, 3.3.53: "the whole of the *Inferno* is full of this grotesque, as well as the *Faërie Queene* and these two poems, together with the works of Albert Durer, will enable the reader to study it in its noblest forms, without reference to Gothic cathedrals." Ruskin distinguishes the "terrible" Grotesque from the "ludicrous," and within the former the "apathetic" (Spenser, Dante) and the "ungovernable" (Revelation, Shakespeare).

22. Among the caves the most interesting, because their inhabitants are shapeshifters or dream mongers, are those of Morpheus (1.2), Merlin (3.3), Proteus (3.8), and Malengin (5.9).

23. Wolfgang Kayser derives the Grotesque impulse from "an agonizing fear of the dissolution of the world": by imaging the horror himself, before it comes upon him from the outside, the artist brings it under esthetic control (1963, 31). An interesting illustration is furnished by the woodcut

borders of John Day's *Christian Prayers* (1569), which combine Renaissance grotesques first with illustrations of the life of Christ, but then with *memento mori* skeletons fetching away the various estates and professions of men, and finally with a vigorously rendered Last Judgment. (The sequence is even more explicit in the edition of 1608.)

24. Busirane, like Mammon, comes from the East, an origin which recalls that among the Romans the Grotesque was ascribed Eastern origins; see Clayborough 1965, 19, citing Vitruvius, *De arch.* 7.5.3.4.

25. Another striking example of this kind of iconophrasis is the decor imagined by Drayton for the bower of Isabella and Mortimer in *The Barrons Wars* (1603), 6.233-344; the place is so given over to love and art that the young men supposed to be on guard are absorbed in the invention of *imprese* when the enemy breaks in, by way of the famous Nottingham Castle caverns.

26. The phrase "dispersed thin" is especially interesting because it can be construed as indicating the kind of work found in the Domus Aurea or the Vatican *logge* in which the individual figures, though interconnected, are rather widely dispersed on a pale ground.

27. The point may be illustrated by a group of late sixteenth-century paintings and prints, by Arcimboldo, Giambattista della Porta, and others, of human figures made up of nonhuman objects—a cook's face composed out of vegetables or cuts of meat, a man of predatory character likened visually to a wild animal. John B. Bender insists that in the Belphoebe passage and others like it the individual details function individually, so that the visual juxtaposition that would make the whole thing Grotesque does not occur (1972, 32ff.); but the Arcimboldo and della Porta pictures indicate that the possibility of literalizing conventional epithets was occurring to contemporary European minds.

28. On emblems as Grotesque, see Bender 1972, 83. The earlier emblem books, including important editions of Alciati's *Emblemata* and Ripa's *Iconologia,* are full of Grotesque borders and motifs.

29. Interlacement is a device of both sophisticated medieval narrative and illumination. It is suggestive that the Renaissance work that shares all these Grotesque qualities with *FQ,* Ariosto's *Orlando Furioso,* was contemporaneous with the great visual grotesques of Raphael, Giovanni, Primaticcio, and Rosso.

30. Bacon, "Of Masques and Triumphs," lists as possibilities for the antimasque "Fooles, Satyres, Baboones, Wilde-Men, Antiques, Beasts, Sprites, Witches, Ethiopes, Pigmies, Turquets, Nimphes, Rusticks, Cupids, Statua's moving, and the like" (1937, 158). Many of these images occur in Grotesque decor.

31. Highly interesting links are supplied by Simeoni's *Vita et Metamorphoseo d'Ovidio* (Lyon, 1584), in which a series of 187 Ovidian scenes are

framed in spectacular Grotesque borders, and by the handsome title pages of the *Biblia Sacra* (Basel, 1553) dedicated to Edward VI.

32. The emphasis on conscious order here contradicts both Kayser (1963, 24) and Harpham (1976, 465), who insist on the antirationalism and structural diffuseness of the mode. But they seem to be thinking about eighteenth- to twentieth-century work. Angus Fletcher speaks of the tendency in Grotesque art of "system" to counterbalance "fantasy" (1964, 82n), while Ray writes of the internal logic of the *logge* paintings, by contrast with the helter-skelter work of later, lesser masters (1974, 121). See also Dacos 1977, 59–82, the fullest account of the iconography of this oeuvre. Dacos does not try to identify the author of the program.

33. Spenser himself expressed his concern (at the end of the Letter to Ralegh) that the poem would be perceived as "tedious and confused." See also Bender 1972, 49.

34. The most celebrated case is the room of Isabella d'Este in the ducal palace in Mantua. Vasari and associates did one in the Palazzo Vecchio in Florence for Francesco de' Medici much more fully programmed, with paintings on the four elements according to a program devised by Vincenzo Borghini. At eye level the encadrements simulate wooden paneling, but the ceiling is grotesquerie.

35. Nashe dominates Rhodes's treatment of the Elizabethan Grotesque (1980).

36. For similar treatment of Sidney, see Lawry 1972, esp. 157–63. It occurs to me that an explanation for the tradition that calls Spenser a primarily pictorial poet, even though, as we shall see, his method is not actually "visual" at all, can be sought in the fact that much more than most of his contemporaries he was content to imitate experience and to eschew the kind of elaborate abstract speechifying, in which illustrations are always subordinated to generalizations, that other writers apparently found irresistible. Only in his proems and in occasional interpolated comments does he work the rhetorical pitch, and then for no more than a few stanzas.

37. This and all subsequent quotations from Shakespeare come from the Riverside edition (1974).

CHAPTER 6. *The Toad in the Garden*

1. On the authority of Vergil's *Georgics*, there appeared humanistic counterparts to the medieval encyclopedias of Jean de Meung, John Lydgate, and Stephen Hawes, works like Poliziano's *Hesperides*, a verse treatise on fruit farming, and Fracastoro's *Syphilis*, an allegory in epic form of the history and treatment of a devastating new disease. But the names and forms of these poems show the degree to which material from the world of fact entered poetry as allegory, pageant, or mythic tale.

2. Sir Roy Strong speaks of the miniature as it was developing when Puttenham wrote as "an art whose whole aim was to record spontaneity of expression" (1983, 12).

3. The observation qualifies Svetlana Alpers's assertion that the kind of painting usually called "realistic" or "naturalistic," but which she labels "descriptive," generally dominates northern European art in the sixteenth and seventeenth centuries (1983).

4. The same features had appeared in the work of the Venetians, especially Giorgione and Giovanni Bellini, but invariably with signs—classical costume and architecture, in particular—that established the idealistic character of the scene beyond question. The debate over the degree to which Bruegel's genre scenes and landscapes are susceptible of iconographic analysis continues unchecked. See Gibson 1977 and Tolnay 1935.

5. In this connection note that even in the sophisticated engravings Thomas Geminus made for the English edition of Vesalius (1549), the complex landscape backgrounds of Geminus's source, Jan Stephen van Calcar's engravings for Plantin, are radically simplified (see Hind, Corbett, and Norton, 1952–55, 1: pls. 20, 21).

6. The seminal treatment of the landscape *topoi* is Curtius 1953, ch. 9. His ideas are followed up in detail by Hansen 1973. For brief summary see Evett 1970. Much useful material is gathered by James Turner 1979. See also Gent 1981, 22–25.

7. The word *optics* entered English during the reign of Henry VIII. Its Latinate counterpart, *perspective,* had been in use in Chaucer's time but assumed several new technical meanings in the sixteenth century. *Vision* meaning "physical sight" is first recorded in 1491, *prospect* in 1538, *view* as a noun in 1606. It is perhaps to the point that the man who can reasonably be identified as the first English art critic, Sir Henry Wotton, studied optics at Oxford around 1570.

8. Svetlana Alpers notes the importance for sixteenth-century artists of "mapping, archaeology, botany," esp. the first (1983, 116–68). Many scholars see all these activities as part of a drift in epistemology summarized by Walter J. Ong, from an ancient pole "where knowledge is conceived of in terms of discourse and hearing and persons" (idealistic?) to one more modern "where it is conceived of in terms of observation and sight and objects" (ikastic?); seamarks are furnished by the title of Isidore of Seville's encyclopedia of the eleventh century, *Etymologiae,* and Vincent of Beauvais's of the thirteenth, *Speculum mundi* (1956, 224). Ong 1958 explores the point more fully. Catherine Ing identifies the visual aspects of printed poetry as a special case of the general renascence shift from verbal to visual (1968, 88). J. A. van Dorsten discusses the close interconnections among mid-sixteenth-century Flemish and English geographers, mathematicians, and painters (1970, 56–58). On renascence optics, see esp. Edgerton 1975. It must be said, however, that a movement almost equally strong privileged

sermo over *visio:* Reformation preaching versus Counter-Reformation art. The struggle is endemic and continues in our own time.

9. On Sidney's extensive use of recent maps in establishing the geography of Pyrocles' and Mucedorus's travels in the revised *Arcadia,* see Lindenbaum 1986, 77–78.

10. Richard Simpson documents Smith's participation in a general European movement, based on "literary criteria of truth and accuracy," toward "a concept of representational veracity" (1977, 5–6).

11. The item may refer to mounted single sheets of the set bound up as Ortelius's *Theatrum orbis.* The other "cards" depict a dance of death, the parable of the king and the unjust servant, Isaac blessing Jacob, and "a little one with a tree in the midst," which might conceivably have been one of the earliest recorded English landscapes but was more probably an emblem of some sort. Virtually all the dozens of emblematic pictures from Lady Drury's cabinet include one or two trees at or near the center; see Farmer 1984, 77–105.

12. Important studies of early European landscape drawing and painting include Clark 1950; Friedländer 1949; Gombrich 1966, 107–21; and A. R. Turner 1966.

13. While it lasted, however, it affected the minor arts as well; landscapes appeared in carvings, inlay work, tapestries, and majolica ware and of course were sent throughout Europe in the prints that, after emblematic images, constituted perhaps the most important single class of European book illustrations. Among the most interesting is the composite topography that can be put together from the several landscape backgrounds in Vesalius's *Anatomia* (1543).

14. It is worth noting that Wyngaerde's views of London, c. 1550, are mostly taken from the river.

15. Petrarch describes the experience in *Familiar Letters* 4.1, writing to Dionisio da Borgo San Sepulcro; his impulse was more ancient than modern, since his expressed model was Philip of Macedon.

16. Fine examples include Parham (1577), Montacute (1595–1601), Burton Agnes (1610), and Blickling (1616). At Audley End, Melford Hall, and perhaps others, stairways to the roof allowed residents and guests to follow the hunt in the park around the house; at Longleat, the roofs even had little pavilions for shelter from sun or rain. The use of such spaces as lookouts is indicated by an anonymous manuscript in the Harley collection describing a gallery built by Elizabeth at Windsor, "of such an excellent grace to the beholders and passers by lyenge open to the sight even afarre of; that the statelynes, pleasure, beaute, and use thereof seemethe to contend with another which of them should have the superiorite" (quoted but not further identified by Way and Chapman 1902, 169). P. J. Drury observes that in the great houses of the eighties and early nineties, like Holdenby and Theobalds, the principal apartments looked into their courtyards, while

those of the great Jacobean houses looked out over their gardens (1980, 18).

17. An anonymous *Jephtha's Daughter* of c. 1530, now in the Royal Collection, shows Windsor Castle in the background. Anthonious van den Wyngaerde made some skillful sketches of London, now at the Ashmolean, around 1550; some other drawings and watercolors survive from the second half of the century. A group portrait of the family of Henry VIII and assorted allegorical attendants, attributed to Lucas de Heere (c. 1570), has a cityscape visible in the background that may represent parts of Whitehall. The great west gallery frieze at Burghley's Theobalds (c. 1580) had twelve trees (molded in plaster from real trees, then covered with real bark) representing the several shires and regions of England, their branches carrying the arms of the most important families of the county, "and between the trees, the towns and boroughs, together with the principal mountains and rivers," while the green or forecourt gallery had "paintings of many Castles and battailes," and the long gallery "correct landscapes of all the most important and remarkable towns in Christendom" (Summerson 1956, 122–24). An "apparently topographical background showing the city of Rye survives in a painted frieze in The Other House, Rye" (Reader 1936, 231). The Admiral's Men apparently owned a scenic painting, perhaps on cloth, of "the sittie of Rome," required for *Dr. Faustus* (Henslowe 1961, 319, from Malone's transcript of some manuscript inventories now lost). An embroidered cushion cover at Hardwick carries a not unprimitive image of Old Chatsworth, its doors open, with suggestions of landscape at either side (reproduced in Digby 1963, pl. 61). Topographical majolica ware seems to have become available in London around 1600; a dish of that date now in the City of London Museum depicts (not very accurately) the Tower and London Bridge (Rackham 1926, 120); the plate is reproduced in Caiger-Smith 1973 (pl. S). Two early seventeenth-century paintings, Flemish in style, show hunting scenes with the royal palaces of Nonsuch and Richmond in the background (both part of the Founder's Bequest at the Fitzwilliam Museum, Cambridge). The monument to Sir Henry Savile (1625) in the chapel at Merton College, Oxford, sets a portrait of the knight against paintings of Eton and Merton. Edward Croft-Murray lists "landscape" among the common subjects of the painted friezes that decorated many Elizabethan rooms; one of his plates shows the frieze at Rothamsted Manor, Hertfordshire, with knights and cannon attacking a castle set in an extensive landscape (1962, 1:29, pl. 44). Below the frieze, incidentally, is a row of painted niches with shell-molding tops, separated by columns and each housing a heraldic animal, that constitutes, Croft-Murray says, "the only complete scheme of *trompe l'oeil* of this period to have survived."

18. Most of the literary citations in Turner 1979a also date from the seventeenth century.

19. The German traveler Jerome Turler lists the "five principall poyntes

to bee considered in everie Cuntrey: the Name, Figure, Bignesse, Iurisdiction, and Cituation," and goes on to recommend that the traveler "note also the ground or soil, Hilles, Rivers, Lakes, Ponds, woods, & the cities also in them" (1951, 50, 54). See Parks 1955, 264–90. Instances of landscape as body occur in Spenser's Garden of Venus and Adonis (FQ 3.6.43–50), Drayton's *Poly-Olbion* (18.25–40), Donne's elegie 20, Phineas Fletcher's *Purple Island,* and Carew's "Rapture."

20. The painting referred to in the last two lines has been lost to view. Anne Lake Prescott thinks the poem refers simultaneously to the cities and to the noblemen who bore their names; if so, then the picture might have been a portrait with a landscape background.

21. Drayton is quoted here and subsequently from the *Works,* edited by Hebel et al. (1961).

22. See also Ralegh's reaction to the scenes along the banks of the Orinoco (42).

23. On "the distancing effect" of the visual, see Gilman 1980.

24. Svetlana Alpers argues that in northern Europe, painters tended to place their point of view in the plane of the picture frame, not some distance in front of it; the effect was to put the viewers (including the painters) into the scene, as a part of it, and thus to suppress the painters' readiness or willingness to impose an ideal order on what they saw (1983, 44–65).

25. Recall Carel van Mander's instructions to painters to frame their landscapes with grotesquerie. There is a corresponding development on the temporal side, the growth of the idea of history as process.

26. According to A. Richard Turner, "The rise of landscape painting accompanied the flowering of city life, for only with the development of a complex money economy did the great landscapists appear. Their art brought an illusion of the country into the city at the very moment when city dwellers began to seek pleasure in the villa" (1966, 193). A more complicated and critical version of the same notion is presented by Raymond Williams (1973, esp. 19–45), and it is implicit in William Empson's formulation of pastoral as literature "about," but not "by" or "for," the people (1960, 6).

27. Historians of the subject commonly list aerial perspective (diminution in contrast and intensity of color, colors tending toward blue), planar perspective (foreground, middleground, background, and variations), and linear or vanishing-point perspective. Among the dozens of studies, see esp. Edgerton 1975.

28. On Sidney's complex spatial integration see Farmer 1984, 1–5.

29. William A. Ringler notes a great advance in geographical accuracy and specificity from *Old Arcadia* to *New* (Sidney 1962, 376). Dorothy Connell disagrees and finds *Old* more accurate (1977, 131–35). But Peter Lindenbaum argues that the "errors" in the *New* can all be traced to Strabo,

whom Sidney would have held authoritative (1986, 77–78). The classical prototype is epic, not pastoral, with Aeneas's view of Carthage (4.418ff.) supplying the overall structure and the rural scenes on the shield of Achilles (18.541ff.) suggesting the imagery.

30. As Frederick Hard observed, E.K.'s letter to Gabriel Harvey, prefixed to *SC,* defends the poem's roughness and archaism by an analogy with painters who surround "the daintie lineaments of beautye" with "rude thickets and craggy clifts" (Hard 1940a, 121). Such contrasts are a common feature of Renaissance painting but rarely occur in English pictures until the last decade of the sixteenth century.

31. Spenser can plan very carefully indeed when it matters to him; consider the intricate structure, involving many different systems, of *Epithalamion.*

32. On the portraits, see Leslie 1985, 26–27. Jonathan Z. Kamholtz proposes that Spenser's characters begin by seeing things in perspective—that is, from a fixed point of view—then "forsake" this "visual field" for a "visual world" that takes account of time as well as space (1980). He cannot adduce instances of systematic spatial representation within the poetry, so that the first part of his argument seems to me untenable. But his emphasis on the dominance of space by time hits the mark. In her commentary on this article, Judith Dundas rejects *perspective* as an appropriate term for what Spenser does; his work is finally aural, not visual (1981, 82–84). I agree. This characteristic helps account for Rudolph Gottfried's insistence that Spenser's visual imagination was "relatively weak" (1952, 209).

33. The Welbeck portrait attributed to Marcus Gheeraerts the Elder shows a similar structure (building, with Elizabeth, at left; garden, with others, at right; landscape beyond) (fig. 16).

34. I disagree with Judith Dundas that in *FQ* "for the first time in English literature . . . details are selected and arranged for pictorial clarity" (1965–66, 476). Ernest B. Gilman's discussion of Spenser emphasizes "how strongly visual his developing poetic is" (1986, 64), but reiterates that for the most part Spenser's images arise from the emblematic tradition which Gilman lays out as background, and in which there is no ultimate priority of either visual or verbal stimulus. He goes on to cite John B. Bender's remarks on Spenser's "discontinuous and fragmented anatomizing" of the visual field (79).

35. Joseph B. Dallett sees this procedure as intentionally archaic (1960, 102–3).

36. Cuts of similar quality appeared in John Derrick's *Image of Irelande* (1581), where, indeed, the pictures are considerably more sophisticated than the text.

37. Mercer insists that Hilliard considered landscape "a piece of inessential nonsense," largely on the strength of the fact that he makes no mention of landscape in his treatise on limning, by contrast with Edward Nor-

gate's, forty years later, which pays a great deal of attention to the topic (1962, 207). Strong proposes that at this time treatments of the figure, in miniatures though not in easel portraits, moved away from iconic rigidity toward "spontaneity of expression" (1983, 12).

38. Oliver's surviving drawings, including a scene of nymphs and satyrs sporting along a stream, are as spatially sophisticated as any European work of the time.

39. The connection with Mannerism is suggested by Cyrus Hoy (1973); we will consider it more fully in chapter 9. See also Dundas 1981; Frye 1980, 341; and Kroeber 1975, 84–85.

40. Lucy Gent claims that Drayton's revisions of this poem show him "naively enthusiastic" over sophisticated pictorial contrivances in 1595, relatively blasé in 1603 (1981, 22).

CHAPTER 7. *Ut Architectura*

1. This understanding appears from the early Renaissance onward; Alberti begins his discussion of the compositional aspects of perspective by commending *copia* and variety, but insists that they must be kept under the artist's firm control; otherwise "It is not composition but dissolute confusion which they disseminate" (1966, 76).

2. These optical oddities are discussed, and the discussion extended to literature, by Ernest B. Gilman (1978). In addition to the Holbein the best-known example is Guillem Scrots's anamorphic portrait of Edward VI. The word *perspective* is discussed by James Turner (1979).

3. A fascinating reference to such perspective devices appears in Brit. Lib. Harley MS 6857, a program for an allegory of Justice that calls for a picture of Jupiter holding a mirror in which appear Juno, Minerva, and Venus. But by "artificyall conveyaunce" all four are to "vanishe cleane out of sighte, and by traiection of the beames of the eye through the strayghte, or narrowe hoale of speculation," to be replaced by an image of Charon and Cerberus (fol. 16). This group is to be balanced by another in which Apollo and the Graces similarly give way to Pluto and the Furies (fol. 17). Just how it works is hard to say in the absence of any more detailed instructions.

4. Roland Mushat Frye connects English visual conservatism to a continuing insistence on symbolic rather than perceptual unity (1980).

5. See the range of Peakes in Strong 1969b, pls. 188–235, esp. the portrait of Prince Henry (Strong dates it 1610 on unspecified grounds, but the figure looks younger than that by three or four years), in which a large rug on the floor behind the full-length figure leads to a draped wall with a window in it through which a landscape can be seen.

6. The device of a series of painted columns is used in Marcus Gheer-

aerts's Garter procession prints of 1576, the frieze at Rothamsted Manor of about the same date, and many other prints and paintings, both English and Continental; according to F. W. Reader, Elizabethan figured murals almost all have a painted architectural frame (1932, 120). At St. Mary's, Bramber, East Sussex, a monastic hostel converted into a private house after the Dissolution, there is an interesting paneled room with marquetry "window arches" framing painted land- and seascapes; the staff calls them "Elizabethan," but the paintings look seventeenth century. Nikolaus Pevsner and Ron Nairn call them "jolly" but hazard no guesses on the date (1973, 118).

7. Hilliard's Ermine portrait of Elizabeth of that year and his picture of Leicester the year after both have rather badly painted mullioned windows piercing the back wall; so may the anonymous Armada portrait of 1588 (though the inset panels on either side of the figure reveal emblematic pictures of the naval battle and the providential storm rather than landscapes). Marcus Gheeraerts's Welbeck portrait shows the queen full length beside her throne, among various emblematic devices. To the right, the room gives onto a garden, with a wall and loggia at the back of it; two ladies and a gentleman are conversing in the garden, two more ladies being admitted by a guard through a gate at the rear (fig. 16). Even more striking is the Sieve portrait of about the same period, which places the three-quarter image of the queen between a pillar adorned with emblematic medallions and a deep and rapid recession along a Doric colonnade to a classical temple, very reminiscent of Tintoretto's St. Mark series. Mercer argues that the Sieve portrait (now in the Pinacoteca in Siena) had both a foreign painter (Strong proposes Cornelis Ketel) and a foreign patron, and that the Welbeck picture was done when Gheeraerts had not yet assimilated the English tradition (Mercer 1962, 176; Strong 1987).

8. Murray Roston's treatment of perspective emphasizes seeing past one thing to another beyond it (1987).

9. Once more, it is a case of a Renaissance phenomenon, "a transition from wall architecture to space architecture" (P. and L. Murray 1963, 61), returning to England for good near the end of the reign of Elizabeth after tentative attempts to enter the culture under Henry VIII and Edward VI.

10. He goes on to argue that the emphasis was borne from philosophy and the arts to science rather than from science to the humanities. Michael Baxandall has rooted it in part in certain activities—for example, the need to estimate the volume of a container by eye—of a commercial as contrasted with a barter economy (1972, 86).

11. The allegorical picture of Sir James Luttrell as a giant wading among shipwrecked pygmies has some of the same qualities. Frye 1980 does not discuss either of these pictures. But even more clearly than the Unton picture, because of the much greater sophistication of the painting, they

demonstrate the continuing dominance of idealistic over ikastic motives in English art. Similar kinds of organization characterize the more sophisticated sculptural assemblies of the period, for instance the fine alabaster overmantel in the hall at Burton Agnes, Yorkshire (1610), whose lower tier shows the Wise and Foolish Virgins, together with angels, the Tree of Life, and assorted souls waiting for judgment, undergirding a second tier in which the arms of various Boyntons swim in a field of Grotesque motifs. The screen is even more elaborate, and no less paratactic. My analysis of the British Library programs for allegorical paintings (Sloane MSS 1041 etc.; Harley MS 6857) persuades me that they envisage only local spatial coherence governing an individual figure or figures with their attributes; the paintings as wholes had no governing space.

12. Although his argument on this point is somewhat unclear, I believe that it is this feature of late renascence art that John Bender refers to in his discussion of "framing" (1972, 68ff.). See esp. his treatment of Edgar's topographic fantasy in *King Lear* (95–97). Only "framed" images, Bender says, can be truly pictorial; in actual Elizabethan practice, such images mostly turn out to be emblems. The argument dodges the issues raised by a good many sixteenth-century ensembles, especially Mannerist, which willfully blur the distinction between picture and frame.

13. Samuel Y. Edgerton proposes that Alberti sought to devise a construct "more a stage than a space . . . within which painted figures could be presented gracefully" (1975, 30).

14. Marion Trousdale has entered a caveat against the tendency to apply our modern belief in "the primacy of structure" to Elizabethan thought and art. In a culture based on commonality of knowledge, she writes, and in which the arts had a rhetorical rather than a cognitive mode, and aimed to arouse rather than to convert, form simply did not carry "the burden of meaning." Hence Sidney, for instance, would not have been sensible of the meanings implied by the order as well as the content of events, because to him any merely chronographic plot would have lacked "providential" causation, and hence providential significance (1973). My argument, however, is precisely that we can see the "modern" sense of structure emerging in English art in the last decades of the Tudor period.

15. Alberti does not use the word *period* but does urge painters to "associate with poets and orators" because in some not very clearly articulated way it will help them in "beautifully composing the *istoria*" (1966, 90). Baxandall has persuasively argued the influence of the study of rhetoric on the development of Renaissance art and art theory (1971).

16. Frances Yates has ascribed the success of Ramism to its "inner" or intellectual iconoclasm, which substitutes an organizational scheme for a particular image and thus becomes the logical counterpart of Reformation theology (1966, 234–35).

17. Marcus Whiffen asserts that builders worked largely without preliminary drawings throughout the period (1952, 15). But Adrianus Junius (1585) borrows from Vitruvius *ichnographia* (ground plan), *orthographia* (elevation), and *sciographia* (room-by-room description); the Greek roots say "Renaissance" loud and clear, while the terms themselves imply planning.

18. Linda Murray sees in the clock tower at Burghley House (1589) an effort to treat a building as a coherent whole, not just a collection of decorative features ornamenting a traditionally determined assemblage (1967, 176). But such an effort had also determined many decisions during the building of Longleat, begun three full decades earlier.

19. Sir John Summerson's tentative datings of the plans in the Thorpe collection (1966) indicate that the builder became more and more concerned with what we might call architectural economy, with compactness and ease of interior communication, after the turn of the seventeenth century. He may have been moved by the increasing costs of land, especially in the city, which made compact design desirable for economic as well as esthetic and domestic reasons.

20. Sypher connects these figures to the use of soliloquy in drama (1955, 144). An interesting English instance is an anonymous painting of the Court of Wards and Liveries (c. 1585, in the collection of the duke of Richmond and Gordon), which uses foreground figures, their backs to the viewer, to make the visual transition between the viewer and the twelve dignitaries, including Burghley, seated in severe dignity around a table. The execution is crude, but the idea is advanced for its time and place.

21. George Williamson speaks of "the psychology of the period, which was a psychology of expectation" (1951, 55).

22. Sidney's concern with spatial relationships undermines the assertion of Judith Dundas that Spenser's *FQ* (1590) was the first work in English literature in which "images are given a spatial orientation" (1965–66, 476). Norman K. Farmer, Jr., relates the passage to renascence perspective and goes on to treat it in detail in terms of renascence critical theory (1984, 5–6). Strong does not mention Sidney, but Kalander's garden is a paradigm of sixteenth-century English gardening practice as Strong describes it; he documents analogies to most of Sidney's elements at Nonsuch (1979, 63–69).

23. Sidney's specification of a *square* room is curious: the form dominates the plans of the period's most esthetically self-conscious buildings, Longleat, Wollaton, and the Queen's House.

24. The fullest account of the relationship between domestic architecture and social behavior is Girouard 1978. The subject is related to literature, and especially to an important group of seventeenth-century poems, by McClung 1977, which includes several dozen plans and photographs.

25. Stone 1973 summarizes much information about the house and its

social and political functions, with special attention to its place in Cecil's endless financial wheeling and dealing. See also Girouard 1978, 113–16. Many similarities can be found with Thomas Howard's Audley End, originally even larger than Hatfield, but built at the same time for the same purposes; see Drury 1980.

26. See the plan in Girouard 1978, 115. Strong observes that the obligatory sequence of rooms included a privy garden (1979, 49).

27. Drury observes that at Audley End, even more heavily influenced by French models than Hatfield, the royal apartments formed a more linear, hence more systematic, *enfilade* (1980, 12).

28. See esp. Duncan-Jones 1980, which offers several possible but not compelling arguments for Sidney's knowing specific works by Titian and other important late sixteenth-century Italian and Flemish artists. Among Sidney's biographers, John Buxton pays special attention to Sidney as patron (1966). The shaped poem (in the form of an obelisk) dedicating Sylvester's translation of DuBartas's *Devine Weekes* (1605) to the memory of Sidney is built around the conceit of Sidney as Apelles/Apollo.

29. Buxton argues that Sidney, unlike most Englishmen of the period, preferred narrative paintings to portraits (1965, 108). Kalander's gallery contains both kinds, but it should be noted that the actual iconophrases in Arcadia are all either portraits or emblems. Arthur K. Amos, Jr., has a complicated, not ultimately persuasive idea that book 1 of the revision is "pictorial," the other two not (1977, esp. 18–20, 73).

30. An interesting analogy is with the *Sileni Alcibiadis,* referred to by Plato in *Apology* and exploited by Erasmus in the *Adagia*—figures of gross mien that open up to reveal beautiful images of a god. Such a mixture of styles was typical of the imagery of mystery cults.

31. The closest visual arts parallels, interestingly enough, are in architecture. At Longleat, Sir John Thynne, moved partly by the need to restore work damaged by fire, but apparently as well by changing conceptions of style, seems to have altered his plans several times over the thirty-year-period during which the building was going up (Girouard 1959). At Hardwick, Elizabeth of Shrewsbury finished one grand house about 1590 and almost immediately began to build another, on more up-to-date principles, across the road.

32. Many students of the work have commented on the second version's increased emphasis on terms like *change, fortune,* and *providence,* and on events to which such terms apply; see esp. Wolff 1912. Amos proposes that book 1 is organized in terms of space, though his analysis seems to me primarily ethical rather than perceptual, and for many pages in a row he makes no use of the concept at all (1977). (He does better by time in book 2.)

33. On the delight that renascence readers seem to have been able to

draw from workmanlike didacticism, see Salman 1979. S. Clark Hulse supplies a useful survey of the *loci classici* behind renascence theories of depiction (1978a, 16); the theories suppose an essentially rhetorical sequence of responses passing from perception through imagination to sympathetic identification and finally reflection.

34. Sara Munson Deats (1980) argues that an ironic subtext of commentary and prophecy is woven by the play's rich uses of mythological imagery (mostly allusions to Ovid's *Metamorphoses*). The irony is largely unconscious, however, in the sense that it comes from the awareness of the author rather than that of the characters; it operates, if you will, at only one rather than two removes.

35. Gordon Braden emphasizes Marlowe's differences from Musaeus but still insists that Ovid is only a secondary source (1978, 125). He focuses on plot and diction, however, rather than what might be called rhetorical design.

CHAPTER 8. *Bottom's Dream*

1. According to Edwin Haviland Miller the professionals tended to come from the cities and from relatively modest circumstances, the amateurs from the landed gentry (1959, 23).

2. See also the extended comparison between Sidney, scion of a great house, and Shakespeare, the country boy come to town, in Danby 1966, 72–73.

3. On the late sixteenth-century taste for literary novelty, see Peterson 1967, 166. Sidney's *Apologie,* by enumerating the established genres and then by asserting that the English have produced only "comedies" and "that lyricall kind of songs and sonnets," suggests the types not yet mastered by English poets: elegy, satire, regular tragedy, ode, epic; within twenty years all the lacks would be filled (G. G. Smith 1964, 1:201).

4. Mercer argues that sixteenth-century English sculpture is less restricted in its subjects and styles than painting because sculpture, mostly funerary to be sure, was commissioned by the gentry and merchants as well as the aristocracy; these classes deflected most of the esthetic energies earlier spent on ecclesiastical art into a kind of quotidian humanism (1962, 241).

5. Phoebe Sheavyn calls attention to some other mutually supportive linkages—Chaucer and Gower, Wyatt and Surrey, Sackville and Norton, all exceptions to the more customary "isolation" of the English writer (1967, 127–31). We might add the Harvey-Spenser and Ralegh-Spenser pairs. It is worth observing that ordinary Tudor artisans, including visual artists, were interconnected by apprenticeship, marriage, collaboration; Mary Edmond has begun to document the elaborate web of such relation-

ships (which reached out to include some writers) among the painters of Tudor and Stuart London (1980, 1983). But the patterns of patronage, and especially the lack of a center in the royal court, seem to have kept more ambitious artists (mostly brought over from the Continent) from forming esthetically self-conscious and distinctive groups. The dispersal of talent would help explain why no rapid indigenous developments occurred until Hilliard attracted half a dozen associates and students—Peake, Lockey, and Oliver among them—into a distinct school.

6. See the full account by Michael Baxandall of the process by which Renaissance artists grew free to select from among a variety of formal and stylistic options, rather than having to follow a single traditional line (1971). Leslie D. Foster has traced the lineage of Sidney's revolutionary concept (1974). To be sure, the triumphant advance of renascence empiricism cannot be gainsaid; some of its spoils were considered in the chapter on topography. But ikastic practices, based on observation, stood shoulder-to-shoulder with the continuing traditions of ideal imitation—that is, the use of closely observed natural phenomena to carry abstract concepts or themes, which, according to Rensellaer Lee, had in turn supplanted the observational "exact imitation" of the late Middle Ages (1940, 203). Sir Kenneth Clark discusses the process with reference to idealized landscape: "The features of which it is composed must be chosen from nature, as poetic diction is chosen from ordinary speech, for their elegance, their ancient associations and their faculty of harmonious combination: *ut pictura poesis*" (1964, 22). According to Nikolaus Pevsner, in even very crowded sixteenth-century canvasses observation is always subordinated to abstract principles (1968, 24).

7. See the suggestive remarks, and the quotations on which they are based, displaying Spenser's constant awareness of his "Ideal Spectator," in Dallett 1960, 88–94.

8. Paula Johnson, writing about music and literature in particular but gesturing toward the other arts, talks about a principle of "guided expectation which is resolved in such a way as to produce intelligible form" (1972, 59). Douglas Peterson first discerns in Gascoigne's *Woodmanship* (1575) a conscious application of what Suzanne Woods has subsequently called "mimetic rhythm," in which normal prose syntax and the phonology it generates override but do not break down the meter; Gascoigne's occasional practice would become routine in Sidney and his successors (Peterson 1967, 159; Woods 1978). For a counterview, see Trousdale 1973, with special reference to Sidney; Trousdale argues that sixteenth-century insistence on the didactic ruled out an esthetic conception of form. A possible solution to the disagreement is set forth by Phillips Salman; the active participation of the reader ("there is an *energeia* of reading as well as of text") means that the reader can be delighted by the form as well as the substance of

the work (1979, 331). Hence readers trained in rhetoric could enjoy art-ists' management of rhetorical procedures in the way amateur football or cricket players appreciate the technical aspects of professional play.

9. Adam White ascribes to the Elizabethans a native taste for "jagged outlines, sudden projections and contrasts of decorated and undecorated surfaces, all of them so shocking to later generations, . . . relished by [the Elizabethans] as providing spectacle and excitement" (1982, 56).

10. Lucy Gent discusses the centrality of the concept of "feigning" to sixteenth-century art and literary theory, both in England and across the Channel (1981, 44–47).

11. Peterson discusses late Elizabethan fashions in connection with En-glish literary chauvinism and distaste for the domination of the court (1967, 167). Paul W. Miller notes the importance of Ovidian erotic narrative "as a subtle form of protest against the established divine and human order of things" (1978, 211).

12. The earliest OED citation for charm meaning "attractiveness" is from Shakespeare, Merry Wives (1598).

13. Sidney uses the word in commenting on how the early poets could "draw with their charming sweetness the wild untamed wits to an ad-miration of knowledge," with references to Amphion and Orpheus; in mentioning the commanding of spirits by verses ("a very vain and godless superstition," to be sure, but also a sign of "the great reverence those wits were held in"); and in referring to the "sweet charming force" of poetry, so great that it can do both more hurt and more good "than any other army of words." According to the OED, the word entered English around the beginning of the fourteenth century, but most of the figurative uses by which its range was extended date from the second half of the sixteenth, and especially from the 1580s and 1590s.

14. The context is a discussion of grotesquerie, interestingly enough. The word charm is not indexed by either Hathaway 1962 or Weinberg 1961, doubtless because there is no single Italian counterpart. (Danti's Italian is utilità, vaghezza, ornamenta, the latter two terms apparently dividing the meanings earlier represented by Horace's dulce.)

15. Toward the end of the period, impressionistic sketches from external nature became a routine practice of the Caracci and other painters. But back in the studio, these became only the sturdy roots on which nature method-ized would be grafted (Ackerman 1961, 84). Not until the Impressionists did painters exhibit as finished paintings their on-the-spot renderings of natural scenes.

16. Thomas M. Greene notes that to many sixteenth-century writers history was "an irrepressible embarrassment" (1982, 178).

17. Andrew Ettin says that by the late 1570s, Spenser could choose between an older style (Lewis's "drab"), which was ethically solid but

esthetically played out, and a newer style (Lewis's "gold"), which was esthetically rich but ethically uncertain; in *The Shepheardes Calender* we find him switching back and forth (1979, 209–11).

18. Joel B. Altman distinguishes between "homiletic" and "exploratory" uses of rhetoric in the drama and documents an increasingly free, increasingly open-ended investigation of all the important political, philosophical, and theological issues from Medwall at the end of the fifteenth century to Marlowe at the end of the sixteenth (1978).

19. Castiglione, and Elyot following him, urged young courtiers to learn about painting not only in order to interpret the didactic messages carried in works of art but also to appreciate better the skill of the artisan; under these conditions, connoisseurship in the patron develops in parallel with entrepreneurship in the artist (Buxton 1965, 3,4).

20. See Herrmann 1972 and especially Strong 1986. Lawrence Stone calls their motives "social and utilitarian rather than visual"; Stone treats collecting as just one expression of the virtuoso spirit, which might also lead into science, waterworks, or the arcana (1965, 715).

21. Romantic *imprese,* and the tilts and other shows for which they were devised, are discussed in detail by Mario Praz (1939, 64) and Sir Roy Strong (esp. 1977, 144–45). Gordon Kipling argues for an essentially unbroken tradition running from Henry VII's Burgundian tilts to his granddaughter's a century later (1977, 117). A fascinating link with literature is suggested by the portrait of Sir James Scudamore (c. 1595–1600; Strong 1977, fig. 76), full length, armed, with his lance (but no shield, unfortunately), in a sylvan landscape. The painting thus supplies through the inescapable association with a major character of the same name a clue to the late Elizabethan idea of the decor of Spenser's *FQ*. (For what it may be worth, the scene of the portrait is parklike; behind the knight opens a series of glades in which the knight's squire and two other knights recline at their ease.) On idiosyncratic handwriting see Tannenbaum 1967, 12, 22–26.

22. Around the turn of the seventeenth century Henry Wotton, Donne's friend, whose position as ambassador to Venice allowed him to act as an art agent for the duke of Buckingham and who presented a mosaic portrait of Robert Cecil for installation at Hatfield, wrote what may be the earliest surviving piece of native English art criticism; he enters the *paragone* of the arts, awarding the laurel for esthetic preeminence to painting over architecture because it comes nearer to being an "*Artificiall* Miracle" (1651 [mostly written much earlier], 64; on the connection with Donne see Douglas Chambers 1971, 33). At about the same time, Richard Haydocke published as *A Tracte Containing the Artes of Curious Paintinge Carvinge & Buildinge* (1598) his handsomely printed and ornamented translation of Lomazzo's *Trattato dell'arte de la pittura*. Soon thereafter came Hilliard's *Arte of Limning;* Peacham's *Art of Drawing* (1606), which includes a good deal

of incidental practical criticism along with its practical instructions; and Fynes Moryson's *Itinerary* (1617, but based on notebooks compiled during the 1590s).

23. Stephen Orgel and Sir Roy Strong argue that the illusionistic force of things like Inigo Jones's stage settings for the Stuart masques depended on a sophisticated recognition of the artifice involved (1973, 1:11).

24. Baxandall notes that early fifteenth-century Italian contracts emphasize materials, late fifteenth-century ones the artist's skill (1972, 15).

25. The chef d'oeuvre is *Hamlet*. In an unpublished essay, Nancy Abraham has brilliantly seen the Prince as an actor caught in a strange, nightmarish play; each time he thinks he has figured out the genre of the piece, and begun to write his own part accordingly, it shifts on him.

26. Annabel Patterson has vigorously argued that sixteenth- and seventeenth-century censorship operated within a dynamic, largely tacit understanding by both artists and power holders that the former enjoyed some license to criticize the latter if they did it discreetly and obliquely (1984). Her position complements my proposals on the uses of the Grotesque and Demotic modes.

27. Mark Girouard has noted that William Cecil's Burghley House was in its original form court-centered, then remodeled during the years after 1577 so that it became outward-facing; he relates the process to a late Elizabethan Gothicism in which the ancestral traditions, distanced by renascence awareness of history and by an intervening classicism (however crude), became to sophisticated patrons not the natural indigenous elements of design, whether in architecture, painting, funerary sculpture, or the decorative arts, but a style, to be used at the option of the artist in preference to some other style (1963b, 23–39). J. A. Gotch points out the self-advertisement implied in the alphabetical balustrades, setting forth the builders' own initials or mottoes, at Thorpe, Wollaton, Hardwick, and Castle Ashby (1914, xli). Jonson and others, themselves building upon a *topos* from Juvenal and Martial, gave the idea literary form in "To Penshurst" and other country-house poems; for very full discussion see McClung 1977.

28. Theseus's own comments can be read as relatively gentle to begin with, but growing sharper as the play goes on and the remarks of the younger gentlemen, Demetrius and Lysander, in effect challenge him to match them in critical rigor.

29. I adhere to the party that dates a revised *Love's Labor's Lost* very close in time to the first production of *Midsummer Night's Dream*.

30. Thus in Liviu Ciulei's 1986 production at the Guthrie, the mechanicals, who had supposed that their "bergomask" was indeed wanted and rushed off to change their costumes accordingly, returned to find the room empty and dark and their efforts thus totally unrewarded, even by applause.

31. At the end of *Love's Labor's Lost*, the ladies do not directly censure the gentlemen for their discourteous treatment of the Worthies. Still, Rosalind's purgative for Berowne's "gibing spirit" and her statement that "a jest's prosperity" is in the hearer, not the speaker (5.2.858–63), can readily be applied not only to his unbridled mockery but to that of the other three.

CHAPTER 9. *All This Knav'ry*

1. On this terminology see n. 2 to the introduction.

2. The fullest and clearest summary of the controversy to date is Mirollo 1984. Mirollo concentrates on literature, however, and should be supplemented by other sources. For bibliographical guidance in addition to that supplied by Mirollo see Studing and Kruz 1979.

3. This list is based on that of Linda Murray (1967, 30); I use it because her view of Mannerism is the most circumscribed of the several recent general studies.

4. Bronzino, Murray says, is a Mannerist in narrative painting but not always in portraiture, while no northerner was truly Mannerist; they used the "vocabulary" but not the essence. Craig Hugh Smyth takes a similar position (1963).

5. Nikolaus Pevsner looks at the Jesuit movement and other religious developments of the sixteenth century that tended to suppress the sense of "the individual significance of the human being" liberated by the Renaissance: the resulting tensions, he claims, produced Mannerism (1968, 14–20). Anthony Blunt likewise argues a theological approach, but sees in Mannerism the iconic Catholic expression of a spiritualizing movement throughout Christendom whose Protestant expression was iconoclastic (1963). Murray Roston makes a similar argument about the particular cases of John Donne (1974) and George Herbert (1987, 301–42). Stephen Greenblatt calls attention to ways in which post-Reformation Englishmen were able to retain the force of Catholic icons by displacing them from "belief into ideology" (1980, 230). To Wylie Sypher Mannerism is the fragmented remains of a broken dream, the "formal dissolution" of Renaissance proportion, harmony, and unity (1955, 102); he perceives in sixteenth-century Mannerism only an especially salient emergence of a widespread esthetic mode. To Daniel B. Rowland, however, the essence of Mannerism is conceptual, not formal, "never fully comprehensible," the effort of men facing a broken cosmos to hold it together by force of intellect (1964, 75–79; he is actually following Sypher pretty closely). And Roy Daniells bases Mannerism on "a new feeling for space" and on the impact on artistic thought of "the new science, the new celestial mechanics" (1966–67, 1).

6. Mirollo's types of Mannerism have obvious affinities with Thomas M. Greene's types of Renaissance imitation (1982); the common ground

between Mirollo's truly "mannerist" and Greene's "dialectical imitation," both involving the artist's reworking of the source to suit changed circumstances, is especially great.

7. Following Hauser closely, and using visual parallels from Rosso and Pontormo, but especially from Tintoretto and El Greco, Hoy finds Mannerism writ all over the work of Chapman, Ford, Tourneur, Webster, and the later Shakespeare. Above all, he emphasizes various dualities: paradox, "the representation of different kinds and levels of reality in the same work" (50), the alienation of Jacobean heroes (and presumptively their makers) from their surroundings, and the deceit and hypocrisy that both cause and express that alienation. Except for brief references to Sir Kenneth Clark, Irwin Panofsky, and S. J. Friedberg, Hoy cites no other art historians besides Hauser; aside from brief quotations from T. S. Eliot and Erich Auerbach, he mentions no literary critics or historians. The absence of references to Sypher seems particularly striking, in view of many substantial similarities in their positions; perhaps the explanation is that Hauser relied very largely on Sypher for his view of English literature (his own direct acquaintance seems to be confined to the best-known plays of Shakespeare and a few familiar anthology pieces).

8. A. D. Cousins calls this kind of activity *contrapposto*, again borrowing a term from art history, and says it is an essential characteristic of Donne's Mannerism (1979).

9. Sypher calls the first movement "capricious"; it is not, for the shift to *graves* is thoroughly prepared, even required, by *times, pass, elder, destruction, decay, Running,* and especially *first, last, everlasting day,* a phrase whose pictorial counterparts universally show bodies in graves. Nor is the return to earthly considerations in stanza 3; it arises from the temporal insistence of *then* and *when.*

10. I have elsewhere challenged the propriety, however venerable the custom may be, of calling the distinctive form of Mannerist art the *linea serpentinata* (Evett 1986).

11. In a way, Sypher's own rhetoric recognizes the problem, for toward the end of the discussion the visual terms give way to terms like *discord, discontinuities, reversal.* And of course in the dynamic arts—dance, enacted drama, and such typical sixteenth-century arts as the masque and the procession—the issues change radically. But except for the drama those arts make little or no part of Sypher's discussion.

12. Consider what a difference it makes to the overall sense we have of *Hamlet* if the arrival of Fortinbras, his valedictory, and his formal assumption of the Prince's place in the scheme of things are cut (as they often are in performance).

13. I got this idea while reading Mary Ann Caws: "The double fascination for both Mannerists and Surrealists of designation or pointing and of

the gesture observed" (1981, 49). The term *gnomon* comes from Euclid by way of James Joyce's "The Sisters," the first story in *Dubliners*.

14. Another example is the Sieve portrait of Elizabeth, with its strongly recessive diagonals drawing the eye to the figures in the background; by comparison with most of the queen's portraits, which isolate and center her, this one reminds the viewer of her dependence on or vulnerability to others.

15. Marianna Jenkins discusses the "Mannerist idealization" of Tudor portraiture (1947, 12–13).

16. Lucy Gent emphasizes the importance of chiaroscuro in the several arts to a general esthetic awakening in late sixteenth-century England (1981, 25–27, 49–53, pl. 2 and note).

17. Some of Gascoigne's critics have argued that he probably had a specific Continental source or sources. None has so far been identified.

18. There is some evidence for a fashion in erotic prints (after Titian, for instance) in London in the nineties. But the whole issue of the availability of Continental prints in sixteenth-century England could stand further exploration. Katherine Duncan-Jones has tried to relate various erotic passages in *Arcadia* and other works of Sidney to specific paintings by Titian and others that Sidney could have seen on his travels, especially in Vienna. Her connections are not improbable, but not compelling, either (1980).

19. Although much of the criticism on Hilliard speaks boldly about his French sojourn, the actual documented evidence is scanty, and the conclusions drawn are necessarily very speculative.

20. The corresponding emphases in Shakespeare's sonnets seem worth noting. An elaborate but not wholly persuasive connection between the two major figures has been proposed by Leslie Hotson (1977).

21. In favor: James Lees-Milne (1951, 84); Mercer (1962, 205); David Piper (1965, 17); John Pope-Hennessy (1949, 11). Opposed: Strong, to whom his stylistic origins are medieval, not Renaissance (1969b, 14); and, by implication, Shearman, who lists as a Mannerist only Isaac Oliver, Hilliard's competitor and successor (1967).

22. Strong is leading an effort to raise Oliver's status above Hilliard's (1983, 97–116; 1984b, 142–85). On Oliver's life, and especially his relationships with other artists, both natives and immigrants, see Edmond 1983.

23. The exception to this rule is the work of the Mannerist Hilliard. Lees-Milne notes how by contrast Oliver's "downright portraits" give "an accurate impression" of his sitters' "physical charms," though Lees-Milne goes on (wrongly, in my judgment) to see Oliver thus belonging to the seventeenth century rather than the sixteenth (1951, 85).

CHAPTER 10. *Something of Great Constancy*

1. Joseph B. Dallett, following Dagobert Frey, makes a suggestive if not wholly satisfactory distinction between "Gothic" and "Renaissance" space, between "space presented only as a constant alteration or movement in the subjective experience of the observer" (as in the simultaneous representation of several scenes in the tapestries viewed by Britomart in *FQ* 3.1.38) and space "presented to the fixed eye of the observer as a simultaneous, geometric totality, a medium receding with the speed of light into distant perspective and demarcated by a uniform scale for the figures and objects in it" (1960, 99–100n). Within this paradigm Mannerist space would bring Gothic alternation inside the Renaissance frame.

2. It may also appear in the characteristic use by later sixteenth-century composers of incomplete or partial cadences and other forms of musical asymmetry, according to Paula Johnson (1972, 76–85).

3. These are among the plays that Cyrus Hoy finds peculiarly Mannerist (1973).

4. S. K. Heninger, Jr., argues that the neoplatonic reading of the poem called for by Spenser's own comments fends off the melancholy likely to be imposed by a modern materialistic view by diminishing the importance of all phenomena, including time, within the ordering steadfastness of his "foreconceit" (1975). But the historical findings of Stephen Greenblatt, Richard Helgerson, and many others urge us to place Spenser in that large group of dejected idealists—Greville and Chapman are others—who cause us to experience melancholy now even as they ask us to await joy later.

5. Arnold Hauser, apparently following Wylie Sypher, places Sidney and Spenser (without explanation) among Renaissance artists (1965, 339). John Shearman, however, sets Spenser among the Mannerists on account of his style, and though he does not so designate Sidney (whose style is surely as full of *maniera* as anybody's), he does quote from the *Apologie* at the climax of his discussion of "the divine right of artists" to invent, dispose, and distribute (1967, 39, 48).

6. The significance of the reference is rendered doubtful by the fact that Shakespeare attributes to Romano excellence in the one major art— sculpture—in which he did no important work, and by the fact that his most characteristic work depends for effect on Michelangelesque distortion of form rather than Raphaelesque perfection of it. Still, it is also the case that the piece Romano is said to have done has a distinctly Mannerist virtuosity about it: a painted sculpture so astonishingly wrought (to the extent of reflecting the changes of sixteen passing years) as to challenge the distinction between life and art (and no doubt featuring the contrapposto pose originally denominated by Michelangelo as generating the *linea serpentinata*). A. Hyatt Mayor suggests that Shakespeare saw "an engraving of

Giulio's fresco of the Fates labelled IV. RO. IN./SCULPTA/ IN PALATIO/THE"
(1964).

7. Such a view has dominated recent accounts of Mannerism, especially
Hauser's; opposition is headed by Shearman, who observes the insulation
of the individual work of art even from the most personal crises of the art-
ist, the danger of projecting twentieth-century values on sixteenth-century
art, and the corresponding salubriousness of trying to study sixteenth-
century art in terms of sixteenth-century assumptions and values (1967,
40, 136). Yet his statement that "no one has ever cited evidence of 'tension,'
or the urge to discomfort, from the age to which these works belong"
(136) seems to me corrected by many literary passages both Continen-
tal and English. It may be true that the ideas are not expressed either
in public theoretical or critical writing or in private correspondence. But
(especially given the rhetorical origins of renascence critical terminology)
the lack of fit between *ethice* and *practice* in sixteenth-century visual arts is
even wider than in other periods, while the absence in letter-writing tradi-
tions of any confessional model, and the tendency of the period to express
strong feelings in ceremonial ways (that is, through art), will explain why
sixteenth-century artists could write matter-of-fact letters but make tense
art.

8. On the widespread interest in hermetic and cabalistic studies see esp.
Yates 1964. Alastair Fowler applies some of the ideas to literature with
mixed results (1964); on the "dyad," see esp. 9–17.

9. For an explanation in terms of the psychology of the court of Henry
VIII, see Greenblatt 1980, 146–56. Thomas M. Greene argues that in Wyatt
the Petrarchan dualism tends to dissolve because the static relationships
necessary to sustain it have given way to more active, determinant relation-
ships (he calls the process *linearization*), perhaps following the replacement
of the older Catholic sense of an endless cycle of fall and expiation by
a Protestant sense of a single act of iniquity followed by a single act of
forgiveness (1982, 246–51).

10. The most famous instance in this period is Parmigianino's (1524),
painted as reflected in a curved surface, which distorts the pretty face
toward monstrousness and makes the hand (the artist's means for self-
definition, of course) disproportionately large.

11. Rosalie Colie states that "self-reference draws attention to the art-
ist's techniques, and usually to his mastery of technique," instancing Jan
van Eyck's virtuoso self-portrait reflected in an illusionistically brilliant
mirror in *The Arnolfini Wedding* (1966, 362). But I think it also works the
other way around.

12. According to James Mirollo, "mannerist art is more individualis-
tic than Renaissance art since it deviates subjectively from the norm, the
public, and the expected" (Robinson and Nichols 1972, 16).

13. This idea allows us to identify at least some art that meets the con-

ditions of two distinct definitions of Mannerism: one in terms of virtuoso performance, such as Shearman's, and one in terms of psychological stress and resolution, such as Hauser's.

14. Miniatures were more costly than ordinary portraits, as noted earlier, so this one must have been very expensive indeed. Strong analyzes the iconography of the piece and identifies its subject as Essex (1977, 56–83).

15. Other Elizabethan works that seem to me to belong in this vein are Smythson's Wollaton, the woodwork at Speke, and the tombs of Mary, Queen of Scots, and of Lord Hunsdon, in Westminster Abbey.

16. I take a simpleminded view of irony here, begging the dozens of important questions raised (and sometimes resolved) by Wayne Booth (1974) and other theoretically minded authorities. Booth touches (1) but does not explore the historical problems set up by the distance between the relatively narrow definitions of irony in renascence rhetorics and the much wider definitions needed to cope with modern uses of the word. Kenneth Burke has noted the proportion between the complexity of a scene or statement and its intrinsic disposition toward ambiguity (1969, 6–7).

17. On the late sixteenth- early seventeenth-century fashion for such fanciful pictures, see Piper 1975, 66–68. The Lee portrait is based on an engraving in Boissard, *Habitus variarum* (Antwerp, 1581).

18. Edgar Wind asserts that since the renascence saw irony as the best mode for dealing with the deepest things, *grottesche,* which mingled "divine secrets with the fabric of fables," constituted the appropriate classical style for burial and mystery chambers (1968, 236–37).

19. No doubt a great deal of impressive work perished with the destruction of Nonsuch, Somerset House, Leicester House, Theobalds, Wimbledon, etc.; see the highly sophisticated reliefs, now at Hardwick, representing the lost glories of sixteenth-century Chatsworth (Girouard 1976, 90, 98).

Bibliography

BIBLIOGRAPHICAL NOTE

For bibliographical guidance in addition to the list of works cited that follows, see Clark Hulse, "Recent Studies of Literature and Painting in the English Renaissance." Hulse is especially strong on the visual arts aspects of the work of particular English authors. The theoretical issues of interarts criticism in general are surveyed by Thomas Munro, *The Arts and Their Interrelations*. More briefly, C. Giovanni, "Method in the Study of Literature in Its Relation to the Other Fine Arts," is of interest. Paula Johnson, *Form and Transformation in Music and Poetry of the English Renaissance,* opens with an excellent account of the problems the interarts critic faces. The several essays in the fall 1972 issue of *New Literary History* (vol. 3) constitute a full treatment of the particular issues involved in interarts criticism of works of the sixteenth century. *Encounters: Essays on Literature and the Visual Arts,* edited by John Dixon Hunt, is another stimulating collection. The special issue of *John Donne Journal* devoted to inter-arts approaches (5.1–2 [1986]) includes many articles relevant to the latter part of the period, several of which engage the theoretical issues. An even larger theoretical envelope is provided by *The Concept of Style,* edited by Berel Lang.

Modern discussions all rest on Heinrich Wölfflin's *Renaissance and Baroque* and *Principles of Art History: The Problem of the Development of Style in Later Art.* The most comprehensive attempt is Mario Praz, *Mnemosyne: The Parallel between Literature and the Visual Arts.* The major interarts study of our period is Wylie Sypher, *Four Stages of Renaissance Style,* which in turn seems to have supplied much of the literary material to an art historian attempting a similar overview, Arnold Hauser in *Mannerism: The Crisis of the Renaissance and the Origin of Modern Art.* A book that is important for methodology, but concentrates on the nineteenth century, is Helmut Hatzfeld, *Literature through Art: A New Approach to French Literature.* Frank J. Warnke, *Versions of Baroque: European Literature in the Seventeenth Century,* opens with an account of the way in which an art historical term achieved wide acceptance in reference to literature as well. His focus is on critics, not works, however, and he pushes past the tough questions with scarcely a glance.

Frederick B. Artz, *From the Renaissance to Romanticism: Trends in Style in Art, Literature, and Music, 1300–1830,* though attractively written, begs most of the serious methodological questions, but in any case Artz's effort to cover the

major arts of all Europe over a five-hundred-year period in three hundred or so pages necessarily entrains superficiality. Roland Mushat Frye has followed the gleam through a series of recent works, including *Milton's Imagery and the Visual Arts: Iconographic Tradition in the Epic Poems* and "Ways of Seeing in Shakespearean Drama and Elizabethan Painting." Much of Frye's work seems to me only a learned Miltonic or Shakespearean version of Leigh Hunt's inquiry whether Botticelli, Titian, or Claude better illustrates *The Faerie Queene,* and the fact that neither he nor most of his critics seem troubled by his blithe disregard for theoretical issues helps explain why I think it necessary to go over this well-trodden ground yet one more time. A method similar to mine, though applied to narrower fields, informs Ernest B. Gilman, *The Curious Perspective: Literary and Pictorial Wit in the Seventeenth Century* and *Iconoclasm and Poetry in the English Reformation.* John B. Bender, *Spenser and Literary Pictorialism,* by contrast imposes some strict definitions and procedures at the outset; the restrictions, though they give great authority to many of his propositions, also prohibit him from dealing with many issues. James V. Mirollo, *Mannerism and Renaissance Poetry: Concept, Mode, Inner Design,* develops an effective approach in the course of his survey of the issues as they have arisen during the long, lively quarrel over the meanings of Mannerism, then applies it to a set of Petrarchan *topoi* as they were treated by various European writers between the fourteenth and seventeenth centuries. I find Mirollo's analysis of the controversy more effective than his treatment of particular works.

WORKS CITED

Ackerman, James S. 1961. "Science and Visual Art." In Rhys 1961, 63–90.

Adams, Joseph Quincy. 1924. *Chief Pre-Shakespearean Dramas.* Cambridge, Mass.: Houghton Mifflin.

Adams, Robert P. 1977. "Opposed Tudor Myths of Power: Machiavellian Tyrants and Christian Kings." In Dale B. J. Randall and George Walton Williams, eds., *Studies in the Continental Background of Renaissance English Literature: Essays Presented to John L. Lievsay,* 67–90. Durham, N.C.: Duke University Press.

———. 1979. "Despotism, Censorship, and Mirrors of Power Politics in Late Elizabethan Times." *Sixteenth Century Journal* 10.3, 5–16.

Adams-Acton, Murray. 1949. "Structural Ceilings of the Early Tudor House." *Connoisseur* 123, 75–82.

Airs, Malcolm. 1975. *The Making of the English Country House, 1500–1640.* London: Architectural Press.

Alberti, Leon Battista. 1966. *On Painting* [*Della Pittura*] (1435–36), trans. John R. Spencer. Rev. ed., New Haven: Yale University Press.

Allen, B. Sprague. 1937. *Tides in English Taste (1619–1800): A Background for the Study of Literature.* 2 vols., Cambridge, Mass.: Harvard University Press.

Alpers, Paul J. 1967. *The Poetry of The Faerie Queene*. Princeton: Princeton University Press.

——. 1977. "Narration in *The Faerie Queene*." *ELH* 44.1 19–39.

Alpers, Svetlana. 1983. *The Art of Describing: Dutch Art in the Seventeenth Century*. Chicago: University of Chicago Press; London: John Murray.

Alpers, Svetlana and Paul. 1972. "*Ut Pictura Noesis?* Criticism in Literary Studies and Art History." *New Literary History* 3.3, 437–58.

Altman, Joel B. 1978. *The Tudor Play of Mind: Rhetorical Inquiry and the Development of English Drama*. Berkeley: University of California Press.

Amos, Arthur K., Jr. 1977. *Time, Space, and Value: The Narrative Structure of the New Arcadia*. Lewisburg, Pa.: Bucknell University Press.

Anglo, Sidney. 1969. *Spectacle, Pageantry, and Early Tudor Poetry*. Oxford: Clarendon Press.

Artz, Frederick B. 1962. *From the Renaissance to Romanticism: Trends in Style in Art, Literature, and Music, 1300–1830*. Chicago: University of Chicago Press.

Attridge, Derek. 1974. *Well-Weighed Syllables: Elizabethan Verse in Classical Metres*. Cambridge: Cambridge University Press.

Auerbach, Eric. 1953. *Mimesis: The Representation of Reality in Western Literature*, trans. Willard R. Trask. Princeton: Princeton University Press.

Auerbach, Erna. 1949. "More Light on Nicholas Hilliard." *Burlington Magazine* 91, 166.

——. 1954. *Tudor Artists: A Study of Painters in the Royal Service and of Portraiture on Illuminated Documents from the Accession of Henry VIII to the Death of Elizabeth I*. London: University of London Press.

——. 1961. *Nicholas Hilliard*. London: Routledge and Kegan Paul.

Bacon, Francis. 1937. *Essays* (1625). London: Oxford University Press.

Balachov, N. I.; Klaniczay, T.; and Mikhailof, A. D., eds. 1978. *Littérature de la Renaissance à la lumiére des recherches sovietiques et hongroises*. Budapest: Akademiai Kiado.

Baldwin, T. W. 1944. *William Shakspere's Small Latine & Lesse Greek*. 2 vols., Urbana: University of Illinois Press.

Baltrušaitis, Jurgis. 1957. *Abérrations: Quatre essais sur la légende des formes*. N.p.: Olivier Perrin.

Bankart, George P. 1908. *The Art of the Plasterer*. London.

Barkan, Leonard. 1975. *Nature's Work of Art*. Chicago: University of Chicago Press.

Barocchi, Paola, ed. 1960–62. *Trattati d'arte del cinquecento*. 3 vols., Bari: G. Laterza e figli.

Barton, K. J. 1975. *Pottery in England from 3500 B.C.–A.D. 1750*. Newton Abbot, Eng.: David and Charles.

[Bateman, Stephen.] 1569. *The trauayled Pylgrime, bringing newes from all partes of the worlde, such like scarce harde of before*. London.

Battisti, Eugenio. 1960. *Renascimento e Barocco*. Torino: Einaudi.

Baxandall, Michael. 1971. *Giotto and the Orators: Humanist Observers of Painting in Italy and the Discovery of Pictorial Composition, 1350–1450.* Oxford: Clarendon Press.

———. 1972. *Painting and Experience in Fifteenth-Century Italy: A Primer in the Social History of Pictorial Style.* Oxford: Clarendon Press.

———. 1979. "The Language of Art History." *New Literary History* 10.3, 453–65.

Bayley, Peter C. 1958–59. "The Summer Room Carvings." *University College Record* 3, 192–201, 252–56, 341–46.

Beard, Geoffrey. 1975. *Decorative Plasterwork in Great Britain.* London: Phaidon Press.

Béguin, Sylvie, et al. 1972. *La Galérie François Ier au Château de Fontainebleau* (special issue of *Revue de l'art*). Paris: Flammarion.

Bender, John B. 1972. *Spenser and Literary Pictorialism.* Princeton: Princeton University Press.

Benesch, Otto. 1965. *The Art of the Renaissance in Northern Europe: Its Relation to the Contemporary Spiritual and Intellectual Movements* (1937). Rev. ed., London: Phaidon Press.

Berdan, John M. 1920. *Early Tudor Poetry.* New York.

Berger, Harry, Jr. 1961. "The Prospect of Imagination: Spenser and the Limits of Poetry." *Studies in English Literature* 1.1, 93–120.

Bergeron, David M. 1971. *English Civil Pageantry, 1558–1642.* Columbia: University of South Carolina Press.

Binney, Marcus, and Emery, Anthony. 1975. *The Architectural Development of Penshurst Place.* Dunstable, Eng.: ABC Historical Publications.

Blomfield, Reginald. 1897. *A History of Renaissance Architecture in England.* 2 vols., London: George Bell and Sons.

Blunt, Anthony. 1968. *Artistic Theory in Italy, 1450–1600* (1940). London: Oxford University Press.

———. 1969. "L'Influence française sur l'architecture et la sculpture décorative en Angleterre pendant la première moitié du XVI siècle." *Revue de l'art* 4, 17–29.

———. 1970. *Art and Architecture in France, 1500 to 1700* (1953). 2nd ed., Harmondsworth: Penguin Books.

Booth, Wayne C. 1974. *A Rhetoric of Irony.* Chicago: University of Chicago Press.

Bradbrook, Muriel. 1965. *The School of Night: A Study in the Literary Relationships of Sir Walter Ralegh.* New York: Russell and Russell.

Braden, Gordon. 1978. *The Classics and English Renaissance Poetry: Three Case Studies.* New Haven: Yale University Press.

Bradford, Alan T. 1981. "Drama and Architecture under Elizabeth I: The Regular Phase." *English Literary Renaissance* 11, 3–28.

Brooke, Nicholas. 1978. "Shakespeare and Baroque Art." *Proceedings of the British Academy* 63, 53–69.

Brown, A. E., and Taylor, C. C. 1972. "The Gardens of Lyveden, Northamptonshire." *Archaeological Journal* 129, 157–63.

Bullough, Geoffrey. 1961–75. *Narrative and Dramatic Sources of Shakespeare*. 8 vols., London: Routledge and Kegan Paul; New York: Columbia University Press.

Burke, Kenneth. 1969. *A Grammar of Motives*. Berkeley: University of California Press.

Bush, Douglas. 1945. *English Literature in the Earlier Seventeenth Century, 1600–1660*. Oxford: Clarendon Press.

———. 1952. *Classical Influences in Renaissance Literature*. Cambridge, Mass.: Harvard University Press.

———. 1963. *Mythology and the Renaissance Tradition in English Poetry* (1932). New rev. ed., New York: W. W. Norton.

Butler, Lawrence. 1972. "John Gildon of Hereford: A Late Sixteenth-Century Sculptor." *Archaeological Journal* 129, 148–53.

Buxton, John. 1965. *Elizabethan Taste* (1963). 2nd. ed., London: Macmillan; New York: St. Martin's Press.

———. 1966. *Sir Philip Sidney and the English Renaissance*. London: Macmillan; New York: St. Martin's Press.

Caiger-Smith, Alan. 1962. *English Medieval Mural Paintings*. Oxford: Oxford University Press.

———. 1973. *Tin-Glaze Pottery in Europe and the Islamic World: The Tradition of 1000 Years in Maiolica, Faience & Delftware*. London: Faber and Faber.

Camden, William. 1610. *Brittania* (1586).

Camille, Michael. 1985a. "The Book of Signs: Writing and Visual Difference in Gothic Manuscript Illuminations." *Word and Image* 1.2, 133–48.

———. 1985b. "Seeing and Reading: Some Visual Implications of Medieval Literacy and Illiteracy." *Art History* 8.1, 26–49.

Carrier, Robert, and Dick, Oliver Lawson. 1957. *The Vanished City: A Study of London*. London: Hutchinson.

Cartari, Vincenzo. 1571. *Le Imagini de i dei de gli antichi*. Venice.

Cary, Cecile Williamson, and Limouze, Henry S., eds. 1982. *Shakespeare and the Arts: A Collection of Essays from the Ohio Shakespeare Conference 1981, Wright State University, Dayton, Ohio*. Washington, D.C.: University Press of America.

Cassirer, Ernst. 1953. *The Philosophy of Symbolic Forms*, trans. Ralph Manheim. 3 vols., New Haven: Yale University Press.

Caws, Mary Ann. 1981. *The Eye in the Text: Essays on Perception, Mannerist to Modern*. Princeton: Princeton University Press.

Chambers, D. S., ed. 1971. *Patrons and Artists in the Italian Renaissance*. Columbia: University of South Carolina Press.

Chambers, Douglas. 1971. " 'A Speaking Picture': Some Ways of Proceeding in Literature and the Fine Arts in the Late-Sixteenth and Early-Seventeenth Centuries." In Hunt 1971, 28–57.

Chapman, George. 1962. *The Poems of George Chapman,* ed. Phyllis Brooks Barnett. New York: Russell and Russell.

Charlton, Kenneth. 1965. *Education in Renaissance England.* London: Routledge and Kegan Paul.

Chew, Samuel C. 1962. *The Pilgrimage of Life.* New Haven: Yale University Press.

Clark, Kenneth. 1950. *Landscape Painting.* New York: Charles Scribner's Sons.

———. 1964. "Landscape in Art: Medieval and Modern Periods." *Encyclopedia of World Art* 9, 2–38.

Clayborough, Arthur. 1965. *The Grotesque in English Literature.* Oxford: Clarendon Press.

Colie, Rosalie. 1966. *Paradoxica Epidemica: The Renaissance Tradition of Paradox.* Princeton: Princeton University Press.

Colonna, Francesco. 1969. *Hypnerotomachia: The Strife of Love in a Dreame (1582).* Amsterdam: Theatrum Orbis Terrarum; New York: Da Capo Press.

Colvin, H. M.; Ransome, D. R.; and Summerson, John, eds. 1975. *The History of the King's Works, Volume III: 1485–1660 (Part I).* London: Her Majesty's Stationery Office.

Colvin, Sidney. 1905. *Early Engraving and Engravers in England (1545–1695).* London.

Connell, Dorothy. 1977. *The Makere's Mind.* Oxford: Clarendon Press.

Corbett, Margery, and Lightbown, Ronald. 1979. *The Comely Frontispiece: The Emblematic Titlepage in England, 1550–1660.* London: Routledge and Kegan Paul.

Cornforth, John. 1984. "Canons Ashby Revisited—II." *Country Life* 176, 20–24.

Cousins, A. D. 1979. "The Coming of Mannerism: The Later Ralegh and the Early Donne." *English Literary Renaissance* 9.1, 86–107.

Cowley, Robert Ralston. 1940. *Unpathed Waters: Studies in the Influence of the Voyagers on Elizabethan Literature.* Princeton: Princeton University Press.

Croft-Murray, Edward. 1962. *Decorative Painting in England, 1537–1837.* 2 vols., London: Country Life.

Cummings, R. M., ed. 1971. *Spenser: The Critical Heritage.* New York: Barnes and Noble.

Curtius, Ernst Robert. 1953. *European Literature and the Latin Middle Ages,* trans. Willard R. Trask. Bollingen Series 36. New York: Pantheon Books.

Dacos, Nicole. 1969. *La Découverte de la Domus Aurea et la formation des grotesques à la Renaissance.* London: Warburg Institute; Leiden: E. J. Brill.

———. 1977. *Le Logge di Raffaelo: Maestro e bottega di fronte all'antico.* Roma: Istituto Poligrafico dello Stato.

Dallett, Joseph B. 1960. "Ideas of Sight in *The Faerie Queene.*" *ELH* 27.2, 87–121.

Danby, John. 1966. *Poets on Fortunes Hill: Studies in Sidney, Shakespeare, Beaumont and Fletcher* (1952). Port Washington, N.Y.: Kennikat Press.

Daniells, Roy. 1966–67. "The Mannerist Element in English Literature." *University of Toronto Quarterly* 36.1, 1–12.

Day, Angel. 1599. *The English Secretarie* (1586).

Deats, Sara Munson. 1980. "Myth and Metamorphosis in Marlowe's *Edward II.*" *Texas Studies in Language and Literature* 22, 304–21.

Dekker, Thomas. 1955. *Dramatic Works,* ed. Fredson Bowers. 2 vols., Cambridge: Cambridge University Press.

Derrick, John. 1581. *The Image of Irelande.*

Dewar, Mary. 1964. *Sir Thomas Smith: A Tudor Intellectual in Office.* London: Athlone Press.

Digby, George Wingfield. 1963. *Elizabethan Embroidery.* London: Faber and Faber.

Dobrez, Livio. 1980. "Mannerism and Baroque in English Literature." *Miscellanea Musicologica* 11, 84–96.

Donne, John. 1967. *Complete Poetry,* ed. John T. Shawcross. New York: Anchor Books (Doubleday).

Doran, Madeleine. 1954. *Endeavors of Art: A Study of Form in Elizabethan Drama.* Madison: University of Wisconsin Press.

Drayton, Michael. 1961. *Works,* ed. J. William Hebel, Kathleen Tillotson, and Bernard H. Newdigate. 5 vols., Oxford: Shakespeare Head Press.

Drury, P. J. 1980. "No Other Palace in the Kingdom Will Compare with It: The Evolution of Audley End, 1605–1745." *Architectural History* 23, 1–39.

Duncan-Jones, Katherine. 1980. "Sidney and Titian." In *English Renaissance Studies Presented to Dame Helen Gardner in Honour of Her Seventieth Birthday,* 1–12. Oxford: Clarendon Press.

Dundas, Judith. 1965–66. "Elizabethan Architecture and *The Faerie Queene:* Some Structural Analogies." *Dalhousie Review* 45, 470–78.

———. 1981. "Fairyland and the Vanishing Point." *Journal of Aesthetics and Art Criticism* 40.1, 82–84.

Dutton, Ralph. 1948. *The English Interior: 1500 to 1900.* London: B. T. Batsford.

Dwyer, J. J. 1946. *Italian Art in the Poems and Plays of Shakespeare.* N.p.: The Shakespeare Fellowship.

Edgerton, Samuel Y., Jr. 1972. "*Maniera* and the *Mannaia:* Decorum and Decapitation in the Sixteenth Century." In Robinson and Nichols 1972, 67–103.

———. 1975. *The Renaissance Rediscovery of Linear Perspective.* New York: Basic Books.

Edmond, Mary. 1980. "Limners and Picturemakers: New Light on the Lives of Miniaturists and Large-scale Portrait-painters Working in London in the Sixteenth and Seventeenth Centuries." *Walpole Society* 47, 60–242.

———. 1983. *Hilliard and Oliver: The Lives and Works of Two Great Miniaturists.* London: Robert Hale.

Elsky, Martin. 1983. "John Donne's *La Corona:* Spatiality and Mannerist Painting." *Modern Language Studies* 13.2, 3–11.

Empson, William. 1960. *Some Versions of Pastoral*. Norfolk, Conn.: New Directions.

Englefield, W. A. D. 1923. *The History of the Painter-Stainers Company of London*. London: Chapman and Dodd.

Esler, Anthony. 1966. *The Aspiring Mind of the Elizabethan Younger Generation*. Durham, N.C.: Duke University Press.

Ettin, Andrew. 1979. "Quality and Direction in *The Shepheardes Calender*." In David A. Richardson, *Spenser at Kalamazoo*. Cleveland: Cleveland State University (microfiche).

Evett, David. 1970. " 'Paradice's Other Map': The *Topos* of the *Locus Amoenus* and Marvell's *Upon Appleton House*." *PMLA* 85.3, 506–16.

——— . 1982. "Mammon's Grotto: Sixteenth-Century Visual Grotesquerie and Some Features of Spenser's *Faerie Queene*." *English Literary Renaissance* 12, 180–209.

——— . 1986. "Donne's Poems and the Five Styles of Renascence Art." *John Donne Journal* 5, 101–31.

——— . 1988. Review of Roston 1987. *Comparative Literature Studies* 25.2, 184–93.

Fairchild, Arthur H. R. 1937. *Shakespeare and the Arts of Design (Architecture, Sculpture, and Painting)*. University of Missouri Studies 12.1.

Farmer, Norman K., Jr. 1984. *Poets and the Visual Arts in the English Renaissance*. Austin: University of Texas Press.

Farnham, Willard. 1971. *The Shakespearean Grotesque*. Oxford: Clarendon Press.

Ferguson, Arthur B. 1979. *Clio Unbound: Perception of the Social and Cultural Past in Renaissance England*. Duke Monographs in Medieval and Renaissance Studies 2. Durham, N.C.: Duke University Press.

Fischel, Oskar. 1948. *Raphael*, trans. Bernard Rackham. 2 vols., London: Kegan Paul.

Fletcher, Angus. 1964. *Allegory: The Theory of a Symbolic Mode*. Ithaca, N.Y.: Cornell University Press.

Focillon, Henri. 1948. *The Life of Forms in Art* (1942), trans. Charles Beecher Hogan and George Kubler. 2nd English ed., New York: George Wittenborn.

Foster, Leslie D. 1974. "Poetry Both Sacred and Profane: The History of the Conception of the Artist from Plato to Sidney's *Defense*." *Michigan Academician* 7, 57–74.

Fowler, Alastair. 1964. *Spenser and the Numbers of Time*. New York: Barnes and Noble.

——— . 1972. "Periodization and Interart Analogies." *New Literary History* 3.3, 487–509.

Foxe, John. 1563. *Actes and Monuments of the English Martyrs*.

Freeman, Rosemary. 1966. *English Emblem Books*. London: Chatto and Windus.

Friedländer, Max. 1949. *Landscape—Portrait—Still-life: Their Origin and Development*, trans. R. F. C. Hull. New York: Philosophical Library.

Frye, Roland Mushat. 1978. *Milton's Imagery and the Visual Arts: Iconographic Tradition in the Epic Poems*. Princeton: Princeton University Press.

———. 1980. "Ways of Seeing in Shakespearean Drama and Elizabethan Painting." *Shakespeare Quarterly* 31.3, 323–42.

Gaither, Mary. 1961. "Literature and the Arts" [bibliography]. In Newton P. Stallknecht and Horst Frenz, eds., *Comparative Literature: Method and Perspective*, 153–70. Carbondale: Southern Illinois University Press.

Gardner, Arthur. 1973. *English Medieval Sculpture* (1935). 2nd ed., Cambridge: Cambridge University Press.

Gascoigne, George. 1968. *Works,* ed. John W. Cunliffe (1902). 2 vols., New York: Greenwood Press.

Gent, Lucy. 1981. *Picture and Poetry, 1560–1620: Relations between Literature and the Visual Arts in the English Renaissance*. Leamington Spa, Eng.: James Hall.

Giamatti, A. Bartlett. 1966. *The Earthly Paradise and the Renaissance Epic*. Princeton: Princeton University Press.

Gibson, Walter S. 1977. *Bruegel*. London: Thames and Hudson.

———. 1981. "Artists and *Rederijkers* in the Age of Bruegel." *Art Bulletin* 53.3, 426–46.

Gilbert, Creighton E. 1980. *Italian Art, 1400–1500: Sources and Documents*. Englewood Cliffs, N.J.: Prentice-Hall.

Gilbert, Neal W. 1960. *Renaissance Concepts of Method*. New York: Columbia University Press.

Gilman, Ernest B. 1978. *The Curious Perspective: Literary and Pictorial Wit in the Seventeenth Century*. New Haven: Yale University Press, 1978.

———. 1980. "Shakespeare's Visual Language." *Gazette des Beaux Arts* 96, 45–48.

———. 1986. *Iconoclasm and Poetry in the English Reformation: Down Went Dagon*. Chicago: University of Chicago Press.

Giovanni, C. 1950. "Method in the Study of Literature in Its Relation to the Other Fine Arts." *Journal of Aesthetics and Art Criticism* 8.3, 185–95.

Girouard, Mark. 1959. "The Development of Longleat House between 1546 and 1572." *Archaeological Journal* 116, 200–222.

———. 1962. "The Smythson Collection of the Royal Institute of British Architects." *Architectural History* 5, 21–184.

———. 1963a. "Arcadian Retreats for the Chase: Tudor and Stuart Hunting Lodges." *Country Life* 134, 736–39.

———. 1963b. "Elizabethan Architecture and the Gothic Tradition." *Architectural History* 6, 23–39.

———. 1976. *Hardwick Hall*. [London]: National Trust.

———. 1978. *Life in the English Country House*. New Haven: Yale University Press.

———. 1983. *Robert Smythson and the Elizabethan Country House*. New Haven: Yale University Press.

Gleason, John B. 1981. "The Dutch Humanist Origins of the DeWitt Drawing of the Swan Theatre." *Shakespeare Quarterly* 32.3, 324–38.

Godfrey, Walter H. 1911. *The English Staircase.* London.

Goldberg, Jonathan. 1981. *Endlesse Worke: Spenser and the Structures of Discourse.* Baltimore: Johns Hopkins University Press.

Gombrich, E. H. 1966. *Norm and Form: Studies in the Art of the Renaissance.* London: Phaidon Press.

Goodison, J. W. 1948. "George Gower, Sergeant-Painter to Queen Elizabeth." *Burlington Magazine* 90, 261–65.

Gordon, Ian A. 1966. *The Movement of English Prose.* Bloomington: Indiana University Press.

Gotch, J. Alfred. 1914. *Early Renaissance Architecture in England* (1901). 2nd ed., London: B. T. Batsford.

———. 1928. *The Growth of the English House from Feudal Times to the Close of the Eighteenth Century* (1909). 2nd ed., London: B. T. Batsford.

Gottfried, Rudolph. 1952. "The Pictorial Element in Spenser's Poetry." *ELH* 19.1, 203–13.

Grant, Maurice Harold. 1957–60. *A Chronological History of the Old English Landscape Painters.* 7 vols., London: F. Lewis.

Greenblatt, Stephen. 1980. *Renaissance Self-Fashioning from More to Shakespeare.* Chicago: University of Chicago Press.

Greene, Thomas M. 1982. *The Light in Troy: Imitation and Discovery in Renaissance Poetry.* New Haven: Yale University Press.

Gresham, Stephen L. 1978. "Literary and Political Consciousness in *A Mirror for Magistrates.*" Paper delivered at the Conference of the Medieval Academy of America.

Greville, Fulke. 1939. *Poems and Dramas,* ed. Geoffrey Bullough. 2 vols., Edinburgh: Oliver and Boyd.

Hageman, Elizabeth. 1976. "In Praise of Poets' Wit: Spenser and the Sister Arts." In David Richardson, ed., *Medieval, Renaissance, and Modern,* 199–213. Kalamazoo, Mich.: Medieval Academy (microfiche).

Hagstrum, Jean H. 1958. *The Sister Arts: The Tradition of Literary Pictorialism in English Poetry from Dryden to Gray.* Chicago: University of Chicago Press.

Hakluyt, Richard. 1903. *The Principall Navigations Voyages Traffiques and Discoveries of the English Nation* (1589). 12 vols., Glasgow: James Maclehose and Sons.

Hall, Sir Peter. 1983. *Peter Hall's Diaries: The Story of a Dramatic Battle,* ed. John Goodman. New York: Harper and Row.

Hamilton, A. C. 1961. *The Structure of Allegory in "The Faerie Queene."* Oxford: Clarendon Press.

———. 1977. *Sir Philip Sidney: A Study of his Life and Works.* Cambridge: Cambridge University Press.

Hansen, Nels Bugge. 1973. *That Pleasant Place: The Representation of Ideal Land-*

scape in English Literature from the 14th to the 17th Century. Copenhagen: Akademisk Forlag.

Harbison, Robert. 1977. Eccentric Spaces. London: Andre Deutsch.

Hard, Frederick. 1930. "Spenser's Clothes of Arras and of Tours." Studies in Philology 27, 162–85.

———. 1934. "Princelie Pallaces: Spenser and Elizabethan Architecture." Sewanee Review 42, 293–310.

———. 1940a. "E.K.'s Reference to Painting: Some Seventeenth Century Adaptations." ELH 7.1, 121–29.

———. 1940b. "Richard Haydocke and Alexander Browne: Two Half-forgotten Writers on the Art of Painting." PMLA 55.3, 727–41.

———. 1951. "Some Interrelations between the Literary and Plastic Arts in 16th and 17th Century England." College Art Journal 10.3, 233–43.

Hardison, O. B., Jr. 1962. The Enduring Monument: A Study of the Idea of Praise in Renaissance Literary Theory and Practice. Chapel Hill: University of North Carolina Press.

Harington, Sir John. 1962. A New Discourse of a Stale Subject, Called the Metamorphosis of Ajax (1596), ed. Elizabeth Story Donno. New York: Columbia University Press; London: Routledge and Kegan Paul.

Harpham, Geoffrey. 1976. "The Grotesque: First Principles." Journal of Aesthetics and Art Criticism 34.4, 461–68.

———. 1982. On the Grotesque: Strategies of Contradiction in Art and Literature. Princeton: Princeton University Press.

Harrison, Stephen. 1603. The Arches of Triumph: Erected in honor of the High and mighty prince James the First of that name. Engraved by William Kip. London.

Harvey, Gabriel. 1884. The Letter Book of Gabriel Harvey [Brit. Lib. Sloane MS 93], ed. Edward John Long Scott. London.

Harvey, John. H. 1951. An Introduction to Tudor Architecture. New York: Pellegrini and Cudahy.

Hathaway, Baxter. 1962. The Age of Criticism: The Late Renaissance in Italy. Ithaca, N.Y.: Cornell University Press.

Hatzfeld, Helmut. 1947. "Literary Criticism through Art and Art Criticism through Literature." Journal of Aesthetics and Art Criticism 6.1, 1–21.

———. 1952. Literature through Art: A New Approach to French Literature. New York: Oxford University Press.

Hauser, Arnold. 1965. Mannerism: The Crisis of the Renaissance and the Origin of Modern Art. 2 vols., New York: Alfred A. Knopf.

H[aydocke], R[ichard]. 1598. A Tracte Containing the Artes of Curious Paintinge Carvinge & Buildinge Written First in Italian by Jo: Paul Lomatius Painter of Milan and Englished by R.H. Student in Physick. Oxford.

Hecksher, William. 1970–71. "Shakespeare in His Relationship to the Visual Arts: A Study in Paradox." Research Opportunities in Renaissance Drama 13–14, 5–71.

Helgerson, Richard. 1976. *The Elizabethan Prodigals*. Berkeley: University of California Press.

——. 1978. "The New Poet Presents Himself: Spenser and the Idea of a Literary Career." *PMLA* 93.5, 893–911.

——. 1979. "The Elizabethan Laureate: Self-Presentation and the Literary System." *ELH* 46.2, 193–220.

Heninger, S. K., Jr. 1975. "The Aesthetic Experience of Reading Spenser." In Richard C. Frushell and Bernard J. Vondersmith, eds., *Contemporary Thought on Edmund Spenser*, 79–98. Carbondale: Southern Illinois University Press; London: Feffer and Simons.

——. 1977. *The Cosmographical Glass: Renaissance Diagrams of the Cosmos*. San Marino, Calif.: Huntington Library.

Henslowe, Philip. 1961. *Henslowe's Diary*, ed. R. A. Foakes and R. T. Rickert. Cambridge: Cambridge University Press.

Herrman, Frank. 1972. *The English as Collectors: A Documentary Chrestomathy*. London: Chatto and Windus.

Hershey, George. 1988. *The Lost Meaning of Classical Architecture: Speculations on Ornament from Vitruvius to Venturi*. Cambridge, Mass.: MIT Press.

Hilliard, Nicholas. 1981. *A Treatise Concerning the Arte of Limning* (c. 1600), ed. R. K. R. Thornton and T. G. S. Cain. N.p.: Mid-Northumberland Arts Group.

Hind, A. M. 1933. "Studies in English Engraving." *Connoisseur* 91, 74–80, 223–33, 363–74.

Hind, A. M.; Corbett, Margery; and Norton, Michael. 1952–55. *Engraving in England in the Sixteenth and Seventeenth Centuries*. 3 vols., Cambridge: Cambridge University Press.

Hodnett, Edward. 1973. *English Woodcuts, 1480–1535* (1935). Oxford: Oxford University Press.

——. 1978. *Frances Barlowe, First Master of English Book Illustration*. Berkeley: University of California Press.

Honig, Edwin. 1959. *Dark Conceit: The Making of Allegory*. Evanston, Ill.: Northwestern University Press.

Hotson, Leslie. 1977. *Shakespeare by Hilliard*. Berkeley: University of California Press.

Howard, Donald R. 1976. *The Idea of the Canterbury Tales*. Berkeley: University of California Press.

Howell, Wilbur Samuel. 1961. *Logic and Rhetoric in Britain, 1500–1750*. New York: Russell and Russell.

Hoy, Cyrus. 1973. "Jacobean Tragedy and the Mannerist Style." *Shakespeare Survey* 26, 49–67.

Hulse, S. Clark. 1978a. "'A Piece of Skilful Painting' in Shakespeare's 'Lucrece.'" *Shakespeare Survey* 31, 13–22.

——. 1978b. "Shakespeare's Myth of Venus and Adonis." *PMLA* 93.1, 95–105.

———. 1985. "Recent Studies of Literature and Painting in the English Renaissance." *English Literary Renaissance* 15, 122–40.

Hunt, John Dixon, ed. 1971. *Encounters: Essays on Literature and the Visual Arts.* New York: W. W. Norton.

———. 1978. "The Visual Arts of Shakespeare's Day." In David Bevington and Jay L. Halio, eds., *Shakespeare: Pattern of Excelling Nature,* 210–21. Newark, Del.: Associated University Presses.

———. 1985. "The Visual Arts in Shakespeare's Work." In John F. Andrews, ed., *William Shakespeare: His World, His Work, His Influence,* 2:425–31. 3 vols., New York: Charles Scribner's Sons.

Hunter, G. K. 1962. *John Lyly: The Humanist as Courtier.* Cambridge, Mass.: Harvard University Press.

Hussey, Christopher. 1967. *The Picturesque: Studies in a Point of View* (1927). London: Archon Books.

Ing, Catherine. 1968. *Elizabethan Lyrics: A Study of the Development of English Metres and Their Relation to Poetic Effects.* London: Chatto and Windus.

Jenkins, Frank. 1961. *Architect and Patron: A Survey of Professional Relations and Practice in England from the Sixteenth Century to the Present Day.* London: Oxford University Press.

Jenkins, Marianna. 1947. *The State Portrait: Its Origins and Evaluation.* Monographs on Archaeology and the Fine Arts 3. N.p.: College Art Association of America.

Jensen, H. James. 1976. *The Muses' Concord: Literature, Music and the Visual Arts in the Baroque Age.* Bloomington: Indiana University Press.

Jeudwine, Wynne. 1979. *Art and Style in Printed Books: Six Centuries of Typography, Decoration, and Illustration.* Vol. 1, *The Fifteenth and Sixteenth Centuries.* London: For the Author.

Johnson, Paula. 1972. *Form and Transformation in Music and Poetry of the English Renaissance.* New Haven: Yale University Press.

Jonson, Ben. 1941. *Works,* ed. C. H. Herford and Percy and Evelyn Simpson. 7 vols., Oxford: Clarendon Press.

Junius, Adrianus. 1585. *The Nomenclator, or Remembrancer,* trans. John Higgins. London.

Kamholtz, Jonathan Z. 1980. "Spenser and Perspective." *Journal of Aesthetics and Art Criticism* 39.1, 59–66.

Kantorowicz, Ernst R. 1957. *The King's Two Bodies: A Study in Mediaeval Political Theology.* Princeton: Princeton University Press.

Kayser, Wolfgang. 1963. *The Grotesque in Art and Literature,* trans. Ulrich Weisstein. Bloomington: Indiana University Press.

Kemp, Martin. 1977. "From *Mimesis* to *Fantasia:* The Quattrocento Vocabulary of Creation, Inspiration, and Genius in the Visual Arts." *Viator* 8, 347–98.

Kernodle, George R. 1944. *From Art to Theatre: Form and Convention in the Renaissance.* Chicago: University of Chicago Press.

Kipling, Gordon. 1977. *The Triumph of Honour: Burgundian Origins of the Elizabethan Renaissance*. The Hague: Leiden University Press.

———. 1981. "Henry VII and the Origins of Tudor Patronage." In Lytle and Orgel 1981, 117–64.

Klaniczay, Tibor. 1978. "La Théorie esthétique du maniérisme." In Balachov, Klaniczay, and Mikhailof 1978, 327–84.

Kroeber, Karl. 1975. *Romantic Landscape Vision: Constable and Wordsworth*. Madison: University of Wisconsin Press.

Kyd, Thomas. 1967. *The Spanish Tragedy* (1587), ed. Andrew S. Cairncross. Lincoln: University of Nebraska Press.

Lang, Berel, ed. 1987. *The Concept of Style* (1979). Rev. ed., Ithaca, N.Y.: Cornell University Press.

Lanham, Richard A. 1965. *The Old Arcadia*. In *Sidney's Arcadia*. New Haven: Yale University Press.

———. 1976. *The Motives of Eloquence: Literary Rhetoric in the Renaissance*. New Haven: Yale University Press.

Lant, Thomas. 1587. *Sequitur celebritas et pompa funebris* [Philip Sidney]. London.

Laude, Jean. 1972. "On the Analysis of Poems and Paintings," trans. Robert T. Denomme. *New Literary History* 3.3, 471–86.

Lavedan, Pierre. 1954. *Représentation des villes dans l'art du Moyen Âge*. Paris: Vanoest.

Lavin, Marilyn Aronberg. 1968. "Piero della Francesca's *Flagellation:* The Triumph of Christian Glory." *Art Bulletin* 50.4, 321–42.

Lawry, Jon S. 1972. *Sidney's Two Arcadias: Pattern and Proceeding*. Ithaca, N.Y.: Cornell University Press.

Leach, Eleanor Winsor. 1978. "Parthenian Caverns: Remapping of an Imaginative Topography." *Journal of the History of Ideas* 39.4, 539–60.

Lee, Rensellaer N. 1940. "*Ut Pictura Poesis:* The Humanistic Theory of Painting." *Art Bulletin* 22.4, 197–269.

Lees-Milne, James. 1951. *Tudor Renaissance*. London: B. T. Batsford.

Leslie, Michael. 1985. "The Dialogue between Bodies and Souls: Pictures and Poesy in the English Renaissance." *Word and Image* 1, 16–30.

Levey, Michael. 1967. *Early Renaissance*. Harmondsworth: Penguin Books.

———. 1971. *Painting at Court*. New York: New York University Press.

———. 1975. *High Renaissance*. Harmondsworth: Penguin Books.

Lewis, Anthony J. 1972–74. "Interdisciplinary Approaches to Shakespeare Studies." *Shakespearean Research and Opportunities* 7–8, 53–60.

———. 1973. "Man in Nature: Peter Breughel and Shakespeare." *Art Journal* 32.4, 405–13.

Lewis, C. S. 1954. *English Literature in the Sixteenth Century, Excluding Drama*. Oxford: Clarendon Press.

Lindenbaum, Peter. 1986. *Changing Landscapes: Anti-Pastoral Sentiment in the English Renaissance*. Athens: University of Georgia Press.

Lodge, Thomas. 1967. *Rosalynde* (1590). In Bullough 1961–75, 2:158–256.

Lomazzo, Giovanni Paolo. 1584. *Trattato dell'arte de la pittura*. Milan.

Louw, H. J. 1981. "Anglo-Netherlandish Architectural Interchange, c. 1600–c. 1660." *Architectural History* 24, 1–23.

Luborsky, Ruth Samson. 1979. "The Allusive Presentation of *The Shepheardes Calender*." *Spenser Studies* 1, 29–67.

Lyly, John. 1902. *Complete Works*, ed. R. Warwick Bond. 3 vols., Oxford: Clarendon Press.

———. 1924. *Campaspe* (1584), ed. Joseph Quincy Adams. Cambridge, Mass.: Houghton Mifflin.

[———] 1953. *Queen Elizabeth's Entertainment at Mitcham: Poet, Painter, and Musician*, ed. Leslie Hotson. New Haven: Yale University Press; London: Oxford University Press.

———. 1964. *Euphues: The Anatomy of Wit* (1578) and *Euphues and His England* (1580), ed. Morris William Croll and Harry Clemons. New York: Russell and Russell.

Lytle, Guy Fitch, and Stephen Orgel, eds. 1981. *Patronage in the Renaissance*. Princeton: Princeton University Press.

McClung, William Alexander. 1977. *The Country House in English Renaissance Poetry*. Berkeley: University of California Press.

Mace, Dean Tolle. 1971. "*Ut Pictura Poesis*: Dryden, Poussin and the Parallel of Poetry and Painting in the Seventeenth Century." In Hunt 1971, 58–81.

McKoy, Richard C. 1979. *Sir Philip Sidney: Rebellion in Arcadia*. New Brunswick, N.J.: Rutgers University Press.

MacQuoid, Percy. 1904. *A History of English Furniture*. 4 vols., New York.

Maiorino, Giancarlo. 1976. "Linear Perspective and Symbolic Form: Humanistic Theory and Practice in the Work of L. B. Alberti." *Journal of Aesthetics and Art Criticism* 34.4, 479–86.

Marabottini, Alessandro. 1969. "Raphael's Collaborators." In Salmi 1969, 199–202.

Marlowe, Christopher. 1973. *Complete Works*, ed. Fredson T. Bowers. 2 vols., Cambridge: Cambridge University Press.

Mayor, A. Hyatt. 1964. "Prints in Elizabethan Poetry." *Metropolitan Museum of Art Quarterly*, November, 135–38.

Mazzaro, Jerome. 1970. *Transformations in the Renaissance English Lyric*. Ithaca, N.Y.: Cornell University Press.

Mercer, Eric. 1953. "The Decoration of the Royal Palaces from 1553–1625." *Archaeological Journal* 110, 150–63.

———. 1962. *English Art, 1553–1625*. Oxford: Clarendon Press.

———. 1975. *English Vernacular Houses: A Study of Traditional Farmhouses and Cottages*. London: Her Majesty's Stationery Office.

Merchant, W. Moelwyn. 1959. *Shakespeare and the Artist*. London: Oxford University Press.

Merriman, James F. 1972–73. "The Parallel of the Arts: Some Misgivings and a Faint Affirmation." *Journal of Aesthetics and Art Criticism* 31.2, 3, 153–64, 309–21.

Miller, Edwin Haviland. 1959. *The Professional Writer in Elizabethan England: A Study of Non-dramatic Literature*. Cambridge, Mass.: Harvard University Press.

Miller, Paul W. 1978. Review of William Keach, *Elizabethan Erotic Narratives*. *Renaissance Quarterly* 31, 250–51.

Miriam Joseph, Sr. 1947. *Shakespeare's Use of the Arts of Language*. New York: Columbia University Press.

Mirollo, James V. 1984. *Mannerism and Renaissance Poetry: Concept, Mode, Inner Design*. New Haven: Yale University Press.

Montaigne, Michel de. 1957. *Complete Works*, trans. Donald M. Frame. Stanford, Calif.: Stanford University Press.

Montgomery, Robert L., Jr. 1961. *Symmetry and Sense: The Poetry of Sir Philip Sidney*. New York: Greenwood Press.

Montrose, Louis Adrian. 1979. " 'The perfecte paterne of a Poete': The Poetics of Courtship in *The Shepheardes Calender*." *Texas Studies in Language and Literature* 21, 34–67.

———. 1980. "Gifts and Reasons: The Contexts of Peele's *Araygnment of Paris*." *ELH* 47.3, 433–61.

Morse, A. K. 1934. *Elizabethan Pageantry: A Pictorial Survey of Costume and Its Commentators, from c. 1560 to 1620*. The Studio 10.

Moryson, Fynes. 1617. *Itinerary*. London.

Mulcaster, Richard. 1582. *The First Part of the Elementarie*.

Munro, Thomas. 1969. *The Arts and Their Interrelations* (1949). Rev. ed., Cleveland: Case Western University Press.

Murray, Linda. 1967. *The Late Renaissance and Mannerism*. New York: Frederick A. Praeger.

Murray, Peter. 1963. *The Architecture of the Italian Renaissance*. New York: Schocken Books.

Murray, Peter and Linda. 1963. *The Art of the Renaissance*. New York: Frederick A. Praeger.

Neale, J. E. 1958. *Essays in Elizabethan History*. London: Jonathan Cape.

Neely, Carol Thomas. 1978. "The Structure of English Renaissance Sonnet Sequences." *ELH* 45.3, 359–89.

Nevinson, John L. 1938. *Catalogue of English Domestic Embroidery of the Sixteenth and Seventeenth Centuries*. London: Victoria and Albert Museum.

Nicolich, Robert N. 1978. "Mannerism and Baroque: Problems in the Transfer of Concepts from the Visual Arts to Literature." In *French Literature and the Arts*, University of South Carolina French Literature Series 5, 23–37.

Nichols, John, ed. 1966. *The Progresses and Public Processions of Queen Elizabeth* (1823). 3 vols., New York: Burt Franklin.

————. 1967. *The Progresses, Processions, and Magnificent Festivities of King James the First* (1828). New York: Burt Franklin.

Nohrnberg, James. 1976. *The Analogy of The Faerie Queene.* Princeton: Princeton University Press.

Norgate, Edward. 1919. *Miniatura, or the Art of Limning,* ed. Martin Hardie. Oxford: Oxford University Press.

Ogden, Henry V. S. and Margaret S. 1955. *English Taste in Landscape in the Seventeenth Century.* Ann Arbor: University of Michigan Press.

Ong, Walter J., S.J. 1956. "System, Space, and Intellect in Renaissance Symbolism." *Bibliothèque d'Humanisme et Renaissance* 18, 222–39.

————. 1958. *Ramus: Method, and the Decay of Dialogue.* Cambridge, Mass.: Harvard University Press.

Orgel, Stephen, and Strong, Roy. 1973. *Inigo Jones: The Theater of the Stuart Court.* 2 vols., London: Sotheby, Parke Bernet; Berkeley: University of California Press.

Panofsky, Irwin. 1948. *Albrecht Dürer* (1943). 3rd ed., 2 vols., Princeton: Princeton University Press.

————. 1962. *Studies in Iconology: Humanistic Themes in the Art of the Renaissance.* (1939). New York: Harper and Row.

————. 1966. *Early Netherlandish Painting.* 2 vols., Cambridge, Mass.: Harvard University Press.

Parker, K. T. 1945. *The Drawings of Hans Holbein in the Collection of His Majesty the King at Windsor Castle.* Oxford: Phaidon Press.

Parks, George B. 1955. "Travel as Education." In *The Seventeenth Century,* 264–90. Palo Alto, Calif.: Stanford University Press.

Parry, Graham. 1981. *The Golden Age Restor'd: The Culture of the Stuart Court, 1603–42.* New York: St. Martin's Press.

Passmore, John. 1972. "History of Art and History of Literature: A Commentary." *New Literary History* 3.3: 575–87.

Patterson, Annabel. 1984. *Censorship and Interpretation: The Conditions of Writing and Reading in Early Modern England.* Madison: University of Wisconsin Press.

Peacham, Henry. 1606. *The Art of Drawing.* London.

Peter, John. 1956. *Complaint and Satire in Early English Literature.* Oxford: Clarendon Press.

Peterson, Douglas L. 1967. *The English Lyric from Wyatt to Donne: A History of the Plain and Eloquent Styles.* Princeton: Princeton University Press.

Petrarch. 1968. *Sonnets & Songs* (Italian and English), trans. Anna Maria Armi. New York: Grosset and Dunlap.

Pevsner, Nikolaus. 1954. "Old Somerset House." *Architectural Review* 116, 163–67.

————. 1956. *The Englishness of English Art.* London: Architectural Press.

————. 1960. *The Planning of the English Country House: A Lecture Delivered at Birkbeck College, 23 May 1960.* London: Birkbeck College.

————. 1964. *An Outline of European Architecture* (1942). 7th ed., Baltimore: Penguin Books.

————. 1968. "The Counter-Reformation and Mannerism." In *Studies in Art, Architecture, and Design*, 1:10–33. 2 vols., New York: Walker.

————, and Nairn, Ian. 1973. *Sussex*. Harmondsworth: Penguin Books.

Phillips, John. 1973. *The Reformation of Images: Destruction of Art in England, 1537–1660*. Berkeley: University of California Press.

Piel, Friedrich. 1962. *Die Ornament-Grotteske in der italienischen Renaissance*. Berlin: Walter de Gruyter.

Piper, David. 1957. "The 1590 Lumley Inventory." *Burlington Magazine* 90, 224–31.

————. 1965. *Painting in England, 1500–1880*. London: Penguin Books.

————. 1975. "Tudor and Early Stuart Painting." In David Piper, ed., *The Genius of British Painting*, 62–110. New York: William Morrow.

Pope-Hennessy, John. 1949. *A Lecture on Nicholas Hilliard*. London: Home and van Thal.

Praz, Mario. 1939. *Studies in Seventeenth-Century Imagery*. 3 vols., London: Warburg Institute.

————. 1974. *Mnemosyne: The Parallel between Literature and the Visual Arts*. The A. W. Mellon Lectures in the Fine Arts, 1967. Bollingen Series 35.16. Princeton: Princeton University Press.

Prescott, Anne Lake. 1978. *French Poets and the English Renaissance: Studies in Fame and Transformation*. New Haven: Yale University Press.

R & B. *See* Rollins.

Rabkin, Eric S. 1976. *The Fantastic in Literature*. Princeton: Princeton University Press.

Rackham, Bernard. 1926. *Early Netherlands Maiolica, with Special Reference to the Tiles at The Vyne in Hampshire*. London: Geoffrey Bles.

————, and Read, Herbert. 1924. *English Pottery: Its Development from Early Times to the End of the Eighteenth Century*. London: Ernest Benn.

Ralegh, Sir Walter. 1928. *The Discoverie of the Large Rich and Bewtiful Empire of Guiana* (1596), ed. V. T. Harlow. London: Argonaut Press.

————. 1951. *Poems*, ed. Agnes M. C. Latham. London: Routledge and Kegan Paul.

Ray, Stephano. 1974. *Raffaello architetto: Linguaggio artistico e ideologia nel Rinascimento romano*. Roma-Bari: Laterza.

Reader, Francis W. 1930. "Wall-Paintings of the Sixteenth and Early Seventeenth Century Recently Discovered in Bosworth House, Wendover, Bucks." *Archaeological Journal* 87, 71–97.

————. 1932. "Tudor Mural Paintings in the Lesser Houses in Bucks." *Archaeological Journal* 89, 116–73.

————. 1935–36. "Tudor Domestic Wall-Paintings." *Archaeological Journal* 92, 242–86; 93, 220–62.

———. 1941. "A Classification of Tudor Domestic Wall Painting." *Archaeological Journal* 98, 181–211.

Redford, John. 1924. *Wit and Science* (c. 1530). In Adams 1924, 325–42.

Reynolds, Graham. 1952. *English Portrait Miniatures*. London: Adams and Charles Black.

Rhodes, Neil. 1980. *Elizabethan Grotesque*. London: Routledge and Kegan Paul.

Rhys, Hedley Howell, ed. 1961. *Seventeenth-Century Science and the Arts*. Princeton: Princeton University Press.

Robertson, D. W., Jr. 1962. *A Preface to Chaucer: Studies in Medieval Perspectives*. Princeton: Princeton University Press.

Robinson, Franklin W., and Nichols, Stephen G., Jr., eds. 1972. *The Meaning of Mannerism*. Hanover, N.H.: University Press of New England.

Rollins, Hyder E., and Baker, Herschel, eds. [R & B]. 1954. *The Renaissance in England: Non-dramatic Prose and Verse of the Sixteenth Century*. Boston: D.C. Heath.

Roston, Murray. 1974. *The Soul of Wit: A Study of John Donne*. Oxford: Clarendon Press.

———. 1987. *Renaissance Perspectives in Literature and the Visual Arts*. Princeton: Princeton University Press.

Rowland, Daniel B. 1964. *Mannerism—Style and Mood: An Anatomy of Four Works in Three Art Forms*. New Haven: Yale University Press.

Rowse, A. L. 1972. *The Elizabethan Renaissance: The Cultural Renaissance*. New York: Charles Scribner's Sons.

Ruskin, John. 1906. *The Stones of Venice*, ed. E. T. Cook and Alexander Wedderburn. London: George Allen.

Sale, Roger. 1968. *Reading Spenser: An Introduction to "The Faerie Queene."* New York: Random House.

Salman, Phillips. 1979. "Instruction and Delight in Medieval and Renaissance Criticism." *Renaissance Quarterly* 32, 303–32.

Salmi, Mario, ed. 1969. *The Complete Work of Raphael*. New York: Reynal.

Sandys, George. 1615. *Relation of a Journey begun An. Dom. 1610*. 1978.

Schleier, R. 1973. *Tabula Cebetis*. Berlin: Gebr. Mann Verlag.

Schroeder, Horst. 1981. "The Mural Paintings of the Nine Worthies at Horsham." *Archaeological Journal* 138, 241–47.

Scoular, Kitty. 1965. *Natural Magic: Studies in the Presentation of Nature in English Poetry from Spenser to Marvell*. Oxford: Clarendon Press.

Sekler, E. F. 1951. "English Staircases." *Architectural Review* 109, 301–3.

Shakespeare, William. 1974. *The Riverside Shakespeare*, ed. G. Blakemore Evans et al. Boston: Houghton Mifflin.

Shearman, John. 1967. *Mannerism*. Harmondsworth: Penguin Books.

Sheavyn, Phoebe. 1967. *The Literary Profession in the Elizabethan Age* (1909). 2nd ed., rev. J. R. Saunders, Manchester: Manchester University Press; New York: Barnes and Noble.

Shute, John. 1912. *The First & Chief Groundes of Architecture* (1563). Facsimile, ed. Lawrence Weaver. London: Country Life.

Sidney, Sir Philip. 1917–26. *Complete Works*, ed. Albert Feuillerat. 4 vols., Cambridge: Cambridge University Press.

———. 1962. *Poems*, ed. William A. Ringler, Jr. Oxford: Clarendon Press.

Simpson, Richard. 1977. "Sir Thomas Smith and the Wall Paintings at Hill Hall, Essex: Scholarly Theory and Design in the Sixteenth Century." *Journal of the British Archaeological Association* 130, 1–20.

Smith, G. Gregory, ed. 1964. *Elizabethan Critical Essays*. 2 vols., London: Oxford University Press.

Smith, Gordon Ross. 1980. "A Rabble of Princes: Considerations Touching Shakespeare's Political Orthodoxy in the Second Tetralogy." *Journal of the History of Ideas* 41.1, 29–48.

Smyth, Craig Hugh. 1963. *Mannerism and Maniera*. Locust Valley, N.Y.: J. J. Augustin.

Southall, Raymond. 1973. *Literature and the Rise of Capitalism: Critical Essays Mainly on the Sixteenth and Seventeenth Centuries*. London: Lawrence and Wishart.

Spenser, Edmund. 1932–49. *Works: A Variorum Edition*, ed. Edwin Greenlaw et al. 7 vols., Baltimore: Johns Hopkins Press.

Stean, J. M. 1977. "The Development of Tudor and Stuart Garden Design in Northamptonshire." *Northamptonshire Past and Present* 5, 383–405.

Stechow, Wolfgang. 1966. *Northern Renaissance Art, 1400–1600: Sources and Documents*. Englewood Cliffs, N.J.: Prentice-Hall.

Steinberg, Theodore L. 1981. "Poetry and the Perpendicular Style." *Journal of Aesthetics and Art Criticism* 40.1, 71–79.

Stevens, Wallace. 1951. *The Necessary Angel*. New York: Alfred A. Knopf.

Stone, Lawrence. 1956. *An Elizabethan: Sir Horatio Palavicino*. Oxford: Clarendon Press.

———. 1965. *The Crisis of the Aristocracy, 1558–1641*. Oxford: Clarendon Press.

———. 1973. *Family and Fortune: Studies in Aristocratic Finance in the Sixteenth and Seventeenth Centuries*. Oxford: Clarendon Press.

Strong, Sir Roy. 1969a. *The Elizabethan Image: Painting in England, 1540–1620*. London: Tate Gallery.

———. 1969b. *The English Icon: Elizabethan and Jacobean Portraiture*. London: Routledge and Kegan Paul; New Haven: Yale University Press.

———. 1969c. *Tudor and Jacobean Portraits*. 2 vols., London: Her Majesty's Stationery Office.

———. 1973. *Splendour at Court: Renaissance Spectacle and Illusion*. London: Weidenfeld & Nicolson.

———. 1975. *Nicholas Hilliard*. London: Michael Joseph.

———. 1977. *The Cult of Elizabeth: Elizabethan Portraiture and Pageantry*. London: Thames and Hudson.

———. 1979. *The Renaissance Garden in England*. London: Thames and Hudson.

———. 1979. *The Renaissance Garden in England*. London: Thames and Hudson.

———. 1983. *Artists of the Tudor Court: The Portrait Miniature Rediscovered, 1520–1620*. [London]: Victoria and Albert Museum.

———. 1984a. *Art and Power: Renaissance Festivals, 1409–1650*. Woodbridge, Eng.: Boydell.

———. 1984b. *The English Renaissance Miniature* (1983). Rev. ed., London: Thames and Hudson.

———. 1986. *Henry, Prince of Wales, and England's Lost Renaissance*. London: Thames and Hudson.

———. 1987. *Gloriana: The Portraits of Queen Elizabeth I*. London: Thames and Hudson.

Strong, Roy, and van Dorsten, J. A. 1964. *Leicester's Triumph*. Leiden: University Press; London: Oxford University Press.

Studing, Richard, and Kruz, Elizabeth. 1979. *Mannerism in Art, Literature, and Music: A Bibliography*. San Antonio: Trinity University Press.

Summers, David. 1972. "Michelangelo on Architecture." *Art Bulletin* 54.2, 146–57.

———. 1982. "The 'Visual Arts' and the Problem of Art Historical Description." *Art Journal* 42.4, 301–10.

Summerson, Sir John. 1949. "John Thorpe and the Thorpes of Kingscliffe." *Architectural Review* 106, 291–300.

———. 1953. *Architecture in Britain, 1530 to 1830*. London: Penguin Books.

———. 1956. "The Building of Theobalds, 1564–1585." *Archaeologia* 97, 107–26.

———. 1966. *The Book of Architecture of John Thorpe in Sir John Soane's Museum*. Walpole Society 40.

Sunderland, John. 1976. *Painting in Britain, 1525 to 1975*. Oxford: Phaidon Press.

Sutherland, James. 1957. *On English Prose*. Toronto: University of Toronto Press.

Sypher, Wylie. 1955. *Four Stages of Renaissance Style: Transformations in Art and Literature, 1400–1700*. Garden City, N.Y.: Doubleday and Co.

———. 1985. "Painting and the Other Fine Arts." In John F. Andrews, ed., *William Shakespeare: His World, His Work, His Influence*, 1:241–56. 3 vols., New York: Charles Scribner's Sons.

Szenczi, Miklos. 1978. "Questions de périodization de la Renaissance anglaise." In Balachov, Klaniczay, and Mikhailof 1978, 295–326.

Talley, Mansfield Kirby. 1981. *Portrait Painting in England: Studies in the Technical Literature before 1700*. N.p.: Paul Mellon Center for Studies in British Art.

Tannenbaum, Samuel A. 1967. *The Handwriting of the Renaissance, Being the Development and Characteristics of the Script of Shakespeare's Time* (1930). New York: Frederick Ungar.

Tayler, Edward William. 1964. *Nature and Art in Renaissance Literature*. New York: Columbia University Press.

Thompson, John. 1966. *The Founding of English Metre*. London: Routledge.

Thomson, Philip. 1972. *The Grotesque*. London: Methuen.

Thomson, W. G. 1973. *A History of Tapestry from the Earliest Times to the Present Day* (1906). 3rd ed., rev. F. P. and E. S. Thomson, East Ardsley, Eng.: EP Publishing.

Tillyard, E. M. W. 1952. *The English Renaissance: Fact or Fiction?* Baltimore: Johns Hopkins University Press.

Tipping, H. Avray. 1929. *The English Home: Period III.* 2 vols., London: Country Life.

Tolnay, Charles. 1935. *Pierre Bruegel l'ancien*. Brussels: Société Nouvelle d'Éditions.

Trevor-Roper, Hugh. 1976. *Princes and Artists: Patronage and Ideology at Four Habsburg Courts, 1517–1633*. London: Thames and Hudson.

Trousdale, Marion. 1973. "A Possible Renaissance View of Form." *ELH* 40.2, 179–204.

Turler, Jerome. 1951. *The Traveiler* (1575), ed. Denver Ewing Baughan. Gainesville, Fla.: Scholar's Facsimiles and Reprints.

Turner, A. Richard. 1966. *The Vision of Landscape in Renaissance Italy*. Princeton: Princeton University Press.

Turner, James. 1979a. "Landscape and the 'Art Prospective' in England, 1584–1660." *Journal of the Warburg and Courtauld Institutes* 42, 290–93.

———. 1979b. *The Politics of Landscape: Rural Scenery and Society in English Poetry, 1630–1660*. Cambridge, Mass.: Harvard University Press.

Tuve, Rosemond. 1961. *Elizabethan and Metaphysical Imagery: Renaissance Poetic and Twentieth-Century Critics*. Chicago: University of Chicago Press.

———. 1966. *Allegorical Imagery: Some Mediaeval Books and Their Posterity*. Princeton: Princeton University Press.

van Dorsten, J. A. 1970. *The Radical Arts: First Decade of an Elizabethan Renaissance*. Leiden: University Press; London: Oxford University Press.

———. 1981. "Literary Patronage in Elizabethan England: The Early Phase." In Lytle and Orgel 1981, 191–206.

van Mander, Carel. 1936. *Dutch and Flemish Painters* (1604), trans. Constant van de Wall. New York: McFarlane Ward and McFarlane.

von der Osten, Gert, and Vey, Horst. 1969. *Painting and Sculpture in Germany and the Netherlands, 1500 to 1600*, trans. Mary Hottinger. Baltimore: Penguin Books.

Wagenaer, Lucas. 1588. *The Mariners Mirrour*, trans. Arthur Ashley.

Walker, John A. 1979. "Art and the Peasantry." *Art and Artists* 13.9, 26–35; 13.10, 14–17.

Wallace, Malcolm. 1967. *The Life of Sir Philip Sidney* (1915). New York: Octagon Books.

Ward-Jackson, Peter. 1967. "Some Main Streams and Tributaries in European Ornament from 1500 to 1750." *V & A Bulletin* 3.2, 58–71.

Warnke, Frank J. 1972. *Versions of Baroque: European Literature in the Seventeenth Century.* New Haven: Yale University Press.

Waterhouse, Ellis K. 1948. "A Note on George Gower's Selfportrait at Milton Park." *Burlington Magazine* 90, 267.

————. 1978. *Painting in Britain, 1530 to 1790* (1953). 4th ed., Harmondsworth: Penguin Books.

Watkin, David. 1979. *English Architecture: A Concise History.* New York: Oxford University Press.

Way, Thomas R., and Chapman, Frederick. 1902. *Ancient Royal Palaces in and near London.* London.

Weinberg, Bernard. 1961. *A History of Literary Criticism in the Italian Renaissance.* 2 vols., Chicago: University of Chicago Press.

Weiss, Roberto. 1967. *Humanism in England during the Fifteenth Century.* Oxford: Basil Blackwell.

Wellek, René. 1941. "The Parallelism between Literature and the Arts." *English Institute Annual,* 29–63.

————, and Warren, Austin. 1956. *Theory of Literature* (1942). 2nd ed., New York: Harcourt Brace.

Whiffen, Marcus. 1952. *An Introduction to Elizabethan and Jacobean Architecture.* London: Art and Technics.

Whinney, Margaret. 1964. *Sculpture in Britain, 1530 to 1830.* Harmondsworth: Penguin Books.

White, Adam. 1982. "Tudor Classicism." *Architectural Review* 171, 52–58.

White, Hayden. 1978. *Tropics of Discourse: Essays in Cultural Criticism.* Baltimore: Johns Hopkins University Press.

White, John. 1981. *The Birth and Rebirth of Pictorial Space* (1957). 2nd ed., New York: Harper and Row.

Whitney, Geoffrey. 1586. *A Choice of Emblemes a[nd] Other Devises.*

Williams, Raymond. 1973. *The Country and the City.* New York: Oxford University Press.

Williamson, George. 1951. *The Senecan Amble: A Study in Prose Form from Bacon to Collier.* Chicago: University of Chicago Press.

Wind, Edgar. 1968. *Pagan Mysteries in the Renaissance* (1958). 2nd ed., New York: Barnes and Noble.

Winters, Yvor. 1939. "The Sixteenth-Century Lyric in England: A Critical and Historical Interpretation." *Poetry* 53, 258–72, 320–35; 54, 35–51. (Repr. in Paul J. Alpers, ed., *Elizabethan Poetry: Modern Essays in Criticism,* 93–125. New York: Oxford Galaxy, 1967.)

Withington, Robert. 1963. *English Pageantry: An Historical Outline* (1918). 2 vols., New York: Benjamin Blom.

Wittkower, Rudolph. 1965. *Architectural Principles in the Age of Humanism.* New York: Random House.

Wolff, Samuel Lee. 1912. *The Greek Romances in Elizabethan Literature*. Columbia University Studies in Comparative Literature. New York.

Wölfflin, Heinrich. 1950. *Principles of Art History: The Problem of the Development of Style in Later Art* (1915; 7th ed., 1929), trans. M. D. Hottinger. New York: Dover Publications.

————. 1966. *Renaissance and Baroque* (1888), trans. Kathrin Simon. Ithaca, N.Y.: Cornell University Press.

Woods, Suzanne. 1978. "Aesthetic and Mimetic Rhythms in the Versification of Gascoigne, Sidney, and Spenser." *Studies in the Literary Imagination* 9, 31–44.

————. 1985. *Natural Emphasis: English Versification from Chaucer to Dryden*. San Marino, Calif.: Huntington Library.

Wotton, Sir Henry. 1651. *Reliquae Wottonianae*. London.

Wright, Louis B. 1958. *Middle-Class Culture in Elizabethan England*. Ithaca, N.Y.: Cornell University Press.

Würtenberger, Franzsepp. 1963. *Mannerism: The European Style of the Sixteenth Century*, trans. Michael Heron. New York: Holt, Rinehart and Winston.

Wyatt, Sir Thomas. 1950. *Collected Poems*, ed. Kenneth Muir. Cambridge, Mass.: Harvard University Press.

Yates, Frances A. 1964. *Giordano Bruno and the Hermetic Tradition*. Chicago: University of Chicago Press.

————. 1966. *The Art of Memory*. Chicago: University of Chicago Press.

————. 1969. *Theatre of the World*. Chicago: University of Chicago Press.

————. 1973. *The French Academies of the Sixteenth Century* (1947). Nendeln, Liechtenstein: Kraus Reprints.

Young, Alan R. 1979. *Henry Peacham*. Twayne's English Authors 251. Boston: G. K. Hall.

Yuen, Toby. 1973. Review of Dacos 1969. *Art Bulletin* 55.2, 301–3.

Index

References to illustrations are printed in boldface type.